BOUNDARIES
IN CHINA

Critical Views

BOUNDARIES IN CHINA

Edited by John Hay

REAKTION BOOKS

Published by Reaktion Books Ltd
11 Rathbone Place
London W1P 1DE, UK

First published 1994

Designed by Humphrey Stone
Jacket designed by Ron Costley
Photoset by Wilmaset Ltd, Birkenhead, Wirral,
Printed and bound in Great Britain
by The Alden Press, Oxford

British Library Cataloguing in Publication Data:

Boundaries in China. – (Critical Views
Series)
I. Hay, John II. Series
951

ISBN 0–948462–37–x
ISBN 0–948462–38–8 (pbk)

Contents

Photographic Acknowledgements

The editors and publishers wish to express their thanks to the following sources for illustrative material and/or permission to reproduce it: Christie's, New York: p. 196; Da Han chubanshe bianjibu (Editorial Committee of Greater China Publishing Company), *Mei Lanfang wutai miben* [Mei Lanfang's Secret Scripts], Taibei, 1976: p. 227; reproduced from Hubei Provincial Museum, *Zenghou Yi Mu* [The Tomb of Marquis Yi of Zeng], Wenwu Press, Beijing, 1989: p. 85 (top); reproduced from Hunai Provincial Museum and Institute of Archaeology, CAS, *Changsha Mawangdui yihao Han mu* [Mawangdui tomb no. 1 of the Han at Changsha], Wenwu Press, Beijing, 1973: p. 87; reproduced from Institute of Archaeology, CAS, and the Hebei Administration of Cultural Relics, *Mancheng Han mu fajue baogao* [An Excavation Report of the Han Tombs at Mancheng], Wenwu Press, Beijing, 1980: p. 85 (bottom); Cheng Yanqiu, Jiao Chengzhi, Jin Huilu and Xu Lingxiao, eds, *Juxue yuekan* [Theatre Studies Monthly] I/3, Beijing, 1932: p. 235; reproduced from *Kaogu* [Archaeology] magazine, no. 2, Beijing, 1975: pp. 91, 94 (bottom), 95 (bottom), 98 (bottom); Xu Muyun, *Liyuan yingshi* [Shadows of the Pear Garden], Shanghai, 1933: pp. 229, 236, 238 (top); Otto E. Nelson, New York: p. 143; reproduced from Shandong Provincial Museum and Shandong Provincial Institute of Archaeology and Cultural Relics, *Shandong Han huaxiangshi xuanji* [Selected Han Dynasty Pictorial carvings from Shandong], Qilu Press, Shandong, 1982: pp. 92, 94 (top), 95 (top and middle), 97, 98 (top), 99, 102; reproduced from Gao Wen, *Sichuan Han dai huaxiangshi* [Han Dynasty Pictorial Carvings from Sichuan], Bashu Press, Sichuan, 1987: p. 101; reproduced from *Wenwu* [Cultural Relics] magazine, no. 3, Beijing, 1991: p. 90; *Wenwu* no. 6, 1977: p. 89; reproduced from Paul Wheatley, *The Pivot of the Four Quarters* (Edinburgh University Press, 1971) cover and p. 16 (top); Wang Dacuo, *Xi Kao* [Compendium of Plays], Shanghai, 1931; reprinted Taibei, 1980: p. 230; Xun Huisheng, *Xun Huisheng yanchu juben xuanji* [Selected Scripts of Xun Huisheng], Shanghai, 1962: p. 228; and Zhongguo yishu yanjiuyuan xiqu yanjiusuo [Research Centre on Theatre of the China Research Institute of Arts], *Mei Lanfang*, Beijing, 1985: pp. 225 and 238 (bottom).

Notes on the Editor and Contributors

JOHN HAY is Professor of Art History at the University of California, Santa Cruz. He received his BA in Chinese Studies at Oxford and a Ph.D. in Chinese Art History from Princeton. He is the author of *Ancient China* (1973) in the Bodley Head Archaeologies series, and has written widely on Chinese figure and landscape painting, art theory, and rocks.

ROBIN D. S. YATES is Burlington Northern Professor of Asian Studies at the Centre for East Asian Studies at McGill University, Montreal. He has published *Washing Silk: the Life and Selected Poetry of Wei Chuang (834–910)* (1988), is currently working on a collection of translated texts, *Lost Classics of Huang-Lao Taoism*, and is a collaborator with Joseph Needham on one part (vol. 5, part 6) of his multi-volume *Science and Civilisation in China*.

WU HUNG is Professor in the Department of Art at the University of Chicago; he won the Joseph Levinson Prize for the best book in the field of traditional Chinese studies in 1991. His publications include *An Illustrated Catalogue of Weights and Measures from Ancient China* (1982) and *The Wu Liang Shrine: The Ideology of Early Chinese Pictorial Art* (1989); his forthcoming books include from *The Double Screen: A Journey into the Chinese Pictorial World* from Reaktion Books, *Monumentality in Early Chinese Art and Architecture* and, co-authored, *3,000 Years of Chinese Painting* and *3,000 Years of Chinese Sculpture*.

PAULINE YU is Dean of Humanities at the College of Letters and Science at the University of California, Los Angeles. She has written and edited several books and articles on issues in Chinese and comparative poetry and poetics including *The Poetry of Wang Wei: New Translations and Commentary* (1980) and *The Reading of Imagery in the Chinese Poetic Tradition* (1987); her *Voices of the Song Lyric in China* is forthcoming. She is now engaged in a project examining the relationship between canon-formation and collections of traditional Chinese poetry.

JONATHAN HAY is Assistant Professor of Fine Arts at the Institute of Fine Arts, New York University. He is currently writing two books, a monograph on the painter Shitao (1642–1707), and a thematic study of painting in the city of Yangzhou, *c.* 1700.

DOROTHY KO is Assistant Professor at the Department of History at the University of California at San Diego. A native of Hong Kong, she received her Ph.D. from Stanford University, and lived in Tokyo for five years. Her primary research interest is the history of women and gender in pre-modern China and Japan. She has published articles on women's education, women's poetry clubs and cults of chastity in 17th- and 18th-century China, and is the author of *Teachers of the Inner Chambers: Women and Culture in Seventeenth-Century China.*

ISABELLE DUCHESNE is an Associate Member of the Ethnomusicology Research Unit at the Centre National de la Recherche Scientifique, and consultant on Cantonese Opera at the Chinatown History Museum, New York; between 1993 and 1994 she was recipient of a Chiang Ching-kuo Post-doctoral Fellowship for research towards her book, tentatively entitled *Actresses and Female Stars in Peking Opera: 1910–1937.* She is currently working on a book about the music of Jingxi (Peking Opera).

REY CHOW was educated in Hong Kong and the United States. She is an associate professor of comparative literature at the University of California at Irvine, and is the author of *Women and Chinese Modernity* (1991), *Writing Diaspora* (1993) and *Primitive Passions: Visuality, Sexuality, Ethnography and Contemporary Chinese Cinema* (1994). Her writings in English have been translated into Chinese, Spanish, French and Japanese.

ANN ANAGNOST is an assistant professor of anthropology at the University of Washington, Seattle. She has published numerous articles on contemporary Chinese society and culture which have appeared in *Modern China, Positions,* and numerous edited volumes. She has just completed a book which explores the discursive production of national subjectivity in socialist China.

ZHANG HONGTU was born in Gansu Province, in northwest China, in 1943, but grew up in Beijing, where he studied at the Central Academy of Arts and Crafts. In 1982 he left China to pursue a career as a painter in New York. Since then he has had solo exhibitions in New York and at Harvard, and has participated in numerous group exhibitions. He was a member of the 'Epoxy' collective in the late 1980s, and his works are in public collections in China and the USA.

Chronology

Neolithic *c.*7000 – *c.*1600 BCE

Dynasties

Xia First half of the 2nd millennium BCE
Shang *c.*1600 – *c.*1027 BCE
Zhou *c.*1027–256 BCE
 Western Zhou *c.*1027–771 BCE

 Period of the Spring and Autumn Annals 722–481 BCE

 Eastern Zhou 771–256 BCE

 Warring States 481–221 BCE

Qin 221–206 BCE
Han 206 BCE–CE 220
 Western Han 206 BCE–CE 8
 Eastern Han CE 25–220

Wei, Jin and the period of North/South Division CE 220–589

Sui 581–618
Tang 618–907
Five Dynasties 907–960
Song 960–1279
 Northern Song 960–1126
 Southern Song 1127–1279
Liao 947–1125
Yuan (Mongol) 1279–1368
Ming 1368–1644
Qing (Manchu) 1644–1911
Republic 1912–1949 Taiwan (Republic of China) 1949–
Peoples' Republic of China 1949–
(Cultural Revolution 1966–76)

Introduction

JOHN HAY

45.30N 72.35W, 41.50N 87.45W, 34.00N 118.15W, 36.58N 122.03W, 40.45N 74.00W, 32.45N 117.10W, 40.45N 74.00W, 33.41N 117.50W, 47.35N 122.20W, 40.45N 74.00W

Harvard, Harvard, Stanford, Princeton, Yale, Stanford, University of Paris (Sorbonne), Stanford, Michigan, Beijing (Central Academy of Arts and Crafts)

Animals are divided into: (a) belonging to the Emperor, (b) embalmed, (c) tame, (d) sucking pigs, (e) sirens, (f) fabulous, (g) stray dogs, (h) included in the present classification, (i) frenzied, (j) innumerable, (k) drawn with a very fine camelhair brush, (l) *et cetera*, (m) having just broken the water pitcher, (n) that from a long way off look like flies.

Scholars and scholarship, a long way off, looking like flies

This volume contains nine essays on very disparate topics in the study of the cultures of China, from the third century BCE to the present. The nine authors, though specialists in sinology, represent disciplines such as art history and literary criticism that are often treated by academic institutions as quite separate. In a period of increasingly interdisciplinary practice, however, this kind of publication has become almost conventional.

Somewhat less usual is the set of concerns that brings these authors together. Indeed, the unity of this collection is an elusive quantity, as suggested by the design on the cover – which (perversely) is intended to signify an absence, rather than a presence, of writing upon boundaries defined in any administrative or concrete sense.

Collections of essays are customarily preceded by a list of contents. Between the summary signalling of topic in the titles, and the substance of the essay itself, intrudes the Introduction, declaring some kind of 'common cause' – either the authentic origin of the project or a retrospective justification. But the list, the subjects under discussion, the common cause, and the underlying pattern of intellectual activity spreading beyond these first three, are four quite different orders of thing.

A list of the latitudes and longitudes at which each author has their office (the first list presented above) is an accurate key to the geography of scholarship, even if the names of the institutions to which those offices belong would be a more orthodox reference. The list certainly provides information relevant to the reader's understanding. The expectations provoked by a list that repeated only one set of coordinates would be quite different from those aroused by one in which 122°/37° alternated with 42°/71°, or one in which the variations seemed entirely random. Similarly, a list of the universities at which the authors trained (the second list provided above) gives rise to another train of expectations. Conversely, an author's name is for many purposes entirely irrelevant to a scholarly analysis, but it is central to the language of *curricula vitae* on which the entire structure of Academe is so irredeemably suspended (Arnold Hauser, although he wrote a chapter on 'Art History Without Names' in his *The Social History of Art*, did not leave his name off the book.) After all, scholarship occurs in the spaces between scholars – but there would be no spaces without the scholars.

Scholarship itself appears to be a category of some sort, but a very elusive one. It seems easier to describe it as occurring in the space between many other categories, such as names, training and affiliations of scholars. It is contingent upon them all but not co-extensive with – let alone the same as – any of them. None of these categories mean anything until located in relation to others; only as, and where, they come into conjunction does a field of meaning develop.

Categories collect similarities, but always a similarity defined by a difference. The difference is a boundary. 'Same as' and 'different from' are not symmetrical, and the topography of these relationships is extremely complicated. In trying to conceptualize it, one could focus on the categories and on a few equations very selectively abstracted from the more obvious linkages of interaction: those between hopeful, anxious and frustrated publishers, editors and authors; between publishers and purchasers; between readers and texts; between discourses in history and historical narration; between different texts and different categories of text, different scholars and different categories of scholar; between written and spoken texts, teachers and students; between different institutions, different methodologies, different disciplines and different traditions of scholarship; between what is called scholarship and what is not; between writing and not writing; between having, losing and not having a job, *et cetera*. The actual work of scholarship is another reality, for it can only proceed within all of these endlessly complicated fields of exchange.

When *living* scholarship, as opposed to discussing it, one does not work directly with categories so much as against and through the many boundaries between which the discourse of scholarship is constructed. The institutionalized or conceptualized structures of sinology/not, post-modernism/other, anthropology/history/literature, or East-coast/Mid-west/West-coast, research/teaching/administration, for example, are not the unmediated, living textures of experience. These are woven out of events at the interfaces where psychological, linguistic and social structures acquire historical meaning.

Seeking for an image, one might suggest the larger pattern of currents in a body of water as energy is exchanged among and across the boundaries of the smaller patterns of energy moving through it. At least there are three dimensions in this marine metaphor; it also attracts attention to the variety of surfaces and textures. When one underwater current meets another, one may think of surfaces not only between the water and the air but also between the two moving masses of water. The surface-surface is a comparatively stable interface between liquid and gas, two very different structures and densities; but the submerged surfaces are very unstable, as two fluid structures identical except in their molecular movement collide, merge and dissolve into each other.

However, if the water eventually washes up on a sandy shore, much greater differences of texture and density will make boundaries vividly clear to the eye, with water and sand in constant interaction, dispersing in each other but never dissolving. The agitated negotiation between water and a pebble beach, or the collision between water and solid rock, present yet different boundary interactions between differently textured surfaces, some open and penetrable, some closed and hard. Beyond what seems at first sight to be a clear set of water-air boundaries, extends the comprehensive pattern of exchange in the hydrological system at large. The scope of visibility and the perception of systematicity depend upon the level of observation.

The point of this, perhaps overly involved, metaphor is not simply the cliché of relativity. It emphasizes that, once beyond the abstraction of linear boundaries in two-dimensional geometry, and of planar boundaries in three-dimensional geometry, the surfaces, textures and spaces of experience are inextricably involved in boundaries whose systematic totality is always a function of interference and observation.

One might object that it is foolishly reductionist to discuss the dynamics of culture in terms of physical structures. However, apart from the fact that the complexity of physical systems is such that a 'reduction-

ist' charge seems severely misconstrued, words like 'field', 'boundary' and 'dynamics' reveal that the spaces between intellectual structures, physical description and material history are themselves among the most elusive but persistent boundaries of all. (Both the concept of reduction and the dichotomization of culture and material are therefore 'paranoiac', in a sense.) Sometimes, rather than setting off oppositions, it is better to modify one's conceptual arrangements bit by bit.

The spatial structure of boundaries in human thought and practice are, indeed, much more complex. To add the fourth dimension would be an improvement to our metaphors, for boundary processes are always active in time. But the relationship between continuities and discontinuities is particularly hard to frame, since the criteria and measure of continuity itself are established within the process itself. The spaces and times may both be discontinuous according to one framing, but continuous in another.

We are nowadays used to the dissolution of traditional topographies into heterotopies of images, words and texts that are transmitted instantaneously around the world; but we find it harder to accommodate heterochronicity as a valid analytical model. In the psyche, of course, there are no discontinuities because there are no different times. The past is, by definition, part of the present. In the culture of contemporary scholarship, in contrast, contemporaneity is a value that is often used to exclude the past. But major cultural traditions often incorporate several temporal constructions of continuity and discontinuity. In the Chinese tradition, for example, there were not only linear and cyclical constructions of time, but also an entire dissolution of linear time in the idea of a perfected state (fostered by utopian views), and a limited heterochronicity, in which several pasts could be contemporary with the present.

There are certainly temporal boundaries operating in all cultures, but as with changing circumstances of geography and communication, the temporal space of the chronologies and the topographical time of the geographies are very mobile, expanding and contracting according to local conditions. In contemporary scholarship, both the exposed and the submerged restraints on this mobility are increasingly loose. It is, in any case, clear that in an intellectual and social practice such as scholarship the critical significances of both times and spaces are articulated at their boundaries; and that what may materialize as adjacent, overlapping or interpenetrating is not subject to institutional control, only to censorship. It may also be that the hybridity of interaction in what socio-linguistics calls 'contact zones', and the dispersals of culture in place and time that

are now receiving much academic attention as 'diaspora', are both also deeply embedded and active within much denser cultural bodies. One thinks of holes in the 'sponge' theory of matter and space, and in Chinese foraminate garden-rocks. The field of scholarship is itself perhaps a hybrid cross between a contact zone and a diasporic culture.

All of these issues can be identified among the lists at the beginning of this Introduction, once the misleading isolation and authority of categories has been broken down. A list of contents is much more than a highly abbreviated index in the front of a book. Or, to put it another way, any index is indexical of far more than its contents. This lesson is most obvious in the last of the three lists, to which I will return shortly.

Collecting

If the common denominator of this volume's list of contents seems elusive, the most tempting response (editorially speaking) is to foreground that elusiveness as a common cause. The generative core of these epistemological dynamics is not so much knowledge as ignorance. These essays form an untidy circle of enquiry into boundaries as a phenomenon – a phenomenon that is coextensive with culture in its much more than geometrical dimensions. The phenomenon is also adumbrated in everything we do as students of culture and history: as nominal subjects vis-à-vis our objects of enquiry and, institutionally and more significantly, as regards our relationship to each other. The essays are 'retrospectively self-reflexive', if such a phrase is permissable. They materialized out of isolated coincidence, but in an environment of increasing commonality.

The collection originated five years ago, with a distinctly inarticulate thought over a cafeteria meal at Kennedy International Airport, at 6:30 am. At the time, realizing that terms such as 'boundary' and 'surface' were persistently flickering in conversations with my colleagues, I decided to ask a number of them if they would be interested in writing around such ideas in their respective fields, leaving the question of what this question meant – and even of whether it meant anything – to be decided simply by whether they said 'yes'. That was the main control over the content of this book.

Since then, I have realized that the conceptual issue of 'boundaries' had already become a lively concern in circles other than my own.[1] At the same time, and as a development out of this first circumstance, words such as 'boundaries' and 'borders' have been appearing ever more frequently, not just in conversations, but as the rubric for academic enterprises – conferences, or books such as this one, for example.[2] The

strongest impetus within this movement has perhaps been an interest in
the structure and dynamics of transgression,[3] especially where such
transgressions predicate boundaries as a necessary resistance. However,
although it is often through accidental transgression that one discovers
the presence and significance of boundaries in both the subjected matter
and the institutions of one's field of study, transgression itself is not the
main focus here. The pattern of this book is divergent rather than
convergent; and its purpose remains more of an intellectual exploration
of the senses rather than an analysis of data.

This should not, of course, obscure the fact that individual authors
have focused on specific issues. They have. It is a matter of what is shared
beyond this: an interest in changes in texture, membranes of resistance,
and fissures of dissolution which betray the presence of boundaries,
unarticulated except implicitly in practice and experience, that run
uncontrolled around and through the categorical conceptualization
explicit in texts and embodied in institutions. Whether one uses one term,
such as 'discourse', for all the levels of articulation in a culture, from sub-
conscious to knowingly explicit, and all regions, from collective to
individual, may be an arbitrary choice. It depends on obscure ontological
distinctions. What is important here is the process of excavating through
the levels and across currents of knowledge, from those fully exposed to
those more subterranean or submarine. Only in Foucault's 'archaeology
of knowledge' can the seemingly explicit systems of categorization and
control be analysed in relation to their original ecologies of response, as
well as being framed by our own needs. The authors in this collection
share an awareness that the boundaries in our own profession are
implicated in those we professedly objectify.

Since the authors are indeed so dispersed on a map of conventional
boundaries, and related by the nature of the exploration rather than by
conceptual categories, I shall by and large leave them to speak for
themselves, introducing their essays mainly through some very general
comments on the matrix to which our enquiries all, in some way, relate.

Lists, categories and boundaries

The last list that precedes this introduction, from 'a certain Chinese
encyclopaedia' opens the preface to Michel Foucault's *The Order of
Things: An Archaeology of Knowledge*. Foucault attributes the origin of
his book to the 'wonderment of this taxonomy', when he came across its
quotation by Jorge Luis Borges.[4] Foucault's *The Order of Things*, first
published in 1966 and appearing in an English translation four years

later, has long become a venerable classic in the methodology of the 'archaeology' of knowledge – even now receding into history as a defining transition in the evolution of knowledge itself. It is worth returning to that distant past.

Foucault's provocative, accidental, fertilizing brush with the utterly disconnected stamen of some singularly, even suspiciously, exotic *flora sinensis* was, so far as I know, never repeated throughout his vast oeuvre. Doubtless its exoticism originally attracted both Borges and Foucault himself to this fragment.

The taxonomy of this mythic encyclopaedia appeared wondrous to these two authors precisely because its categories seemed meaningless. The puzzlement did not lie in the categories themselves, which are remarkably precise. Instead, it lies in our inability to perceive any purpose in the way the lists' inner boundaries are drawn, and by the frustrating lack of clues to any larger pattern of significance to which the list might be subordinated. The enigma of the list disturbs us because of its – possibly fictitious – attribution by Borges to an organized encyclopaedia, and the authoritarian validation it gains as a product of that vast cultural envelope, China. How complex, multiple and elusive are the contexts from which every text derives its meanings!

This resistant obscurity draws out an anxious assessment of the instruments that we have for articulating our engagement. In this case, Foucault begins to ruminate on a set of four interlinked concepts: categories, surfaces, boundaries, and the spaces 'in between'. Excavating these multiple territories in the histories of – mainly French – culture, he established the investigative concept of discursive space and began to map out the boundaries of a set of fundamental discourses.

Of course, the meaning of 'discourse' has generated a discourse of its own in the past thirty years. I take it (very broadly) to refer to the articulatory and expressive practices evolving in specific cultural spheres between and among individuals, groups and institutions, in media such as language, visual imagery, social relationships and psychodynamics. Discourses are the matrices and the products of exchange, rather than a body of objectifying commentary. Although coterminous with their specific cultural ecologies, which are their sum pattern, they are implicit and not explicit, and only fragmentarily or indirectly visible. Their most visible symptoms are probably the explicit systems of classification and the categorical patterns generated within a culture: systems of cosmology and governance, of economic and social production, for instance. Such categories are often represented as binary divisions, such as purity/

pollution, active/passive, legitimate/illegitimate, governing/governed, male/female; or as the boundaries of different but often adjacent spheres, such as word/image, mountains/valleys/plains, Confucianism/Buddhism/ Daoism, politics/religion/sustenance/pleasure.

A characteristic of the explicit articulation of such categories (as opposed to the associated articulatory practices), however, is that they aim for managerial concepts which enable particular phenomena to be grouped together, rather than highlighting the sites of difference themselves – the spaces between the concepts. In situations where the boundary of difference is directly addressed, this tends to be in reaction to a perceived transgression which threatens the clarity of some category with pollution. Although the rhetoric may be that of defending borders, attention to the boundary itself is transitory. The boundary may temporarily become a site of meaning, but has little meaning in itself.

This may seem rather obvious in matters such as political geography and international relations. Equally prominent, however, is the way in which academic analysis values the clarity and organizing power of categorical boundaries. All such boundaries, however, are *drawn* for specific purposes, demarcating particular regimes of power. They are not the *discursive* boundaries of Foucault and others.

Discourses in this latter sense always involve the dynamics of power, but their fields are never subject to control. They extend elusively, inaccessibly and subversively through political and social demarcations that are partly conscious reactions to them. The demarcations are erected as barriers. The boundaries are invisible no-man's lands of subterranean activity, interpenetrating the territoriality of explicit categories. Where a culture's engagement with them takes on characteristics that are more spatial than linear, this space is, of necessity, within the culture, even if it is projected as beyond it. In one context it has been called 'paranoiac space', and its primary form is the distinction between 'Self' and 'Other' – a difference that is not only internal but even central to the self itself.

Boundaries in China: ritual

Foucault, in meditating on the perhaps mythical Chinese encyclopaedia, quite unashamedly resorted to the stereotypical China, a Kingdom of No-Progress:

In our traditional imagery, the Chinese culture is the most meticulous, the most rigidly ordered, the one most deaf to temporal events, most attached to the pure delineation of space; we think of it as a civilization of dykes and dams beneath the eternal face of the sky; we see it spread and frozen, over the entire surface of a

continent surrounded by walls. . . . the Chinese encyclopaedia . . . and the taxonomy it proposes, lead to a kind of thought without space, to words and categories that lack all life and place, but are rooted in a ceremonial space, overburdened with complex figures . . .[5]

Here Foucault was, presumably deliberately, using the figures of Orientalism as figurations of Europe's Other. The centrality of ritual discourse in traditional China, implicit in Foucault's stereotype, has long been acknowledged. In contemporary scholarship, interest in ritual has been revived by changing methodologies that enable us to see ritual as a dynamic system rather than simply as a frozen body of pre/proscriptions.

Ritual does indeed have, as its principal purpose, the maintenance of stability in a system. This inherently sets it against the forces of change; its inception, however, is a reaction to those forces, which are therefore always implicit in it. Ritual is not 'non-change', but tries to demarcate a fundamental boundary between stability and instability. Crucial in the traditional Chinese world view, it was an essential discourse in the language of those who had the explicit responsibility of negotiating the boundaries between historical continuity and discontinuity. The difference between the Confucian and Daoist world views, if such could be singularly defined, might be described as that of ritual and its negation.

It is generally accepted that one of the first evolutionary demarcations of ritual and society is that of 'sacred space'. It is more useful to characterize this as a 'boundary-between': between place and space, the known and the unknowable, the controlled and a threatened surrender of this control to external forces.

Such initial demarcation must occur extremely early, but in the Chinese archaeological record its systematic representations first arise in the late Neolithic and become clear around 2000 BCE, on the cusp of the Bronze Age. This leads rapidly to China's first archaeologically identified political state, the Shang (sixteenth-century BCE to mid-eleventh century BCE) – a culture distinguished by the centrality of its ritual representations. Their most prominent surviving medium is that of many thousands of bronzes, almost all of which are now described as 'ritual vessels'. K.C. Chang, among other archaeologists, has defined the main cultural horizon as a conflation of politics, ritual and bronze.[6] It is on the bronzes that the earliest systematic language of imagery appears. It is also in this period, in the second millennium BCE, that the use of the written language is first clearly institutionalized on bronzes and in divination inscriptions on bone, and starts to become the transformative medium of

history itself. The boundaries between text and image are articulated in very distinctive ways throughout Chinese history, with its peculiarly self-reflexive attitudes toward media; their conjunction in ritual during this early period is symptomatic.

At the beginning of the Zhou (mid-eleventh century – 256 BCE), the later centuries of which are a 'ritual' rather than a political definition, we find the first systematic articulation of both Centrality and Celestial Authority. Both of these closely-related concepts necessitate a critical boundary of difference, again within the ritual construction of the horizontal (politico-territorial) and the vertical (cosmo-ontological) dimensions.[7] A ritual bronze vessel, cast immediately after a critical victory of a Zhou over a Shang army, is one of the earliest Chinese historical narratives surviving. Its inscription contains the earliest known reference to 'the Mandate of Heaven', invoked as the legitimizing cause for the Zhou assault, and records the Zhou king as 'announcing [his victory] to Heaven with the words: 'I must dwell in the centre, and from there rule the people.'[8]

The earlier Shang constructions of the state had been symbolically ordered and justified partly by cardinal orientation, but more importantly by the specific authority of the ancestral lineages of the ruling clans, ultimately deriving from Shangdi. This latter title could be translated as 'Highest Lord'. However, the dimensionality of *shang* (usually 'upper') is one of authority rather than geometry, and I think that 'Supreme Ancestor' is a better reading.

The difference is critical. Instead of a stratified, ontologically different entity, Shangdi legitimizes the Shang lineages as the source of a generational and sequential (temporal and directional) process. Difference, in these structured dynamics, is specifically tied to continuity. It is transformational, repetitive and parallel, as a consecutive series of articulations in births and deaths of the clans' collective identity through time, and as a concurrent series in the co-relational contemporaneity of agnatic lineages claiming a common ancestor.

Within this clan system there was both centrality and stratification, since at any one time it supported the authority of a single ruler. As K.C. Chang succinctly puts it, 'A large lineage was thus a highly stratified society within itself.'[9] This clan structure was continued by the Zhou, with the firm institution of two main parallel lines, but with Shangdi demoted, distanced, and dispersed through various subcultures, and the whole subjected to the timelessly hegemonic Mandate of Heaven.

The construction of a boundary between origin and authority becomes

a persistent discourse, extending beneath and beyond much explicit conceptualization. *Tian*, 'Heaven', never acquires an unequivocally prior status, and origin never becomes a fundamentally important question.

After only a few periods of Zhou emperors, as political, technological, commercial and intellectual resources became richer and more hetero- geneous, power was increasingly dispersed among multiple centres competing for authority. From the eighth century BCE onwards, various states expanded, shrank, and sometimes disappeared in the struggle for dominance. Until the formal demise of the Zhou in 256 BCE, all these states acknowledged the otherwise powerless Zhou court as the ritual authority at their nominal centre (although it had moved eastwards in 771 BCE). It may be worth bearing this in mind, not as an example of political posturing, but as an instance of how the 'centre' as meaning, rather than geometry, was articulated. In later periods the 'rhetoric of the centre' could sometimes redefine the court as a quiescent pool of power – a symbolically privileged place to confine those with no actual power.

Walls

The Great Wall not only sets off Foucault's China as Other; in surrounding its entirety it also constructs China as a single and unified Other, its surface marked, but not divided by, dykes and dams. The Wall, which is associated with only one of China's main boundary regions, the North, has recently become the subject of a lengthy and illuminating study.[10] In China itself it is frequently used as a signifier of difference, unity and nationhood. This image, however, appears to have been a very recent contribution of the West to China, a case of the Self repossessing itself from the Other's Other.

China has a history of approximately 2500 years of wall-building. Almost all walls were constructed of pounded earth, until some of them were faced with bricks in the sixteenth century. Some of the walls were very long; but there was no 'Great Wall'. Neither was there any clear or single line of demarcation between agricultural society, on one side, and the nomadic societies on the other. These societies interpenetrated each other.

Waldron's thesis, however, is that there was a continuing struggle between the discourse of China/non-China, Han/barbarian, culture/non- culture, Self/Other within Chinese society,[11] and that this was compli- cated by the pragmatics of negotiating with nomadic cultures that needed resources available from the settled culture – and depended upon trade or warfare to acquire them. The responses of the Chinese government over

two millennia were threefold: attack and punish the nomads on their own ground; open a tributary trading relationship; or build walls. The option of walls was usually adopted when there was a stalemate between the more active tactics of rejection or acceptance.

The period of most intensive wall building was in the late sixteenth and early seventeenth centuries in the late Ming, when the north was increasingly threatened by the nomads. Even then, the so-called 'Great Wall' was an erratically developing scheme involving several related walls – and certainly not symbolic of any nationhood. The rulers of the following and final great dynasty, the Qing, had themselves originated from north of the walls and had little interest in them.

This thesis is convincing, yet lacking in some respects. In claiming that the walls actually built were simply a product of military and political debates, confounded by the obscurantism and obstinate myopia of the Han/barbarian discourse, Waldron grants this discourse a symbolic function and simultaneously denies it weight. But these debates were themselves not so much an argument between pragmatists and a discourse of culture, but the categorized responses and negotiations of various parties in a discourse of difference that ran through them all, reacting with other discourses of exchange. The autonomy of the pragmatist is an illusion – both in history and narrative.

Walls and cities

Walls, although a product described in some detail in Waldron's account, become little more than a moveable stage prop in his narrative. But walls themselves are a particular discourse in China, at once highly visible in the topography but fragmentary in the textual topology. Waldron remarks on their beginnings in the archaeological record, enclosing palaces, cities and towns increasingly from the sixteenth century BCE onwards.[12] China was a landscape of walled towns until most of them, including the outer walls of Beijing, were demolished after 1949. Historical answers to the question of why walls were built can only be made in specific cases, with the kind of documentation that Waldron provides for examples in the late Ming.

The discourse concerning walls, so far as it survives in artifactual and literary texts, is not an explanation but the sedimentation of an historical process of representation. The essential representation is that of differ-ence. The earliest evidence of walls, in regions of late Neolithic culture such as Shandong, seems to accompany the rapid development of two kinds of difference: horizontally between communities and vertically

between social strata. These two boundary fields are themselves differentiated: outer and inner; defence and control; event and narrative; the instruments of direct engagement and the representations of ritual.

Political, military, cultural and commercial boundaries were continually shifting in the period known as that of the 'Warring States' (403–221 BCE). In this period, walled cities multiplied. The functions of identity and defence fulfilled by these centres of political, economic and military authority must both have been consciously articulated, but that of defence is more visible in the texts. In a collection of texts known as '[The Book of] Master Guan', variously written between the fifth and first centuries BCE, in a section on local administration and national security, walls are singled out:

The main city wall must be well constructed, the suburban walls impenetrable, village boundaries secure from all sides, gates kept closed, and residential walls and doorlocks kept in good repair. The reason is that if the main walls are not well constructed, rebels and brigands will plot to make trouble. If suburban walls can be penetrated, evil fugitives and trespassers will abound. If village boundaries can be crossed, thieves and robbers will not be stopped. If gates are not kept closed and there are passages in and out, men and women will not be kept separated. If residential walls are not solid and locks are not secure, even though people have rich possessions, they will not be able to protect them.[13]

All of these walls are categories of boundary between sociological differences in allegiance, subjecthood, locality, gender and wealth. The various boundaries are themselves categorized by name, function and position. Thus the 'main city wall' is the *cheng*, a term which can also stand for the walled city in its entirety. It is the inner walls of two concentric enclosures. The suburban and outer wall is the *guo* (in layout, this often dated back to the neolithic). Both terms survive in the modern terminology of city planning.

The walls as boundaries were in themselves sites for meaning, having no inherent meaning of their own beyond the bounding function. The *Master Guan* texts refer to this in various ways: 'The preservation of territory depends upon walls; the preservation of walls depends upon arms. The preservation of arms depends on men, and the preservation of men depends on grain. Therefore, unless a territory is brought under cultivation, its walls will not be secure.'[14] In this mode, walls are an internal differentiation supporting a material definition of the state: agriculture. But through this sequence of dependencies runs the single lineage of ritual and ethical reference: 'City and suburban walls, moats and ditches will not suffice to secure one's defenses. . . . [nor arms, nor

territory, nor wealth] . . . Only those who adhere to the true Way are able
to prepare for trouble before it arises. . . .'[15] Discontinuities are always
given meaning by continuity, and continuities are always signalled by
discontinuities. What one might think of as the hook from which the
central summit of the spatial hierarchy is suspended, or as the first marker
between continuous space and discontinuous place, is located at the
conceptual and representational centre: 'The ruler of men is the most
politically powerful person in the world. So long as he lives secluded men
will dread his power. . . . If the ruler of men leaves his gates and presses
himself upon the people, the people will treat him lightly and be
contemptuous of his power.'[16] This conceptual articulation could materi-
alize through a variety of fields, beside that of space and place. Heaven/
earth, potential/actual and invisible/visible are three more. They all flow
through the spreading of what is called the 'true Way': successive
boundaries in the pattern marked by walls and gates.

The early texts of Master Guan are contemporary with some of the
texts of canonical ritual produced within the surviving traditions of the
imperial Zhou court. The *Zhou Book of Rites* [*Zhouli*] includes the
'Artificer's Record' [*Kaogongji*], probably a late first millennium version
of an earlier text. This contains a description of the *Wangcheng*, 'King's/
Kingly City', originally a name for the Zhou capital and subsequently a
term for the symbolically generic imperial city:

. . . [The Master Builder] constructs the state capitals. He makes a square nine *li*
on each side; each side has three gates. Within the capital are nine north-south
and nine east-west avenues. The north-south streets are nine carriage tracks in
width. On the east is the Ancestral Temple, and on the right are the Altars of Soil
and Grain. In front [i.e. at the centre] is the Hall of Audience and behind it the
markets.[17]

A combination of military needs, political theory and ritual represen-
tation was subsumed in an exemplary ritual representation. This
tradition of legitimization confronted each succeeding dynasty, and those
employed in the establishment of each dynasty were eventually bound to
engage with it. The evidence for this is especially extensive for those
greater dynasties that construed themselves as unifications of both
territory and culture. The first of these was the short-lived Qin (221–206
BCE). The others, in succession, were the Han (Western, 206 BCE–9 CE,
and Eastern, 25–220 CE), the Tang (618–906), the Yuan (1279–1368),
the Ming (1368–1644), the Qing (1644–1911), and Mao Zedong (1949–
?). Notably, the most vigorous of these, namely the Tang, Yuan and
Qing, were established by non-Chinese conquerors.

Beijing has been the site of capitals in the Yuan, Ming, Qing, Republic and Peoples' Republic. Compressed in the layout of Beijing today, itself a fractured series of layers, are representations such as that on the cover of this book (and page 16) – a drawing of a fifteenth-century diagram derived from the *Kaogongji* description. The plan of Beijing is a construction of boundaries. Its singularly powerful conception, and the corresponding diagram, provides an appropriate core for this introduction because it implicates so many issues in representation. Even to start talking about it, however, one has to put in abeyance many other boundary issues of great interest, such as those between text, plan and artifact, between conception and perception, icon and narrative, space and movement, memory and expectation.

The essential structural elements in its conception are rectangular halls, walls, grids of avenues and gates. The essential functions are: symmetry and centrality; successive differentiation between inner and outer through a series of enclosures; four-fold orientation; a conceptual celestial-mundane vertical axis transposed into an actual, horizontal north/south main axis at the centre of an east/west bilateral symmetry; a mapping of movement along axial directionality onto centrality through an assymetrical opposition between south-facing ruler and north-approaching subject; and a mapping of a social hierarchy onto territorialized power through the correlation of inner with higher and outer with lower.

The irreducible thema are cosmic symmetry and the interface between the ritually assymetrical ruler and subject. The subterranean discourse most crucial to the Kingly City seems to have been the construction of power as authority, itself a translation of process/structure in the material universe. The critical function within this process of translation is the articulation of boundaries, as diagrammed in the *Wangcheng* representation.

There were a great many considerations knowingly negotiated through this representation, in reference to politics, society, commerce and defence. Beneath these ran other more complex patterns of subterranean discourse: the densest intersection was perhaps that of the city as an urban centre, the development of which was so prominent a feature of Chinese history. This discourse was far wider than that of the imperial capital, although the functions of control and interaction were implicit in every city. The totality (as an open and not a closed concept) was perhaps too complex ever to be explicitly articulated at the surface. More specifically, however, the dominant political thought and practice of

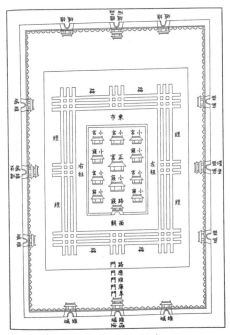

A schematic plan of the central section of Wangcheng,
the 'Kingly City', redrawn from the Imperial Chinese encyclopaedia
[*Yongle Dadian*], completed CE 1407.

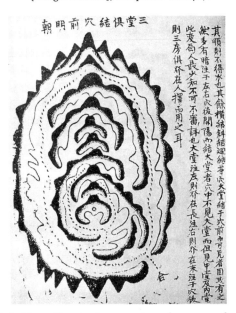

'The Three Halls Come Together', mountain-and-water configurations [*qimo*]
for optimal siting of a building. From a Korean edition of *Shanfa quanshu*,
a Qing dynasty 'earth-pattern' [*dilixue*] manual.

Neo-Confucianism drew its boundaries very firmly. It acknowledged some other discourses in a carefully controlled topology. Religious practices outside of state ritual were laterally supportive, to east and west of the main city axis. Commerce was behind, out of sight. But the Neo-Confucian statecraft did not permit the overt transgression of its own discourse by any other.

Another very prominent and persistent field of boundary-making in which conceptions of urban layout can be traced is the enormous number of encyclopaedias compiled in China during the last two millennia. An early example is the 'Collection [of Matters] to Study First', *Chuxueji*, compiled by Xu Jian in the Tang dynasty. Its principal categories are: The Celestial, The Annual and Seasonal, The Earthly, Regional and Administrative Divisions, Officers of Government, Ritual, Music, Mankind, Government and Regulation, Literature, Military, Daoism and Buddhism, Dwelling, Vessels and Instruments, Dress, Treasures, Fruits and Trees, Animals, Birds. Within the category of 'Dwelling' we find: capitals, inner and outer enclosures (*cheng* and *guo*), palaces, halls, two-storied buildings, terraces, residences, storehouses, gates, walls, parks, gardens, routes and markets. These all mark generic functions, explicated through references to *loci classici*. The 'proper place' is essentially a ritual concept, and the systems of value remain implicit. The need to draw boundaries is fundamental to such a ritual classification of propriety, and they appear in a visibly expressive form, such as walls, with gates marking the permissible sites of transgression.

Bodies

Later Chinese thought is often explicitly concerned with the notion of embodiment, *ti*, which is paired to application, *yong*. A cosmology in which actuality was a state of manifestation out of potentiality could not help but develop some notion of manifestation-as-embodiment, or body as process rather than object. This was indeed the case. Chinese medical theory and practice was a type-site for this, its fundamental texts appearing during the Han dynasty. It was characteristically concerned with organ-functions in terms of zones, activities and states, rather than with a geometrical demarcation of body parts. It has remained a tradition of physiology and pharmacology, rather than of anatomy.

In this physiology, energy (*qi*) was active in differentiated functional states, such as breath or blood, embodied in a complex pattern of circuits under the control of an organ-as-function.[18] Internally, therefore, boundaries were regions of interaction. Externally, the skin was more like the

configuration of a cloud: a very sudden gradient in density rather than a physical enclosure; a dynamic interface rather than a marker of radical difference. The skin area was the main boundary of affective exchange between the body and its environment. The body's surface, therefore, more like a textural depth than a plane, was an extremely important site of intervention in practices such as acupuncture and moxibustion.[19]

The term for an organ-function, for example the heart or lungs, as a functionally precise but spatially indefinite governor of each subsystem, was *zang*, 'depot', the 'storage' of a particular category of energy. The systematic articulation of that function in physiology was called a *xiang*, or 'image'. *Zangxiang*, a term that we might understand as 'representational schema for a physiological system', was attached to the body itself. In this body there was an intersection of boundaries, but no gaps of geometrical space between organs. In the ontology there was no gap between the map and the territory. To put it in Platonic terms, there was no geometry in the ontology of representation, as the mediating device between absolute truth and perceived reality. To put it another way, the epistemic structure allowed very little room for *mimesis* – imitation as an ontologically central function – since the entire process was one of representation manifested in the heaven-earth world. Authenticity unfolded in representation.

Geology also had its embodiments, most predominantly in the *shan-shui*, the 'mountains and waters' that defined both landscape and landscape painting. Comparing the history of painting in Europe and China, one might well characterize the former as a tradition of the human body, and the latter as one of the mountain body. In an art of manifestation, the great tenth-century mountain and water painter, Li Cheng, was said to have 'plundered the productive powers [of the heaven-earth world]'.

Painting was perhaps the most visible way in which the embodiment of mountains was represented, but the practice of 'siting', in which mountain-and-water configurations were analysed to identify the best spot to locate a dwelling, is of particular interest here. Mountain ranges were earthly arteries of pulsing energy called *qimo*; the same term was applied to energy circuits in the human body. The house site was called a *xue*, 'cavity'; the same term was applied to the acupuncture points on the skin. In both cases, these were the points of exchange between the internal and external energy systems. Any specified region of mountains-and-water could be evaluated as an energy field, with its lines of force feeding into particular cavities. The earliest textual evidence for this

'earth-pattern' study, *dilixue*, dates from the period of the First Emperor of Qin. Later there were instruction manuals for such evaluation, and some of these were illustrated with diagrams of exemplary categories of field. The best were ranked as sites of 'ruler's energy'. There are a number surviving from the late Ming and Qing periods and they were probably much older.

These configurations of dynamic processes are basically oriented south, but local configurations of the terrain can shift this somewhat. Typically, however, as in the illustration reproduced on page 16 (taken from a Korean edition of a Qing manual), the site faces south and so the artery of energy must feed in from the north, behind it. The site itself always lies at the foot of the 'lord mountain', encircled by water courses that control the flow of energy. The energy running through the artery of a mountain is pulsed, one might say, by the articulations along the ridge. Any long ridge system, however, will intersect with other ridges and as it crosses through each of these other boundaries, the pulse receives another burst of energy. What is especially interesting to observe is that these later and very coherent diagrams clearly map the 'earth-pattern' configurations onto a plan of the 'kingly city'. The boundary-field system (itself a *xiang*, or representation) must therefore have been seen as essentially the same.[20]

We can further note an even more fundamental concept, that of the *shi*, or 'configuration of energy', in one of its varied renderings. In texts of the Warring States and Qin period it is often paired with *xing*, 'external shape'. A stone has a 'shape'. A boulder balanced at the edge of a cliff is a *shi*. In the language of the legalists, the emperor has his *shi*, so long as he remains within the centre of his government. In this case, *shi* is the power vested in authority. As a general descriptive term it acquired a great many usages, all characteristic of the Chinese tradition, all difficult to translate. I believe it refers, most generically, to the configuration of any phenomenon as it is manifested out of a state of potentiality, from entropic energy into specified matter. Its boundaries are therefore in time as well as space; they are never geometrically precise or fixed. Instead of exterior planes, they have a changeable envelope of textured energy. The bodies of both humans and mountains are *shi*, and we should bear this distinctive concept in mind when trying to excavate many kinds of Chinese boundary.[21]

A case-full of words

An etymological mapping of usages and definitions would be a worthwhile exercise in this current enterprise in boundary exploration, were

etymology the field of any of the authors of this volume. However, a mundane dictionary-check may still be useful. Distant relatives of the dykes and dams in Foucault's fantasy are found in some more readily identifiable Chinese dictionaries, such as the modern general-purpose *Sea of Phrases*. Taking, arbitrarily, the character *jie*,[22] a word that crops up in *jiehua*, a technical term in painting often translated as 'boundary-painting', we find that the *Sea of Phrases*: (1) quotes the 'Explanation of Terms' (*Shuowen jiezi*, compiled by 120 CE), defining *jie* as *jing*, 'specific/circumscribed/walled area'; (2) glosses it through a third-century BCE usage (in 'Intrigues of the Warring States', *Janguoce*) as *pilian*, 'shared boundary'; and (3) through the fifth-century CE 'History of the Later Han' as 'a limiting [standard]'. This game could be taken much further, and I have sampled it only to indicate that categories of demarcation, such as 'wall' and 'standard', are at once revealed; while others such as the configurational *shi* are not.

Boundaries such as *shi* are more deeply embedded in language. Recent scholarship has tended to show that the 'reality' of early Chinese thought is essentially one of language. There is an enormous amount of attention given to categorizing and naming as an essential, but very distinctive, convergence of ontology and epistemology. No real boundary divides these two fields of thought. Categories do not have boxes for boundaries, but are defined by functional relationships.[23] In studying the language itself, Chad Hansen has defined its 'ontology' (he uses the word) as 'mereological'.[24] He bases this on the function of 'mass-nouns' – such as *water, rice* and *paper* – in English. These nouns are delineated by 'measures', by means of which they can be divided up into countable units, such as a *cup of water* and *bowls of rice*. The contents of a mereological ontology are particular 'kinds-of-stuff' and the mereological world is made up of 'interpenetrating stuffs or substantives organized basically under the part-whole relationship'. The name 'water' refers to 'water-stuff', a substance scattered in space-time. 'A cup of water' is one piece of this stuff. Hansen writes:

> The mind is not regarded as an internal picturing mechanism which represents the individual objects in the world, but as a faculty that discriminates the boundaries of the substances or stuffs referred to by names. This 'cutting-up things' view contrasts strongly with the traditional Platonic philosophical picture of objects which are understood as individuals, or particulars which instantiate or 'have' properties (universals). . . . [T]he Platonic view of the mind is one in which the mind knows (has or contains) these 'meanings' or intelligible abstract objects. Chinese philosophy has no theory either of abstract or of mental entities.[25]

Hansen means no limitation by this. It is simply another linguistic way of modelling the universe. His distinction is extremely important in warning us against the whole episteme of abstraction and its boundaries. Of equal interest is the fact that the mereological 'stuff' that he describes is completely consistent with the material universe of *qi* and *shi*. But Chinese thinkers had little inclination to try to go beyond the boundaries of language, in which *qi* and *shi* were phenomenologically incorporated.

Since knowledge is language, and language is representation, representation is perceived as the language of knowledge itself. In contemporary scholarship, representation is recognized as doubly implicit: the representations under study and the system through which those representations are re-represented. Taken historically, there can be no original presentation, only an articulated continuum (space-time) of re-presentation. Teleological traditions such as Christianity represented an original presentation. Autonomous traditions, such as China's, were more inclined to represent its impossibility: 'There is "beginning", there is "not yet having begun having a beginning". There is "there not yet having begun to be that "'not yet having begun having a beginning'" ".'[26]

Zhuangzi (active *c.* 300 BCE), that extraordinary mind at such a critical intellectual juncture, comes to this endlessly recessive speculation after raising the problem of representation in knowledge and, implicitly, in language:

The men of old, their knowledge had arrived at something: at what had it arrived? There were some who thought there had not yet begun to be things – the utmost, the exhaustive, there is no more to add. The next thought there were things but there had not yet begun to be borders. The next thought there were borders to them but there had not yet begun to be 'That's it, that's not'. The lighting up of 'That's it, that's not' is the reason why the Way is flawed. . . . Is anything really complete or flawed? Or is nothing really complete or flawed? . . . It was only in being preferred by [certain great sages in whom knowledge had reached completion] that what they knew about differed from an 'other'; because they preferred it they wished to illuminate it, but they illuminated it without the 'other' being illuminated. . . . Now suppose that I speak of something, and do not know whether it is of a kind with the 'it' in question or not of a kind. If what is of a kind and what is not are deemed of a kind with one another, there is no longer any difference from an 'other'. However, let's try to say it: . . .[27]

And at this point Zhuangzi proposes the nest of questions quoted above: 'There is "beginning" . . .' In his approach, loosely translated into contemporary terms, both of these erasures are representations, as in the *daxian* itself. They are purposeful structures of cultural meaning refer-

ring to other such constructions arrayed in both time and space. Whether Zhuangzi had a sense of cultural relativity, that is, was able to draw a boundary around 'culture' itself, is an open question. There are indications that he had such an awareness, perhaps as a result of the compression of cultural heterogeneity in the Warring States period. For the appropriate contemporary methodology, of course, all boundaries are those of the inescapable episteme of representation. The question for early China is whether a discourse of representation was being consciously articulated, and the example of Zhuangzi gives a positive answer in a field of philosophical enquiry. It is much more concretely demonstrated in the *Yijing*, or 'Book of Change', where it is simply given and described epistemologically as the basis of the correlative universe. The *Yijing*, the relevant section of which was probably compiled during the third to second centuries BCE, became the cosmology of the Confucian canon. The critical term is *xiang*, usually translated as 'image' in both a nominal and verbal sense. The phenomena of this world are all 'images', imaged forth from a state of potentiality (heaven) into actuality (earth). The universe (literally, the 'heaven-earth world') is sustained by the ceaseless transforming, both in and out of potentiality, of this imaging process. Since all phenomena maintain their meaning only through this activity, which also has differentiation/return as one of its axes, there is no divorce of relative from absolute reality, and therefore no role for mimesis as a representational relationship between them. Cosmologically, there is no space of geometry opened up between a representation and its represented. Instead, one has to contemplate the boundary between heaven and earth, potentiality and actuality, source and outcome, as some kind of activity, a phase of 'in-between'.[28] Humanly, we must emphasize, there was a difference and a boundary between the mind and the body, but no ontological distinction. The heart-mind was the chief governing system among the body's many governing systems.

The Chinese language would doubtless be a very rich field to mine for boundaries. The boundary between the spoken language and the written script was ascribed even greater significance in China than it was in the west. The act of writing was persistently *materialized*, and the surfaces of inscription, whether stone, silk or paper, were venerated. Such surfaces became one of the culture's most highly signifying boundaries. The difference between the script and the word is also connected to that between the literary language of authority and the dialects of regionality. Even today, Cantonese scholars sometimes assert that there is no 'dictionary of Cantonese'. This is presumably because only a written

language has a dictionary, and the script of Cantonese, though visible to the eye, is apparently culturally invisible. Analogously, residents of Hong Kong, where culture in its contemporary sense furiously thrives, are likely to say that Hong Kong 'has no culture'. The boundaries of language run deep indeed.

The question of how strange the classifications arising out of language may or may not seem is, as Foucault remarks, not a matter of their content: 'The quality of monstrosity . . . does not lurk in the depths of any strange power. It would not even be present at all in this classification had it not insinuated itself into the empty space, the interstitial blanks separating all these entities from one another.'

Most of the individual categories in Borges' list seem familiar but, as a set, they lie far beyond our common experience. At one extreme, the conjunction is merely an entertaining accident, but at another it becomes a deeply disconcerting glimpse of systematic anarchy. For both Borges and Foucault, once posited as valid within some alien culture, even the possibility of the series promises to dissolve the certainties of our own boundaries and suggests a surprising mobility of horizons in the natural sphere. The discovery confirms the comprehensive encirclement of the most important of these boundaries, that between the sameness of our selves and the difference of the other, yet also emphasizes that boundary's historical and cultural contingency. It is with the primary boundaries between, and the secondary boundaries within, such discourses that all of the essays in this collection are variously concerned. For the purposes of this Introduction I shall shamelessly exploit the first three essays in my attempt to map out the earlier historical territory.

Three essays: foundations and constructions

In 220 BCE, the King of the state of Qin brought several centuries of military contestation to a conclusion in the territorial and political unification – and therefore the initiation – of 'China'. Although the political philosophy of the Qin was officially repudiated by its successor, the Han, it is apparent that Qin influence was great. This was a critical phase of boundary-making in a great many field and at many levels. The attribution of the 'Great Wall' to the First Emperor is a summary myth representing an enormously complex history – it is not surprising that it has been a very attractive myth to the government of communist China.

The first essay in this collection, by Robin Yates, establishes an analytic frame of reference for getting inside this complexity. He examines the way in which boundaries were articulated by Qin political culture in

constructions of space, body, time and bureaucracy, analysing both traditional texts and some very recently excavated legal documents that open up unsuspected windows on this extremely important, but surprisingly obscure, period. He takes much of his analytical methodology from the more recent work of Foucault and his intellectual colleagues. He finds the notion of boundary-making central to political thought of that time, and explores how this concern gave rise to an extraordinarily comprehensive and tightly integrated system. In Yates' view, this 'obsession with boundaries' was a major factor not only in the extraordinary achievements of the Qin, but also in its rapid failure.

Yates states that, for Chinese thinkers of this period, there was an 'isomorphic fit' between language and the world, and he therefore examines the way in which the former categorized the latter. Similarly, he investigates how an understanding of space was represented in border policies, the land-tenure systems and social organizations adopted by different states. Yates examines how developments in the understanding of time implicated changing attitudes towards human destiny, how such destiny depended on the homologies of microcosms in a macrocosmic universe, and how these were incorporated in the conceptualization of the human body itself. A 'vital force or energy (qi)' was universal in the constitution of all matter, including bodies. Boundaries of the body were therefore a matter of configuration rather than of a geometry of flesh, and the function of mind was rather mobile in this ecology. The function of boundaries in such a categorically correlational and materially dynamic system was not only of great theoretical importance, it was also an essential factor in political practice.

The scholars – or political consultants – working under the Qin had to design a bureaucracy to match this ecology. Since the boundaries inherent in the ecology were always relational and unifying, the boundaries determined for political control had to be compatible. As Yates writes, 'all things in the phenomenal world were assigned to their appropriate bounded spaces and functions, and the ruler was required to demonstrate by his ritual actions their correct use.' Among the most important of these ritual demarcations was the establishment of a calendar, although recent discoveries show that 'the Qin state did not . . . have absolute control over the definition of time.' Yates looks at the evidence discovered in the tomb of a local official, and sees an amazingly precise elaboration of ritual distinctions governing everyday administrative practice.

These calendars 'strongly suggest that all the different categories of

activities in the Qin state and empire had their own temporalities, their own modalities of time, their own contrasts and liminalities reflecting the hierarchies and oppositions perceived to exist . . . within Qin society as a whole.' Officials who worked within these boundaries were pure and clean. Those who offended against them transgressed the most dangerous boundary of all: that between purity and pollution. For this, a draconian legal code specified severe punishment. Many of these punishments operated on the boundaries of the body; to what extent such physical mutilation was consistent with the contemporary physiological view of the body, or implied another, is not yet clear.

Whether, more broadly speaking, there was also a discourse of real contention, in the sense of attempts to construct boundaries that were absolute and isolating in conscious opposition to the relations between entities that took place in the 'real' world, is an issue Yates does not go into. One may wonder whether the construction of anything as 'absolute' necessarily involves something analogous to a Platonic ontology and the abstraction of Euclidean geometry. On one hand, these were both absent from a tradition of thought that drew its boundaries in fundamentally different ways. On the other, some aspects of both Qin political thought and other preceding schools, especially the Mohists discussed by Yates, suggest that the contention of alternative conceptual modes was unusually vigorous at this time.

Yates notes the enormous importance of death as a boundary, across which a living human was transformed into an ancestor, but only after passing through a very dangerous phase of pollution. Ritual practice focussed great attention on the successful negotiation of this critical barrier. Today, of course, the most melodramatic manifestation of the First Emperor's megalomania is the terracotta army that was probably intended to march with him into immortality. This other world must have seemed an extraordinary challenge to the First Emperor. What did he expect to meet and accomplish across this boundary? In what form did he expect to meet ancestral spirits? Did he expect to do battle with the Duke of Zhou, or with Shangdi himself? Did he intend to conquer the world of immortality, just as he had the world of the living? Whether any of these questions are answerable I do not know; but in some sense the First Emperor contemplated and engaged with some of the larger discourses that also concern this volume.

In 210 BCE, when travelling back from the coast after killing with his crossbow an enormous fish that was said by his magicians to have prevented them reaching the Isles of the Immortals, the First Emperor

died. From different regions three military leaders, Xiang Liang, Xiang Yu and Liu Bang, rose against his heir. The Qin empire began to break up into many proposed, de facto and declared kingdoms, including one under Liu Bang calling itself the Han. After the conquest of the First Emperor's heir by Liu's forces in 206 BCE, Liu eventually accepted the title of *Huangdi*, Han Gaodi, 'Emperor' Gaodi of the Han, in 202 BCE. This violent transitional phase between two major dynasties was subsequently repeated at each of the five major dynastic transitions.

The division within the Han, after Wang Meng's usurpation of 9–25 BCE, was marked by a removal of the capital from Chang'an to Luoyang (the relationship between cultural and political boundaries involved in the various moves of capitals is one of the many boundary topics not addressed in this volume). Whatever the reasons for this particular mid-life dynastic crisis, ranging from lack of heirs to celestial politics, it is clear that the Western Han was a period of vigorous contention, negotiation and synthesis, in which many discursive boundaries were substantiated and consolidated. Even in the dissolutions attendant on dynastic demise, the greatest changes were probably not so much refragmentation as recuperative, in response to the introduction of the major discourses of Buddhism. (That particular development of boundary-making, a particularly long and complex one, is also not addressed here.)

The second essay, however, by Wu Hung, addresses a boundary (dramatized in particular by the First Emperor), that can be described as an obsession of both individuals and of Han society, and at which one of the primary discourses of transcendence in Buddhism specifically operated.

Buddhism took both the desirability and the necessity of transcendence as a given. It differed radically in this from pre-Buddhist China, where the various specific passages of transcendence, such as death, were accepted as a given, but the nature of transcendence was in itself very problematic, its desirability very much in question. The most striking exemplification of this ontological structure is probably the general absence from Chinese cosmology of an external creator, especially in the hypostasized/dichotomized/mirrored form of 'God'. While Buddhism generated a continuing debate around the problematics of transcendence, there was no substantial competition for the elite, authoritative view of Heaven as the exemplary authority, the macrocosm of the microcosm.

This absence of an external cosmic agent has been termed by F.W. Mote the 'cosmological gulf' that divided the cultural history of China from that of the West.[29] Buddhism's engagement in this question

continued to be negotiated over many centuries. Important though it was in Chinese history, however, that engagement is omitted from this initial exploration.[30]

In the early Han, members of the imperial and aristocratic clans continued to march after the First Emperor, accompanied by their troops, into the world of the spirits. But much more typical and widespread in the Han is the residential aspect of this transposition, the earliest full-scale survival of which is the spectacularly furnished, subterranean tomb-dwelling of the Marquis Yi of Zeng, who was buried in 433 BCE at Suixian in Hubei province. It is difficult to disengage the regional, historical, conceptual and functional differences among the many different aspects of funerary practices that are compressed in the Han material record; but certainly these boundaries appear permeable. There is increasing domestication, bureaucratization and even democratization in the many representations and fragmentarily surviving narratives of the otherworld.

In 'Beyond the Great Boundary: Funerary Narrative in the Cangshan Tomb', Wu Hung offers a schema for this very rich but far from coherent mass of material culture in terms of shifting constructions of death as a limit to a world and as a boundary between worlds. Analysing the cultural history of the *daxian*, 'great boundary', a Chinese term of ancient but obscure usage, Wu finds that it moved around in the working, reworking and elaboration of a critical antithesis: 'this life' and 'the afterlife'. Life itself, however, as both an unbounded medium of continuity and as a bounded category with complex frames of reference, is constituted with some flexibility. Wu thus clarifies the frequently confusing circumstance of 'immortality', a state of being that may be achieved in *this* life, as an erasure of the 'great boundary' itself. He understands 'immortality' to be a specific construction that arose out of the more general belief in autonomy for the soul. Immortality is an elaboration of this broader ecology, in which the soul and a widening context of dwelling, including both the body and its physical environment, can be hidden within this world.

On this basis, the First Emperor's visits to the ocean in the east would be seen as a search for immortality here, in this life. There was another view of this worldly immortality (that of Zhuangzi, for instance), in which body functions were dissolved through purification, leaving only a living essence.

In the Han dynasty a much more complicated situation developed, in which the *daxian* came to be accepted as unavoidable, thus necessitating

that any continuing form of life had to be 'after'. At the same time, the afterlife itself becomes increasingly, if what confusingly, differentiated. Wu Hung discusses an Eastern Han tomb in Cangshan, Shandong Province. As with many later Han tombs, the Cangshan chambers have an extensive pictorial scheme engraved on the walls, but in this case there is also an inscription, unique in its detailed explanation of the funerary scheme. Wu Hung translates this text and analyses a distinction between the static entities of the two lives (this life and the after-life), and the transitional narrative within the boundary passage of death itself. As that boundary temporarily expands, so the afterlife becomes spatially much more systematic.

Among the very interesting boundary issues opened up by Wu's analysis, I will mention three: the problematic of the 'great boundary' itself; the boundaries of the body; and the question of representation. The qualifying 'great' in the term *daxian* certainly marks this bound- ary's importance, but not the absolute significance of a dichotomy between two totally incommensurable worlds, either of man and God, or matter and mind. Nathan Sivin once remarked of the Chinese concept of immortality that 'it was thought of as the highest kind of health.'[31] Under some circumstances, it was even possible to be 'tempor- arily' immortal. Boundaries of space and time evolve as inseparable and distinctively permeable, moveable, reversible, relational and subject to reconstruction. There are no transcendent absolutes. There is, however, a hierarchy in which degrees of cultural perfection (political, social, intellectual or physiological) provide graduated privileges in the con- struction.

The boundaries of the body are deeply, if obscurely, implicit in this account. The early second century BCE burial at Mawangdui, briefly discussed by Wu Hung, was a spectacularly successful example of a body-preservation technology that went back to the Marquis Yi and beyond. There have also been several excavations of Western Han burials in which the corpse was encased in suits of sewn jade plaques. The purpose of this practice was also to preserve the body. The suits were sewn with gold, silver or bronze thread, according to the status of the deceased, presumably indicating graduated rights to the erasure of the death/dissolution boundary. What means were used to preserve the First Emperor is unknown. (Those used for Mao Zedong, of course, are much better known but not necessarily more efficacious.)

The preservation of corpses must surely have been connected in some way to an increasingly sophisticated understanding of the body as a

configuration of processes. This was in the period when the main principles of Chinese medicine were articulated, as discussed above.

Just as Chinese physiology incorporated ritual functions, so did ritual incorporate the body. One of the most recent and valuable discussions of ritual is by Angela Zito, in an anthology of essays on the body in China. In discussing the systematic control of alternative and analogous realms in the highly evolved ritual practices at the Chinese court in the eighteenth century CE, Zito writes:

In [the ritual process of] centering, contrasting categories were encompassed and hierarchized as parts of a totality. The bounding of difference brought difference into being, mediated it, and most important, allowed for its control. Thus boundaries and interfaces were highly charged, highly significant, and uniquely human creations. . . .

Participants, victims and vessels were inspected and manipulated to prepare them as boundaries between an inner and outer field. A logic of resemblance through imitation, . . . contiguity, and correspondence underlay these elaborate homologies. From the intricate textual discussions . . . the abstraction of the yin/yang bipolarity of inner and outer materialized in things. . . . The altars of Grand Sacrifice were concentric zones of boundary walls and levels of platforms. Ritual manuals highlight action at the points of transition. . . . Each participant's own body was not a closed container-thing but rather, like the altar spaces, a complex concatenation of ever more intimate boundaries. The body was an ensemble of focused fields whose shifting edges and surfaces provided the sites for articulation between inner and outer. What we interpret in philosophical texts as the privileging of interiority, an inner self, can be better understood as valuable proof of boundary creation and control.[32]

After two millennia of repeated examination, re-articulation and re-presentation of ritual principles and practices, some essential discourses on the cultural body had come remarkably close to the surface. Ritual itself, of course, is an exemplary genre of representation. The imperial precision of eighteenth-century ritual represented, quite consciously, a concentric ordering of historical and cultural boundaries around the space-time of legitimacy, extending through a very long dynastic sequence. Returning for a moment to its sources, we should note that the unification of the Qin had established the first effective political centre, and the hypostasized Confucian ideology of ritual shattered by that brutal, yet crucial, imposition of order could not itself be recentered and placed on an inexorable train to hegemony until the Han succeeded the Qin. That is, even though 'unification' explicitly presumed diversity, the successive establishment of coherent practices of centrality, first in social ritual and political morality, then in governance and standards, and then in political and social institutions, must have succeeded in obliterating

from the record an equally authentic diversity that surely survived in other realms. It is important to remark this fact, since it should alert us to watch for hidden diversity in boundaries that seem coherent and developments that seem linear. The Han is a critical period as much for the disappearance, as for the appearance, of cultural forms.

For example, the historical development is unlikely to have been as neat as the summarized account which Wu Hung is obliged to present. It is likely that views of immortality and death, of their interrelationship or separability (and therefore of the boundaries of the body) were rather complex and variable. It is certain that there must have been regional and cultural differences. The jade-suits of North China and the insulated tomb-construction of South China in the Western Han, together with other differences in funerary practice, were probably indicators of much greater heterogeneity earlier. The painted silk banners from the Mawang-dui tombs, and the earlier *Chuci*, chants and poems from the southern cultures of several preceding centuries (and of which the Mawangdui principality was a remnant), clearly describe a separate spirit world. Entry into that world seems to have required a physical transformation, and its alterity is signalled in warnings such as, 'O soul, come back! In the south [of the spirit world] you cannot stay. . . . They sacrifice flesh of men and pound their bones to paste. . . .'[33] If sinologists such as David Hawkes and Kwang-chih Chang are correct, the boundaries in this particular part of the pre-Han world were those characteristic of shamanism, with its privileging of transformational and reversible crossings.[34]

Wu's essay, however, takes a first major step in excavating the third stratum of enquiry among this fascinatingly rich and elusive material. The three strata are those, first, of identifying the representations preserved in texts and material survivals and describing their schema; second, of analysing the languages and systems of representation; and third, of tracing and mapping the subterranean patterns and dynamics of the boundary-workings that are articulated through the explicit rep-resentations. The scholarship of even the first level is still only prelim-inary.

One of the particular attractions of *daxian* as an historiographic instrument is that the issues it incorporates tend to be so powerful at all three levels. In excavating through their boundary-areas one may find the visible structural ghost of the invisible processes of representation, like the patterns of differently coloured earth through which archaeologists recognize dissolved objects. The problems inherent in the phenomena of

death and life, and the disputatious nature of pre-Han intellectual enquiry, were such that any thinker of vigour and originality was likely to explore their representation in more than one way. A.C. Graham writes of Zhuangzi, probably the readiest in engaging with these issues, that he sometimes considers:

... the withdrawal from the many into the one as a detachment from the entire world ... one's own body included, into a solitude beyond the reach of life and death; at others he sees it rather as a bursting out of the limits of the single body, to be born and die with every new generation. It would be pointless to ask which is his true position, since in trying to put it into words he is caught up in another dichotomy which he can transcend only by moving freely between the alternatives ... something like 'In losing selfhood I shall remain what at bottom I always was ...'[35]

Zhuangzi comes close to discussing the self and the body as representation, and this is one of the reasons he can seem so extraordinarily modern. His position, while not transportable directly into the twentieth century, certainly invites translation. Living, inevitably, with an epistemological horizon of existence itself as a material and transformational process, and choosing to treat the differentiation of language and representation as a first enclosure around a primal unity at their centre, he implies the construction of all boundaries, surely including the *daxian*. This most critical boundary is not only that of death in life, but also of the body in the mind. The dichotomy of mind and body, which is a version of God and creation, is a boundary in a very different episteme. In that of Zhuangzi, and the First Emperor, the analogous boundary can be erased by a philosophical poetics and by a material immortality.

The Qin-Han transition is clearly extremely important in representational evolution. It used to be said that the Han marked a divide between decorative and representational art, but the issue is much more complex than that. There is no 'pure' decor, and that of Shang dynasty bronze vessels, with or without the predominating *taotie* mask, was certainly a representation of some sort. Whatever and however it signified (and certainly not through mimesis), one might attribute to that period the first achievement of a consistent language of visual imagery. In the subsequent Zhou period, human and animal forms begin to appear in subsidiary and supporting roles. The terracotta army buried with the First Emperor in 210 BCE, with its thousands of life-size figures, is a spectacular shift, for it appears to be entirely mimetic. How it was actually *understood* as representing is an entirely different matter, complicated and as yet unexplained. One may suspect that the differen-

tiation of features that has been considered as individual portraiture –
surely a gravely anachronistic idea – suggests rather the totalitarian
system of anonymous identification by assigned roles, each figure
precisely shaped and detailed by the specifically appropriate *fa* ('mould'/
'law') in a legalist (*fajia*) state. The megalomaniacal emperor may have
realized his ability to take with him into immortality a perfect and rot-
proof army. This would not be mimesis but a perfected control of
manifestation, or *xiang*.

It is noteworthy that, right down to the eighth century CE, the
development of naturalistic appearance in 'representational' images was
most strongly associated with funerary art. Accompanying a deceased
into the after-life, 'realism' had a very specific and obvious purpose – to
ensure living. As Western art history has finally noticed, 'realism' is not
an inherent end of 'art' itself. It is, instead, a very powerful instrument of
culturally specific ideologies. In Han burials there is a sudden effflores-
cence of naturalistically specific representation, in painting, engraving,
modelling and sculpture. Wu Hung's essay arises from this fact. The
extraordinary precedent of the First Emperor's army is only a sign, not an
explanation. The painted banners of Mawangdui, for instance, relate to a
very different evolution of pictorial representation in the south. It is not
possible here to excavate this discourse of representation, but we must
certainly note that there was a critical transition around about the
Western Han – the period of the *Yijing* commentary. Just as a language of
imagery had been discovered in the Shang so, now, there was apparently
a revelation of the epistemology of representation in a universe con-
structed by man. This, in itself, was an historical boundary of great
importance. Equally important was the fact that the ontological bound-
aries within the episteme of representation continued to be drawn quite
differently from those in the West.

Lu Ji (261–303 CE) was the author of one of the most impressive
writings on literature in the whole Chinese tradition. Itself a poem, his
'Description of Literature' includes, among many famous lines, 'At the
beginning of the process of writing,/The poet closes himself to sight and
sound,/Deeply he contemplates, widely he enquires in spirit;/His spirit
roams in the eight directions,/. . ./. . ./[His] feelings gradually dawn to
increasing clarity/Objects become clear and present themselves to him in
a stable order/ . . .'[36] For Lu, as for other literati, literature was feeling
embodied in images, *xiang*, and writing was representing, *xiang*, in
words. The power of representation was thereby appropriated by the
gentry-literati; and among the many cultural forms that emerged from

the Han (as vigorous as the political body itself was weak), was the writing of literature, both as calligraphy and text. In terms of the discourse of power underlying the rhetoric of culture, calligraphy and text might be described, respectively, as the exclusively appropriated media of a particular social class and that class's self-construction as the cultural elite.

As with the other cultural constructions we have mentioned, this involved a synchronic, horizontal stratification in a hierarchy, and a diachronic evolution of legitimacy. Some functions, such as clan lineages, were doubtless already available to the social groups out of which the gentry-literati developed. In a rapidly changing society, other constructions of legitimacy and control had to be appropriated or created. Among these was the production of critiques and texts by advisors to the Qin court. In the slow accretion and erratic dynamics of a developing core cultural tradition, the importance of language and texts in this construction was widely realized. The First Emperor, or his advisors, were exceptionally perceptive in this regard. A shared but variable script, the 'great seal', and even more variant regional orthographies, were current in the late third century BCE. Under the Chancellor of the Left, Li Si, the Qin government purposefully regularized this heterogeneity into the 'small seal', as they did in other crucial fields, such as laws, currency, transportation and weights and measures. Whether they faced this problem in language, as well as script, is not known. At a court banquet in 213 BCE, however, an academician was rash enough to suggest that successful government had always been achieved through following antiquity as a model. Li Si, enraged, stated that the great emperors had never imitated each other, and ordered that the Academy's books and documents be burned. The First Emperor approved. This destruction of texts was not total, though it was certainly extensive.[37] The government of the succeeding Han devoted a massive effort to reconstructing the lost texts central to the tradition; and the event left a profoundly negative mark in history's representation of the Qin.

In such a highly textualized tradition, both the destruction and the response were probably more important as symptoms of how the culture formed its discourses, rather than as bibliographic events. The textual tradition was a critical field for the contestation of legitimacy, most centrally in the form of a lineage of moral and political authority and in the control of this lineage. Pauline Yu, in her essay in this volume, refers to John Henderson's observation that 'efforts to construct a canon typically occur after . . . moments of political and cultural rupture.' The

Qin was certainly such a moment of rupture, disturbing existing boundaries and creating new ones. One might suggest that, in the preceding Zhou period, a Confucian discourse of cultural authenticity had evolved. In the Qin this discourse of antiquity as the inexorable exemplar was first isolated, and the convergence of political and (whatever) canonical authority established, but the Confucian discourse itself had no clearly demarcated embodiment beyond the 'documents of the academicians'. It was the Han dynasty's desire to assert a legitimacy which could exploit the Qin's act of unification but neutralize their destruction of Zhou culture, that generated a canonical corpus of 'recovered' texts and the critical demarcation of the 'Five Classics' in the reign of Wudi (141–87 BCE).

Not coincidentally, of all Han emperors Wudi was the most aggressively concerned with boundaries of all sorts, including that between Chinese and nomadic cultures. His reign was marked by vigorous and various activities in diplomatic and military campaigning and in wall-building, provoked by a series of arguments over whether that cultural boundary should be negotiated, contested or demarcated. We must remember that the concept of a 'border' was still very vague, and that the arguments were as much conceptual as practical. The textual canon, likewise, was fundamentally a matter of understanding and controlling boundaries. Whether they were exclusively those of Confucianism or, as in this case, much more heterogeneous, was not of primary importance. But institutional control of the controlling mechanism *was*. Once the significance of this became clear, then such 'border control' became an issue of social class, focused through the privileges of literacy retained by the heirs of the pre-Han political scribes, who formed a class of land-owning gentry that deliberately selected Confucian ideology as its main field of literacy. Confucianism had eventually become the cult of the state, supporting the imperial institution, but the Confucian gentry made themselves essential to its maintenance.

The maintenance and critique of this Confucian canon was one of the literati's main concerns. At the same time, and perhaps comparable to the hierarchies of parallel clan lineages in politics, as other genres of literature developed, especially in poetry, appropriate canonical traditions were constructed. These were most essentially bound up with writing as an expressive social practice, rather than as an individual act. Recent or even contemporary genres of literature could be sanctified only by derivation as culturally *ab originem* in terms of morality, ritual and governance. However, the genres that were current as a production of the

gentry themselves, and therefore adjudicable only by them, were especially valuable as active instruments in the maintenance of a social structure. The issue of boundaries in the textual field was therefore of extreme importance: boundaries between categories and genres (such as historical, intellectual, ritual, political), and the lineages of expressive art, became wrapped up with wider concerns about legitimacy and the disconnections of illegitimacy.

Pauline Yu analyses this phenomenon, so central in the textual discourses of China's elite tradition, in a key essay on 'The Chinese Poetic Canon and Its Boundaries'. She traces the evolution of a collection with which any student of Chinese literature is unavoidably familiar, the *Tang shi sanbai shou*, or 'Three Hundred Tang Poems'. In the largest collection of Tang poetry, the *Quan Tang shi*, or 'Complete Tang Poems' (imperially commissioned in 1705), there are forty-nine thousand poems. The anthology of three hundred, published in the 1760s, was the product of a long sequence of commentaries and reviews, however, in the representational process of boundary-making through selection that was complementary to the boundary-marking of *quan*, 'comprehensiveness'.

Yu discusses her material in the theoretical context of cultural legitimation, and charts it through the sequence. She grounds her account in the decision of the Tang government to include poetry as a field in the *jinshi* civil service exams. These exams, one of the most characteristic institutions of the Chinese state, were usually the only gateway to officialdom, the only orthodox career for the gentry-literati. They were therefore one of the most central and explicit institutions of boundary control. Even the canon of Confucian classics was subject to its jurisdiction. Yu notes, very appropriately, that the evolution of a canon in poetry is itself an important historical issue. Even more important, however, is her perception that the contested and varying position of poetry at the periphery of the *jinshi* exam and, therefore, in the spaces of negotiation between a social class and the institution of government, signals its critical significance in the historiography of boundary-making.

Yu establishes the difference between the establishment of a canonical field in poetry and the retrospective, evolutionary establishment of a specific canon for the poetry actually written during the Tang. She then observes how categories used to organize the canon represent a mapping of centrality and marginality. Thus we find what might be called a landscape poetics of Gao Bing (1350–1423), in which the critic equates an imaginary journey through a hierarchized national geography with the study of the hypothetically total realm of Tang poems. Yu notes how

Gao yokes 'the experience of "delight" with the awareness of "bound-
aries" (literally "hedges and fences")'. Gao hierarchizes the realm of
poets into nine ranks, the highest two of which are the 'Pioneers of
Orthodoxy' and the 'Orthodox Patriarchs', the lowest two being the
'Lingering Echoes' and the 'Overflow Currents'. The 'Echoes' are
remnant poets from the end of the Tang, while the 'Currents' are a
miscellany of women, monks and foreigners.

Beyond the obvious marginalization of the latter category, Yu catches
the importance of Gao's apparently trivial note that he does not have
adequate biographical information about these poets to make an
informed judgement. That is, the canon is essentially, if not entirely, an
ethical one. However their poems may read, the most lowly ranked poets
lie beyond the boundary of the ethical category itself. This ethical (and
therefore social) criterion was fundamental for Yan Yu, the early
thirteenth-century critic responsible for the establishment of a durable
Tang canon. As Yu analyses this canonical process, she makes clear how
complex were the criteria at work (some of them very explicit, some not
at all). Gao's first rank shows another critical boundary at work, that
between 'originality' and 'orthodoxy'. In this case, it is the boundary
itself that seems to act like a glue between the two qualities; or, one might
say, the boundary-space provides a field of contention and negotiation
that is necessary for a transcendentally canonical quality.

Transcendence is a key problem here, not unrelated to the cosmologi-
cal dimensions mentioned earlier. Its significance, obviously enough, is in
the crossing of boundaries. Its definition, however, is the subject of
institutional power. Transgression is judged offensive, while transcen-
dence is promulgated as an ultimate confirmation. Without the notion of
a creative agency external to this world, and despite the efforts of
Buddhist belief to move the construction of centrality beyond the realm
of society and imagination, a transcendent move had to be turned back
into the world of man: from pioneer to orthodoxy, for example, bounded
ultimately by a horizon of control.

Yu, in discussing what she lists handily as 'prosody, pedagogy,
politics and personality', deals in a clear way with a complex set of
boundary conditions. These conditions may also be seen as a linked
dialectic between regulation and choice, substance and decoration. This
is a set that seems to leave little room for our own conception of
'originality' and its assumed opposition to canonical rule. Indeed, this
should be seen within the horizons of 'transcendence'. The boundary-
making/crossing implicit in our own, transcendent conception of 'orig-

inality' is of a very different order. Within the reflexive transcendence of the Chinese world, a conception of 'authentic' is much more appropriate. There was no *ex-nihilo* beginning, and each beginning was a repetition. Equivalently, authenticity (understood as the positioning of a personality within a cosmological ethics), was constantly and indeed necessarily repetitious.

This distinctive difference is analogous to the seeming oddity of a temporary immortality. This temporal function appears in Yu's reference to the essentially 'main-stream' discourse of *fugu*, 'return-to/recovery-of antiquity', which was central to both the contemporary poetics and the subsequent canonization of Tang poetry. Yu quotes with approval Stephen Owen's remark that 'literary history and the formation of canons of major poets [were] the exclusive province' of *fugu*. In fact, this discourse remains one of the most prominent and problematic for sinologists and it is clearly an issue of boundaries. As a question of continuity and discontinuity, it problematizes distinctions between space and time in cultural cartography; as a question of incorporation and differentiation, it problematizes the differentiation of genres, in that canons were constructed in a variety of cultural forms, some obvious and some less so. In Owen's terms, this latter circumstance might be answered by saying that all these forms – classics of statecraft, morality, poetry, calligraphy, eventually painting, in other institutional fields and in 'minor' applied traditions – were all knowingly marked as 'texts' in our post-modern sense. Literature, *wen*, was constructed as not only exemplary but also paradigmatic.

The paradigm, of course, was a necessary condition for sustaining the position of the literati class (one might suspect something of the same sort today). Yu, citing theoretical sources such as Jane Tompkins, John Henderson and Robert Weimann, pays close attention to the way in which practitioners of seemingly innate codes of categorization (such as 'good poetry') were themselves the code-writers. Whatever cultural differences may impose a boundary condition, in the sense of a 'cosmological gulf', on Western theorizing of canonical phenomena, this basic perception is an essential one. The sustaining codes of the Chinese literati class were increasingly muddled and undermined by both national and international developments throughout its history. In the later empire, the original context of the *jinshi* exam and the resulting development of the canon were transformed into a modernized conception of education – and the handy volume of the 'Three Hundred Tang Poems'. As Yu concludes, 'in constructing a canon, literati in late imperial China were

attempting to shape the identity of their culture and themselves as well.'
The boundaries of that formation are still discernible today.

Four essays: loss, recuperation and return, resistance and release

Yan Yu's critical formulation of Tang poetry was made in the thirteenth
century. Pauline Yu writes of this period that it was 'characterized by a
consuming search for orthodox principles and legitimate lines of des-
cent', and also by 'a crisis of nerve, an increasing loss of confidence in the
ability of the self to serve as a locus of moral or aesthetic judgement.'
Clearly, these two circumstances were somehow paired around a
common boundary.

Characterizing this boundary is not so easy. One might identify it as
the massive historical and cultural ruptures, signalled most dramatically
by the losses of the Northern and Southern Song capitals, in the Jurched
conquest of Kaifeng in 1126, and the Mongol conquest of Hangzhou in
1276. However, the neatness of all this pairing is little more than an
historiographic formula. Territorial defeats and nomadic incursions were
frequent and widespread not only during this period but throughout
history. It would be more appropriate to describe the rupture as a
discursive earthquake, occurring in a complex pattern of faults that was
as much connected to the Empress Wu's usurpation in 684 and An Lu-
shan's rebellion of 755–63 as it was to events in Kaifeng and Hangzhou.
In terms of social and economic history the dynamics were prolonged and
complex, and many historians have come to locate the beginnings of
'modern' China in the eighth through tenth centuries, with a cataclysmic
reversal at the end of the thirteenth. As John Haeger wrote of this latter
period:

> The T'ang-Sung transition is real enough, but the Sung-Yuan (or even Sung-
> Ming) transition seems rougher by comparison. The roads which led to Southern
> Sung, in both a literal and figurative sense, led nowhere, and the process of
> historical evolution was in one sense interrupted . . . the Yuan reinfused south
> China with T'ang values, essentially northern ideas about the organization of
> society and the management of economy . . .[38]

The reversal cannot simply be laid at the Mongol door, for many Chinese
intellectuals embraced the return to Tang (or earlier) values enthusiasti-
cally as a *fugu* restoration. A seismic release of stress in the geology of
cultural discourse seems to have been necessary before the tectonic plates
of history could continue their slow slippage. The principal and subsidi-
ary fault lines in this geology must have been many. As a heuristic, rather
than an analytic device, therefore, we might consider the boundary in

question as both a zone and a phase of slippage, with a network of interfaces appearing in a mixture of gradual slides and sudden judders. To become analytical, the geometry of this metaphor, however, would have to be translated into the elusive dimensionalities of society and the self. Leaving aside that problem of theorization, we may suggest much more simply that the differential was between the *de facto* and the *de jure* articulation of critical cultural discourses. Within culture and the self, and increasingly threatening a divorce between the two, the slippage was both a social and a psychological state, a condition of disjunction, disorder and dismay at the interfaces of contemporaneity.

A paradigm of these highly stressed boundaries can be found in the life of Zhao Mengfu (1254–1322), a scion of the Song royal clan who held several distinguished posts in the Yuan government, rising to the highest level that was permitted to the Chinese by their Mongol overlords. This in itself represented a transgression of the most problematic kind, although it was not rigidly categorized until much later, as another dynastic cataclysm approached. Zhao was exceptionally gifted in the 'three arts' of poetry, calligraphy and painting, heir to the twelfth-century manipulation of discursive boundaries in which implicit analogies between these arts were articulated into a theory and, increasingly, a practice of their mutual inclusion. As a canonical pre-emption, this was inevitably an exclusionary move, leaving many practitioners (principally 'professionals') outside the literati class and powerless in the writing of culture.

Zhao himself did not full subscribe to this 'pre-emptive strike'. For him, the discourse of skill had not yet been fully subverted by his own class. He did, however, take full advantage of it, assiduously working at all the connections which had become so charged with meaning. These included the interfaces between ideology and practice, which had become severely misaligned; between the arts of poetry, calligraphy and painting, the coherent integration of which promised a new canonical security; the interface with the past, across which recent history had spread a screen of noisome interference; and that between self and society, which had become extremely problematic.

This last problem was partly due to a duality developing within literati ideology itself, as the cultural heroism of the individual was increasingly valorized as a defining characteristic of a social class. Zhao tended to approach these problems as either lineages or surfaces, boundaries prioritizing either time or space. Thus the literary rhetoric of his artistic practices was primarily in terms of *fugu*, which was the orthodox field for

cultural heroics; while his material engagement was literally and explicitly with the surfaces of brush, ink and paper – the original media of the scholars' difference. These surfaces became deeply implicated with the manifesting of the psycho-physiological self to a visual gaze, with the relationships between the self and society, and between the 'now' and history.[39] This was, indeed, critical 'boundary work'. The micro/macrocosmic model of embodiment was still dominant, with its homologies between physiological and sociological bodies, so the incipient rupture between literatus (individual) and literati (class) could be restored from within the painter/calligrapher/poet's practice.

A particularly contradictory intersection of the boundaries in class discourse and cultural practice was very effectively resolved in this restoration. In the Tang-Song transition, the distinction between intellectual and applied activity had been identified as critical in the literati's own construction of themselves as an elite. At the same time, a specific cultural application of the reflexive and self-sustaining cosmology, which did not dichotomize the worlds of heaven and earth, was represented in the conjunction of poetry, calligraphy and painting. For the literati, 'writing culture' was explicitly a material practice; they now sought to claim the representational power of painting. Painting, however, was also seen as an applied practice. Its descriptive skills were subordinated to the transient external shapes of things, rather than to culture. This problem was extensively discussed, and one incidental indicator of it is the term *jiehua*, literally 'bounded-painting'. Originating perhaps in the early Song, the term referred mainly to the painting of architecture but included other highly detailed subjects carefully rendered with outlines. It acquired a more specific reference to the use of geometrical aids such as rulers, probably of the sort developed in architectural practice itself.[40] This kind of 'bounding' practice was concerned only with 'shape', the most ephemeral form of signification. It also made the artist 'other-dependent', on both technical tools and merely external truth, rather than inwardly on the cultural self. The tools of brush, ink and paper, however, had to be classified as a syntagmatic link within literati practice, an essential vehicle in the externalization and materialization of culture, not as a marker of categorical difference. The recuperation represented by Zhao Mengfu brought the literary body and physiological body of the literatus into alignment, and the surface of the paper became a cultural field in which those two bodies could materialize. One boundary, the external limit of *jie*, was preserved and clarified. Another, that between intellect and

action, was strengthened as an interior conjunction. The set of brush-and-ink itself became an instrument in the discourse of power.

In my own essay, later in this book, I consider this development as articulated among a small group of literati painters closely following Zhao, who were in their turn identified as canonical in the late Ming period. Like Pauline Yu, I also draw explicitly on Western sources for a theoretical frame. I do so, however, more heuristically than analytically, in an attempt to find a language of description that is not conventionally available in Chinese art history. The fields are those of material science, chaos theory and psychoanalysis, all of which are specifically concerned with boundary formation. It should be noted that boundary, surface and texture have been identified as a characteristic Chinese phenomenology in Angela Zito's work on the body in Qing ritual, mentioned above. She writes:

The various discourses of painting, ritual and medicine in China shared this construction of an underlying 'principle of thirdness', a site of emergent knowledge as an ever shifting, humanly created boundary. Metaphors for this site were two-dimensional – those of the surface – the woven web . . . the network . . . and the vessel. . . .

. . . in the eighteenth century, with its hyperdevotion to discourses of *wen* [the signifying practices producing both bodies and texts] [t]he proliferation of surface decoration on porcelain, furniture, walls, and clothing reached an apogee of excess. . . .[41]

The restoration of Chinese rule under the Ming (1368–1644) brought about a combination of stabilization and retrospective absorption, together with deeply disturbing shifts of many interior discursive boundaries. This is marked by the conventional art-historical dichotomization of seventeenth-century painting into the 'individualists' versus the 'orthodox' masters. Although this binary opposition is breaking down under more recent scrutiny, as an historiographic phase it retains its significance. The canonical formulation of Yuan dynasty painting was pushed to its most orthodox extreme in the seventeenth century. Its articulation, apart from analogies in other media, began in the sixteenth century and achieved particular intensity with Dong Qichang (1555–1636).[42] It is very hard to decide how much of this development was due to incipient dynastic collapse, eventuating in defeat by the Manchu armies in 1644. Certainly the late Ming was a state in dissolution; the extensive construction of walls in the sixteenth century was a sign of weakness and not strength. Equally certainly, the construction of orthodoxy in art was not only enthusiastically promoted after 1644 by

early Qing painters, such as Wang Hui and Wang Shimin, it was also acknowledged by many other painters. The situation, however, was perhaps akin to the late thirteenth century, when a long-term, radical shifting of discursive boundaries coincided with – and partly contributed to – a spectacular political debacle.[43] In 1644, as in 1279, Chinese society was at first thrown into a chaos that promoted fundamental structural shifts; yet subsequently the discourse of authority radically regressed to a more orthodox rigidity.

The upheavals of the mid-seventeenth century, in any case, present one of the most colourful concatenations of radical might-have-beens in all of Chinese history. In their preface to an important collection of essays on this period, described as 'a crucial moment in the history of late imperial China', Jonathan Spence and John Hillis remark that the essays are 'soundings in an oceanic subject'.[44] Their oceanographic equipment did not include an art historian. The essay here by Jonathan Hay approaches art as a prominent vehicle of this history, providing an illuminatingly analytical entry into the historiographic conventions of the Ming-Qing transition. He locates his entry at this juncture, precisely within the contested region of a major boundary. Significantly, however, the boundary functions can be analysed with some precision. Their temporal and spatial geometry was peculiarly elastic and permeable.

In his essay, Jonathan Hay works from the perception that there were several constructions of space and time in Chinese ideologies, and that historical circumstances could generate profound problems when the continuities and discontinuities of different constructions came into conflict and boundary markings were lost. He examines the interaction between two kinds of traditional category, subject-matter and politico-social class, in Chinese art history, at a moment when the boundaries of legitimate practice collapsed under the forces of history. The subject-matter is landscape painting, described by Jonathan Hay as 'the pre-eminent genre for the metaphoric exploration of the individual's relation to state and nation'. The class is that of the literati, self-legitimized as the *wenren*: the produced and the producing 'men of literacy (i.e., culture)'. The boundaries are those differentiating and sustaining that class's identity in its construction of historical legitimacy, specifically embodied in dynastic transmission.

In the modern historiography of China, the significance of dynastic change is still a major question. So many of the forces of history, such as social and economic change, have a pattern that may seem independent of political authority. But, as an historical phenomenon in its own right,

the obsession with cultural legitimacy and its connection with dynastic ritual is indubitably a major issue. The literati class, in order to sustain its identity with the administrative bureaucracy, was obliged to construct its own centrality as a relationship of filial piety to the ritual centre, that is, the imperial government. Even when it was agreed that a specific dynastic house had lost the mandate of heaven, the familial structure of the relationship decreed that the administrative officers of the state, as members of the imperial ritual family, still owed their loyalty to the deposed house. Even if this was a circumstance of 'what goes around comes around', it need not be viewed cynically. Ritual boundaries shaped the intellectual and emotional growth of literati from the cradle to the grave. The circumstance was so embedded in history that a possible escape from these boundaries had been institutionalized as early as the Han. The theoretical answer lay, generally speaking, in the possibility of a higher loyalty, to heaven itself. More specifically, this depended on what construction of heaven was in question. Buddhism offered a religious construction, an often used, but always suspect, alternative to that of the imperial state. Schools of thought loosely categorized as 'Daoist' offered a radical neutralization, in which emptiness and inaction were posited as superior to the usually harmful intervention of ritual and politics. For the Confucian (and the privileged elite could variously be all three), legitimacy remained critical and heaven therefore had to be posited as the highest form of government. However, its resources were limited and ambiguous. Indeed, all of these celestial options had their particular costs, and a direct loyalty to the imperial government was accepted by most literati as the least problematic choice.

The final collapse of the Ming was a slow and agonizing process. A 'southern' remnant hung briefly on past the Manchu conquest. The Manchu declaration of the new Qing dynasty, communicated through a shattered literati class spread over a huge nation in chaos, was erratically effective. It was some time before the Kangxi emperor (r. 1662–1722) began to re-impose an extremely effective, traditional order on the empire.

In these circumstances, the religious 'frame of reference' was painfully confused. The Daoist and Confucian constructions of heaven had the benefit of being indigenous and, as Jonathan Hay notes, in their positive form they were tied to an ancient utopian theme. The 'Peach Blossom Spring' of the poem by Tao Qian (365–427 CE) was the paradigmatic text of this theme, but its origins lay in ancient views concerning immortality. Hay calls this poem 'the classic literary emblem of the

suspension of dynastic time' and it was particularly influential in the mid-seventeenth century. However, as he describes, even for those who resorted to it the utopian construction itself lost its supporting boundaries in the dynastic chasm, becoming a fragmentation of dystopias.

Jonathan Hay traces the struggles of certain artists through this dystopic 'suspension of dynastic time' to reconstruct their boundaries. He observes the tradition of painting through the minds and brushes of men like Gong Xian, as it moved from a despairing attachment to the 'afterlife' of the Ming, through a ritual phase of mourning, to an historical grasp of the Ming in its cultural entirety. Retrospectively emerging from a state of loss in interdynastic time, therefore, the Ming was finally granted its own dynastic boundaries. This process could also be followed in more institutionalized media, such as the writing of histories, but in the imagery of artists it has remarkable emotional substance.

Thinking about the emotions involves particularly complex boundary-making in all cultures. Feeling, in a very general sense, was accepted as implicit in the expressive arts throughout the Chinese tradition, but its status was as problematic as it was central. It was most comfortably projected into the female sphere. Even the emotion of loss, culturally so powerful (as is apparent in Jonathan Hay's account), was usually allegorized as a deserted woman. Records of the actual activities of women in the arts go back as early as the Han, but it can hardly be said that women were emotionally privileged as a logical consequence. It is rather the case that they were severely limited. In the official record, if women painted at all their subjects were flowers and not landscapes.

It is possible that the role of women was refined and greatly reduced in the mid-Tang. There are early Tang records of women playing polo, but whether this indicates that boundaries were then less rigidly drawn within Chinese society, or that Chinese society was still much more open to nomadic incursions, is hard to say. The later records that exist are of women whose talents were allowed to flourish by exceptionally open-minded husbands. Guan Daosheng (1262–1319) was a highly respected painter of bamboo, whose calligraphy was collected by a prince at the Mongol court. But she was Zhao Mengfu's wife, and her calligraphy was mounted with that of her husband and son.

The preserved artistic record is in no way commensurate with female achievement. Liu Yin (1618–64) is known as a woman highly accomplished in poetry and painting. She learned these arts as a prostitute and (according to the orthodox account) used her attractions to install herself

in a concubine's chamber in the household of a famous poet and critic, Qian Qianyi. Had she not done so, she would probably have survived only as brief entry in one of the male compilations of cultured prostitutes. Many women were certainly skilled at painting in the seventeenth century, a period when the question of 'emotions' had just come under renewed intellectual scrutiny. What was probably once a fuller record, however, was obliterated by subsequent historiographic choices. One woman, Chen Shu (1660–1736) is unusually well represented by both records and surviving works. As Marsha Widener has written, however, this is almost certainly because she was fitted into a Confucian stereotype of the woman of great virtue as 'filial daughter, dutiful wife, devoted mother, strict teacher, and [incidentally] as talented painter'.[45] Even males, of course, had little chance of surviving in the record if their fame depended on their painting alone. In this period, however, it is still in the record of arts and literature that women's activities are most in evidence. This continues to be so in the century of Chen Shu's death.

During the eighteenth century, under the long reign of the Qianlong emperor (r. 1736–96), 'traditional China' was reconstructed as a self-conscious enterprise of extraordinary depth and comprehensiveness. Under the objective analysis of an alien rule, the articulation of discursive boundaries was more specific and concrete than at any other time in Chinese history. At the same time, the dynamics of social, economic and even epistemological change that were internal to China and which had been well under way in the Ming, began to assert themselves again, slowly undermining the kind of orthodoxy that perhaps only an alien imposition could have achieved.

Dorothy Ko, addressing the issue of women in society through their collective appearance in the art of poetry, uses the analytical tools of contemporary scholarship to prise out some surprising conclusions. Her essay takes as its starting point the sociological formulations that we have met much earlier, in the Zhou 'Book of Rites' and the legalist's urban planning. That demarcation and restriction of female space and time was certainly part of the Qing orthodoxy. As Ko discovers, however, daily practice could negotiate these boundaries much more flexibly.

Ko notes the records of women's poetry circles, which, by their very existence, invalidate the systematic claims of orthodoxy. She investigates two processes, the 'crafting of an educated woman's personhood' and the 'making of hierarchies that informed both male–female and female–female interactions'. She does this by examining the particular case of Ren Zhaolin (*fl.* 1776–1823), a Suzhou man of culture who tutored ten

women students. She points out three major transgressions: the physical proximity and intellectual exchange that mocked 'the supposed boundary between the man's sphere and the woman's'; the implication that education could overturn 'an overt assumption of patriarchy – the moral and intellectual inferiority of the weaker sex'; and, worst of all, the proud and public printing of the women's poetry. With all this, she notes the curious fact that, whereas Yuan Mei, a very prominent scholar of the preceding generation, was being posthumously attacked for taking women students, the unspectacular Ren was adopted as a symbol of local pride by his own community.

Ko finds this difference rooted in two traditional aspects of Chinese society at that time. Yuan Mei exploited the latitude for play permitted within literati society. He also adhered to the late Ming formulation of *qing*, a traditional term loosely referring to socially acceptable emotions that was developed into an ideological concept of man's true nature in resonance with others. As a poet, Yuan considered the emotional relationship between man and woman as paradigmatic of *qing*. Socially, he adapted the pattern of romantic relationships that men had customarily pursued within the boundaries of prostitution, and extended it into his private literary life. The pattern was essentially radial, with individual relationships spreading out from Yuan as their common centre. He must have had sexual affairs, but seems to have valued most of his female students for their cultural finesse and their ability to inspire poetry. A relationship between a male master and a female student that was based upon learning, and carefully confined, was not unacceptable. Yuan himself, however, was judged a libertine, and even though there was a place for the male libertine in society, the social nature of *qing* was not validated symmetrically between the sexes. The manner in which Yuan admitted women into a male literary culture as part of his own emotional sphere, extensively and publicly, was radically unacceptable.

Ren Zhaolin's circle of women poets was constituted on an entirely different basis. It was not centred on personal relationships, but formed a network mapped onto the accepted social boundaries, in which actual and metaphorical kinships connected the poets as much with each other as with Ren. This coincided with the local pattern of community ties, and the poetry itself could thereby be appropriated as a community achievement. The significance of this discourse of locality was reinforced by the Confucian academic model the group adopted. Ren himself was construed as a *men*, literally 'doorway', the conventional term for an intellectual school centred on an individual master. The community

appropriation of a *men* was probably even more weighty than that of the poetry itself.

Ko discusses the importance of names and terms such as *men*, analysing their precise occurrence in the group and among individuals. In the Chinese tradition, names had been a singularly explicit and valued way of marking boundaries ever since the 'rectification of names' in pre-Qin philosophy. The use of aesthetic geography and numerology in classifying the group as a group, the 'Clear Brook Poetry Club' and the 'Suzhou Ten', clearly signalled the ambition of the group to place themselves within masculine literary territory. For individuals, beyond the names by which they were securely located in a family kinship, there was an established set of naming categories designating particular spheres of private and communal lives. Chinese literati always had several, and often many, names, but women's customary absence from these male spheres was marked by their lack of this self-naming privilege. The Suzhou Ten asserted both their collective and their individual identities by naming themselves.

Ren himself certainly approved of these claims. He and his students held the thoroughly disruptive belief that women should have access to a classical education. Ko notes that this preceded by many decades the assaults of Western society and was, in fact, connected to another *fugu* movement in Confucian learning, that of evidential scholarship. This school was a reaction to what some literati saw as the massive interference of centuries of commentary, which had acted to obscure the substantive word. A concerted attempt to recover the original texts, it was to a significant degree an effort to establish a clear boundary between traditional knowledge and contemporary society. Ironically, as Ko explains, it also eroded the self-reflexive certainty that Neo-Confucianism had constructed for itself as a comprehensive socio-cultural system. Women were found to participate in the social order after all, due to a more egalitarian interpretation of *qing* as a common denominator in humanity at large. It was a remarkable demonstration of how the power inherent in discursive boundaries differed from that in the rhetoric of authority.

Ko observes that the crucial classic in this context is the 'Book of Songs', the most ancient stratum of both the literary and the ethical canon, supposedly edited by Confucius himself. The classic view of poetry, located in the very earliest preface to the 'Songs', was that it was the verbalization of feeling. It was seen, therefore, as particularly appropriate to the 'pure' voice of women. Ko writes of 'a prevalent valorization of the female poetic voice in the Jiangnan market towns in

general' and offers evidence that the type of local network represented by the Suzhou Ten was repeated and interconnected throughout the whole Jiangnan region at this time. She further comments:

> . . . the Suzhou Ten . . . was merely one of the many networks that structured the life of the men and women concerned. Such ideological boundaries as male/female or senior/junior are not static and one-dimensional entities that lock an individual into absolute positions in a hierarchical order . . . the spread of women's education also testifies to the flexible nature of the Confucian order and its capacity for changes from within.

Ko, however, sees the severe limitations still imposed by dominant discourse and admits that the only really viable position available to these women was as 'surrogate men'. The cultural forms they adopted all served to valorize themselves in the male mode. Even their privileged poetic voice was itself a suppressive boundary condition, excluding them from other classical voices. It was also, one might add, an example of an arguably universal discourse: the limiting difference between women-as-nature and men-as-culture. Ko offers a surprisingly benign assessment of Confucian ideology within a feminist critique. This careful balancing act is very helpful to the subtleties of her analysis. Feminist critiques of the historiography itself are likely to prove particularly effective for excavating cultural boundaries in history and analysing the processes of boundary-making.[46]

Three essays: the boundaries of modernism and post-modernism

The changing boundaries of women's lives in the Qing were closely tied to a different kind of social change from that in the elite tradition reviewed above. Shifting patterns and the economy led to breaches in social barriers, physical and behavioural. Women increasingly needed, and created, public space for themselves in various fields. One of these was the arts or rather, that category of art culturally delimited as 'entertainment'. Very little is known about this still, and it is highly likely that much earlier examples have been buried in other boundaries, such as literate/illiterate and urban/rural. Twenty years ago, Joanna Handlin's study of women's literacy in the Ming was very suggestive in this respect. The growth of theatrical institutions, however, and the manner of their integration in society is surely an important theme in the modernization of Chinese society, for theatre is where society chooses to examine its own representations. As seen by authority, it is a public place to promulgate its chosen boundaries; seen from within, it can be a privileged place for their transgression.

Isabelle Duchesne's essay, 'The Chinese Opera Star: Roles and Identity', is therefore a particularly valuable contribution to this collection. Culturally, it places the issues right at the centre of an elaborate and coherent set of representational practices which, in a very literal sense, 'staged' those boundaries which Chinese society was currently negotiating. Forces of unity and difference were highly stressed by the dense compaction of regional and other traditions in the Jingxi, 'capital [Beijing] theatre' of the Republican period. Chronologically, Duchesne tracks these issues through the later period of go-stop-go modernism, from the second through to the eighth decades of this century. The contested nature of many cultural boundaries at this time was exemplified in the extraordinarily hybrid nature of the Beijing style of theatre. Duchesne analyses 'the way complex identities were constructed by defining boundaries between the professional, private, social and public realms of the . . . star.' She finds that these boundaries were often blurred, and that the significance of boundaries was insistently foregrounded in a perception that the act of interpretation 'reached its height through transgressions which only the greatest actors were able to carry out'.

She is right to multiply these realms: professional, private, social and public. But the conventionally binary boundary between individual and society remains a helpful frame of reference in this extraordinarily fluid intersection of currents. This is partly because of the 'doubled' function of the arts, especially theatre. They are constructed as a representation of society's own system of representations, and the appropriation in a particular work emphasizes the duality of a mirror image. When the artist her/himself is also singled out as representing the secondary construction of representations, then the function is tripled into a series of mirrored images. The Chinese literati tradition was particularly given to such hypostatizing of what we might call the relationship between the individual's society and society's individual. If Zhao Mengfu was a cultural hero in the crisis of the late thirteenth century (even though his performance was panned by later critics), then Mei Lanfang was a cultural hero of the Republican crisis – with his critical reputation still holding up well.

The fabric that Duchesne weaves out of these issues is rich, and there are too many threads for them all to be traced in a summary. The phenomenon of the theatrical star, however, is one of the most interesting. It focusses attention on the performer, the producer of representations, as a representation produced by society. The production of an

actor in China around the turn of the century, as described by Duchesne, might be compared to other traditional arts, where the boundary between the endwork and viewer was very open, and the history of its production was a built-in convention. A calligrapher, starting out only with the presumption of potential ability, would work arduously through the styles (as a cluster of techniques around a personality) of several masters. Only if extraordinarily successful would he 'achieve his own home': a transparent construction of this process in which style finally was equivalent to the person *as a whole.*

The apprentice actor, as Duchesne describes, was first categorized according to physical potential for a particular role. Then, as completely raw material under an unrelenting regime of conventions, stage by stage was 'completely moulded . . . within a system of representation, expression and dramatic behaviour that . . . reconstructed him as a person'. Duchesne characterizes this as the young apprentice 'crossing a boundary between self-definition and theatrical impersonation'. One wonders how much self-definition could have been achieved before puberty, but it is clear that there were successive self-constructions under different agencies. Apprentices were adopted into theatrical lineages under particular masters. They were first moulded in the conventions of their innate rôle-type, but then went on to model themselves on their masters as actor-persons. They did not take the name of their master, but they renamed themselves to mark their changing identities and successive achievements.

In traditional theatre, Duchesne writes, a student learnt to 'efface his own self'. Students may even have learnt that there was no 'own self' to efface, representing in their lives the very notion of social construction of the self. The extent to which the actor retained a choice between different constructions remains unclear. Duchesne's evidence seems to be that the actor's off-stage identity may often have been a secondary image produced by rigidly defined theatrical roles. The circumstances changed with a shift of social boundaries. As Western notions of the protagonist as individual interacted with the theatrical tradition of hero as a stereotypical role, actors began to differentiate heroic roles in terms of personality. When the actor-person as well as the theatre was permitted a place within society, society then had its own interest in constructing that actor-as-person, and that person acquired the ability to participate in her/his own construction. The actor's professional ability to enter a rôle thus acquired a distinctive social autonomy under the aegis of modernization, and the socio-theatrical representation of this is made vividly clear by

Duchesne. One might say that the actor's choice no longer occurred at the theatre door, or perhaps that this door was often now located far beyond the theatre walls.

Duchesne makes it clear that international influences were at work, and one might imagine a film made of Mei Lanfang's career – 'A Chinese Opera Star is Born' – as the forces of modernism in Republican society pushed China nearer and nearer to Hollywood. But the word 'born' might not have been transferable. The Hollywood version represents a mythology of creation and the individual, while the Chinese version is social construction and representation. One was framed by a corporate industry in a capitalist economy; the other by a tradition of theatre as actors, afloat in an economy of indefinable hybridity.

Perhaps nowhere was this more evident than in the crossing of genders. Genders certainly got crossed in Hollywood but, for example, the practice of homosexual stars in heterosexual marriages was precisely an effort to control and marginalize (productively) the transgression of boundaries. In *Jingxi*, as Duchesne makes clear, such transgression was at the heart of representational practices that were not epistemically mimetic. The arranged marriage, lasting one year, between Mei Lanfang, the leading male performer of female roles, and Meng Xiaodong, the leading female performer of male roles, is described by Duchesne as 'one of the strangest blends of art and life in modern *Jingxi*', at 'an extreme point' in the manipulation of the star's image. Certainly, manipulative interests thrived on the modernizing media, but the themes of transgression, especially transvestism, had been at the core of representational practice for many centuries.

Duchesne discusses the history of this with respect to the merging of the parallel traditions of all-female and all-male theatrical traditions in twentieth-century *Jingxi*. Which boundaries were implicated (and how) in the male representation of the female, and vice-versa, is an important and perennial question. Universal issues of psychology are culturally articulated and the Chinese context, with its concern for authenticity rather than mimesis, would doubtless attribute distinctive values to these transgressive representations. In the merging of complementary institutions of transgression, the Mei-Meng union itself was a quintessential, if transient, icon of redoubled ambiguity. We may suspect that this semiotic play of gender positions was, in itself, a core discourse of eroticism and correlated fields, validated not only by the throes of modernism but also by traditional society. Duchesne concludes her essay with 'M. Butterfly', another quintessential if transient icon of the culture/

modernism boundary. As the last of many carefully noted details, she observes that Shi Peipu, the Chinese actor of female roles on whose exploits 'M. Butterfly' was based, asked to play himself on Broadway.

Gender equations and inversions are a prominent theme in literature and theatre as least as early as the sixteenth century.[47] In many cases, such slippages of identity provide the crucial dynamics for a romance. In others, however, it is a moral choice. Lu Kun, a local official, published his 'Regulations for the Women's Quarters' in 1590. Unusually thoughtful and supportive in women's issues, Lu praised as an example Hua-mu-lan, a woman of the 6th century CE in historical mythology, who dressed as a man and served as a soldier for twelve years to save her father. She was a popular subject for stories and plays.[48] Lu's specific point was that Hua-mu-lan's individual conscience preserved her moral purity, despite her transgression of conventional mores. He even declared her his teacher. The implicit and larger point was that identities, even including gender, are a product of social constructions rather than of anatomical bodies. There is, of course, a material vessel for these constructions: the physiological body we talked about earlier. But physical gender seems to have been regarded more as a mobile boundary condition, an equation of interior dynamics, rather than two geometries separated by a gap-in-between.[49]

As Tani Barlow observes, in a recent article on 'theorising women', the terms for the sexes of 'male' and 'female', *nanxing* and *nuxing*, are modern. She writes of Li Shichen, a sixteenth-century physician:

What [he] says, then, is that the dynamic forces of yin/yang do 'produce' – only not anatomical men and women, but rather subject positions or hierarchical, relational subjectivities named mother and father, husband and wife, brother and sister, and so on.[50]

Trans-sexuality, therefore, might be understood as a natural, if erratic equation within a dynamic polarity; while transvestism could be seen as a manifestation of this at the level of a socially determined subject-position. Homosexuality also, which was apparently seen by Western visitors to late Ming China as a singularly Chinese vice, was logically not a sexual identity but one relational position in a spectrum of many.[51] The entire spectrum, of course, was oriented to a male perspective. However, the interest in transgression itself as a semiotic representation seems to have provided a subjectivity of the female position with a new opening into social discourse.

Rey Chow, in '"Love Me, Master, Love Me, Son": A Cultural Other

Pornographically Constructed in Time', insinuates herself with extra-ordinary analytical finesse into the inviting spaces and subtler fissures in the text of Bai Xianyong's novella, *Yuqing Sao*, published in 1960. She emerges with an understanding of the novel that is made possible by locating the text and contextualizing the author within a very complex set of boundaries and their transgression. In her own terms, she supplements the increasingly imperious methodology of the 'cultural other' within a cultural space that resists stereotyping. She sees in the pleasures of intellectuals a homology between subaltern-representation's objectification of social debasement, and pornography's objectification of sexual debasement. And she asks how the flow of time, as deterior-ation in retrospect, can be aggressively reconstructed as a frame within which a chosen 'other' can be kept in place.

At one level, *Yuqing Sao* is all about boundaries, their transgression and its cost. Yuqing Sao, a respectable widow in her thirties, is hired as a nanny to Rong Ge, the young son of a wealthy family. Deeply drawn to her immaculate appearance, Rong Ge is first surprised to learn that she has an adopted brother, and is subsequently astonished to discover they are lovers. Tragedy follows for Yuqing Sao. The story is told by Rong Ge, recollecting his childhood observation. Bai Xianyong is a distinguished contemporary author whose own life has transgressed many boundaries. Known for the complexity of the relationship between his life and his writing, he is also a declared homosexual. Chow explores the positions of Yuqing Sao, Rong Ge and the author as complementary subjectivities, their visibility and authority differentiated at one level within the boundaries of authorship, but at another with an audible autonomy that is perhaps greater for Yuqing Sao than it is for the author himself. Bai uses the innocence of Rong Ge as a child very deliberately as a surface on which to inscribe two fundamental texts: the paired dangers of Yuqing Sao's sexuality and the passing of the author's own time.

One has a sense that the formation and contestation of boundaries in the cultural body have increasingly been pulled within the explicit field of the individual as actor. The question of which boundaries demarcate China have only recently been transformed into those of what it means for an individual to think, or be thought of, as 'a Chinese'. The intersection of boundary conditions becomes ever more problematic, as Western discourses of modernism and post-modernism, evolving orig-inally in the deconstruction of traditions formerly dominant in the West, become increasingly active in the secondary-subaltern construction of other traditions. China can be seen as a subject of post-modernism as well

as of colonialism. But boundaries such as modernism/post-modernism or
colonialism/neo-colonialism cannot necessarily be mapped in China,
and to ask whether there is 'post-modernism in China' may not be a
useful question. This does not mean that some conditions within post-
modernism or neo-colonialism are not to be found in China, only
that the historiographic boundary conditions may have been quite
different.[52]

The First Emperor of Qin demolished walls in which he recognized the
patterns of the authority he had just defeated. He also built new walls
where he felt a need to define his borders more specifically. Mao Zedong
demolished the walls of Beijing and most other cities and towns (except
those circumscribing the Qing palace and the headquarters of the Party).
Chastizing the Confucian reactionaries of old, who had denigrated the
First Emperor and his wall, and accepting the Western view of the Ming
walls as representing an original Great Wall, he also celebrated it in
poetry as a symbol of China's unity and his own legitimacy:

> Either side of the Great Wall
> One blinding vastness
> . . .
> To touch this pure white with a blush of rose –
> O, enchantment past compare![53]

What were the boundaries of Mao's desire at such moments?

Ann Anagnost's essay, 'Who is Speaking Here? Discursive Boundaries
and Representation in Post-Mao China', provides a very appropriate and
effective conclusion to this collection. Observing the resurgence of an
inclination in Western scholarship to position 'China' as a specular
entity, subject to critical perception or misperception, she starts by
situating herself within what has generally been taken as a paradigmatic
achievement in the negation of that tendency. William Hinton's study of
the village of Fanshen, published in 1966, is a classic in the ethnography
of China, a product of long and intimate field study. But, as Anagnost
emphasizes, though not in an attempt to belittle, it is still an ethnography
– and one in which Hinton's own participation remains peculiarly
undefined. Applying this to her own position as an anthropologist, she
examines the 'cogs' on the wheels of her own narrative.

To do this, she considers the status of fragmented official declarations
as they 'surface so naturally in the chatter of everyday life', finding that a
dichotomy between state and society is not only inappropriate but even
impossible. Speaking subjects are located neither wholly in the state nor
outside it. Their collective voice signifies the 'will of the masses', which

Anagnost calls 'the trope that both anchors and contests the politics of representation in socialist China'.

She singles out the narrative of 'speaking bitterness', crucial in *Fanshen* as chronicles of personal sorrow that helped produce a national consciousness in the revolutionary context of class struggle, and then examines their transformation as it appeared in her own fieldwork in a post-revolutionary society in an anti-Mao (but still would-be totalitarian) state. Re-appropriated and articulated at the local level, the narrative of national consciousness was at first resistant to the anthropologist's enquiries, revealing itself eventually as a re-constitution of local identity. In the subsequent muting of the class subject, Anagnost sees the 'emergence of a quite different narrative of . . . despair, producing a new national subject in terms of lack'. A discourse of the subaltern subject as newly debased, 'rendered passive by the flawed promises of Maoism', not only dominates official speech in a policy of eugenics; it pervades popular consciousness and echoes even in the rhetoric of the opposition. On the one hand, the discourse was predicated on the proposition that China has failed to come into its own as both internal and external boundaries collapse. On the other, it resecured the boundaries of a state in which subjects were condemned to remain helpless in their subaltern position.

Anagnost explores how 'the liberatory discourse of socialist revolution' was brought to such an impasse, tracking the 'discursive trail' of the speaking subject across the actual – but increasingly permeable and disrupted – boundaries between state and society, past and present, party and masses, Chinese self and significant others. Between the one hand and the other, she finds a third hand in the emergence of a 'highly reflexive discourse that mirrors . . . China's opening out to the world in the post-Mao period and the evaluative gaze of foreign capital'. Are there boundaries between generations? Do generations exist? Within the boundaries of 1993–94, 'Generation X' has been both constructed and demolished. Is this rule by historiography, or do generations need to be constructed? As Anagnost talked with a Chinese parent in Beijing during the Tiananmen massacre, he pointed to his daughter and said, 'Her generation will not stand for this'.

Our final words are left to the Muslim-Chinese artist Zhang Hongtu, living in New York. After the Tiananmen massacre, he painted a version of da Vinci's *Last Supper* in which every face was that of Mao. It was banned from a federally funded exhibition in Washington, DC, as offensive to Christianity: 'I believe in the power of the image, but . . . not [its] authority'.

I

Body, Space, Time and Bureaucracy: Boundary Creation and Control Mechanisms in Early China

ROBIN D. S. YATES

What is it that makes a man human? I say that
it lies in his ability to draw boundaries[1]

In this essay, I intend to examine the problematic of boundaries in early China in four contexts, those of space, body, time and bureaucracy, and to attempt to demonstrate their significance and relations within the cosmology of the Qin state and empire. The achievements of the Qin are well-known. King Zheng, who came to the throne as a minor in 246 BCE, led Qin to supremacy by defeating his rival states and became the First Emperor in 221 BCE, founding in the process the Chinese imperial system. He ordered the completion of the Great Wall of China and instituted many important political, social and economic changes. Since 1975, the Qin has also gained world-wide recognition with the discovery of the remarkable life-size pottery army guarding the First Emperor's mausoleum at Lishan, Shaanxi province.

Historians of China have traditionally focused on what I would call the external features of Qin rule, particularly its creation of a penal system that was as sophisticated as it was harsh for keeping its population under control. In many ways, the Qin state and empire might appear to be a typical example of despotism, exploiting its people until they revolted to throw off their oppressors' yoke. But I believe that there is more to the disciplinary system of the Qin than meets the eye. Specifically, the concepts of space, time and body were articulated at the dawn of China's imperial age in such a way as to form a tightly integrated symbolic structure which seemed to express the very nature of the cosmos itself. These concepts were as present in the language through which both intellectuals and people spoke and thought, as they were in social, political and economic institutions; they formed a powerful discourse which appeared to be self-evident and true. Indeed, through their

particular interpretation of this discourse, the Qin gave order to the world.

Furthermore, time and body were pervasive conceptual categories in the structure and daily functioning of the bureaucracy – the organization by which the early imperial rulers were able to unify the very disparate regions and states, cultures and peoples that existed in the subcontinent of East Asia at that time. It is my opinion, therefore, that the Qin's success, and also its dramatic failure, can be attributed in large part to its obsession with boundaries in these four contexts; thus I have chosen to analyse space, body, time and bureaucracy together in this limited but highly significant historical period.[2]

The problem of data

The history of the Qin has long been obscure, but in recent years Chinese archaeologists have made a series of remarkable discoveries relating to the Qin, including the world-famous mausoleum of the First Emperor at Lishan, east of Xi'an, the capital of Shaanxi province, in northwest China. These new materials are now allowing scholars to excavate the long-hidden secrets of the Qin's rise to glory and the factors that enabled them to conquer their rival states and found the Chinese empire in 221 BCE, two hundred and fifty years after Confucius's death in 479 BCE, and thus ending the Warring States period in Chinese history.

Why has the history of the Qin been so obscure? The reasons are multifarious, but two should be mentioned straightaway: the first is the shortness of the Qin's rule and its rapid collapse in a series of rebellions led by discontented peasants and officials shortly after the First Emperor's death in 210 BCE. The second is that the dynasty that replaced it, the Han (206 BCE–CE 220), while consciously inheriting and modelling its bureaucratic administration and legal system on that of its predecessor, eventually sunk its ideological roots into Confucianism, accepting Confucian doctrine as the soundest basis for its own claims to legitimacy, albeit a Confucianism that was heavily influenced by strains of thought that were quite distinct from the master's initial vision. The Han, therefore, after a little over seventy years, no longer justified itself by demonstrating that it had destroyed the Qin, but rather by claiming that it had inherited the moral mantle of the Zhou, the decrepit dynasty whose last king was ignominiously eliminated by Qin generals in 256 BCE. Qin, therefore, was considered an illegitimate aberration in the otherwise uninterrupted transmission of the moral leadership of the world, the all-under-heaven, from the beginning of the world and the

utopias of the ancient sage kings to the rule of the Han. Qin was ignored not least because in its last days, after 213 BCE, it espoused the noxious teachings of the legalists, or *fajia*, the intellectual rivals of the Confucians, whose proponents were primarily men of action, statesmen or administrators. The legalists' interest lay in achieving the most efficient and objective running of the bureaucratic machine possible: for by that means, they believed, order in the world could become a reality. Utopia could exist on earth and last forever.

Although the present essay will not offer a detailed exposition of the teachings of the Confucians, or of the legalists, or indeed those of the other schools of philosophy (the Mohists, the followers of Mozi, the Daoists, the 'egoist' subscribers to the teachings of Yang Zhu, the *yin-yang* specialists etc.), it is necessary to review some elements of the intellectual background to the Qin unification as it affects the understanding of boundary creation and maintenance in early China, and to explore where the philosophies were in agreement. The Qin synthesized in their ideology many currents of thought circulating prior to their time, and in their social and bureaucratic practice they gave shape and form to the social and political institutions of later imperial China. Thus, as the founders of the imperial system, they have a far greater importance for understanding Chinese beliefs and practices than the brevity of their dynasty would suggest.

Of course, it is extremely difficult to reconstruct the *mentalité* or modes of discourse of such an ancient culture. This is especially so in the case of Qin, because so little remains of the popular beliefs and practices of the oral, lived culture – we are condemned to peruse only what was written down by the elite and what has survived by chance. Fortunately, however, Chinese archaeologists have been making extremely significant and valuable discoveries in recent years, both of textual materials and of artefacts, and it is these, especially the former, together with an unjustly neglected philosophical work, that I will use to approach Qin society and institutions and its concomitant beliefs, attitudes and ideology. The new texts I will employ are those that were found in 1975 in the tomb of a local official of the Qin empire who died in 217 BCE, a man whose given name was apparently 'Happy' (Xi). These texts are partly portions of the Qin legal code and partly almanac texts or day books. The former have received an enormous amount of attention from Chinese and Japanese scholars, and a few Westerners, including myself, whereas the latter have been almost totally ignored since their publication in 1981,[3] despite being of immense interest and value in reconstructing Qin culture. The

neglected philosophical text is the *Spring and Autumn Annals of Mr Lü* [*Lüshi chunqiu*], written under the auspices of Lü Buwei, the first prime minister of King Zheng. The text that bears Lü's name, completed in 239 BCE, was composed by a large group of scholars under his patronage, scholars who drew their inspiration from many or most of the philosophical currents of their time but who consciously forged out of these disparate elements a unified vision of ideal government based on ultimately true, or what they perceived to be true, cosmological foundations.

Language and space

Within a particular history, the conception of boundaries may initially be approached through an examination of the nature of the world assumed by a culture's thinkers, and more particularly from an examination of their language. Thus my first observation on the concept of boundaries in early China concerns the nature of the world that Qin thinkers assumed as a consequence of the language that they used. Bao Zhiming is surely correct when he asserts that the conception of language in ancient China was different from that to which we are accustomed. 'The classical conception of language does not view language as a mere descriptive tool that is a separate entity independent from the world it describes. Rather, language and the world are inseparably bound up.'[4] Language and the world were conceived of as having 'an isomorphic fit'. Thus by the very form the language took to describe the world, the ancient Chinese people gave order to that world.

Clear boundaries between all objects named by language, as well as the relations between those objects, were specified by the very naming or articulating process itself. This is not to deny that there was debate among philosophers and logicians about the 'fit' between words, or the names employed (*ming*), and the realities (*shi*) designated by those names – there certainly was.[5] Thus we see in the language the development of sets or schemes of enumeration which seem to give shape to the phenomenal world. Each unit in these sets was considered to be normative: each item was conceived of acting *as that item should*, or of being capable of being *made to act as that item should*, or of being capable of being *thought of as acting as that item should*. The most basic sets were binary pairs which were opposite, yet complementary, where the one could only define itself in relation to the other. A partial list would include: one-many; superior-inferior; lord/ruler-subject/minister; father-son; husband-wife; inner-outer; left-right; order-disorder;

Heaven-Earth; Yin-Yang; form/shape-name; name-reality; being-non-being; action-nonaction; movement-quiescence; public-private; reward-punishment; long-short; light-heavy; light-dark; north-south; male-female; noble-mean, etc. Any one of these pairs could be interpreted as homologies or templates of the entire system. So, for example, the First Emperor of China could claim in one of the inscriptions on stone which he set up to commemorate his triumph in unifying China, that he had separated noble and mean, interior and exterior, and that men and women conducted themselves according to the rites – and thus he had brought order to the world.[6] At the same time, of course, in a few of these pairs, the name and/or function could stay the same, while the person filling one name and/or function could also be located in another. For example, a father was a son to *his* father, and all individuals within the social and political hierarchy were at one and the same time master or controller (*zhu*) of the levels below them and subject to the levels above. All were subject to the Son of Heaven, who was himself subject to Heaven. In addition, moral qualities were similarly associated with different elements of the pairs: a son was filial, a father kindly, a subject loyal, and so on.

From these sets of binary terms, other sets were developed: triads (e.g. Heaven, Earth, Man); quadruplets (e.g. the four directions; four barbarians); quintuplets (e.g. the Five Phases; Five Tastes; Five Colours; Five Sounds; Five Animals) and so on.[7] Eventually, in the Han, all things in the entire universe were ordered using this correlative thinking into their appropriate categories. And things within a single category were believed to respond to each other. By using the name of one unit of the set, the qualities of, and actions appropriate to, both it and its complementary opposite were automatically invoked and set in motion. The Chinese seem to have believed that they had almost magical powers to substantiate the interpretation of the world being proposed paradigmatically and syntagmatically in language. By performing the linguistic act of speaking a word, or uttering a sentence with its particular semantic and syntactic structure, the literal and symbolic/conceptual meanings were called into existence. Hence, for example, Confucius, by using the words that he did in the particular structure and order that he did, was conceived of as allotting normative praise and blame to the individuals who figured in the historical records of the state of Lu, the *Spring and Autumn Annals* [*Chunqiu*]. By bounding, limiting, and compartmentalizing the world in this way, the Chinese gave the world both existence and order.

Crossing the boundaries, transgressing the borders, 'leaping over' the

distinctions thus linguistically and conceptually defined, on the other hand, brought about the disruption of the entire system. Rulers *had* to behave in a ruler-like way at all times and subjects likewise in a subject-like way. If they did not, all harmony in the cosmos was threatened. There could not be partial harmony, for both forms and names derived from the Dao or the 'Way', the nameless transcendental Unity from which all things ultimately derived. The HuangLao text 'Dao and Fa' puts it succinctly:

The Dao of seeing and knowing is merely vacuity and non-existence. With respect to vacuity and non-existence, an autumn hair brings them [i.e. objects] into existence, for they then necessarily have a form and a name. If form and name are established, then the distinction between black and white has been made.[8]

In other words, the very appearance of the autumn hair – in Chinese philosophical discourse, this was the smallest possible thing in the world – out of the Dao, brings into existence forms and names and the paradigmatic distinction between black and white and hence of all phenomena.[9] The ruler who should be the all-seer and all-knower, must dwell in the Dao of vacuity and non-existence.

From this basic predisposition of thought, the early Chinese gave form and shape to their world. They regularized and contained it, segregated it and named it. By naming it, they created it. All the philosophers and all the political leaders, therefore, seemed to have assumed that there was *one* method of returning to order, even though each of their methods to achieve the goal of order was different. The problem was to choose the correct method. As the Confucian Xunzi stated:

Mo-tzu [Mozi] seeing no farther than utility did not understand culture, Sung Hsing [Song Xing] seeing no farther than desire did not understand fulfilment, Shen Tao [Shen Dao] seeing no farther than law did not appreciate personal worth, Shen Pu-hai [Shen Buhai] seeing no farther than the power-base did not appreciate wisdom, Hui Shih [Hui Shi] seeing no farther than wordings was ignorant of objects, Chang-tzu [Zhuangzi] seeing no farther than what is Heaven's was ignorant of what is man's.[10]

I shall turn next to the issue of space. Just as the ancient Chinese interpreted language by means of divisions, so they also divided space up into distinct units, each with its own peculiar concrete characteristics and each coordinated with time: the east was spring, the south summer and so on. Even the moral qualities and customs of the people living in the different parts of the all-under-heaven were affected by and linked to the locus in which they found themselves dwelling.[11] For the Chinese, earth and space were square, and heaven and time were round; as Granet has

argued, 'forming a complex of emblematic conditions at the same time determining and determined, Space and Time were always imagined as an ensemble of concrete and diverse groupings of *sites* and *occasions*.'[12] By 'sites' he means locations favourable or unfavourable for a given action, and by 'occasions' he means times favourable or unfavourable for carrying that action out. In the course of his analysis, he correctly points out that space was conceived of as forming a series of 'boxed squares' that were ordered into a hierarchy.[13] The Chinese ruler or emperor was located at the centre, protected by his closest liege-lords, and at the periphery were the four types of barbarians who were not really human.[14] Of course, in reality, these 'barbarians' actually lived in amongst the Chinese themselves and were not confined to the outer reaches, beyond the pale of civilization.

These characterizations of space may be said to exist on the ideal level. They were represented in a number of different myths, the most important of which were those associated with the name of Yu, the controller of the flood. Bodde has observed that the theme of the flood in Chinese mythology was 'the earliest and by far the most pervasive'.[15] What is of relevance in the stories surrounding Yu in the present context is that he created social geographic space by channelling and bounding the waters that were threatening to drown the whole of China. He cut through mountains and dug deep trenches, leading them along fixed courses to drain away in the eastern sea. His father Gun had tried to achieve the same ends by damming the waters, but had not been successful. This myth in essence fulfils the same role in China that creation myths have in Western mythology, and it expresses acknowledgement in ancient China of the power of drawing lines and limits in the soil to organize space and preserve civilization: in the words of one nobleman recorded for the year 541 BCE: 'Were it not for Yu, we would indeed be fish!'[16]

Throughout the evolution of the early states in China, this dividing and demarcating of the territory, regulation of the waters and division of the lands was one of the main political, economic and culturally significant and symbolic acts of government. It was one of the means by which the states claimed legitimacy. It is not possible to determine the exact historical details of all the different systems said to have existed in ancient times, though traditional and modern scholars have spent years trying to clarify the issues involved. But as a generalization, Granet is surely right in saying that for the ancient Chinese all space was *civilized* space, organized space.

Mirroring the mythological organization of space in concrete political

and economic policies, by the time of the late Warring States period, each of the contending states had its own land system;[17] one of the most important reforms was instituted by Shang Yang in the state of Qin in the mid-fourth century BCE when, in the course of his radical reconstruction of the laws of that state, he redrew the size of the traditional acre. Shang Yang increased the size of this unit from one hundred to two hundred and forty square paces, and delineated the boundaries of the fields by pathways running north-south and east-west (the cardinal directions).[18] By this means he is said to have destroyed the feudal (*fengjian*) system of the Zhou and to have created a new system of land tenure in which land could, for the first time in Chinese history, be freely bought and sold. While this may be so, the divisions between fields in the new system were still indicated by a small elevated mound called a *feng*, and it was illegal to move these boundary markers.[19]

As I have shown elsewhere,[20] the Qin organized its entire population into a hierarchy of which the lowest level consisted of five-family units geographically dispersed throughout the countryside in accordance with the strict divisions laid down in Lord Shang's land reform programme. The members of each of these units were mutually responsible for each other's behaviour, and were held legally liable for any and all infractions of the law by their fellow family members. This social organization was coordinated with the land tenure system; above the family was the village, the county, the commandery and eventually the whole state and empire. Thus Qin society resembled an enormous intricately interwoven and interlocking set of mutually responsible cells. This system was based upon contemporary military practice: the Qin army was similarly organized, probably having derived its ideas from the state of Qi as described in the *Guanzi*.[21] The disciplinary structure employed by the Qin state may be contrasted with that of early modern European states in that the smallest unit held accountable to government was the family group, rather than the individual. Thereby it created group solidarity *against* the state. In China, the state was never able to 'individualize' members of the population completely: it relied on the family and the lineage to help it control the population, but by so doing it created centres of opposition which prevented it from ever monopolizing entirely the techniques and powers of discipline. Right up to the present time, Chinese people feel as much, if not more, loyalty to their families and lineages as they do to the central government authorities. The tension between particularistic ties to the family and the general loyalty to the state and nation has been an enduring feature of Chinese history.

In short, therefore, the Qin, by their land reform, redefined social space using the same conceptual principles that they perceived to exist in the nature of things, following the example of the civilizing sage Yu when he saved the world from chaos by harnessing and directing the waters. Thereby they claimed that they were instituting a cosmic renewal and creating a cosmic harmony that would, in the end, legitimate their conquest of the world.

Time and fate in the Warring States period

Over the centuries, the Chinese have lavished an immense amount of energy on trying to foresee the fate of both individuals and the state. While this latter proclivity may be said to go back at least as far as neolithic times in the third millennium BCE, it made its first clear appearance towards the end of the second millennium BCE, in the Shang dynasty. The Shang rulers subjected every single one of the major activities of their daily lives to the advice, or rather commands, of their dead ancestors and gods. Before entering into war, or planting, or harvesting the fields, or sacrificing to the spirits and so on, they divined the will of the departed by making and interpreting cracks on the shells of turtles or on the shoulder blades of cattle.[22] They were not, apparently, able to foresee their own demise in about 1046 or 1045 BCE, at the hands of their erstwhile subordinates to the west, the Zhou.

The Zhou forged an alliance among various tribes and with, they claimed, the assistance of their god Heaven (tian), destroyed the vastly superior forces of the Shang in a single battle and founded their own dynasty, starting a new time-cycle. This dynasty lasted the longest of any in the whole course of Chinese history; but from 770 BCE, the Zhou themselves were forced out of their homeland in the west and obliged to move to the Central Plains of the Yellow River valley, where they controlled only a very small piece of territory. They retained, however, ritual authority and legitimacy, but not political or military power. This passed into the hands of the kingdoms that were their nominal vassals. From this time on, therefore, there was an increasingly bitter struggle waged between these kingdoms for the domination of the whole country. There was an increase in social differentiation, and social mobility became more and more apparent; as the competing states fought and absorbed their rivals, the aristocratic lineages, which had been socially and politically dominant for more than a thousand years, wiped themselves out – committing, essentially, class suicide.[23] Needless to say, as the political and social structure changed, the sources of legitimate

authority also changed, and the general *mentalité* altered. There was a distinct sense of social malaise. The old ways were dead: what was to replace them?

The response of Confucius and his followers was to advocate a return to the golden days of the early Zhou dynasty, to accept the ways of the former kings; to cultivate benevolence (*ren*), wisdom (*zhi*), righteousness (*yi*), trustworthiness (*xin*), loyalty (*zhong*); to ensure that proper ritual behaviour be maintained in the essential and archetypal relations of father–son, husband–wife, ruler–subject, elder brother–younger brother, and friend–friend. Rulers were to accept the advice of sages and cultivated gentlemen in all their actions, and to yield to the mandate/fate of the morally good Heaven. They saw cosmic renewal as being possible only in a return to the ways of the past.

This is not to accept the opinion that the Confucians, or the Chinese in general, had a cyclical notion of time – as opposed to the linearity of modern (Western, scientific) man.[24] Confucius and his followers rather conceived that they were in some sense coeval with the sages of antiquity.[25] Not only did they believe that dead ancestors continued to have some sort of existence in the present and required on-going worship and sacrifice appropriate to their status, but they also held that the golden age of the past could be immediately, even instantaneously, recreated if only the proper names and correct political and social institutions were restored – although, of course, Confucius himself sometimes despaired that renewal was possible in his own time.

The Daoists of the *Laozi*, on the other hand, were not interested in locating their golden age in some definite past period, although they do imply in one instance that the Way was practised at some vague point in times past.[26] Their Way was not just that of the former kings, but was itself a transcendent cosmological first principle, the origin of all material phenomena, and immanent in the world, conceptually, if not temporally, prior to heaven and earth. The Dao was neither good nor evil, and if it could be characterized at all, was closer to non-being than being, was more feminine than masculine, softer than harder. The ruler was to model himself on this Dao, to be absorbed into it, to be invisible himself, and to be without any conscious action (*wuwei*), while all of his realm was to be manifest to him. He was to keep his people without knowledge, without desires, in a state of child-like bliss: thus could he manipulate and control them. While Heaven, Earth and man each had their own Dao, the specifics of each are not spelled out in detail in the text. Yet it is clear that by conforming to the rhythms of the natural and eternal cycle

of movement (*yang*) and rest or quiescence (*yin*), the ruler and all people could survive the dangers of their degenerate and savage age and live out their lives in peace and harmony. These ideas came to be elaborated by the HuangLao and *yin-yang* schools and by the Five Phases theorists in the later Warring States period, and they were picked up by scholars who contributed to Lü Buwei's *Spring and Autumn Annals* [*Lüshi chunqiu*], which formed the foundation of Qin ideology, as we shall see.[27]

Within a hundred years of Confucius's death, the influential Mohists, and later the legalists, recognized that it was not possible to recreate the utopia of the ancient sage kings. Times had changed and, therefore, new policies, new governmental structures and new laws, had to be created to respond to the changing conditions.[28] The Mohists accused the Confucians of encouraging moral laxity, and of advocating the sort of fatalism that led to chaos in the world:

Motse [Mozi] said: At present, in governing the states the rulers all desire to have their countries wealthy, their population large, and their administration orderly. But instead of wealth they obtain poverty, instead of increase they obtain a decrease in population, instead of order they obtain chaos; i.e. they lose what they like but obtain what they dislike. What is the reason for this? Motse [Mozi] said: It is due to the large number of fatalists among the people.

The fatalists say: 'When fate decrees that a man shall be wealthy he will be wealthy; when it decrees poverty, he will be poor; when it decrees a large population this will be large; and when it decrees a small population this will be small; if order is decreed, there will be order; if chaos there will be chaos. If fate decrees old age, there will be old age; if untimely death, there will be untimely death. Even if a man sets himself against his fate, what is the use?' With this doctrine the rulers are urged above and the people are kept away from their work below. Hence the fatalists are unmagnanimous. And their doctrines must be clearly examined.[29]

There was, Mozi argued, no reason to act in a socially responsible or moral way if the fatalists were right and all was pre-ordained.

So Mozi then went on to advocate three tests or principles for the evaluation of every doctrine or opinion, and this represents the first effort in Chinese history to generate objective criteria for a philosophical idea or governmental policy. These tests were firstly a consideration of the doctrine's basis, secondly of its verifiability, and thirdly of its applicability:

1. *It* [the doctrine/opinion] *should be based on the deeds of the ancient sage kings.* That is, did it conform to the policies or actions of the paragons of virtue of the past as recorded in the books of antiquity? These paragons were more ancient than those followed by the Confucians. This criterion the later Mohists quickly dropped, both because

they and their contemporaries became sceptical of knowing *anything* about the past, and because they recognized how conditions changed over time.

2. *It is to be verified by the senses of hearing and sight of the common people.* This criterion represents an empiricist position that could be easily distorted and ridiculed: was every account of a supernatural phenomenon spread among the people to be accepted as true?

3. *It is to be applied by adopting it in government and observing its benefits to the country and the people.* This criterion, for which the Mohists were justly famous, gained them immense popularity among rulers and common people alike, but earned them the unmitigated hatred, scorn and jealousy of the Confucians.

Body

Who were these fatalists and what did they believe? It is known that more than twenty-five different calendrical/tempotechnical systems were in circulation by the time of the Qin empire, as the remains of these were found among the almanac texts at Shuihudi in Yunmeng xian, Hubei province.[30] These were all prescriptive and presuppose a belief that the future could be predicted and that a person's life was controlled by fate. Among the philosophers, however, the belief may have begun with Zixia, a disciple of Confucius, whom Wang Chong, the Confucian of the first century CE, quotes as saying, 'Life and Death depend on Destiny, wealth and honour come from Heaven.'[31] And Wang proceeds to argue that:

The destiny regulating man's life-time is more powerful than the one presiding over his prosperity. Man shows by his appearance, whether he will die old or young, and there are signs indicating, whether he will be rich or poor, high-placed or base. All this is to be seen from his body. Length and shortness of life are gifts of Heaven. Whether the structure of the bones be good or bad, is visible in the body. If a man's life must be cut off in its prime, he cannot live long, although he be endowed with extraordinary qualities, and if it be decreed that he shall be poor and miserable, the very best character is no avail to him.

Thus, by the middle of the Han dynasty, physiognomy had become completely accepted even by the most sceptical of philosophers, despite the arguments advanced by Xunzi, the Confucian of the third century BCE, against the practice.[32] Many texts were apparently composed providing theoretical justifications and explanations of the efficacy of physiognomy, as well as guidelines for practitioners, but all of these were lost long ago. Only recently have two books been rediscovered, but these are concerned with the art as it applies to animals, specifically horses and

dogs, and the latter text is extremely fragmented and hard to interpret.[33] Nevertheless, from extant writings, the general theory behind physiognomy can be understood.

Those with a strong constitution were thought to possess vital force or energy (*qi*) in abundance. Hence their bodies were strong and they lived a long time, whereas those with a weak constitution had 'a feeble vital force and a delicate bodily frame', and they died. This vital force or energy was considered to be the basic constituent element of the universe; it was a sort of fluid that flowed through all things animate and inanimate. At the beginning of the world the more refined, quintessential *qi* rose up to form Heaven and the stars, whereas the grosser, more material *qi* fell down, congealed and formed the Earth.[34] Inside the human body, it flowed like the blood through channels to the extremities – indeed blood and *qi* are frequently spoken of in unison – and it was believed that many diseases were caused by the blockage or seeping out of the flow of this vital force.[35] A man received this fluid at birth, and when it was used up, he died. As Wang Chong put it:

Just as Heaven emits its fluid, the stars send forth their effluence, which keeps amidst the heavenly fluid. Imbibing this fluid, men are born, and live, as long as they keep it. If they obtain a fine one, they become men of rank, if a common one, common people. Their position may be higher or lower, and their wealth bigger or smaller, according as the stars distributing all this, rank higher or lower, are larger or smaller.[36]

In the same way as an individual's life-process was thought to be controlled by the heavenly *qi*, the destiny of states was also conceived of as being affected by the celestial panoply: Heaven itself was conceived of as being a kind of giant bureaucracy, the stars being the bureaucratic officials, mirroring the officials on Earth. It was a kind of template: if something affected a given star in the sky, something would happen to the holder of that specific office on earth.

Earth, too, was considered to possess arteries (*mai*) through which the vital essence/fluid flowed. Meng Tian, the general in charge of constructing the Great Wall along Qin's northern border to keep out the nomadic Xiongnu peoples and to symbolically demarcate the civilized realm, was accused after the First Emperor's death, in the course of a *coup d'état*, of the crime of having cut through these arteries during his building activities.[37] Fearing the excruciating pain of the torture Qin regularly applied to those accused of high treason, he drank poison to commit suicide.[38]

So the *Spring and Autumn Annals* explains specifically and clearly that

the correct motion of the quintessential *qi* (*jingqi*) is to flow through its courses unhindered.[39] If it does, then disease has nowhere to locate itself and evil has no place to grow from. But if it is blocked, then disease stays in place and evil grows. So if water is blocked, it becomes polluted (*wu*); if the *qi* in trees is blocked, noxious insects start their attack; if the *qi* in grasses is blocked, they become weedy; and if the *qi* in a state is blocked, then the ruler's virtue cannot penetrate to the local areas. In its bureaucratic administration, therefore, the Qin emphasized that the flow of information between the central government and regional and local offices had to be swift and sure. Reports travelled from the bottom of the hierarchy to the top, while orders and laws were transmitted from the centre down and had to be immediately executed. Any delay or impediment in the flow was subject to the assessment of penalties and/or fines.[40]

Thus Heaven, Earth and Man were intimately connected and considered to be homologies of one another: they were similarly constituted and mirrored each other. It was essential that each element in the three different spheres should keep to its own designated function, within its own boundary, for if it did not the entire system was adversely affected. Each part affected the corresponding part in its homologous sphere, and if a part was affected, the whole was knocked out of balance.

To return to the composition of the human body in more detail: the *Guanzi*[41] contains a HuangLao Daoist text of the early Warring States period, the 'Nei Ye', that states that, 'When people are born, heaven gives them essence (*jing*) and earth gives them shape (*xing*). Joined together these two make human beings develop.'[42] This text further provides one of the earliest explanations of the relationship thought to exist between the internal spirit and the external appearance, from which the later physiognomists drew their inspiration:

> When the essence exists [within] and gives life naturally,
> Being stored internally, it acts as a fountainhead.
> How great!
> Being peaceful it acts as a wellspring for the breath of life.
> So long as the wellspring does not dry up, the four parts of the body
> then remain firm.
> So long as the wellspring is not exhausted, the passages of the nine
> apertures remain clear . . .
> If the heart is complete within, the form will be complete without . . .
> When a man is capable of being correct and quiescent,
> His flesh is full, his ears and eyes sharp and clear,
> His muscles taut, and his bones sturdy.[43]

By the first century of the Han, the *Huainanzi* text could elaborate that, 'Essence and spirit (*Jing shen*) belong to heaven, the bones and shape belong to the earth. [When people die], their essence and spirit enter [heaven's] gate, and the bones and shape return to their roots [in the earth]'.[44] In this text the commentator Gao You explains that the essence and spirit can enter heaven's gate because they lack form (*wu xing*), whereas the bones and shape return to earth because they possess form (*yu xing*).

In outward appearance, man's shape was also conceived of as corresponding to the macrocosm. The head is round, imaging Heaven, the feet are square (we should say rectangular), imaging Earth. And just as Heaven possesses the Four Seasons, the Five Phases (Metal, Wood, Water, Fire and Earth), the Nine Openings (the eight directions and the centre), and 366 days, so man possesses four limbs, the five orbs (storehouses, somewhat similar to the major organs of Western medicine), nine openings, and 366 sections to the body. As heaven possesses wind and rain, hot and cold, so man has taking and giving, joy and anger; the various orbs of the body correspond to the meteorological phenomena of clouds, *qi*, wind, rain and thunder.[45] The ears, eyes, nose and mouth were conceived of as the four officials in *Spring and Autumn Annals*,[46] for they guarded against excess pleasures that could enter and corrupt the body.

The ruler of the body was the mind, located primarily in the organ of the heart (*xin*).[47] While many philosophers thought of this organ physically and as receiving the sense perceptions, they also believed that it generated the thinking processes. For Zhuangzi, it acted as a mirror of, and a repository for, the bright and flowing Dao.[48] Hidemi Ishida, however, has recently shown that the mind for the early Chinese was not a fixed entity dwelling exclusively in the heart, but was a fluid constituted of the essential spirit or energy that could move round the body with the blood and *qi* and could even leave the body entirely.[49] If the mind fixed on an external desire, it could find itself permanently exiled from its dwelling place and the person would die. And, of course, in death this is what they believed happened: the mind abandoned the body.

As it was considered possible, or even natural, that during the course of normal life the mind should leave the body temporarily – it did so in dreams – so too the *qi* of a person could and did emanate from that individual, and might therefore be seen at a distance. From the Warring States period on, for at least fifteen hundred years, this conception was a common cultural property of the Chinese. Every army contained within it

experts at watching this vital energy, who observed the *qi* as it arose and hovered in the air above an individual general, an army, or city, manifesting itself in certain colours and certain shapes, as animals, birds or utensils of common use. By observing the shape and colour, and the direction of any movement, it was believed that the outcome of a battle could be predicted. It was often seen as a sign of moral or spiritual attainment or degeneracy, and its less ethereal manifestation would be seen in the face or the colour of one's complexion. This practice was paralleled with the similar activity of watching for the emergence of the cosmic energy or ethers (*qi*) on specially propitious occasions, such as the solstices, when the balance of *yin* and *yang* forces shifted from the one to the other and potential changes in the weather, the harvest of crops and so on could be predicted.[50]

Thus it was essential for the sage to curb his desires and to be actionless, conforming to the unity of the Dao, for great dangers resulted from yielding to those desires. As one of the newly discovered texts from Mawangdui states:

In birth and growth there is harm, meaning desire, meaning not knowing sufficiency. Birth and growth entail movement; in movement there is harm, meaning not acting at the proper season, meaning, though acting at the proper season, . . . [text lost]. In movement there are human affairs. In affairs there is harm, meaning opposition, meaning lack of balance and ignorance of what to use them for. Affairs entail speech. In speech there is harm, meaning unreliability, meaning not knowing one should fear men, meaning false self-promotion, meaning empty bragging, and considering what is insufficient as being a surplus. Therefore, though they [things/phenomena/beings] emerge together from the darkness, some die by it [i.e. the process of emergence or Dao], some live by it; some are defeated through it, some come to completion through it. Disaster and good fortune share the (same) Dao, but no one knows where they grow from.[51]

From birth itself, the text is arguing, desires flow, and from them all discord inevitably follows: lack of right-timing, failure of speech to accord with reality, and so on. Perhaps only the sage can understand this and is capable of developing a regimen that can resist the inevitable logic of the degenerative process that begins at birth and ultimately ends in death. So we find in the *Huainanzi* a belief that, 'when the mind (the will) is concentrated on the inside of the body, it can pervade everything just as the One or the Dao itself.'[52] But the people were encouraged to have desires, for only if they had desires could they be controlled and used by the ruler.[53]

This recognition of desires, often interpreted physically as the desires for meat and drink and sexual pleasure,[54] as being one of the main, or the

only, constitutive elements of human nature, and as playing a fundamental role in, or being the potential principal cause of, human death and destruction was also shared by the Confucian Xunzi.[55] This philosopher argued that the origin of ritual lay in desires, or, more specifically, that rites were a means of satisfying desires, in regulating them according to the position of each individual in the social hierarchy.[56] He advocated strict adherence to sumptuary regulations in all major rituals, especially the most important life-crisis rituals of birth and death. Rites associated with the funeral, however, occupy most of Xunzi's discussion, and this emphasis on death ritual has lasted to modern times,[57] for at death an individual was transformed from a living human being to an ancestor, and the names and functions and relationships of all the members of the dead person's family were likewise altered and reordered. In China's patriarchal society, therefore, the liminal period during which a dead person, conceived of as being polluted and polluting, was transformed and purified was fraught with danger. Great attention was focused on the successful passage through the barrier between life and death. For proper performance of the ritual ensured the continuity of the social order: in fact it ensured right-thinking and even the possibility of attaining sagehood.

Unfortunately, it is not known exactly *how* the rituals were performed in Xunzi's time, although it may be possible to gain some notion from the writings on ritual in the Han that are preserved in the Confucian classics *Book of Ritual* [*Yi Li*] and *Book of Rites* [*Li Ji*]. These works have not been subject to any meaningful interpretation in recent years, though they certainly deserve examination. Without reviewing any one ritual in detail, one can say that what was important was the harmonizing of the colours and types of the clothing worn with the status of each of the participants, the types of food prestated and eaten, together with the correct positioning in the course of the ritual of each individual in relation to the others and to the cardinal directions. One example, describing the sacrifice to the ruler's ancestors, will suffice. It derives from the *Book of Rites* and contains the explanation:

The courses of the heavenly (bodies) supply the most perfect lessons, and the sages possessed the highest degree of virtue. Above, in the hall of the ancestral temple, there was the jar [of wine], with clouds and hills represented on it on the east, and that with the [sacrificial animal] victim represented on it on the west. Below the hall the larger drums were suspended on the west, and the smaller drums answering to them on the east. The ruler appeared at the (top of the) steps on the east; his wife was in the apartment on the west. The great luminary [the sun] makes his appearance in the east; the moon makes her appearance in the west. Such are the different ways in which the processes of darkness and light are

distributed in nature, and such are the arrangements for the positions (corresponding thereto) of husband and wife . . .[58]

Now just as Man derived his vital energy, mind-spirit and corporeal form from Heaven and Earth,[59] so too was it believed that the four seasons derived from Heaven and Earth. So time was conceived of as a kind of energy, not just as a pure physical duration.[60] 'When heaven and earth are in harmony, their essence is joined as a mixture of *yin* and *yang*. When this essence is concentrated it emerges in the form of the four seasons. When each of the four seasons radiates its essence, the myriad beings are created.'[61]

Perhaps as early as the Shang dynasty, and definitely by the time of the Eastern Zhou dynasty, it was believed that diseases could be caused by evil spirits or ghosts taking up residence in the body and wreaking havoc therein; however, it was only in the later part of the Han dynasty that the seasons themselves and the Five Phases were apotheosized, being conceived of as divinities that resided in the human body. The religious Daoist work *The Classic of Great Peace* [*Taiping jing*] states:

The energies of the five agents/phases and the four seasons enter into the human body and there manifest as the divinities residing in the five orbs. When they leave the body, they revert to being the essence of the spirit of the four seasons.[62]

Later on, the twenty-eight lunar mansions, the Chinese equivalent of the Western twelve signs of the zodiac, and each year in the sixty-year cycle, were also apotheosized.[63] The power of these 'temporal divinities' is believed in to this day: an entire hall in the famous and newly reopened Daoist 'Temple of the White Clouds' in Beijing is devoted to the statues of the years, and some Chinese still worship the spirit of the year in which they were born.

Time, body and bureaucracy

Given these conceptions of the body and time, it was natural for the scholars working under Lü Buwei to believe that the ruler had to conform to the changing patterns and rhythms of the natural cycle; for the ruler was the quintessence of man. If he was to bring about the unity of the world, and by the late Warring States period most philosophers and politicians had accepted that unity in an empire was inevitable, all his actions, the clothes he wore, the emblems of his court, the food he ingested, the sacrifices he performed, the policies of his government, had to be in strict and complete harmony with Heaven and Earth, with the waxing and waning of *yin* and *yang*. He had to be 'In Time'. Eventually,

all things in the phenomenal world were assigned to their appropriate categories, their appropriate bounded spaces and functions, and the ruler was required to demonstrate by his ritual actions their correct use. By using every object correctly, he manifested his power over them and thus he created order in the world. 'He has to be careful about distinctions (*fen*) for only then can good order be reached.'[64]

So it was the ruler's responsibility to promulgate a calendar which matched as exactly as possible the rhythms of Heaven and Earth, *yin* and *yang*, the Four Seasons, and the Five Phases that followed each other in succession throughout the year. If he did not, and if he failed to keep harmony with the cosmos, and issued orders appropriate to a different season, all sorts of untoward natural disasters would occur; snow and frost would fall in summer, for example, if he issued winter orders in spring.[65]

The calendar therefore came to be the basis of a 'liturgical order'.[66] As Kalinowski commented with regard to the *Spring and Autumn Annals*, from the point of view of the government, 'All change not conforming to the Natural Order brings about for the Emperor the diminution or even the loss of his sovereignty. The theme of seasonable irregularities is there [in the text] precisely to signify the consequences brought on by an evil government.'[67]

The *Spring and Autumn Annals* text also proclaimed, 'Heaven, Earth, and the ten thousand things are the body of a single man, this is what is meant by Great Unity or Sameness',[68] and the cycle that man had to conform to was perpetually in movement and perpetually recurrent. In addition, the ruler and his officials, the bureaucracy, also formed an indivisible body, in which the ruler, like the mind in the body, was to be quiescent and actionless, while the officials were to be the ruler's eyes, ears, and other sense organs and to perform the actions under his direction.

Just as the mind was conceived to course through the body, to be not attached to any one fixed orb or organ, so the ruler was not to locate himself in any one position. If he did, he could be tracked and perceived and his ministers and his enemies could take advantage of him. 'The highest wisdom is to cast away wisdom; the highest benevolence is to forget benevolence; the highest virtue is to be not virtuous; speechlessly, thoughtlessly, to be quiescent and wait for the proper time/season, and when the proper time arrives, to respond. When the heart is at ease, it is victorious.'[69] It was otherwise with the officials. They had to be located, they had to be apparent; the name of the office they held and the reality of the actions they performed had to coincide. 'When an intelligent ruler

keeps ministers in service, no minister is allowed either to override his post (*yueguan*) and get merits thereby nor utter any word not equivalent to a fact. Whoever overrides his post is put to death; whoever makes a word not equivalent to a fact is held guilty of a crime.'[70]

This radical distancing of the ruler from the pragmatics of the exercise of power, so that the ruler rested passively at the still centre, generating limitless potency or charisma (*de*) that reached the furthest quarters of the world, while the officials acted around him, or rather at either side (left and right), recalls the Confucian idea that the gentleman should place himself in the middle way, in the elided centre from which he could influence all around him; starting from his own person, he could transform the world. In this privileging of the centre by emptying the centre, therefore, the legalist and Daoist theorists were curiously in agreement with the Confucians, even though the latter achieved centrality by practising self-cultivation through the study of positionality in the sphere of ritual. Through perfect adherence to the requirements of personal spatial positioning, the Confucians believed that the utopia of the ancient sage kings could be recreated and that Order could be achieved in the All-under-Heaven.

How were the officials controlled under the Qin? By the legalist techniques of reward and punishment. 'Men have no other means of knowing Heaven than by the mediation of the movement of the four seasons, of hot and cold, of the sun and moon, of the planets and stars. When these movements are correct, all that, by birth, is made of blood and *qi* obtains its (proper) place and security of its goods. Subjects, in the same way, have no other means of knowing their sovereign other than by the rewards and punishments, by the rank and salaries which he confers (on them). When these are appropriate, relations near and far, those who are at the court and those who are distant, the wise and the stupid, all exert their energy to the utmost and find full employment.'[71]

The Qin laws that were found in the tomb of 'Happy', the local official who died in 217 BCE, provide us with a wealth of information about the day to day functioning of the bureaucracy: the strict and detailed rules about the procedures of appointments, the checks that were made on their performance, the fines they were subject to for malfeasance, the reports they had to make to the central authorities about every last item in the offices under their control, the salaries they received, the promotions they could hope for if they passed the rigorous tests to which they were subject. I will not review these here. Suffice it to say that the separation into areas of jurisdiction in which the name or title (*ming*) of

the office matched the reality (*shi*) of its function, an idea that was advocated by Hanfeizi from a theoretical legalist perspective, was evidently put into practice by the Qin government. By doing this, the Qin also conformed to the strictures of the HuangLao Daoists that name (*ming*) and outward appearance/shape/form (*xing*) should correspond and be applied in all government business.

In the daily routine of administration, Qin officialdom was extremely conscious of timing: everything had to be done on time, reports had to be made within a specified period, and the names of the responsible officials scrupulously recorded. Even the hours of the work-day, which differed from summer to winter, were written down and, it would seem, strictly adhered to. If the prescribed regulations were not followed, the officials were subject to heavy administrative penalties in the form of fines.[72]

The prescriptions for right-timing are even more apparent in the almanac texts that were, as mentioned above, buried in the same tomb: there were more than twenty-five different, and frequently mutually contradictory, calendrical systems. They stated exactly what could or could not be accomplished on any given day, and what the fate or fortune would be if an action took place on a given day; 'Happy' even included the first geomantic text, which indicates what results would pertain if the various parts of a mansion were situated in different directions. Good days for horses, sheep, grains and trees are recorded, as are the fortunes of children born on a given day, and the activities proscribed on those days on which the gods had performed certain actions in ancient times, such as marrying.[73]

Now, theorists of time from Hubert and Mauss on have noted that the 'calendar does not have as its aim to measure, but to give rhythm to time.'[74] And Geertz has asserted that the calendar 'cuts time up into bounded units not in order to count and total them but to describe and characterize them, to formulate their differential social, intellectual, and religious significance.'[75] This is certainly true of the calendars we see in the almanac texts. Time was extremely heterogeneous for the Qin state and its people, and the observance of the temporal strictures must have posed serious difficulties for performing regular day-to-day activities. Indeed, all days seem to bear some symbolic value: there was no day of complete rest, as there is in the Judaeo-Christian tradition, but many Qin days were tabooed for different activities. For example:

In the first month, fifth month, and ninth months, to travel north is very auspicious; (to travel) northeast is less auspicious; if in these months you travel east, you will be struck; southeast, you will be stabbed; south, you will abandon

quintessence; northeast, your house will be destroyed; west you will be in difficulties; northwest, you will be put to shame.[76]

The twenty-third day of the sixty-day cycle, a male day (all days were characterized as being either male or female, and were correlated with the Five Phases also), was good for markets, but bad for building houses in the three months of winter, and bad for working the earth in the seventh month; in the second, sixth, and tenth month one could not construct houses or damage trees, and in spring one could not raise or destroy walls; on this day one could not marry off sons or take a wife at any time of the year, or make beds; and if this day occurred in the first ten days of the fifth month, one could not drink, eat, sing, enjoy music, gather in domestic animals, and husbands and wives could not have sexual relations. These are just some of the prescriptions for this day and, as I said, *all* the days of the year are treated in this manner.

Yet in our present state of knowledge it is hard to determine the actual daily routine in the Qin state – be it of bureaucrats, merchants or peasants. It is entirely possible that all the calendrical schemata found recorded in the tomb of 'Happy' were no more than intellectualist rationalizations of Qin practice, developing along lines opened up by contemporary structures or modes of thought.[77] It is impossible to know now to what extent ordinary people followed one particular calendar rather than another, or whether they justified their actions on certain days in terms of one or other of the alternative calendars.

What is certain, however, from the discovery of these calendars, is that the Qin state did not monopolize, or have absolute control over, the definition of time. The liturgical time of the 'Yueling' chapters of the *Lüshi chunqiu*, in which the ruler harmonized his activities with the cosmic temporal sequence and therefore gave order to the universe, and which has been taken by scholars to be the only operative calendar in Qin, was but one of many alternatives. A member of the Qin bureaucracy, such as 'Happy', had the freedom to choose between such alternative time systems in his day to day life. It is quite possible that he would have rejected carrying out a specific order issued by higher authorities to do something on a particular day or at a particular time, because that action was subject to prohibitions, or seen to be dangerous, in one of the hemerological systems accepted by him as valid. Time, therefore, may well have been one of the most crucial matters under debate in the Qin, and a matter of contention and of conflict. Time may not have seemed coherent or understandable, despite the efforts of the Qin state to impose its own temporal sequence.[78]

The incorporation of the 'Yueling' into the *Book of Rites* [*Li Ji*] by the Han Confucians gave that calendar ideological predominance later on, especially in the circle of the emperor and his officials. However, some of the other systems among the common people survived even up to the present day: for example, the Jianchu week system and the reckoning of the cycle of twelve years by the names of animals. Throughout Chinese history there was a tension between the time of the people and the time of the emperor and his bureaucracy. This tension or contradiction not infrequently influenced the ideology of popular uprisings, peasant rebellions and millennarian movements.

Nevertheless, it does seem to me that, within and across the systems represented in the calendars of the Qin, though time was boxed and separated, compartmentalized and segregated into units into which particular actions had to be fitted,[79] it was also interpreted relationally: each unit with its particular qualities extended beyond itself, because its qualities were always seen in complementary opposition to the qualities of other units. These units extended infinitely into the past and infinitely into the future. They were manifestations of the infinite flow of the energy of the Dao. But from the point of view of *lived* time, the closer the relationship of one unit to another, perhaps, the more vital or important the prescriptions and prohibitions were thought to be.[80] By their very internal coherence, the various calendars invited acceptance of their meaning. We might take, for example, one of the two systems of reckoning days according to the names of the twenty-eight lunar lodges (*xiu*):[81]

(slip 975) [First Month] *Yingshi*: it is beneficial to sacrifice; you may not build houses or enter them.[82] In addition, if you marry a wife,[83] she will not be peaceful. Boys born (on this day) will be officials.

(slip 976) *Dongbi*: you may not travel; all activities are inauspicious. In addition, offspring (born on this day) will not be whole.[84] You may not do anything else.

(slip 977) [Second Month] *Kui*: sacrifices and travel are auspicious. In addition, if you marry a wife, women will love her. [Boys] born (on this day) will be officials.

(slip 978) *Lou*: [it is beneficial to] sacrifice and all activities are auspicious. In addition, if you marry a wife, men will love her. Boys born will abscond but other people will remember them(?)[85]

And so on through each of the twenty-eight days. I suspect that an ordinary person of the Qin period would not necessarily have understood the complicated astronomical/astrological basis of this system, but rather would have chosen to do a certain action at a certain time because he

wished to conform the reality (*shi*) of his action to the name (*ming*) prescribed in the text (presuming that he accepted the official Qin ideological position on the relationship between names, forms and realities);[86] or because he accepted that the text possessed some sciento-magical properties (it could indeed foretell the future); or as an act of social conformity because his friends and neighbours followed the same system; or for some more personal reason that we cannot now recapture. Within each day, however, and over several contiguous days, certain types of activities or occurrences were coordinated, and as these conjunctions are made explicit in the text, the ordinary user of the calendars would surely have been aware of them.

Despite these conjunctions, the calendars most strongly suggest that all the different categories of activities in the Qin state and empire had their own temporalities, their own modalities of time, their own contrasts and liminalities;[87] furthermore, these temporalities reflected the hierarchies and oppositions that were perceived to exist within Qin society as a whole.

Conclusion

It is clear from these newly discovered documents that the cosmological foundations of the bureaucracy were not just of theoretical importance to the scholars working for the prime minister Lü Buwei. Great care was taken that the actual daily practice of administration, in which all members of the society participated, from the ruler down to the least of his subjects, was carried out in accordance with the spatial, corporal and temporal boundaries established by the Qin state. These boundaries were perceived to form an interlocking and integrated structure that had to be maintained in order for the Qin to fulfil its role as unifier of the world and harmonizer of the cosmos.

As the ruler could not personally oversee all the minutiae of routine bureaucratic administration – indeed, as we have seen above, almost all of the political philosophies advocated that he remove himself from them – he needed bureaucrats to help perform the necessary tasks in his place. Thus the bureaucrats came to occupy a central and essential position in the regulation and control of the entire cosmic system. In order for them to fulfil their roles, they had to conform to certain personal and bureaucratic norms. What these were can be discovered in another text which 'Happy' included in his tomb appended to a letter that Teng, the Administrator of Nan Commandery and a high regional official, circulated to all officials under his jurisdiction:

In general, good officials make clear the laws, statues and ordinances, and in no matter whatsoever are they incompetent. Furthermore, they are pure and clean, sincere and prudent and love to assist their superiors.[88]

Bad officials are the opposite: they are unclean and impure, and by implication they pollute the religious or sacred routine of daily administrative life and the bureaucratic cosmos.

The Son of Heaven, the sage, was forced to use men, the bureaucrats, to control the phenomenal world, and to do this by keeping the world in complete harmony, in perfect time with the rhythms of the natural order. By bounding and positioning, the Qin tried to control individuals and groups and to create social and political space. They thought that they had developed an ideal system which would last for ten thousand years. But by their very natures, human bodies were subject to the corrupting influence of desires and to the gradual diminution of their Heaven-given essence or energy.[89] The Qin tried to create the perfect bureaucratic system, but the cosmology on which they founded it contained a fatal flaw: Man.

Careful use of time was one of the principal ways, even the most powerful way, that the Qin sought to differentiate and yet relate, separate and yet combine, the actions of Man and the constant movement of the cosmos. Through the manipulation of time, the Qin tried to create a power with which to organize the universe. They placed the emperor at the centre, giving him the 'positional advantage' (*quan*) that enabled him to measure the actions, the performances, the desires of every single one of his subjects. 'Therefore it is only right-timing (*shi*) that the sage (*shengren*) values.'[90]

But within two years of the First Emperor's death in 210 BCE, the system that the Qin had created with so much effort and ingenuity collapsed through the greed, rapacity, pride and fear of the highest officials of the land, and through the oppression by the local officials of the populace at large. It was a great experiment, but it failed in the short term: only when the state ideology was refigured by incorporating Confucian doctrine did it become capable of surviving the next two thousand years, and thus influence us to this very day. Yet the organization of space into bounded units, the differentiation of the social order into mutually dependent categories, the acceptance of a natural hierarchy, the strict division of all phenomena within a single unitary totality, and the control of all parts, all persons, from a single centre: these dominating ideas the Chinese inherited from the Qin.

2

Beyond the 'Great Boundary': Funerary Narrative in the Cangshan Tomb

WU HUNG

The ancient Chinese word *daxian*, or 'great boundary', refers to the natural phenomenon called death, in which bodily functions and living experience cease. Yet, as is often the case in Chinese, the word is ambiguous and the concept of 'boundary' has multiple meanings: on the one hand, it means the 'end', 'termination', 'cessation', and 'expiration' of life; on the other, it implies a 'dividing', 'demarcating', 'joining', and 'juxtaposing' of this life and the afterlife. *Daxian* thus defines a single space and duration (this world and this life) or dual spaces and durations (this world and this life versus the other world and the afterlife). Moreover, since death (or more precisely, a death ritual) is a process in which the departed soul travels from this world to the world beyond, *daxian* is often conceived not as a transparent line but as an independent space and duration. The 'great boundary', therefore, can be understood in at least three different senses. These may be expressed diagrammatically:

———————— 'great boundary' ————————
this world/this life

(1)

other world/afterlife
———————— 'great boundary' ————————
this world/this life

(2)

other world/afterlife

'great boundary'

this world/this life

(3)

This essay argues that the complex implications of the 'great boundary' help to deepen our understanding of ancient Chinese ideas of immortality and the afterlife, and that in particular they supply a useful means to analyse art-forms which are related to death. Modifying a conventional iconographic method which focuses on individual 'scenes' in funerary art, I will pay particular attention to forms which are invested with the notion of boundaries and thus signify the relationship between individual scenes. Taking an Eastern Han tomb in Cangshan county, Shandong province, as my chief example, I will show that such forms, though often eluding iconographic identification, serve as structural keys to a funerary narrative which developed in Chinese ritual art.

Immortality and the afterlife

Death inspires fear, and the recognition that life has its 'great boundary' leads to the desire to postpone crossing that boundary or even to avoid it entirely. The incessant pursuit of longevity by ancient philosophers, necromancers and princes aimed not at overcoming death but at infinitely prolonging life – if their efforts were successful, the dangerous 'great boundary' would be erased altogether for them. This goal, which may be called 'achieving immortality during one's lifetime', might be pursued by internal or external means – longevity might be realized either by transforming oneself into an immortal or by transporting oneself to an immortal land. As early as the late Zhou period, people began to think that through certain physical practices, such as purification, starvation and the breathing exercise called *daoyin*, the practitioner could gradually eliminate his material substance, letting only the 'essence of life' remain. On the other hand, there simultaneously emerged the belief in the 'lands of deathlessness' – the two most prominent being in Penglai Islands in the east and Mount Kunlun in the west.[1] It was thought that on reaching such a place, one's biological clock would automatically stop ticking and death would never occur.

('great boundary' erased)

this world/this life:

immortality

ordinary life

(4)

The happy endings of both types of pursuit of longevity are suggested in the above diagram, and were described in ancient literature. Zhuangzi (active *c.* 300 BCE) vividly portrayed those ageless men unaffected by time and other natural rules: 'There is a Divine Man living on faraway Ku-she Mountain, with skin like ice or snow, and gentle and shy like a young girl. He doesn't eat the five grains, but sucks the wind and drinks the dew, climbs up on clouds and mists, rides a flying dragon, and wanders beyond the four seas.'[2]

With similar vividness, the lore of immortal lands was spread by necromancers. They told their audience, often rich and ambitious princes who were anxious about losing their worldly glory, that Penglai was in the Bohai Sea and consisted of three individual island-peaks. There, all the birds and beasts were pure white, and all the palaces and gates were made of gold and silver. Gazed at from afar, the islands looked like clouds but, as one drew nearer, they seemed instead to be drowning under the water.[3] Understandably, such an elusive fairyland could only be spotted by experts, and so necromancers could demand wealth and servants from their powerful patrons in order to accomplish their costly missions.

Zhuangzi focused on *man*, while the necromancers focused on *place*: but in their accounts, a *divine man* and a *divine place* share similar features and both appear in disguise. Both are still found in this world and still assume human and natural forms; only their unusual colours, habits and locations make them seem unworldly. Their extraordinary features, therefore, are signs of immortality or longevity: these *men* and *places* are no longer governed by the laws of decay and death, and the concept of the 'great boundary' can no longer be applied to them. Once we understand this train of thought, we can correct a confusion in modern scholarship on early Chinese religion and art, which often equates 'immortality' and 'afterlife'. In fact, the pre-Han idea of *xian*, immortals, firmly rested upon the hope of escaping death. The notion of an afterlife, however, was based on the other implication of the 'great boundary' as a predestined event – that death marked the beginning of one's continuous existence in the other world.

Indeed, instead of approaching death as the total elimination of living consciousness, the ancient Chinese insisted that it was caused by, and thus testified to, the separation of the body and the soul. In a learned paper, Ying-shih Yü demonstrates that this concept had appeared long before the desire for immortality: 'the notion that the departed soul is as conscious as the living is already implied in Shang-Chou sacrifices.'[4]

Based on a new archaeological find, we can further date the idea of the autonomous soul to at least the 5th millennium BCE: a Yangshao pottery coffin was drilled with a hole in its wall to allow the soul to move in and out. The same belief must have survived into the 5th century BCE, for it seems to have inspired the decoration of Marquis Yi's coffin, on which large painted windows symbolize the entrance and exit of the soul of the deceased lord.

Belief in 'immortality during one's lifetime' and 'the conscious soul after death' were inherited and developed by the Han (206 BCE – CE 220). The search for Penglai and Kunlun continued, but now these magical places were imagined to be occupied by immortals who, having themselves gained the secret of deathlessness, would unselfishly grant mortal beings eternal life.[5] More replicas of magic mountains were made at this time than at any other time in Chinese history; people believed that these and other imitations of divine forms would attract the immortals with their elixir.[6] At the same time, though almost self-contradictorily, funerary art flourished to an unprecedented degree, and it became customary for a person to prepare his or her own tomb while still living.[7] The fundamental premise of this practice – that death is unavoidable and must be faced squarely – seems to indicate a kind of rationalism. Yet the idea of the posthumous soul led to intense concerns with the afterlife, as well as with mortuary structures and rites. It can be said that the whole of Han funerary art was based on the notion of accepting the 'great boundary' but also attempting to go beyond it. Emperor Wen, for example, began his testamentary edict of 157 BCE with a philosophical statement: 'Death is a part of the abiding order of heaven and earth and the natural end of all creatures.'[8] But the same emperor also constructed for himself the only Western Han imperial mausoleum dug into a mountain cliff, with a special stone coffin that aimed to preserve his body forever. He also carefully planned his own funeral in advance, so that when death took place he would be safely transported into his stone palace. Even more telling, a regulation in the Book of Rites [Li ji] requires a ruler to prepare his inner coffin as soon as he ascends the throne, and to paint and repaint it every year until his death.[9] This coffin was thus both a symbol and a practical piece of mortuary equipment. As a symbol, it was a reminder of the inevitable 'great boundary', and as a piece of mortuary equipment, it would eventually become the ruler's underground home beyond this boundary. In this way, it attests to the central idea underlying funerary art, that is, accepting death but attempting to overcome it.

It is apparent that this kind of thinking differs radically from the notion

Drawings of the 5th century BCE painted lacquer coffin
from the tomb of Marquis Yi of Zeng, Suixian, Hubei.

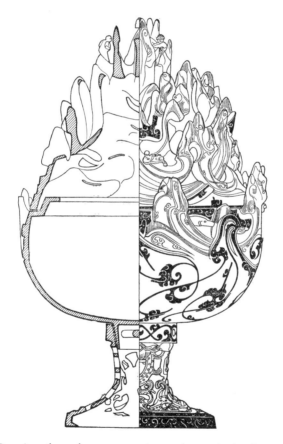

Drawing of a 2nd century BCE incense burner in the shape
of an immortal mountain, from the tomb of Prince Liu Sheng,
Mancheng, Hebei.

of becoming a living immortal, and that we must distinguish the principles of funerary architecture and art from those of longevity symbols. But as in many historical situations in which opposing ideas are mixed together and influence each other, during the Han the concepts of immortality and the afterlife drew increasingly closer until they were finally integrated. Frequently, a person spent his whole life searching for a magic island while also preparing his tomb. It would be simplistic to interpret such common, but contradictory, practices as symptoms of opportunism. A more profound reason can be found in the complex implications of the 'great boundary' in Han thought. When viewed as the end of life, death was nothing but a threatening tragedy that had to be avoided by all possible means; but when viewed as the beginning of a promising afterlife, the important thing became how to safely undergo the transformation from this world to the other. These two opposing points of view, which were inherent in the single concept of the 'great boundary', allowed a person to envision and pursue both an ideal life and an ideal afterlife.

The idea of immortality was gradually absorbed into funerary art. During pre-Han times, the afterlife in its most ideal form seemed no more than a mirror-image of life itself – the tomb of an aristocrat was usually arranged as his or her underground dwelling, containing all kinds of luxury goods and all sorts of food and drink for a comfortable life. This 'happy home' of the dead was further protected by tomb guardians, who were at first buried soldiers and then sculptured and painted underground deities. The great Lishan Mausoleum of the first Qin emperor, in Shaanxi province, though constructed and considered as a monument of a new historical era, was still based on this traditional approach. Its underground chamber contained models of 'palaces and pavilions', and 'self-triggering crossbows' were installed there to shoot unwelcome visitors. Sima Qian has also told us that in this chamber, rivers and oceans were made of mercury and were activated by a mechanical device, while 'all of the Heavens' were represented above and 'all of the Earth' below.[10] If the Grand Historian's words are reliable, the home of the deceased emperor was modelled upon the whole Universe. This Universe, however, cannot be simply identified as a 'paradise' (as some writers have proposed), since all its components – rivers, oceans and other heavenly and earthly phenomena – were symbols of nature, not of immortality. There were no replicas of an immortal land – such motifs became a legitimate part of funerary art only from the early Han, as we find in the famous tomb no.1 Mawangdui, Hunan province, of the mid-second century BCE.

Drawings of the 2nd century BCE painted coffin from Mawangdui tomb
(no. 1, Changsha, Hunan).

The Mawangdui tomb signifies a transitional period of early Chinese funerary art, characterized by the increasing complexity of the supposed afterlife.[11] On the one hand, the tomb incorporates almost all the beliefs and forms that were traditionally related to death: its 'central unit' (consisting of the fourth or innermost coffin and the well-known silk banner placed on it) preserves the tomb-occupant's body and soul; the decorative theme of its second coffin is the divine protection of the deceased in the underworld; and its *guo* section with more than 1,000 pieces of tomb furnishings duplicates the real household of an aristocratic family. On the other hand, beliefs and forms which were not traditionally related to death also found their way into the tomb. Most importantly, immortality was now conceived as part of the afterlife. We find Mount Kunlun, with its three adjacent peaks and flanking auspicious animals, depicted on the third coffin, transforming it into a transcendent paradise. This new practice of placing immortality symbols in a funerary context testifies to an essential change in the concept of immortality itself: instead of being equated with 'longevity' and pursued during one's lifetime, it was now hoped that one's soul would attain immortality after death. The afterlife thus also correspondingly changed its meaning: rather than passively mirroring this world, it became 'superior' to this life because it made the soul eternal.

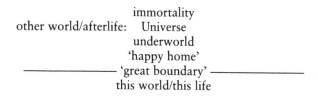

(5)

The scene beyond the 'great boundary' was thus enriched, but not yet unified. The afterlife is conceptualized and constructed as an assemblage of independent realms represented by different objects and images in various sections of the burial. The relationship between these realms is by no means certain; nor is it clear in which particular realm the deceased should abide. It seems that in their eagerness to express their filial piety and to please the dead, the tomb builders simply provided all the answers that they knew of to the mute question about the world beyond the 'great boundary'.

We may assume that such ambiguities and inconsistencies in the notion of the afterlife would have anticipated a more systematic theological interpretation. But, for better or worse, this interpretation was not attained before the introduction of Buddhism. The Han Chinese of the pre-Buddhist era seemed to have adopted a more practical or formalistic approach: since each of the realms in the afterlife could offer something special and valuable to the dead, the important matter became how to represent these realms in a more unified manner, rather than which to sacrifice for the sake of a consistent theory. Thus, while a serious inquiry into the ontological status of the afterlife is absent in the huge corpus of Han literature, the structure and decoration of burials did constantly change. The tomb designers either attempted to depict the journey of the dead to the immortal paradise, or tried to relate the disconnected realms in the afterlife into a single pictorial composition. The first effort gave rise to narrative art, as exemplified by the Bu Qianqiu tomb of the late first century BCE. The second effort, which aimed at synthesizing divergent images into a coherent but static structure, is typified by a sarcophagus of the second century CE from Guitoushan in Sichuan.

A mural in the Bu Qianqiu tomb is the earliest illustration known of the soul's journey to the paradise of the Queen Mother of the West. The long, horizontal picture is framed at both ends by male Fuxi and female Nüwa, two cosmic deities who, with the sun and the moon beside them, symbolize the opposition and harmony of yin-yang forces. Between them, the Queen Mother, the primary symbol of immortality, is situated on wave-like clouds, awaiting the arrival of a deceased couple who are travelling on the backs of a snake and a three-headed bird.[12] Most significantly, the central theme of this scene is not the final attainment of immortality, but the path and movement leading to it.

The Guitoushan sarcophagus, on the other hand, reflects the other tendency of Han funerary art: instead of organizing images into a diachronic sequence, a synchronic structure combines previously scat-

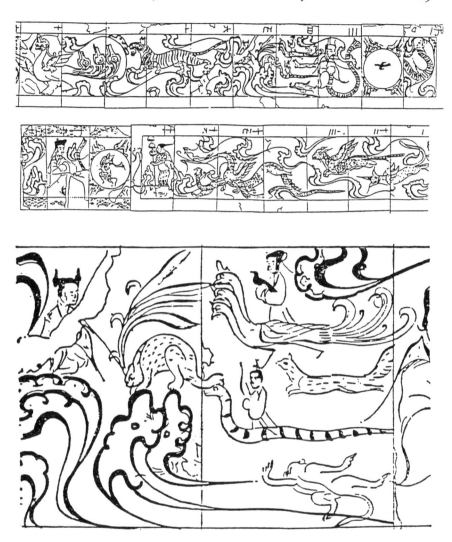

Drawings of the 1st century BCE mural, and a detail thereof, from the tomb of Bu Qianqiu, Luoyang, Henan.

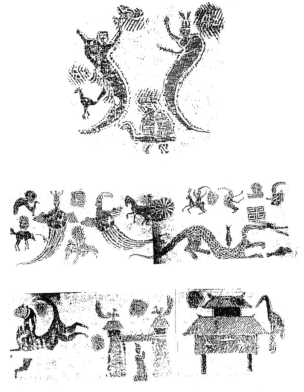

Rubbings of carvings on a 2nd century CE stone sarcophagus,
Guitoushan, Sichuan.

tered images. Unlike many similar examples, this newly discovered
sarcophagus is thoroughly inscribed with cartouches explaining its
carvings.[13] We find that an engraved pillar-gate is identified as 'the Gate
of Heaven' (*tianmen*) – the entrance of the departed soul into the afterlife.
Other images, including Fuxi and Nüwa, the sun and the moon, and
directional animals (a tortoise, a dragon, and a 'white tiger'), transform
the stone box into the Universe of the dead person. The third group of
motifs are symbols of immortality – two winged fairies are playing chess
(labelled '*xianren bo*') and another immortal is riding on a horse (labelled
'*xianren qi*'). A fourth category of images symbolizes wealth and
prosperity: a raised two-storied building is the 'Grand Granary' (*taicang*)
which would supply the dead (as well as all the figures and animals
engraved on the sarcophagus) with inexhaustible food; a 'white pheas-
ant' (*baizhi*), a 'cassia-coin-tree' (*guizhu*) and a beast called a *lili*, typify
three basic kinds of auspicious omens of animals, birds and plants. In an

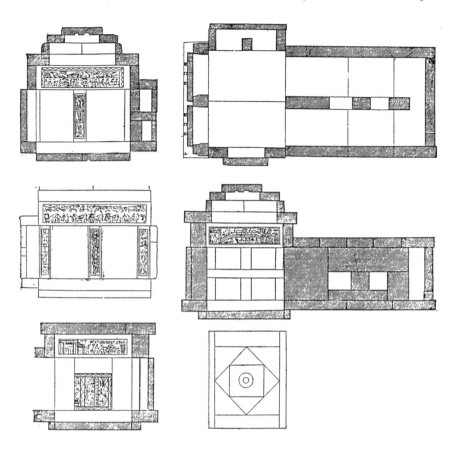

Plans and elevations of the 2nd century CE Cangshan tomb, Shandong.

almost graphic manner, these carvings express an image of the ideal afterlife: in the land of darkness the sun and the moon will still shine; *yin* and *yang* will operate in full harmony; the departed soul will never suffer from hunger; and, most importantly, as the 'great boundary' of death has been crossed, the deceased will forever enjoy 'longevity'.

The Cangshan tomb represents both the fusion and the culmination of these two trends. Ten relief carvings found in this tomb comprise a sophisticated narrative, which is also told in a long, rhymed inscription from the same tomb. Most importantly for this present analysis, both pictorial and textual evidence allow us to pin-point certain key motifs that punctuate this narrative – dividing it into sections that pertain to the various stages in the soul's transformation from this life to the afterlife, and also linking these sections and stages into an organized whole.

Rubbing of an inscription in the Cangshan tomb.

The Cangshan funerary narrative

In 1973, archaeologists from the Shandong Provincial Museum
unearthed an ancient tomb in the west of Cangshan county in southern
Shandong. According to the excavation report, published in 1975, the
burial consisted of two principal sections constructed of sixty stone slabs,
among which ten were carved with pictorial scenes.[14] The rear section
was further divided into two narrow compartments by a partition wall,
in which two 'windows' were left open. The front section took the form
of a rectangular hall, whose facade was formed by three columns
supporting a horizontal lintel. A shallow niche was opened onto the east
wall of this 'reception hall' (called *tang* in the inscription), and a side-
chamber was attached to the hall's west wall. The facade of this side-
chamber was again constructed with a lintel and three supporting
columns; the inscription, consisting of 238 characters, appeared on the
central and right columns. This inscription, in fact, is the only existing
Han funerary text to explain an entire architectural/pictorial pro-
gramme.[15] Judging from its many wrong characters and homonyms, its
indefinite appellation of the deceased, and its ballad-like literary style, we

can deduce that this text was in all likelihood from the hand of the artisan who designed the tomb.[16] My translation of this difficult passage takes into consideration a number of readings by Chinese scholars,[17] and tries to relate the text to the ten pictorial scenes in the tomb:

On the twenty-fourth day of the eighth month,
in the first year of the Yuanjia reign period [CE 151],
We completed this tomb chamber
to send you, the honourable member of the family, off on
your journey[18]
If your soul has consciousness,
please take pity on your descendants,
Let them prosper in their livelihood and achieve longevity.

[Allow us] to list and explain the pictures inside the tomb.[19]

The rear wall (p. 94, top):
The Red Bird encounters a roaming immortal.
Phoenixes trail after the White Tiger who is strolling in
the middle.

The central column [in front of the rear section] (p. 94, bottom):
Here a pair of intertwining dragons,
guard the tomb's heart and ward off evil.[20]

The ceiling of the [rear] chamber:[21]
A *wuzi* carriage is followed by servant girls who
are driving carps;
The chariot of the White Tiger and the Blue Dragon
runs ahead (p. 95, top);
The Duke of Thunder on wheels brings up the rear;
And those pushing the vehicle are assistants – foxes
and mandarin ducks.

[The lintel above the west chamber] (p. 95, middle):
Ascending the bridge over the River Wei,
here appear official chariots and horsemen.
The Head Clerk is in front,
and the Master of Records is behind.
Together with them are the Chief of a Commune,
the Assistant Commandant of Cavalry,
and a barbarian drawing his cross-bow.
Water flows under the bridge;
a crowd of people are fishing.
Servant boys are paddling a boat,
ferrying [your] wives across the river.

[The lintel above the each niche] (p. 95, bottom):
[The women] then sit in small *ping*-carriages;[22]

Rubbing of a relief carving from the rear wall
of the Cangshan tomb.

Rubbing of a relief carving from the façade column
in the rear chamber of the Cangshan tomb.

Rubbing of a relief carving
from the ceiling of the rear chamber
of the Cangshan tomb.

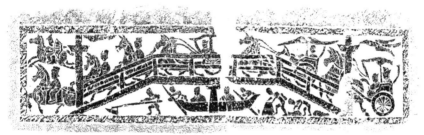

Rubbing of a relief carving from the west wall of the
main chamber of the Cangshan tomb.

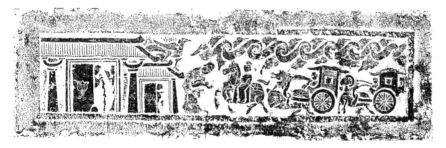

Rubbing of a relief carving from the east wall of the
main chamber of the Cangshan tomb.

following one another, they gallop to a *ting*
 station.[23]
The awaiting officer *youxi* pays them an
 audience,[24]
and then apologizes for his departure.
Behind [the procession],
 a ram-drawn carriage symbolizes a hearse;[25]
Above, divine birds are flying in drifting clouds.

The portrait inside [the east niche] (p. 97)
 represents you, the member of the family.
The Jade Maidens are holding drinking vessels and
 serving boards –
 how fine, fragile and delicate they look!

The face of the door lintel (p. 98, top):
 You are now taking a tour.
 Chariots are guiding the retinue out,
 while horsemen remain at the home.
 The *dudu* is in front,[26]
 and the *zeicao* is at the rear.[27]
 Above, tigers and dragons arrive with good fortune;
 a hundred birds fly over bringing abundant
 wealth.

The back of the door lintel (p. 98, bottom):
 Here are musicians and singing girls
 playing the wind-instruments *sheng* and *yu*
 in harmony,
 while the sound of a *lu*-pipe strikes up.
 Dragons and birds are driving evil away,
 and cranes are poking at fish.

The three columns of the front hall:
 In the middle, dragons ward off evil (p. 99, left);
 On the left, are the Jade Fairy and immortals (p. 99, middle);
 And on the right, [two characters missing],
 the junior master is called upon,
 and drink is served by his newly wedded wife (p. 99, right).[28]

The ceiling of the front hall is decorated beautifully:
 Surrounding a round protrusion,
 melon-leaf patterns embellish the centre;
 And fish patterns are added at the end of the leaves.

[All these figures and animals,] when you eat and drink,
 May you eat in the Great Granary,
 and may you drink from the rivers and seas.

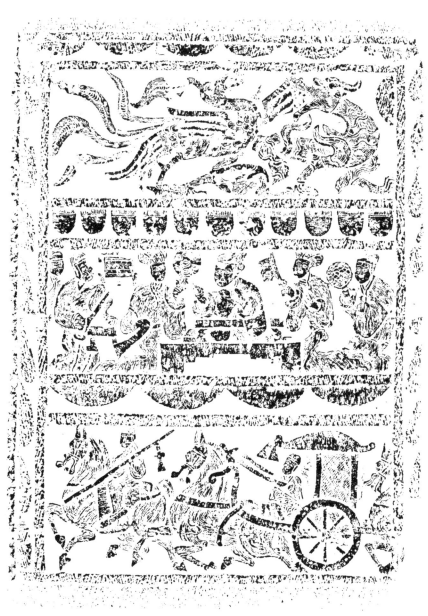

Rubbing of a relief carving from a niche on the east wall
of the main chamber of the Cangshan tomb.

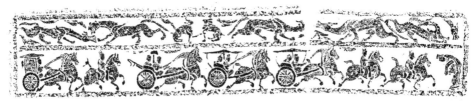

Rubbing of a relief carving from the front of a façade-lintel
in the Cangshan tomb.

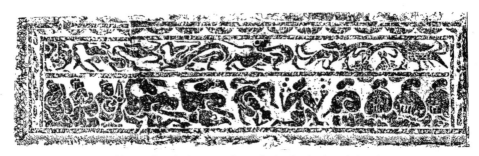

Rubbing of a relief carving from the back of a façade-lintel
in the Cangshan tomb.

You who devote yourself to learning,
 May you be promoted to high rank and be awarded
 official seals and symbols.
You who devote yourselves to managing livelihood,
 May your wealth increase ten-thousand fold in a single
 day.
[But you, the deceased,] have entered the dark world,
 Completely separated from the living.
After the tomb is sealed,
 It will never be opened again.

Two scenes described in this text are missing from the tomb. Since these
are both supposed to embellish the ceilings, including the strange
creatures and chariots in the rear chamber and the melon-leaf patterns in
the front hall, it is possible that the tomb was somehow hurriedly finished
before the top parts were fully decorated. But the absence of these carvings
only confirms my earlier proposal: the text must have been written by the
artisan and must document the original and *intended* design.

The designer of these carvings begins his description from the rear
chamber, which contained the physical remains of the dead. The images
planned for this chamber were all mythical: directional animals and

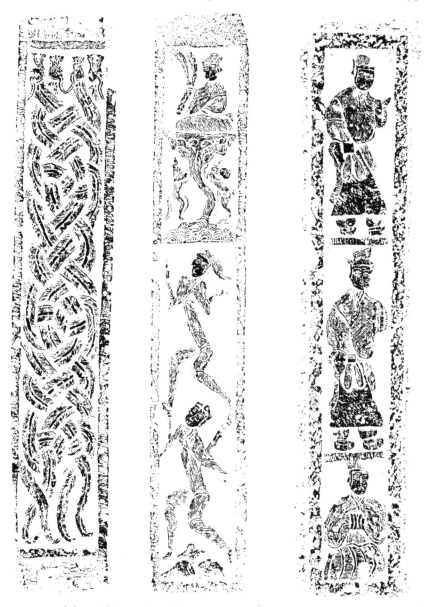

(left) Rubbing of a relief carving from the central façade-column
in the Cangshan tomb.

(middle) Rubbing of a relief carving from the east façade-column
in the Cangshan tomb.

(right) Rubbing of a relief carving from the west façade-column
in the Cangshan tomb.

heavenly beasts transformed the solid-stone room into a microcosm
(p. 94, top; p. 95, top), while intertwining dragons guarded the entrance
to keep the corpse safe (p. 94, bottom). The artist then moves on to tell us
his design for the front hall, which provided him with another enclosed
space for the following parts of his pictorial programme. His voice
suddenly changes from description to narrative, as he now follows a
funerary procession which would be illustrated in two compositions. The
first picture on the west wall shows the procession crossing a bridge over
the River Wei (p. 94, middle). Two famous Han emperors, Jing and Wu,
had built bridges across the River Wei north of Chang'an to link the Han
capital with their own mausoleums; imperial guards of honour and
hundreds of officials had accompanied their departed lords across these
bridges; and the River Wei had become a general symbol of death.[29]
Inspired by these royal precedents, our artist determined to label the
riders in his picture with official titles, but only with the names of the
local ranks familiar to him. He also decided to draw the wives of the
deceased, who would dutifully accompany their deceased husband to his
burial ground. But the women had to take a boat across the river, since
female (*yin*) had to be separated from male (*yang*), and since water
embodied the *yin* principle.

 As the movement of the funerary procession continues on the east wall,
the participants are reduced to the close family members of the deceased
(p. 94, bottom). The wives, having crossed the River of Death, get into
special female carriages, delivering the hearse to the suburbs. They arrive
at a *ting*-station, and are greeted by an official in front of it. This station,
which in real life was a public guesthouse for travellers, symbolized the
tomb of their husband; and the official who greeted the procession would
be the tomb's guardian. Elsewhere, stone statues erected in cemeteries
with the official title *tingzhang* (the officer of a *ting*-station) inscribed on
their chests convey the same idea.[30] To emphasize this special implication
of the station, the artist adapted a popular motif and depicted the station
with half-opened gates, with figures emerging from the unseen place
behind these gates. Holding a still-closed door-leaf, each figure seems to
be about to open it for the dead. This image thus reminds us of the 'Gate
of Heaven' on the Guitoushan sarcophagus and another stone coffin
from Sichuan (p. 101). Belonging to a certain Wang Hui who died in 220
CE, this second sarcophagus bears a similar half-opened gate on the front
end, as the entrance to an underground Universe inside the coffin that is
defined by cosmic symbols on the other sides of the stone box.[31]

 The first two pictures in the front hall, therefore, both represent a

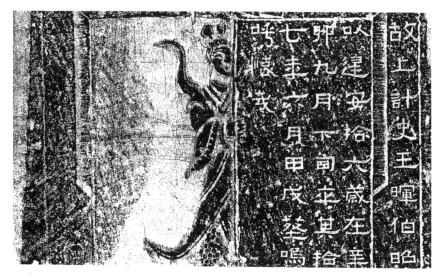

Rubbing of a carving on the front side of the sarcophagus
of Wang Hui, Lushan, Sichuan, dated 221 CE.

funerary ritual. Stated plainly, in the first scene the deceased is sent out by
a formal ceremonial procession of local officials, and in the second scene
he is further escorted by his wives to his burial ground. This funerary
journey ends at his tomb — the station with the half-opened gates — and
entering these gates meant the burial of the deceased and the beginning of
his underworld life. This is why, in the next scene, he resumes his human
form as the honoured guest in an elaborate banquet (p. 97). This
'portrait', engraved in a special niche in the front hall, therefore,
announces his rebirth: he is now *living* in his underground home with his
human desires regained. Logically, this 'portrait' introduces the next
series of carvings: his fulfilment of all of his desires in the afterlife. He is
accompanied by immortal Jade Maidens, is entertained by musicians and
dancers (p. 98, middle), and takes a grand outdoor tour (p. 98, top).
These last two scenes are engraved on the front and back of the tomb's
facade-lintel. One facing outside and the other inside, they summarize the
two main aspects of the life of leisure which the occupant of the
Cangshan tomb would forever enjoy. The divine animals on the central
facade-column (p. 99, left; p. 102) protect the front hall, just as the
intertwining dragons guard the rear chamber. Images on the other two
columns portray immortals and descendants of the deceased (p. 99, right,
middle). Flanking the tomb entrance, these two groups of figures seem to
symbolize the two worlds that are separated by the 'great boundary'.

In retrospect, we realize that this pictorial programme has three main parts with different themes. The rear chamber is transformed into a microcosm for the deceased, where his physical body is the reminder of his former existence. The next two carvings in the front hall depict a funerary journey, during which the deceased is transported to the threshold of the other world. The following scenes, inside and outside the front hall, represent the life of the deceased in the other world: he is enjoying all the delights and wonders promised by death. But if viewed as independent

Rubbing of a relief carving from the back of the central façade-column in the Cangshan tomb.

units, the first and third sections in this series are not 'narrative' at all, but only depict static 'realms' or 'states' of being. Their scenes do not form temporal sequences, but only reveal different aspects of these realms and states. It is the second part – the journey – that supplies the sense of happening, event, movement and orientation. But what is this second part? We find that it is a complex interpretation, perhaps the most complex interpretation, of the 'great boundary' in Han art:

other world/afterlife
——————————————————————— station
'great boundary'
——————————————————————— river
this world/this life

(6)

No longer a punctuating moment, here 'death' is represented as a lasting stage in which the deceased remains shapeless, concealed in his coffin and carried by the hearse. The key images of the two scenes define this stage: in the first picture, the 'river' separates this stage from the living world, and in the second picture the 'station' distinguishes this stage from the world beyond. The concept of 'death' or the 'great boundary' is thus understood differently from its conventional meaning as the expiration of bodily functions. Instead, it means precisely a 'ritual duration', which provides a crucial transition that links life and the afterlife into a narrative of the soul's transformation. I would like to term this kind of representation a *transitional narrative*.

This *transitional narrative* mirrors the structure and function of a funerary ritual. Many anthropologists have pondered on the meaning and definition of ritual. No single agreement has been reached but, as James Watson observes, 'in all studies of the subject it is generally assumed that ritual is about transformation – in particular, it relates to the transformation of one being or state into another, changed being or state.'[32] In the Cangshan tomb, what is being transformed is the state of the deceased or his soul; what transforms the deceased is the 'transitional' ritual sequence. Watson continues: 'rituals are . . . expected to have transformative powers. Rituals change people and things; the ritual process is active, not merely passive.'[33] A ritual process demands its own space and duration; a single liminal 'boundary' must thus be multiplied to frame this space and duration.

We can thus understand why the two ritual scenes in the Cangshan tomb emphasize the efforts made by the living to convey the dead across the 'river' and send him through the 'half-opened gate', and why these two scenes are presented in the central hall in the tomb. Placed in such a prominent position, they not only define an individual space and duration, but also set up a distinctive point of view for comprehending the first and third parts of the pictorial programme. From this point of a funerary ritual, the mundane world and immortal paradise appear as static entities, with their respective 'features', but without internal movements. A swimmer in a river senses the flow of water, but sees only the still banks on either side; to him, this moving river connects the separated terrain and makes it into a whole landscape. We can apply this analogy to the Cangshan funerary narrative: it becomes a *narrative* because its non-narrative parts – static pictures representing the former and future existences of the deceased – are linked into a continuity by the scenes depicting the movement in the intermediate zone. And it is a

transitional narrative because the narrator's point of view is determined neither by this world nor by the world beyond, but by the funerary procession which escorts the dead person as he crosses the 'great boundary'.

3

The Chinese Poetic Canon
and its Boundaries

PAULINE YU

It has become something of a commonplace to assert that the supreme literary achievement of Chinese elite culture lies in its classical poetic tradition, and that the highest expression of this high culture was reached during the period later labelled, appropriately, the High Tang, which corresponds roughly to the first half of the eighth century CE.[1] Either constituent of this commonplace could be interrogated with profit, of course, for the cultural priority assigned to poetry in China is as vulnerable to scrutiny as is the privileging of Tang – and especially High Tang – poetic production. Attention to the latter element first, however, not only affords a more specific and therefore manageable focus, but it also illuminates likely motivations and conditions behind the larger question as well.

The historical record tells us that some 2,200 poets and almost 49,000 works were collected in the *Complete Tang Poems* [*Quan Tang shi*], commissioned by the Qing emperor in 1705 and completed two years later; and yet, fewer than one hundred of these writers are represented in the anthology that has become most familiar to both scholarly and popular audiences: the *Three Hundred Tang Poems* [*Tang shi sanbai shou*].[2] Of these, perhaps only half might enjoy some name recognition among Western scholars of Chinese literature. And although the more than 2000 poets from the Tang whose works were collected in the larger compendium certainly reflect a considerable increase over the poetry-writing population of previous eras, the figures are even more impressive in the following centuries: four times that number were active during the succeeding dynasty, the Song, when individual poets are known to have produced several thousands of poems on their own, not to speak of the thousands of writers and tens of thousands of poems from the Ming and Qing dynasties thereafter. Moreover, hundreds of poets who happened to be women or monks – and thus not potential examination candidates – were either consigned to the margins of anthologies, collected in

volumes that are only now regaining scholarly attention, or not recorded at all.

These numbers notwithstanding, the Chinese poetic tradition was dominated for centuries by a canon comprised of a handful of poems by a handful of poets, most of whom wrote during a fifty-year period over a millennium ago. The recent critical literature on canon-formation has engaged in extensive explanations and critiques of such cultural practices, which are by no means unique to China.[3] Some critics have asserted, for example, that identifying a small group of canonical works provides a mnemonic device that is essential to a community if it is to 'process' a long and rich tradition. As Frank Kermode puts it, 'canons are useful in that they enable us to handle otherwise unmanageable historical deposits. They do this by affirming that some works are more valuable than others, more worthy of minute attention.'[4] Others have argued, on a more concrete level, that 'there is a continuing need for the social and, in particular, educational uses of the literary canon as some convenient conglomerate of teachable texts.'[5] Contemporary challenges to the Western literary canon have therefore been especially concerned with enlarging or reshaping it through the addition of previously forgotten, undervalued or suppressed texts. But as Russell Ferguson has pointed out, they 'tend to leave many of its most fundamental assumptions unchallenged. . . . The demand for admission to the canon remains a contradictory project, because it implies an acceptance of essential features of the existing structure.'[6] And the imperative – often moral and political, but certainly intellectual – to recognize such structures as contingent and constructed, rather than axiomatic, is a compelling one.

Ferguson argues that this 'centre of power always prefers to present itself as transparent,' to exist as 'the invisible centre which claims universality without ever defining itself, and which exiles to its margins those who cannot or will not pay allegiance to the standards which it sets or the limits which it imposes.'[7] This is true even though the actual substance or occupants of the centre may change. Jane Tompkins has pointed out, for example, the striking variations among lists of 'major' American authors published at different moments over the course of the twentieth century, and she notes that none of the editors of the anthologies in which these lists appears acknowledges his active hand in shaping a canon. Despite the fact that the instrumentality of their determinations 'emerges clearly in the prefaces, where the editors anxiously justify their choices, defend them against other possible selections, and apologize for significant omissions', their 'beliefs about

the nature of literary value – i.e., that it is "inherent in the works themselves", timeless, and universal – prevent them from recognizing their own role in determining which are the truly great works . . . as if they themselves had played virtually no part in deciding which authors deserved to be included, but were simply codifying choices about which there could be "no question".'[8]

However powerful such a will to transparency may be, in the contemporary Western context both the ongoing critiques of the canon and the benefits of the long historical view have served to bring the mechanisms of its formation to the critical foreground, where it may be seen as 'an active and continuous selection and reselection, which even at its latest point in time is always a set of specific choices.'[9] Similarly, in the case of China, the demarcation of a poetic canon and the arguments this process has generated, have charted a course that is remarkably visible in both the critical essays and the anthologies of the past millennium. In what follows, I shall be concerned with the arguments and methods by which such boundaries were conceptualized, and with the impulses behind them. The process was a protracted one; its roots may be traced back to the Tang itself, but its first triumphs could not be claimed until 700 years later. It is a process, moreover, within which are inscribed not only a culture's writing of its own literary history, but its vision of itself and its heroes as well.

Such inscriptions can be traced, first, not only to poetry's discursively canonical position within the sphere of literary production in general, but also – and perhaps more importantly – to its embeddedness on several levels within the elite culture of pre-modern China. During the Tang dynasty, writing poetry was integral to the daily life of the educated class, and it was institutionalized as the accepted currency of personal, social and political exchange. Poetic composition was a skill that any bureaucrat would be expected to master and display, on occasions both serious and trivial. The emperor celebrates a birthday: the assembled officials all write poems to wish him a full hundred years. The crown prince hosts a party at his summer estate: they celebrate his generosity. The emperor promulgates a new edict: they praise his sagacity. The emperor composes a poem: they all write poems in harmony, using the same rhymes – and woe to the laggard who finishes last, for anecdotes may record both his name and the number of cups of wine that he was made to drink as a penalty. An official accepts another commission: his colleagues bid him farewell, and he leaves them a keepsake poem in exchange. He returns

from his posting, and they welcome him back. A friend is visited, and both host and guest respond to the occasion by writing a poem. A friend is not at home, and the disappointed visitor leaves a poem – on the garden wall, perhaps – to convey his regret at having missed him. Formal or informal, public or private – such social events were at least as likely to provide the context for a poem as were solitary ruminations or grandiose occasions. It is difficult to imagine how depleted the collections of the past would be had such circumstances not inspired – or compelled – the composition of a poem. It is thus not difficult to understand, given the necessary swiftness of production, the impetus behind the refinement of, and increasing preference for, shorter and more highly regulated forms.

The cultural importance and institutionalization of poetry were peculiarly evident during the Tang in that poetic skills were tested in the imperial civil service examination that, when passed, conferred on the successful candidate the most prestigious degree, that of the *jinshi*, or 'presented scholar'. Contrary to common belief, it was not in fact an element in the exam for very long and, indeed, its place in the exam was continually assailed throughout most of the dynasty. As David McMullen has pointed out,[10] more than one critic at the time complained that the ability to write poetry did not necessarily provide a reliable indicator of a person's future administrative competence. The section requiring poetic composition was thus periodically attacked, and even removed, at various times up until the end of the eleventh century, after which it was virtually held in abeyance until the middle of the eighteenth century. That it did survive, nonetheless, as the most prestigious mark of qualification for civil office during the Tang – and one that was often sought after even by members of the aristocratic clan families for whom other routes to government positions remained open – attests not only to the vested interest of the educated elite in perpetuating the grounds of its own status, but also to the fact that – from the examiners' perspective – fidelity to strict prosodic regulations was relatively simple to evaluate.

Whether or not the examination system's valorization of poetry was instrumental to the genre's flourishing during the Tang was the subject of disagreement among traditional Chinese critics. The Southern Song figure, Yan Yu (c. 1194–c. 1245), indicates that this topic was already under some discussion, and provides his own unequivocal response: 'Someone has asked, "Why is poetry of the Tang superior to that of our own dynasty?" The Tang used poetry to select officials, thus many people devoted their exclusive attention to it. This is the reason why poetry of our dynasty does not attain [its level].'[11] Other critics, however, disputed

this assessment. The Ming scholar, Yang Shen (1488–1559), for example, argued that, 'The flourishing or decline of poetry is related to the talent and learning of individuals and is not based on its use as a means of selection by those above. Of the pentasyllabic eight-rhyme regulated verse by which Tang officials were selected, those poems written to examination topics that have survived are largely lacking in skill, and those that are known throughout the world are not examination poems.' Shortly thereafter, Wang Shizhen (1526–90) echoed this opinion, writing that 'People say that the Tang used poetry to select officials, thus its poetry alone is skilful, but this is untrue. Among all the poems written for the examination, very few are any good.'[12] The unimpressive quality of the poems that were composed to set topics should not surprise us; the fact remains that the presence of poetry in the examination fostered an unprecedented attention to poetic composition and coincides indisputably with the period which became canonized by later critics.[13]

Moreover, whatever the actual precariousness of poetry as an item in the civil service examination, its centrality to the identity of the elite in the Tang seems incontrovertible. This process of self-validation centred, almost without exception, on a consideration of the relationship of the individual to society and to the body politic. Within the dominant Confucian tradition, this concern was grounded in the presumption of a morality shared by human nature, its larger constructs, and the universe alike, which would allow literature to reveal individual feelings, provide a gauge of governmental stability, and serve as a practical, didactic tool. The assumption underlies the question addressed by poet after poet, in poem after poem: What is the nature of my involvement in the running of the state? If we bear in mind that life as a government functionary was both the only respectable and, indeed, the only possible *career* for the educated elite – whether as statesman, sheriff or scribe – then we hardly need wonder at the obsessiveness of this concern. It is a concern embodied in the very figure of Confucius himself, who spent much of his lifetime looking for suitable employment. In literature, it finds its paradigm in the work of a figure of the third century BCE, Qu Yuan, whose long poem 'Encountering Sorrow' [*Li sao*] was read as a passionate critique of a state that refused to acknowledge his desire for political engagement. Thus, in later works, declarations of a willingness to serve can be read as a vote of confidence in the government; statements of a failure to be recognized can be interpreted as a critique of governmental oversight and hence decline; and the decision to retreat altogether may be seen as a negative comment on the general state of affairs.

During the period that came to be characterized as the High (*sheng*; literally, 'flourishing') Tang, just as the Confucian ideology of political engagement on the part of the educated elite found its institutional realization in the examination system, so did issues enmeshed with this commitment appear overtly in the poetry. By contrast, one of the marks of cultural decline ascribed to the end of the dynasty was the perceived inability or failure of poets to address such issues directly – thus necessitating the excavations of Qing dynasty allegorists, who were determined to uncover concealed political references. The High Tang also benefits from favourable comparisons to the immediately preceding eras, and in particular the Qi and Liang dynasties of the fifth and sixth centuries, during which what was later castigated as a mannered, elegant, but intellectually and morally frivolous style, was cultivated at court. In fact, it was precisely during this earlier period that there were discussions of, and experiments with, complexities of tonal prosody; these comprised the essential groundwork for the quintessential High Tang style, which incorporated the formal sophistication and impersonal polish cultivated in these effete southern courts with a return to what, from the seventh-century perspective, were defined as ancient values of personal and moral commitment.

All of these factors played a role in defining a canon of poetry in traditional China. First, High Tang poetry established and implemented a rigorous system of prosodic regulations that, in its requirements for tonal and semantic parallelism and balance between emotional expression and scenic description, embodied and confirmed the mutual integration of individual and cosmos. Second, its highly systematic nature not only lent itself to practised execution, whether at court or in the country, but offered significant pedagogical advantages in comparison with less stringent forms: rules could be taught. Third, the many political topics of the poems themselves, and the nature of the civil service examination, underscored the important relationship between poetry and politics that had been articulated since the first commentaries on the *Book of Songs* [*Shi jing*] – the classic of the sixth century BCE. Fourth, the direct and often poignant impact of these contexts and concerns on the lives of many High Tang poets themselves, as manifested in their works, affirmed the equally hoary truth that poetry was a genuine expression of personality, and allowed them, as personalities, to embody the highest of cultural ideals. And finally, the very anteriority of the Tang was prerequisite to its enshrinement by later ages; not only were presumptions of temporal decline entrenched within Chinese philosophical and

historiographical traditions, but respect for the past could be conveniently mobilized to validate a present that was uncertain of its own legitimacy. Prosody, pedagogy, politics, personality and pastness – this interrelated complex shaped the cultural norms and orthodox forms of classical Chinese poetry.

Although the Tang itself was as disposed as any other era to bewail the thoroughgoing degeneration of the culture and its own consequent inferiority to earlier ages, eighth-century scholars were not incapable of celebrating the accomplishments of their contemporaries. This is evident from a look at the poetic anthologies dating from the period, of which nine have survived relatively intact from the more than fifty collections that are known to have been compiled during the dynasty.[14] Of these, the most important volume is the *Collection of Eminences of Our Rivers and Peaks* [*He yue yingling ji*], compiled by Yin Fan in 753.[15] Along with Gao Zhongwu's *Collection of a Renewed Official Spirit* [*Zhongxing jianqi ji*], compiled at least two decades afterward and clearly modelled on the earlier volume, Yin Fan's *Eminences* garnered consistently high praise from later anthologists and critics.[16] In addition to including well over two hundred poems by a relatively small number of poets, it contains two prefaces in which the editor criticizes the imprecise selection standards of anthologists before him and clarifies his own. Notable throughout the discussion is the care with which Yin Fan balances the two dominant and countervailing trends in contemporary poetics: the interest in musical effect and sophisticated tonal prosody, on the one hand, and the call – initiated a century earlier – for a return to the morally suasive force of older forms, on the other. Each pronouncement on behalf of 'ancient forms' (*gu ti*), 'substance' (*zhi*), 'air' (*feng*), and 'vital spirit and bone' (*qi gu*), therefore, finds its counterpart in praise for 'new sounds' (*xin sheng*), 'refinement' (*wen*), 'lamentation' (*sao*), and *gong* and *shang* (the first two notes on the pentatonic scale).[17] And while the selection of poems itself actually contains far more examples of ancient-style verse than of the newer regulated forms,[18] Yin Fan's critical comments on the poets he includes repeatedly stress the 'innovative distinctiveness' (*xin qi*) of his exemplars. These 'eminences', in contrast to those whom he has not deigned to select, 'are rather different from most writers [today], for although they are trained in the new tones, they are also knowledgeable about ancient forms.'[19]

Within this recuperation of the ideals of the literary and political past, successfully united with prosodic innovation, are inscribed the values of

the elite culture itself. The emphasis on balance and integration, its recognition of the importance of both 'refinement' or 'ornament' (*wen*) and 'substance' (*zhi*), recall Confucius's well-known remark in the *Analects* [*Lun yü*] to the effect that only a complementary union of the two qualities will produce the true gentleman. While affirming his respect for euphony and the craft of adhering to sophisticated tonal rules, Yin Fan also demands a personal, moral and political stance of a kind associated with ancient poetry, a stance that court poets in the preceding dynasties, entranced with the beauty of surfaces, had rejected for its 'vulgarity'.

Of the poets who figure most prominently in Yin Fan's collection, the two who continued to elicit respect in subsequent ages were Wang Wei (701–61) and Li Bai (701–62). Wang Wei was evidently well-regarded throughout the dynasty, for of the nine intact Tang collections, four others also include poems by him, while Li Bai is represented in two others.[20] The relative stability of Wang Wei's stature is unremarkable at first glance; for most of his life he managed to maintain an ideal literati profile. He did not profess to desire this, however, and his poetry discloses the powerful attraction, for someone securely enmeshed in the political life, of simply 'walking away from it all'. To a certain extent this is a pose: there are countless poems in Wang's collection demonstrating his commitment to public life, and he never utterly retired from it. But to an equally great extent the impulse was manifestly controlled by the graceful, apparently artless and impersonal ease of his verse. Indeed, the poems for which he is best known typically draw directly from court-poetic values of evocative imagery and witty understatement, revealing his mastery of the rules of the game from which he repeatedly, with their assistance, declares his graceful exit.

The very obsessiveness of Wang Wei's desire to retreat attests to the way in which politics consistently defined the poetic self; the irony of his stance is only apparent, for he enjoyed the luxury of the well-positioned to look askance at that position and embrace other values.[21] Critics from the Tang through the Qing declared their esteem for his style, with its strong Buddhist/Taoist inclinations, and a patriarchal mantle within a putative tradition of literati painting was conferred upon him in the Ming reconstruction of Chinese art history as well. But whereas his own age paid him his due respect, the tradition as a whole retained an equally profound fascination with the maligned, the ignored and the frustrated – those who sought meaningful involvement but were never granted the recognition they deserved during their own lifetimes. Even Yin Fan, in the

prefaces he appends to the selections from each poet's work, makes a point of noting whether or not the individual attained a political prominence commensurate with his talents. Another collection compiled by 760, shortly after Yin Fan's by the scholar Yuan Jie (719–772), makes a virtual fetish of memorializing a handful of worthy yet unrecognized talents, as a kind of last-ditch cultural salvage operation. In this little anthology, the *Collection in a Portfolio* [*Qie zhong ji*], Yuan Jie excavates seven unknown poets whose obscurity reflects the moral decline of his age. As 'upright scholars' embodying values neglected by contemporary fashion, they 'all, because of their rectitude and upright-ness, lacked emoluments and position; they all, because of loyalty and faithfulness, were long impoverished and humble; they all, because of benevolence and flexibility, have utterly vanished', whereas 'those who differ from them are eminent and glorious in the present age'.[22] Only one of the seven poets he collects is included in any other Tang anthology, and, given his presumption of the inverse relationship of virtue to renown, any recognition would logically only have served to seriously compromise their moral stature.

Yuan Jie's undertaking may have been purposely and literally eccentric – looking away from the centre of power to those on the margins – but its underlying principles derive clearly from the mainstream of the Chinese written tradition. For one thing, his lamentation over the decline of the culture is part of an ancient, shared discourse that took on new strength during the Tang with a call to 'return to past' models of writing (*fugu*); and, as Stephen Owen has observed, 'literary history and the formation of canons of major poets [were] the exclusive province' of *fugu*.[23] Whether or not such programmes represented a true return to the past, or disguised altogether novel projects, the fact remains that the most powerful canonical boundaries in Chinese poetic history were always the ones located in antiquity.

Moreover, one need only think of Confucius, or of the historian of the second century BCE, Sima Qian – who was slandered at court but chose the humiliating punishment of castration rather than the honour of death in order to write his comprehensive history of China – or of Qu Yuan, to appreciate in Yuan Jie's project the powerful appeal of apparent powerlessness and the enduring question as to whether writing could serve as an adequate substitute for action. Among the poets of the Tang, the paradigm in this respect was Du Fu (712–770), who, as is well known, was basically a failure as a public man: he passed the civil service examination only after repeated attempts and at a relatively late age, and

spent much of his life awaiting meaningful employment. Significantly, his works do not appear in any Tang anthology until well after his death. He is included in Wei Zhuang's *Collection of Additional Subtlety* of 900, but he was certainly no 'eminence' at the time Yin Fan was putting his volume together in 753.[24]

In the words of an epitaph written in 813 by the poet Yuan Zhen (779–831), however, Du Fu 'attained all the styles of past and present and combined the unique, particular masteries of each other writer',[25] and then in turn, through transformation and innovation, provided putative models for later poets as well. His signal accomplishments as the 'great synthesizer' (*ji da chengzhe*) – following in the footsteps of Confucius himself, who was so designated by Mencius – were widely recognized by major eleventh-century poets,[26] who were evidently puzzled by the failure of Du Fu's contemporaries to include his works in their anthologies. Speculation circulated to the effect that such omissions, as well as the relative inattention to Li Bai, derived, in fact, from their enormous respect for his work. This was true, to a degree, of some post-Tang anthologies. For example, the *Selection of Poems from One Hundred Tang Masters* [*Tang bai jia shixuan*], attributed to Wang Anshi (1021–86), appears to have intentionally left out poems by major figures such as Li Bai and Du Fu whose collected works enjoyed wide circulation at the time,[27] and the *Sounds of the Tang* [*Tang yin*], completed in 1344 by Yang Shihong, omitted them for the same reason.[28] However, as the Ming scholar Hu Yinglin notes, Song dynasty hypotheses that such must also have been the case during the High Tang itself are utterly anachronistic, for Du Fu was simply a relative unknown when men such as Yin Fan and Rui Tingzhang were compiling their anthologies.[29]

The historical reception of Du Fu brings to the fore the multiplicity of forces shaping a literary reputation. As is well known, the primary responsibility for placing Du Fu at the centre of a canon located in the high Tang must be assigned to the Southern Song figure, Yan Yu. The intellectual climate within which Yan was situated was characterized by a consuming search for orthodox principles and legitimate lines of descent in philosophical, religious and artistic arenas,[30] as well as by what can only be called a crisis of nerve – an increasing loss of confidence in the ability of the self to serve as a locus of moral or aesthetic judgement.[31] Coupled with the political destabilization attendant upon the loss of the north to the Jin empire in the early twelfth century, and the resulting ineluctable sense of diminishment, the atmosphere was ripe for a new,

legitimating vision. As John Henderson has recently pointed out, efforts to construct a canon typically occur after such moments of political and cultural rupture.[32]

In his collected remarks on poetry, Yan Yu argued strenuously against both the infatuation with late Tang poetry that is predominant throughout much of the Song, and also against the over-emphasis on what he saw as the sterile imitation being promulgated by the so-called Jiangxi school. He employed metaphors borrowed from Chan Buddhism to provide, for the first time, a stylistic 'periodization' of Chinese poetic history,[33] and to identify poetry from the Han, Wei and Jin dynasties and the High Tang as that of the unequivocally highest order. He singled out masters from the High Tang who, in contrast to those of earlier and even finer ages, wrote in an era in which poetry was becoming a self-conscious craft with externalized conventions, as the most suitable models for latter-day poets. In particular, Du Fu was exemplary, both because his careful application of poetic rules was open to observation and study, and because it was comprehensive. Moreover, poets like Du Fu served as ideal models for emulation not only owing to the perfection of their style, but also because of their personal character. As Richard Lynn has observed, Yan Yu implies that the poets of the High Tang 'represent the pinnacle of cultural/moral excellence; they are for him the great cultural heroes of the tradition whose perceptions of and insights into reality are thoroughly penetrating and infinite in their implications and whose personal characters share such perfectly estimable qualities as "bravery", "power", "restraint", "magnanimity", etc.'[34] Du Fu stood out by virtue of the sincerity of his desires for public action, the appealing pathos of their frustration, and his thematization of writing as an alternative venue – however precarious – for significant action.

Convinced of the definitive and enduring validity of his vision, Yan Yu announced, in a letter to his maternal uncle, Wu Ling, that his 'Analysis of Poetry' (*Shi bian*, the first section of *Canglang's Talks on Poetry*), 'does nothing less than provide a discussion that can truly awaken the world while breaking with common ways of thinking, an analysis that manages perfectly to reduce all poetry to one single set of standards – it settles once and for all questions which have perplexed countless ages.'[35] The task remained for later editors and critics to develop and promulgate his views.

Yang Shihong (Boqian) took an important intermediary step in the Yuan with his *Sounds of the Tang*, which he organized according to a revised version of Yan Yu's schema. Working for over a decade, Yang

surveyed the field of Tang poetry and collapsed Yan's five period styles into three groupings of extremely unequal size: the first, 'incipient sounds' (*Shi yin*)', consisted of only one chapter devoted to the seventh-century writers known as the 'Four Bravos of the Early Tang' [*Chu Tang si jie*]; the second, 'Orthodox Sounds' [*Zheng yin*], was much larger (six chapters), was subdivided according to prosodic form, and included poets from throughout the dynasty; and the last, 'Echoes Handed Down' [*Yi xiang*] consisted of seven chapters of works by lesser talents, monks and women.

Yang's categories are no less curious than Yan's for their unsystematic relationship to actual historical time, for which he was criticized almost immediately. In a preface written for another anthology of Tang poetry, for example, Su Boheng (1329–?92) first expatiates upon the axiomatic connection between literary history and political change that had been established in commentaries on the *Book of Songs* – whose 'orthodox' songs were read as having been produced under a morally correct government and whose 'deviant' works, conversely, reflected the decadence of the times – and on the related assumption that change inevitably meant decline. Just as any one dynasty was not equivalent to its predecessor, so:

> . . . looking at the entire age of Tang poetry from this perspective, the Late does not reach the Middle and the Middle does not reach the High. How could [Yang] Boqian in discriminating among High Tang, Middle Tang, and Late Tang not have based himself on this? Instead, poems from a flourishing time he does not call 'Orthodox Sounds' but rather 'Incipient Sounds', and poems from an age of decline he does not call 'Deviant Sounds (*bian yin*)' but rather 'Orthodox Sounds'. Furthermore, he puts High Tang, Middle Tang and Late Tang together in the group he calls 'Echoes Handed Down': this is basing a discussion on formal style rather than historical change.[36]

As noted above, Yang Shihong also purposely omitted poets like Li Bai and Du Fu, whose collections were readily available, from his anthology, for which several other critics took him to task. Nonetheless, his efforts did not go unrecognized; the volume was heavily studied in the early Ming, new and expanded editions were prepared, and the eminent official Yang Rong (1371–1440) of Fujian even wrote poems to match the rhymes of all 536 of the five- and seven-word regulated verse (*lüshi*) and quatrains (*jueju*) included in the *Sounds of the Tang*.[37] The statesman Li Dongyang (1447–1516) also recorded the following high praise:

> In selecting poems what is difficult is to have integrity (*cheng*). One's integrity must be sufficient to encompass all writers fairly, and only then can one select

from among all writers; one's knowledge must be sufficient to encompass an entire dynasty fairly, and only then can one select from within a dynasty. One dynasty has countless individuals, and one individual has countless works. How truly difficult it is for one individual to make a selection! Among those who have anthologized Tang poems, only Yang Shihong's *Sounds of the Tang* is not far from [the mark].[38]

The most important early readers of this Yuan anthology hailed from the same province as Yan Yu and Yang Rong; they were a group of scholars known as the 'Ten Talents of Fujian' [*Minzhong shi caizi*], of whom Gao Bing (1350–1423) produced the most clearly influential work.[39] His *Graded Compendium of Tang Poetry* [*Tang shi pinhui*] attempted to correct what were perceived to be the flaws in Yang's framework and to implement the views articulated in *Canglang's Talks on Poetry*: 'Kao's [Gao] anthology, with its classified selections headed by critical introductions, was compiled as a practical, illustrated guide to what he considered the 'true' T'ang style – it is his attempt to put together an anthology which illustrated, in concrete examples, the critical assertions made by [Yan Yu].'[40] His enterprise is at once more self-consciously inclusive, analytical and critical than any prior collection. In addition to providing a more systematic periodization of the Tang as a whole into what are now the four commonly accepted epochs of Early (618–713), High (713–766), Middle (766–835) and Late (835–906),[41] Gao Bing made it clear that, while these demarcations were more chronologically consistent than those of his precedessors, they were also framed by an unambiguous system of values.

The many forces motivating Gao Bing's delineation of the poetic canon are evident in both its overall organization and in his explicit statements throughout the compendium. He articulates these concerns in the general preface to the volume, where he takes a cautionary lesson from his own protracted learning experience to explain the need for such a collection:

I have always taken delight in poetry and have continually tried to search out the boundaries which separated the Tang poets from each other, but when I first set foot in their realm it was as if I had fallen into the middle of the myriad ridges of the Zhongnan Mountains, so lost that I had utterly no sense of which way to go. Later on I tried clambering up the right side here or fording across to the left side there, ascending some height in the morning so I could look down from it by evening. First down, then up, I climbed and halted. Now advancing, now retreating, I went around in circles. This lasted some ten-odd years. Along the way I followed obscure country paths to mountain villas, whose lofty gates and secluded buildings I was able to point out one by one. Therefore, disregarding the measure of my own talents, my secret wish was to commune in heart and mind with these worthies of long ago, to gather together all the heroes, while weeding

out those undeserving of attention, and put together an anthology to serve as a gateway and path for the study of Tang poetry.[42]

Notable here is the apparently necessary yoking of the experience of 'delight' with the awareness of 'boundaries' (*fanli*, literally, 'hedges and fences'). The first set of boundaries is immediately apparent in the overall arrangement of the 5,769 poems by 620 poets – an arrangement according to prosodic form. Although many Tang and Song anthologies of Tang poetry had used prosody as a standard of selection, choosing to include, for instance, only ancient-style or only regulated verse, Gao Bing's collection is the first to contain both types and then use specifics of prosodic form (type of poem, number of words per line, number of lines per poem) as his first ordering principle. His example was a compelling one, and was followed by countless editors of subsequent collections. Such a foregrounding of formal features makes perfect sense in a volume aiming to provide practical models for would-be poets: if one mastered the shape of the vessel first, then the hoped-for contents would at least have a place to go.

Gao Bing's pedagogical aspirations are also evident in the second set of boundaries he delineates: the ranked categories of the poems in the collection. Whereas Yang Shihong had assigned poems to one of his three qualitative categories first, and then differentiated them by prosodic form, Gao Bing's decision to group them first by prosody, then by rank, and then by author produces a more apparently systematic arrangement. The tradition of grading individuals – particularly government officials – or works had deep roots going back to the Han,[43] and the nomenclature of Gao Bing's categories underscores both the political implications of such evaluations and his esteem for the High Tang. Like the civil bureaucracy, Gao Bing's system has nine ranks: 'Pioneers of Orthodoxy' (*zhengshi*), 'Orthodox Patriarchs' (*zhengzong*), 'Great Masters' (*dajia*), 'Famous Masters' (*mingjia*), 'Wingmen' (*yuyi*), 'Footstep Followers' (*jiewu*), 'Orthodox Innovators' (*zhengbian*), 'Lingering Echoes' (*yuxiang*), and 'Overflow Currents' (*pangliu*).[44] Within each level the poems are grouped by authorship, with the names of the poets listed in chronological order, primarily according to birthdate; for any particular prosodic form, such as five-word regulated verse, all of the poems by one author are assigned to one rank, although it may differ in the case of a different form. The categories correlate, with a few exceptions, with historical period. The 'Pioneers of Orthodoxy' are located in the Early Tang; the 'Orthodox Patriarchs', 'Great Masters', 'Famous Masters' and 'Wingmen' in the High Tang; the 'Footstep Followers' in the Middle

Tang; and the 'Orthodox Innovators' and 'Lingering Echoes' in the Late Tang. The poets labelled as 'Overflow Currents' actually fall outside the grading system, for they are individuals, like women, monks and foreigners, for whom collections and biographical information are too incomplete to make a reliable judgment.

That Gao Bing finds it impossible to evaluate a work without this knowledge confirms that, in his view, as was the case with Yan Yu, canonical values are as ethical, in their links to personal character, as they are aesthetic. In discussing canon-formation in early modern Europe, Hans Ulrich Gumbrecht has observed that, from antiquity until the eighteenth century, 'we still encounter names of authors rather than titles of works. The discursive constitution of the canon as a series of authors' names can be associated with the fact that the imitation of exemplary action, objectified in texts and constantly being reproduced in new texts, created the perspective of relevance that made the canon an element of education and socialization, for competencies of action are bound to people.'[45] Gao Bing's reference in the passage cited above to his secret desire to 'commune' with the 'worthies' and 'heroes' of ancient poetry, and 'weed out' those without merit, points to similar aims. As Richard Lynn explains, with the *Graded Compendium* 'the student of poetry could hope to find his way through all of T'ang poetry to what constituted its orthodox core, and, by emulating this core, achieve the same results himself. Moreover, this emulation was not meant to be restricted to formal considerations alone but also included the cultivation or shaping of personality, sensibilities and character.' In other words, Gao Bing 'meant the student of poetry to model himself personally upon the heroic proportions, the refined personalities and the magnanimous characters of the poets of the High T'ang, viewing them as ideal cultural types.'[46]

Gao Bing's search for such cultural ideals was very much rooted in the intellectual and political climate of the early Ming, consumed as it was, having displaced the Yuan, with the need to validate its claim to power. Thus the founding emperor 'and his advisors made great efforts to utilize notions of legitimacy, based upon claims of cultural and political orthodoxy, as means to bolster political, social and economic control and overall reconsolidation and unity.'[47] The government sponsored a number of other codifying projects as well, and eventually adopted Gao's version of Tang poetry as the officially sanctioned one.[48] Tang literary culture, after all, appeared to have institutionalized more dramatically than any other era the mutual implication of self and society, the links

between the individual and the body politic that informed the identity of
the elite as upholders of culture and the imperial order. The High Tang
poet's face was, at root, a public one; there was an intensity and grandeur
to this stance and to the obsessiveness of the issue of service itself. This
was a grandeur that, during succeeding dynasties, inevitably seemed to
have become attenuated as occasions for poems multiplied and more
intimate, casual and apparently trivial topics were addressed, and as it
lost its privileged and privileging role in the civil service examination.[49] In
promulgating a literary archaism that called for poetry to be written only
in emulation of High Tang models, Ming literary critics – many of whom
held high offices within the government – were affirming, or perhaps
wishing into being, other cultural and political homologies between the
two dynasties as well.

Thus Gao Bing's programme was enthusiastically promoted by influen-
tial figures in literary circles throughout the dynasty, and in particular the
two groups of scholars and statesmen known as the Former and Latter
Seven Masters (qian hou qi zi). Space does not permit a thorough review of
their critical positions, but one of the most effective means of implement-
ing their central principles was through the compilation of anthologies
that replicated Gao's configuration of the Tang canon. One such volume
that was particularly influential was edited by Li Panlong (1514–70), one
of the Latter Seven Masters; titled the Edition of Ancient and Modern
Poetry [Gu jin shi shan], it offered a vision of the poetic past that
confirmed other meanings of the word 'to edit' (shan), namely, 'to efface'
or 'expunge'. Of Li's selection of 2,229 poems from ancient times through
into the Ming period, slightly fewer than one-third are pre-Tang, one-
third are from the Tang, and over one-third are from the Ming. The Song
and Yuan dynasties are notably unrepresented. Moreover, of the 742
Tang poems, well over two-thirds are examples of regulated verse and
quatrains, and a total of 325 are by High Tang poets. Of these High Tang
poets, Du Fu enjoys the highest visibility with eighty-two poems, Li Bai
has seventy, and Wang Wei is a distant third at forty-two.[50]

Li's anthology did not lack its critics: some took issue with his
disparagement of Tang ancient-style verse, others deplored his consign-
ment of Song and Yuan poetry to oblivion, and still others found his
selection of Ming contemporaries self-serving and overly generous to his
intellectual allies. At the same time, however, his seven chapters of Tang
poetry were highly enough regarded to be extracted and published under
his name, posthumously, as Selections of Tang Poetry [Tang shi xuan] – a
volume that circulated widely in both China and Japan. Li's selection

served as a basis for other anthologies over the next centuries, such as Tang Ruxun's *Explanations of Tang Poetry* [*Tang shi jie*], printed in 1615, and Wang Yaoqu's volume of a similar title, *Combined Explanations of Tang Poetry* [*Tang shi he jie*], published in 1732.[51] His choices of specific poems from various poets proved decisive as well. For example, the two best-known five-word quatrains from Wang Wei's 'River Wang Collection' [*Wang chuan ji*] are now, without question, its fifth and eighteenth poems, 'Deer enclosure' [*Lu zhai*] and 'Bamboo lodge' [*Zhu li guan*]. No Tang anthology includes any poems from the sequence (nor indeed, any other of Wang Wei's quatrains); several appear in Song and Yuan collections, many of which were devoted exclusively to regulated verse forms. Li Panlong, however, chose these two quatrains alone to represent the sequence; this decision was followed by the editor of the *Three Hundred Tang Poems* and thus has shaped students' notions of the most important quatrains in Wang Wei's collection for over 400 years.[52]

Moreover, Li's particular valorization of Du Fu, Li Bai and Wang Wei as the three pre-eminent poets of the dynasty continued to be supported in both critical discourse and poetic anthologies through the Qing. In his collection of Tang poetry, for example, the Qing scholar Shen Deqian (1673–1769) chronicles the historical oversights going back to the Tang that are evident in the inadequate representation of Du Fu and Li Bai in other volumes, and states that even Gao Bing's broad selection 'does not exhaust their riches'; he announces that his collection will 'regard Li and Du as pre-eminent (*zong*)', a statement confirmed by a count of the poems he includes.[53] Although a long-standing cultural penchant for binary formulations led many other critics to echo this pairing of Du Fu and Li Bai as complementary ideals, Wang Wei had his partisans as well and was placed at the head of such collections as Lu Shiyong's *Mirror of Tang Poetry* [*Tang shi jing*], compiled in 1633, and Wang Shizhen's (1634–1711) *Samadhi Collection of Tang Worthies* [*Tang xian sanmei ji*].[54] These judgements coalesced in the *Three Hundred Tang Poems*, where no other poets are better represented than Du Fu at thirty poems, Wang Wei at twenty-nine, and Li Bai at twenty-seven.[55]

Needless to say, challenges to this canon were mounted periodically and systematically, almost as soon as its outlines became clear. Indeed, Shen Deqian's explicit declaration of veneration for Li Bai and Du Fu suggests that contrary opinions also flourished. Esteem for the High Tang, after all, had simply displaced a long-standing passion for late Tang poetry, which maintained its popularity in certain quarters. Several late Ming

and early Qing critics lavishly praised poetry from the Song over that from the Tang, or rejected the canonizing process altogether, on the grounds that slavish imitation of archaic models could only inhibit the free expression of a poet's own nature.[56] Furthermore, Qing dynasty scholars successfully revived and rehabilitated other poetic forms, such as the song lyric (ci), that had been discredited almost since their invention by associations with eroticism, excessive sentiment, and the denizens of the entertainment quarters. Many of the most accomplished practitioners of this genre were women, and recent scholarly interest has begun to focus attention on what appears to be an extensive surviving body of writings by women – over two thousand anthologies of poetry alone – that did not merit the attention of mainstream critics and bibliographers.[57]

The fact remains, however, that the pedagogical concerns articulated by Yan Yu, and by critics after him, maintained their paramount importance, and the style perfected in the High Tang could be incorporated into a standard curriculum with considerably less difficulty than doctrines of inspiration or iconoclasm. Following Gao Bing's example, one anthology after the other highlights this educational mission. Shen Deqian writes of his collection, for example, that 'this edition will aid the student of poetry to start his journey' (literally, 'remove the skid' [fa ren] to allow a cart to proceed forward),[58] and the preface to the *Three Hundred Tang Poems* is even more emphatic:

Throughout the world when children begin their studies, they are taught the *Poems of a Thousand Masters* [*Qian jia shi*, a primer popular since the Ming]; because it is easy to memorize and chant, it has circulated widely and not been discarded. But its poems have been quite randomly assembled, with no distinction between the skillful and the clumsy. Moreover, it only includes the two forms of five- and seven-word regulated verse and quatrains, and Tang and Song poets are freely intermingled within in a remarkably eccentric format. Thus I have focused on the works of Tang poetry that have pleased all tastes and selected the most essential examples. There are approximately ten examples of each poetic form, over 300 in all, collected to form a volume. This will be a textbook for home and school that children can study and that will be remembered even in old age. Will it not be on a par with the *Poems of a Thousand Masters*? According to the proverb, 'After thoroughly studying three hundred Tang poems, even someone who can't chant poetry will be able to do so.' I offer this volume as a test.[59]

Although Sun Zhu addresses his volume to a youthful audience, the publication of his volume in the early 1760s was surely not unrelated to the reinstitution of a poetry section in the civil service examination in the preceding decade, which had already inspired the compilation of other

anthologies specifically focused on the types of composition to be tested.[60] And as the Tang dynasty receded in time, efforts throughout the Qing to recuperate it intensified, with the increasingly extensive annotations, critical comments and punctuation systems in the anthologies providing guidelines for the uninitiated.

Thus pedagogical interests joined forces with aesthetic and political concerns to establish the boundaries of a canon of poetry located during the eighth century of the Tang dynasty. Robert Weimann has written that, 'as a cultural institution, a literary canon may be defined as a publicly circulating usable body of writing which, by definition, is held to be as much representative of certain national or social interests and traditions as it is unrepresentative and exclusive of others. In fact, the very representativity of this privileged body of writing appears as a sine qua non for its function as a tradition or heritage, for receiving and projecting patterns of social, cultural, and national identity.'[61] These boundaries of value were predicated on a conceptualization of difference as well, and critical discourse on the subject, particularly during the Ming, characteristically invoked a binary opposition between two hypostatized constructs, the Tang and the Song,[62] in ways that suggest the aptness of Weimann's observation.

Conceived as the product of a circumscribed elite working with a shared poetic language and within relatively defined social and topical boundaries, the High Tang style offered a mythic image of cultural unity that must have seemed haunting by virtue of its very distance from the complexities of a much later reality. By contrast, the major intervening body of poetry, that of the Song dynasty, appeared more informal, overtly intellectualized, multifarious or 'prosaic' – there was also simply much more of it. Poets and poems had proliferated as poetry's dispensation to record the minutiae of the quotidian expanded and as the spread of printing allowed for more widespread circulation and more effective preservation than before. Not only did Song poets come from a wider social spectrum than had been true in the Tang, thus broadening the composition of the elite, but poetry had lost its privileged position for this class as well, moving over to make room for other activities such as painting, calligraphy and the writing of prose as a means for self-definition. In constructing a canon, literati in late imperial China were attempting to shape the identity of their culture and themselves as well. High Tang poetry offered a powerful icon from the past to inscribe into the self-image of the present, but it was a power that could stultify as readily as it might inspire.

4

Boundaries and Surfaces of Self and Desire in Yuan Painting

JOHN HAY

The central importance of written texts is one of the most obvious characteristics of the Chinese cultural tradition. The terminologies of 'culture' and 'text' are closely related. For the purposes of this essay, it is essential to bear in mind not only this central fact, but also two others. First, in Chinese cultural tradition, the practice of textual commentary is as important as that of original production. Second, the significance of textual commentary is essentially sociological.

In the political culture of China, the practice and presence of written textual commentary evolved as one of the principal fields of power for the educated elite. This movement is visible as early as the third century BCE, as a special interest of the class of experts in political ritual and intellectual debate who clustered around the centres of government. By the third century CE, it was established as a defining praxis in the class that we now usually call 'the literati'. These cultural aristocrats were, by then, well on their way to developing an impregnable social stronghold as the administrators of a vast and increasingly centralized empire; they became both the producers and guardians of its cultural self-constructions, and eventually the most persistently resilient holders of its real estate. The power of this land-holding, gentry-scholar, civil-administrator network lasted well into the twentieth century.

As early as the third century CE, the material infrastructure of literacy became one of the self-conscious concerns of these literati. The technologies of paper, brush and ink, critical in the production of texts, were described and extolled in literary forms that mapped morality and materiality into the same aesthetic language. The subsequent history of calligraphy and, following it closely, of painting, chart the ceaseless attempts to re-incorporate these psychological and physiological bodies into repeated cycles of self-examination.

One of the most obvious of these cycles occurred in the Yuan dynasty (1279–1368), under the alien rule of the Mongols. Intersecting dynamics

of cultural energy and political collapse during the twelfth and thirteenth centuries generated an extraordinary pattern of interference. This was especially visible in the artefactual screen of literary and visual arts in which the literati so typically sought to discover and reconstruct the imagining of their own selves.

Literati painting of the Yuan dynasty (1279–1368) has been understood, from its own time to the present, as engaging issues of the self to an unusually intense degree. To quote James Cahill's summary of the views of the artists themselves, 'The proper motivation, scholars felt, was "to give lodging to one's mind"; the activity was intrinsically valuable as a form of self-cultivation.'[1] Wen Fong, taking another phrase from the original discourse, titled his own study of this phenomenon *Images of the Mind*.[2] Contemporary views of this history have been complicated through the predelictions of current methodologies which, though often profitable, rarely take the original discourse at its face value. Fong's study investigates the cultural values and practices that made it possible to advance such a function for painting in the first place. Cahill, finding the concept of 'lodging one's mind' to be almost useless as a basis of analysis, shifted to a more sociological enquiry into how such painting was used as a form of social exchange. A more deconstructive turn has been taken by studies such as Jerome Silbergeld's analysis of a horse painting by Zhao Yong, and Jonathan Hay's work on another horse painting by Zhao's father, Mengfu (1254–1322).[3] It is not coincidental that these two methodologically critical studies have been of horse painting. This was a significant genre and its symbolic language is more amenable to modern semiotic analysis than is landscape, which was the most widely practised genre of all.

The present essay adopts a stance that is situated between these three approaches. The works which it discusses are mostly landscape. It takes the representational choice as significant, but is more concerned with a level of engagement that, while exploiting some subject-matters as more congenial than others, is not bounded by them. Subject-matter will here remain peripheral. My assumption is that the explicit rhetoric of 'mind-lodging' was not necessarily either empty convention or cynical ploy, and was as much founded in material practice as it was articulated through a highly sophisticated discourse; and that its meaning is therefore partly to be sought among the unverbalized circumstances in which specific acts of painting and writing were embedded. By such 'circumstances' I do not here mean the framework of social conventions on which Cahill, for example, now generally hangs the analysis of meaning or function in

Chinese painting. This essay does not quarrel with the value of such analyses. But it takes painting as a form of culture to be distinguished – above all – by the centrality of visuality and material practices as they are folded into and out of each other. Such centrality may be deliberately displaced, of course, but it is its inextinguishable presence that gives meaning to any such efforts. This approach entails problems in regard to both reductionism and the issue of realism, problems that I shall not directly address. But what is central to this essay is another assumption, that at some place, at some level, in some way, all these processes are driven by human desire. If the artist is not an automaton, then his desire is also, and in some circumstances primarily, implicated. But none of these functions, such as visuality, materiality and desire, can be imagined, let alone embodied, without boundaries. It is at boundaries that difference and therefore definition occurs. In constructions such as selfhood, the difference or boundary between selves may be the most critical of all fields of action. Boundaries, also by definition, have surfaces. But such surfaces may be of many kinds. This essay will examine that issue in the field of Yuan literati painting.

Within a rather short time after their lives, the phenomenon of Yuan painting had come to be summarized and signified by a very select group, the 'four great masters': Wu Zhen (1280–1354), Huang Gongwang (1269–1354), Ni Zan (1301–74) and Wang Meng (c. 1308–85).[4] The 'four great masters' exemplify the highly typical phenomenon of canonical formation in Chinese history, an historical process that nowadays makes subversive historians look under the covers for the hidden aspects of reproduction, and seek outside the room for dispossessed players. But I am not concerned here with 'seeing behind the canon' in the sense of writing a more equitable history, important though that may be. I will take 'mind-lodging' as the field of enquiry, although other histories are certainly waiting to be written.[5] It is a field established in history as a history, a history within which the 'four masters' are, by definition, central. Drawing mainly on Ni Zan, and without even attempting to distribute the enquiry among all 'four masters', I will choose surviving works that preserve image and text as necessarily conjoined, in relationships that are given but not determinate. My methodology is no more than that of the settling dog. Having chosen an area, I will go round and round in what may seem to be quite disparate circles, until the spot feels sufficiently familiar to settle down.

The few works chosen are all long-established favourites on the circuit. In a very conventional area, I hope to raise some new issues, some of them

avowedly speculative. By trying to make such an area slightly messier, one may perhaps make it more inviting to further intervention. Despite the increasingly sophisticated understanding of how selfhood may be constructed, in many cases art historians still have not really dealt with the significance of the fact that these works were always made by *someone* to begin with.

The Chinese tradition was deeply concerned with the question of authorship. In literature, the issue begins to be well articulated in the third century CE. It filters through into calligraphy and painting, erratically, over the following seven centuries, and then begins to expand into a significant body of theorizing in the late eleventh century. I am not concerned here with the content of the theorizing. The important fact is that it appeared and continued to evolve.[6]

If the 'pictorial charge', the context of expectations within which a painter must work, includes an expectation of significant authorial creativity – even to the extent of the signature becoming the most important aspect of the painting – then this expectation must be accepted as a defining aspect.[7] We should not rewrite the acceptable spectrum of expectations according to the boundaries of our own values, even though we cannot avoid rewriting the histories themselves. The strength of this authorial demand upon painters of a particular category, from the late eleventh century to the fourteenth, may not readily fit our idea of how things should have been. But the question is, to what extent was it part of the social formation and how was it embodied?

From the standpoint of this present enquiry, the theory itself is more a symptom than a prescription, but to some extent it may also be taken as a description. Theorizing in general, of course, did serve to articulate a subjectivity for the literati class. But in the case of painting it was often a product of environmental processes; protective tissue generated around a material and inherently craftsmanly activity within a social organism that was committed to an amateur and apparently dematerialized ethos. This dematerialization, nevertheless, derived its meaning from a fundamentally materialist cosmology. The status of painting continued to seem problematic to literati from the eighth to the eighteenth centuries. But literati painters were literati. The expectations, sensitivities and perceptions of both themselves and their audiences were socially constructed psychological functions. A 'charge' of self-inscription was itself, fundamentally, not a theory but just such a socially constructed product. If we wish to insinuate an enquiry within the processes of painting, we must embark on an enterprise of the imagination; a kind of manual

mining, working at material surfaces reconstructed through expectations that we try to make culturally and historically appropriate.

With such a purpose, one may turn to painting itself, to works such as *Hermit Fisherman on Dongting Lake* by Wu Zhen painted in 1341.[8] Wu's biographical conventions place him as an artist who suffered penury due to his refusal to produce works for patrons. In his paintings, however, we are typically faced with a seemingly impenetrable surface. His biography, and the idea of self-inscription framed thereby, seem irrelevant. At this point, it is traditional to resort to mentioning the Chinese concept of 'the artist's hand' as derived from calligraphic practice, in what must surely be one of the most specific, subtle and sophisticated versions of that widely shared notion. This critical position takes the brushwork, especially at the level of individual strokes, as the crucial deictic 'shifter' that establishes the psycho-physical presence of the artist within the painting.[9] Calligraphy, with its peculiar emphasis on the point at which a brush impregnated with ink meets the writing surface, offered an acceptable and exemplary field of material activity, of its descriptive translation and theoretical articulation. As Norman Bryson has remarked, placing the idea of 'deictic markers' at the foundation and beginning of a development radically differentiates the East Asian from the Western tradition.[10] Disregarding the stereotypical and a-historical generalizing, there is an underlying validity to his contrast, and I would even draw it more strongly in one particular way. The differing shape and even the different *direction* of East Asian and Western historical development can cause major problems in the context of our own methodology, which has expectations and priorities that arise out of a particular chronological dynamic that is often disguised.

For the literati in China, calligraphy was sociologically validated as an essentially literate activity. For this reason, and despite the remarkable degree to which calligraphic theorizing did manage to penetrate into materiality, the very centrality and explicitness of its cultural status ironically present a diversion in approaching the marginality and transparency of the object of the present enquiry.

Nevertheless, apart from acknowledging its material priority in history and society, we must note one important aspect of calligraphy criticism. As a cultural praxis, it is a forerunner of a point in modern art history from which post-modern theory tends to diverge. It strongly suggests that the personality of the artist may be inscribed in the surface of his work, but it also implies the viability of an artistic alter ego – a personality contained in the work of art and not necessarily convergent with a

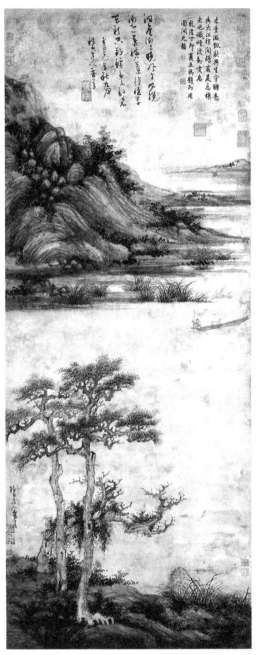

Wu Zhen (1280–1354), *Hermit Fisherman on Dongting Lake*, dated 1341,
hanging scroll, ink on paper. National Palace Museum, Taiwan.

biographical person. There was sometimes argument over this, because the coincidence of biographical and artistic persona was usually asserted as a norm. The practice and the idea are both centred in calligraphy, and they enter painting through technique. Su Shi (1037–1101), one of the most interesting observers of creative processes, often entertained the conventional idea of identity between these two personae, but was well aware of its problems:

If, from examining a person's calligraphy one can tell what kind of man he is, then the character of superior men and mean-minded men must both be reflected in their calligraphy. This would appear to be incorrect. To select people on the basis of their face is considered improper – how much worse, then, to do so on the basis of their calligraphy![11]

We might think that Su Shi simply suffered from a confusion over person and morality. But he was more subtle than that, and nowadays we know that he was right to be puzzled. He lived two centuries before Wu Zhen, but we may be sure that he would have looked for the person of Wu Zhen in the paintings of Wu Zhen, even as he puzzled over the phenomenon.

Focused both by the technical relation between calligraphy and painting, and by the actual presence of writing on the painting itself – a presence established as a norm in the Yuan dynasty – one must obviously ask whether the inscription on Wu Zhen's painting suggests answers to our problem. It does not at first reading, and it is very rare for such inscriptions to do so, at least in any obvious way. The poem written on Wu's *Hermit Fisherman on Dongting Lake* is taken from another source, one of a series of 'fishermen odes' that he also uses elsewhere.[12] The content of the poem seems personal only at a formulaic level:

> Over the surface of Lake Dongting an evening breeze is born,
> The wind strikes, in the heart of the lake, a leaf-small skiff.
> Magnolia-wood oar held firm, grass rain-coat light,
> Fishing just for perch, not for fame.[13]

The obvious reference, one that is endlessly repeated over the centuries, is to Yan Ziling, an official-turned-hermit, and a paragon of political virtue of the first century CE. When offered a high post by a former friend who had ascended to the imperial throne, Yan refused and turned back to his fishing rod. Although the peculiar concept of political virtue here is not irrelevant, I will leave it aside and look at another of Wu's painting, the *Fisherman*, dated 1342.[14] This has a longer poem, which is perhaps singular to this work. But it is another variation on the same angling

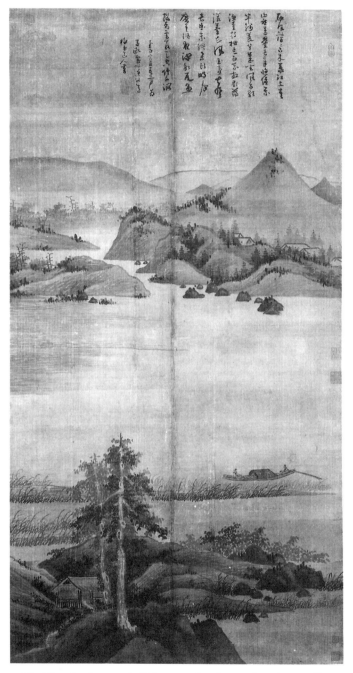

Wu Zhen (1280–1354), *Fisherman*, dated 1342, hanging scroll,
ink on silk. National Palace Museum, Taiwan.

theme, common throughout Chinese painting and especially so in the
work of Wu Zhen. The poem begins:

> West wind soughing softly, pulling down tree leaves,
> Blue hills above the river, endless layers of melancholy.
> Sorrows of old age – pleasure in a rod and line,
> How often, in grass coat and hat, waiting on the wind and rain.[15]

In both works, the image of the solitary angler quite clearly invokes what
one might call a psycho-ecology, in which conditions of the self are
addressed. The two poems, equally clearly, embody a partially trans-
figured desire, more sharply articulated in the second poem. The angler's
longing, which has no obvious address, is both frustrated and dissolved
by the damp weather. Nevertheless, both of these poems can be seen as
utterly conventional, and the harder one looks at such works the more
the artist seems to fade into a cliché, and the more one may feel inclined to
analyse the painting as formulae of brushwork or social exchange.

But we may look again, with slightly different expectations formed by
the way in which, from the Song onwards, interior meaning often seems
to lie within the surface of Chinese paintings. To summarize this
circumstance very crudely: Northern Song paintings of the eleventh
century deny the surface of the silk on which they are painted and open
up an illusion of expansion in space. Works of the Southern Song,
especially in the thirteenth century, exploit a contradictory interaction
between the still-expansive space and a growing assertion of the physical
surface of the silk.[16] One result of this, apart from an electrifying
perceptual tension, is the validation of the place of calligraphy within the
space of the painting. By the fourteenth century, the surface is commonly
asserted as primary. Space is not, however, denied. It now expands
within the surface itself. This assertion of the materiality of surface is
intimately implicated with the increasing preference for paper over silk,
for random texture over rectilinear weave, for absorption, interaction
and revelation over layering and occlusion.[17] The spatial texture, or
textural depth, that results, may be seen in comparing the details of the
two works by Wu Zhen illustrated here – one on silk and one on paper. A
more aggressive development of this possibility, in the *Dwelling in the
Fuchun Mountains* painted by Huang Gongwang between 1347 and
1350,[18] exemplifies the technique described by Huang in a text: 'The
texture strokes must be done with wavering dilute ink by sweeping the
brush in wavering strokes. Over these one adds more dilute ink to break
[the flatness].'[19]

At this point, returning to Wu Zhen's inscriptions on his paintings, we simply need to be alert to surface as a critical environment. Taking a second look at the two poems, we may notice that the fingers of their language touch on the idea of surface with particular sensitivity. The poem on *Dongting* begins,

> Over the surface of Lake Dongting an evening breeze is born,
> The wind strikes, in the heart of the lake, a leaf-small skiff.

The poem on *Fisherman*, opening also with the wind across the water, continues, 'Blue hills above the river, endless layers of melancholy.' It ends,

> Night is deep, at the boat's stern fish break surface, splash,
> Clouds dissolve and the sky is empty, mist and waters stretch wide.

Not only does the entire environment turn into a surface here, across both the water and the sky, but the surfaces themselves imply depth; depth within the sky, the night and the water. (We are imposing the English word 'surface' on a complex of images in another language, of course, but this general move can be controlled, and we will return to the issue below.) The first poem specifically introduces a wind 'born' *on* the lake, and then a leaf-skiff *in the heart of* the lake. The images invoke both a surface and its 'within'. The second poem offers a topographic surface, again with the sensory agency of the wind, 'soughing gently, pulling down tree leaves', and 'layers of hills on the river'. At its conclusion, apart from the imagery of sky, mist and water, in the depth of the night the fish, literally, 'pierce through, splash'. The surfaces are evoked, not only by their extent but, even more, by their texturing – the corrugations in the hills, the wind over the water and through the trees – and by their rupture.

This imagery, as already noted, is part of a long-established tradition that extended well beyond the boundaries of such painting. In that broader context, of course, one could pursue issues of surface more widely. But the pertinent point here is that this existing potential was specifically exploited in painting as an aspect of historical development. The fisherman and lake imagery is especially prevalent in painting during the middle third of the fourteenth century, as Chu-tsing Li pointed out twenty years ago. He identified this as a river-view phase in the development of Yuan landscape painting.[20] It derived from one of the two main categories of landscape composition that were well-developed in both practice and theory by the eleventh century: 'high extension'

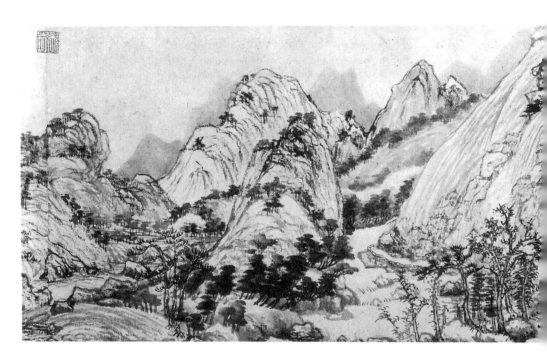

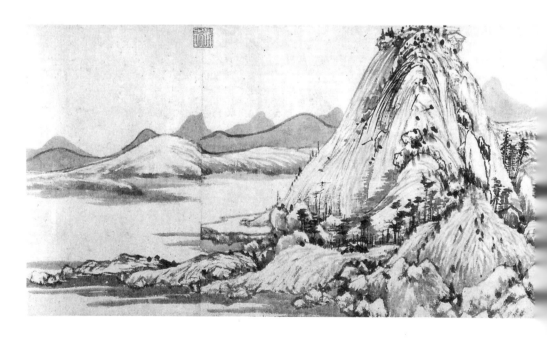

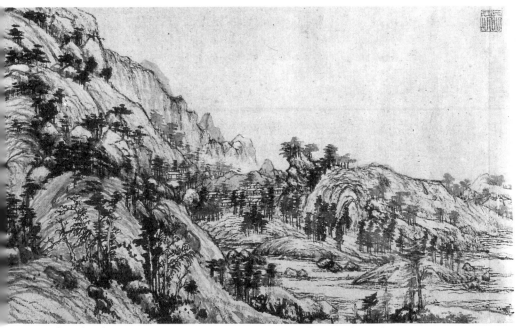

(Left and right) Huang Gongwang (1269–1354), *Dwelling in the Fuchun Mountains*, painted 1347–50, handscroll, middle section, ink on paper. National Palace Museum, Taiwan.

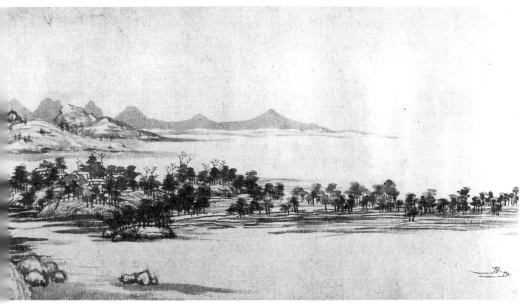

(Left and right) Huang Gongwang (1269–1354), *Dwelling in the Fuchun Mountains*, painted 1347–50, handscroll, final section, ink on paper. National Palace Museum, Taiwan.

(*gaoyuan*) and 'level extension' (*pingyuan*). The first is understood as looking up at a high mountain, and the second as gazing across a broad expanse of water and low hills.[21] The 'level extension', incorporates, from the beginning, a tangible quality of surface within its encompassing gaze.

The causes and purposes behind such compositional preferences and shifts are usually obscure. The markers of this particular preference, clearly visible through the exemplary sequence of the painters Dong Yuan (10th century), Mi Fu (1051–1107) and Zhao Mengfu, can be interpreted in various contexts. The preference itself cannot have simply been distributed from such exemplary centres. The 'level extension' must have served the needs of a particular kind of engagement in the material practice of painting, an engagement characteristic of the kind of artist culturally exemplified by Dong, Mi and Zhao.[22]

The approach to this problem taken here is to examine how the potential, embodied especially but not exclusively in the 'level extension', was exploited at the material level. Wu Zhen was a generation younger than Zhao Mengfu. Ni Zan, one generation younger than Wu, was perhaps the painter most persistently attached to this compositional type. His example pins down Chu-tsing Li's chronology of development. Of all the Yuan literati artists, Ni perhaps offers the clearest links between personality and biography. A wealthy landowner and a man of social eminence and literary distinction in the Wuxi district of Jiangnan in South China during the political and military chaos which heralded the end of the Yuan dynasty, he divested himself of much of his material estate and spent the last three decades or so of his life as an itinerant guest of his home district. Although psychologically distressed, he was probably not materially deprived, and seems to have spent much of the time comfortably supplied in an elegantly equipped houseboat. Such circumstances were shared by other local gentry, but in Ni's case they only served to emphasize even more his reputation for an obsessive fastidiousness – an attitude that marked all his contacts with the surfaces of the social and material world over which he floated.[23] His life and his painting seem to exemplify disengagement.

Ni Zan was admired for his calligraphy, and the hand in his painting is exceptionally characteristic. The personal style of his painting is thus very amenable to the morphological analysis of brushwork, which becomes almost a species of phrenology in such a case.[24] For the present enquiry, however, the significance of this style and his predeliction for 'level extension' compositions is that, to an unusual degree, they intensify,

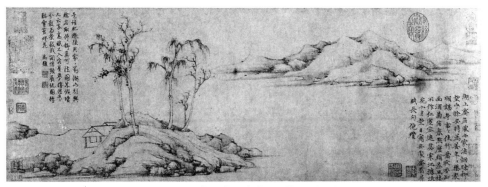

Ni Zan (1301–74), *Studio of Settled Dwelling*, datable *c*. 1368,
hanging scroll, ink on paper. National Palace Museum, Taiwan.

rarify and identify his disengagement – and subsequent re-engagement –
with surface.

A representative painting is Ni's *Studio of Settled Dwelling*, a short
handscroll which has been dated to *c*. 1368, the time of dynastic
restoration. The poem he inscribed on this painting begins,

On the lake, studio dwelling, a hermit home,
Pale mist, sparse willows, gazing into space.
In peaceful times activity is good pleasure year after year,
Dwelling in a favourable flow, planning for one's self, affair after affair goes well.

It ends,

Roosting in remoteness, not a guest in the red-dust world,
Sufficient that wave-flowers curl the cold river.[25]

The imagery of surface here is more subtle than in Wu Zhen. It is
nevertheless quite apparent. Ni Zan was a much better poet and was also
further into the process that I am describing. Apart from the poem's
opening and concluding reference to the surface of the lake, the
environment is primarily one of sensory surfaces and textures. There is a
gazing, across, past and towards receding surfaces. It is important to
note, in this connection, that the 'three extensions' recorded by Guo Xi
(died *c*. 1090) and their atmospheric elaboration by Han Zhuo (*c*. 1090–
c. 1125), although highly visual, have nothing to do with geometrical
optics. They are all distinctively material, and their sense of 'distance' as
an extending of connectedness between locations is inseparable from the
feeling of connected surfaces.

Who is gazing in Ni Zan's poem, and in many comparable poems?

There is a subjectivity – or perhaps we should say 'agency' – a minimum required by the function of gazing. But it seems to be located rather than personified. In both poem and painting – and characteristically of Ni Zan – it is a hut that gazes. The function of gazing here requires most essentially a location, which does not need to be embodied in human physiology.

Just as Wu Zhen locates some aspect or function of self in the boat, so Ni Zan has a dwelling-place in the surface. Desire dwells there, albeit much transformed. We should also note, as an aspect of location, that the second and third lines incorporate the correlated axes of time and space that are so highly characteristic of the sense of spatial frame in the Chinese tradition, but that, equally characteristically, these are combined with a sense of flow.

One could continue searching, as though feeling in the dark, for other evidence of the peculiar presence of surface in the art of this time. Another painting by Ni Zan, from whose oeuvre one could almost pick examples at random, is *Gazing at Mountains over a River Bank*, dated 1363. Cahill uses this work as an example of Ni's 'ultimate [compositional] formula'. The poem on *Gazing at Mountains over a River Bank*, which is Ni's own title, invokes the definition of 'level extension', and begins,

> On the river, spring wind, gathered rain now clears,
> Screening the river, spring trees, evening sun bright,
> Sparse pines, near the water, flute sounds distant,
> Blue cliffs, drifting mist, streaks of dark lying across.
> On Qinwang Mountain, grieving ancient traces,
> In a temple at Cloud-gate, seeing a name inscribed.
> Lame, I also desire to seek strange wonders,
> My boat is merely half-way along its way to Qiantang [Hangzhou].

> On the seventeenth day of the second moon, composed this poem and wrote 'Gazing at Mountains over a River Bank', I present them to my dear friend Weiyun [Chen Ruyan], sending him on his way to Kuaiji. Ni Zan[26]

The surfaces here are even more textural. Light shimmers through screens of tree branches and across water as rain passes. The sounds of a flute are woven over the interpenetrating surfaces, through the textural depths. Complex desires are subtly yet painfully woven through the fabric. As with every work of these dispossessed townsmen and gentry, and as is general throughout the entire tradition, these desires hang on the threads of multi-layered cultural allusions. They are also present in the Wu Zhen works. They provide, here, not only connections across space and time

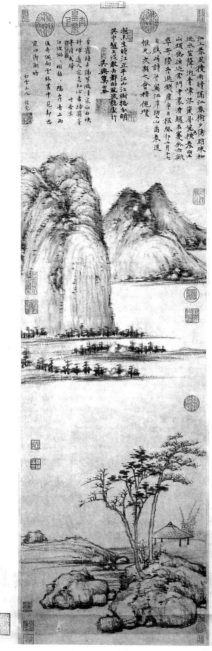

Ni Zan (1301–74), *Gazing at Mountains over a River Bank*,
dated 1363, hanging scroll, ink on paper.
National Palace Museum, Taiwan.

but also an alienating absence, as Ni's thoughts are carried onward by his friend and his boat, across the watery surface of memory and desire.

Another poem by Ni Zan almost casually reveals the importance of the material surface in which these psychological surfaces were elaborated:

> By the Eastern Sea there is a sick man,
> Calling himself 'mistaken' and 'extreme';
> When he paints on walls, on silk or paper,
> Isn't this the overflow of his madness?[27]

In the fourteenth century, walls were still an accepted ground for both calligraphy and painting, for both formal and spontaneous work. Ni Zan's view of his own activity is inherently structured through this variety of surface, which offers a typology of both texture and technique.

A distinctive interest in the material surfaces of art-work persists through the tradition. In the eleventh century, at a critical stage of development in landscape painting, Song Fugu 'stretched white silk over ruined walls' and Guo Xi painted mountains-and-waters on roughly plastered walls.[28] The quality of both silk and paper, and sometimes of walls, was crucial to both calligraphy and painting, and the concern was extended in various ways. Even in techniques where the material was well-covered it was never completely obscured. And in many circumstances the texture of the material became a fundamental aspect of the work's content. This tendency, which I believe was fundamental to what is sometimes called the 'Yuan revolution in painting',[29] was later elaborated much further, at times almost quixotically, as in the example of coloured paper and silk sprinkled with gold and alum.[30] But paper, with its comparatively random texture and its natural facility to absorb the ink, was established during the Yuan as the literati's most favoured material.

Ni Zan, besides his obsession with river scenes, also favoured bamboo and rocks as a subject-matter of painting. *Bamboo, Rock and Proud Old Tree*, an undated painting in the Cleveland Museum of Art, is a characteristic example.[31] Ni's poem reads,

Wind and rainy days – harvest time is chill,
Picking up my brush in hand to make copies, forcing myself to open up.
Fortunately, I can depend on you, my friend, to send me consolation –
Pine-lard incense and meat with bamboo shoots never fail to awaken appetite.[32]

Maoyi has brought wine and urged me to eat with him in the Eventide Pavilion. So I write 'Bamboo shoots, rock and proud old tree' and inscribe a quatrain. Master of the Cloudy Grove, Zan.

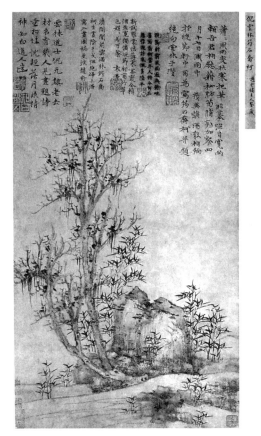

Ni Zan (1301–74), *Bamboo, Rock and Proud Old Tree*,
hanging scroll, ink on paper. Cleveland Museum of Art.

The invocation of surface in this poem is indirect but vivid. The surfaces of the artist's environment, the damp atmosphere of wind and rain, press on his spirit. The presence of a friend lightens this texture. The reference to 'copying' is probably loose. The 'originals' may have been in his head. It is the process as well as the relationship of re-presentation that is important. We can almost hear the soft scratching of brush on paper, as Ni seeks to escape his ennui by concentrating himself in the material activity at the point of his brush. The incense and pickle, exciting the tips of other senses, agitate the sensory surface and provoke the juices within. Ennui fades as desire is aroused – and desire needs a surface. This topology is very distinctive.

The rock is an important motif in this painting. Chinese garden and

studio rocks, in the flesh – so to speak – are always defined by surface as a
primary aspect of their morphology. The dry bark and twigs of the old
tree are less conventionally established, but nevertheless unmistakeable.
Their scratchy texture, the richer surface of the rock, and the crisp leaves
of the bamboo (exemplifying the quality of the shoots even better than
would a picture of the shoots themselves), re-present the surfaces and
textures of the poem. Subsequently, in a characteristic instance of action-
at-a-chronological-distance, the inscriptions of (possibly) Zhang Yu
(1277–1350), Yuan Hua (1316–late 14th century), Lu Ping (1438–
1521) and Zhao Yu (1638–1713) come to re-present these textures yet
again. Reading this work from the poem outwards, and in isolation, one
might not be alert to the importance of its surfaces. Reading inwards
from the painting itself, however, this is an extraordinarily tactile object
at all its levels of meaning.

Although there is a characteristic intensity and complexity of such
surfaced meaning in the oeuvre of Ni Zan, it should not be seen as a
personality 'trait', revealing itself consistently and inescapably as a brush
persona is taken to do. As culturally articulated, the phenomena of
surface are invested in the material practices themselves. From these
practices they derive their meaning, and that meaning can then be drawn
into further levels of significance by the conventions of imagery and
language. Inherently, surfaces are boundaries, presenting temporary or
permanent resistance and limits to the practices that encounter or
establish them.

Ni Zan's persistent interest in the subject-matter of *Bamboo, Rock and
Proud Old Tree* exemplifies this. As an increasingly common convention
it served various socially symbolic needs, none of which adequately
account for its effectiveness in the hands of an original artist. To remark
that, of all subject-matters, it is one of the most readily accessible to the
brush technique of a person trained in calligraphy, shifts the problem, but
does not provide much explanation. Another opening in the search for
explanation is offered by considering the referents in the 'natural world',
such as the rock and bamboo. These were more *given* than a painting, but
no more 'natural', and it is appropriate to treat them as sub-sets of sign
systems. The deconstructionist convention of treating signs and their
referents as a correlation of different sets of signs, rather than as a
reference of representation to reality, is no more than commonsensical
here.

The Chinese rock, one might say, is a classic instance.[33] Typically, the
pervasive practice of collecting and privileging such rocks expressly

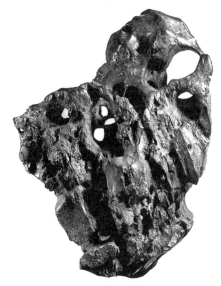

Foraminate limestone 'rock-mountain'. Private collection.

attributes the semiotics of the human world to that of the 'natural'. As 'found' objects, what is found in nature is a projection of human values, which in this case are encapsulated in the threefold criteria for the quality of a rock derived from a complex of somatic representations: 'leanness' of body (*sou*), 'foraminate structure' of interior space (*tou*), and 'wrinkled' textural surface (*zhou*). Chinese rocks are exemplars of a concern for the morphology of surface. Their adoption into painting by the tenth century – a millennium or so after their adoption into society – was a meta-commentary on this concern.

Bamboo represents another aspect of such primary and secondary adoption. It is possible to see the foliage of bamboo as a form of surface, one not dissimilar to the texture of paper, but it re-entered the realm of surface in another highly distinctive way. There is an account of a young woman named Li, of the tenth century, who was kidnapped during the warfare that fractured China in that period. Imprisoned in a courtyard one moonlit night, and suddenly entranced by the shadows of a bamboo on a paper window, she was inspired to trace the shadows with brush and ink.[34] This poignant story, true or not, is paradigmatic of the surfaces of desire, physical and emotional, hostile and friendly. But, more specifically, the window as a screen on which a shadow is projected, presumably from one side while the image is translated into brushstrokes on the other, became an implicit key to the painter's visualization of this subject-

matter. Combined with the technique of 'ink bamboo', as it necessarily is for such visualization, the paper becomes integral to the work's execution and its subsequent perception. In this genre, several surface realities are superimposed in a most remarkably compressed way. Ni Zan's *Bamboo, Rock and Proud Old Tree* is a close relative.

But what is the wider context that gives these surfaces their meaning and their persistence? So far, this discussion has taken the English word 'surface' for granted. At this point, however, translation is not yet an issue. We are trying to grasp an aspect of material culture that does not necessarily have to be directly specified in texts. The Chinese original of the phrase written by Wu Zhen that was translated earlier as 'over the surface of Lake Dongting' is literally 'Dongting lake-on . . .' It is helpful, perhaps essential, to move away from the texts here, and to examine the issue as one of cultural ecology.

The material environment may be defined as physically structured meaning. Material arts engage with this material meaning, reworking and recontextualizing it. Their materiality is necessarily mediated by the senses as a perceptual system, and in this mediation the priorities of visual, tactile and kinetic (and other) values are constantly oscillating. To re-establish the multiple levels of material significance which provided the original contexts of a work of art is perhaps impossible. We have to approach the problem in an indirect and fragmentary way.

For the sake of this discussion it is also necessary to describe a very general horizon for the enquiry. Although this can only be done in a way that is so generalized as to offend against all historical sense, it remains necessary because *some* horizon will inevitably be framing our meanings. It is preferable to work self-consciously with a partially appropriate horizon, rather than unconsciously with a wholly inappropriate one. The surfaces which we have been addressing, for instance, are clearly not defined by geometrical formulae.

From the early cosmological articulation as preserved in texts of around the fourth century BCE, the Chinese world can be read as one of pattern imposing upon, or arising in, process. There are two principal directionalities: the complementary movements outwards and inwards between potentiality and participated actuality. Within this transformational reality, phenomena arise in patterns of mutual resonance. The material world is composed by categories in resonance, a structure of paradigms in flux. The world is inscribed in energy rather than explained by geometry. Man is implicated from the beginning in this inter-activity. Since there is no external creative agency – no God – the constant

transformations are self-ordering and proceed, we might say today, as though genetically directed. The world exists along inseparable extensions of space and time. To be fixed is to be temporary, to move in and out is to endure. The most important concept of material description becomes that of an elastic envelope, so to speak, embodying the constantly and coherently changing configurations of phenomena as they mutate along the outwards and inwards movements between potentiality and actualization. The commonest term for these changeful and changing configurations of energy is *shi*. As a field of these dynamic patterns, rather than an architecture of volumes and spaces, the world can be seen as mapped by permeable boundaries, the surface of pressure, interaction and interpenetration between all the fluxing configurations. Identities are a function that is secondary to the primary values of interface and interaction, rather than the other way round, and this is as true of humans as it is of other phenomena.

This world, however, is also an oriented cosmos, organized within cardinal and astronomic axes of horizontality and verticality. Mankind, participating microcosmically in these axes, arises as the third term of interaction between heaven and earth. But the material world, human and otherwise, is also sociologically ordered in a hierarchy that is aligned with the same axes. The hierarchy is a scalar phenomenon. That is to say, the same structure is seen from very large scales, such as the empire, to very small ones, such as the family. Such hierarchy imposes both place and quantity, critical dimensions of locational and relational identity. Identity has two interactive sources, one that we might call 'energenetic'; the other, the identity of difference, which is essentially semiotic. These are always being mapped on to each other, and quantity and quality are hardly ever dichotomized. Relationships between energy, power and authority are formulated through the mapping. The manner in which, and the degree to which, the Chinese tradition articulated the processes of over-mapping are complicated questions. A major synthesis occurred in Neo-Confucianism of the Song period, especially in the work of Zhu Xi (1130–1200), but the same world seems still in charge in the eighteenth century. The critical terms become *li* ('pattern') and *qi* ('matter-energy'). (There are always problems with the translation of such terms, but those given are within the bounds of respectability.) In the words of Ho Peng Yoke, 'What Zhu Xi has in mind about *li* and *qi* seem similar to the cosmic principles of organization and matter-energy respectively . . . we must [also] note the existence of a third entity which was supposed to govern or explain the whole operation of nature, namely

numbers (*shu*) . . . Zhu Xi said, "Just as the existence of *qi* follows from the existence of *li*, so the existence of numbers follows from the existence of *qi*."'[35]

This is a differently constructed world from that in which the majority of our own conceptual and material culture was engendered. Twenty years ago, Stephen Toulmin made an extraordinary attempt to define our own geometrically constructed world in terms of axioms formulated in the 17th century.[36] It is almost impossible to sustain the degree of self-consciousness necessary to factor an awareness of this situation into all our cultural descriptions. I believe, however, that if geometricized assumptions were somehow to be withdrawn from all the constructions of Western culture during even the present century, we would look a great deal worse than Santa Cruz after the Loma Prieta earthquake! A sparse network of highly significant figures, such as Einstein and Freud, would be left bloody but standing in a huge field of dust and rubble. Much of art history would lie shattered among the chaos, together with its methodologies. This is not a criticism, only the description of a problematic around which this essay is trying to take a very small side-step.

Translation, in both the literal and the cultural sense, has always had to call upon all relevant resources in the receiving language. It is therefore merely logical to turn to other frames of reference, if they become available, to see whether they assist the translation. Such help lies within chaos. Were one able to suddenly withdraw from our present world the support of the geometrical tradition, then among the surviving structures would certainly be the recently developed field of chaos studies. In the words of its inspired popularizer, James Gleick, 'Where chaos begins, classical science stops.'[37] An increasing variety of enquiry brought under this admittedly problematic rubric is concerned with the evolution of dynamic systems in a real-world ecology; with the fact that very simple initial conditions can generate enormously involved patterns – patterns that pass through phases of apparent chaos and startlingly complex order, appearing and reappearing endlessly through infinite regressions and expansions of scale. Its most publicly visible results are in the Mandelbrot sets and fractal imaging that can be generated by computer graphics. The term 'fractal', coined by Benoit Mandelbrot, refers to the indefinite divisibility of dimensions, as opposed to the numerical quantities of length, depth and thickness in Euclidean geometry. The concerns and the articulations of certain areas of chaos studies are helpful in trying to grasp the language of Chinese cosmology. The astonishing beauty of

the endlessly self-generating fractal imagery that Mandelbrot discovered, an ultimate demonstration of scalar phenomena on the mundane level of the home computer, is a powerful aid to the imagination in understanding *shi* configurations in a hierarchic or scalar cosmology.[38]

Albert Libchaber, a physicist, designed an exquisitely refined experiment to examine the shape of flows at the material level – that is, the phenomenon of shape plus change, motion plus form. In his words, 'There has been since the eighteenth century some kind of dream that science was missing the evolution of shape in space and the evolution of shape in time. If you think of a flow, you can think of a flow in many ways, flow in economics or a flow in history. First it may be laminar, then bifurcating to a more complicated state, perhaps with oscillations. Then it may be chaotic.' Libchaber, translated, is both describing and theorizing *shi*.[39]

In a world in which *shi*-type phenomena are paramount, it turns out that surface is equally so. Another chaos researcher has been Christopher Scholz, a geophysicist especially interested in earthquakes. Scholz came across Mandelbrot's classic work on fractals, in which surfaces are constantly reiterated. As Gleick writes, 'Scholz cared deeply about surfaces', and fractals provided a new and very powerful approach to problems of surface. To quote Gleick at greater length:

As Scholz saw it, it was the business of geophysicists to describe the surface of the earth, the surface whose flat oceans make the coastlines. Within the top of the solid earth are surfaces of another kind, surfaces of cracks. Faults and fractures so dominate the structure of the earth's surface that they become the key to any good description, more important on balance than the material they run through . . . They control the flow of fluid through the ground – the flow of water, the flow of oil, and the flow of natural gas . . . Understanding surfaces was paramount, yet Scholz believed that . . . no framework [for understanding] existed.[40]

These surfaces are not those of Euclidean geometry, with its planes and surfaces and its two or three dimensions, a language in which much formal analysis of art is still carried out. If one considers the way in which the language of this physical world of surfaces might more appropriately be framed, one will find that our most basic conceptualization of dimensions becomes singularly impotent. The dichotomy between three and two dimensions, which is not unrelated to that between mind and body, becomes a major obstacle to understanding. Beyond its absolute conceptual clarity, there is relatively no reason whatever for language to enter the physical world in this particular way. The surfaces in a world of

shi are very definitely those of a material world, and we must take them as such.

This is profoundly relevant when trying to formulate an approach to the perceptual problems of painting in general, and those of Chinese painting in particular. The reductive formulation of 3:2 in the relationship between the three-dimensional world of objects and the two-dimensional image on a canvas is unconvincing in terms of perceptual dimensions, even where it is appropriately grounded in the theoretical frame. Beyond the appropriate cultural sphere, as with Chinese painting in relation to Euclidean geometry, the 3:2 formulation of dimensions becomes merely an analytic convenience at best. At worst, it could be a seriously misleading diversion.

Modern physics long ago moved beyond this sphere. But it also moved beyond the ability of many a layperson, such as myself, to comprehend. Chaos studies reasserted the physicality of context. To turn again for a moment to the geophysicist Scholz; among the geological formations to which he applied the continuously variable dimensions of fractals was that of the talus, formed by an accumulation of rocky debris down a hillside. Quoting Gleick's account again:

From a distance it is a Euclidean shape, dimension two. As a geologist approaches, though, he finds himself walking not so much on it as in it – the dimension has become about 2.7, because the rock surfaces hook over and wrap around and nearly fill three-dimensional space, like the surface of a sponge.[41]

Students of Chinese art will probably have guessed why I am so taken with Scholz's geophysics. To begin with, we have already introduced the Chinese 'ornamental' rock, to whose complexly wrinkled and foraminate form the last quotation from Gleick might be directly applied.[42] Its play of dimensions becomes even more complex when paintings refer to rocks and rocks refer back to paintings. Second, there was a distinct fascination in Chinese culture with the structural qualities of rock surfaces, even apart from the singular rock. In the early twelfth century, Han Zhuo, author of the most systematic of all accounts of mountain-and-water painting, remarks:

In depicting rocks, we admire largeness and boldness, hardness and roughness, alum crystal tops and sharply-facetted surfaces, the thickness or thinness of layering, the weight or depth of rock pressure.[43]

This is fractal rather then Euclidean language. Third, the distinction of 'earthen slopes covered with rocks' and 'rock slopes covered with earth' was persistently drawn for nearly two thousand years.[44] The point may

seem trivial unless one wonders *why* it was so drawn. The form of rocks on earthen slopes, a subject-matter associated with the centre of literati activity in Jiangnan, was culturally more highly validated. From the tenth century onwards, this 'talus slope' became not so much a common motif as a major theme. Huang Gongwang's *Dwelling in the Fuchun Mountains* places it right at the centre of the viewer's experience. His version of it could almost be used to illustrate a modern textbook of geology.

Fourth, not unconnected with the second and third points – and also from the tenth century onwards – a highly distinctive practice proliferated in both painting and in the texts on painting: the categorization of 'texture strokes' (*cunfa*). Particular shapes of brushstroke came to specify particular kinds of rock, mountain, tree and drapery. Then the categories were translated from particular natural features into particular stylistic traditions, in terms of the particular master associated with the origin of a particular 'texture stroke'. Han Zhuo's early 12th-century text notes:

In addition [to various kinds of rock] there are various kinds of texture strokes, *cun*. There is hemp fibre *cun*, the ornamental dot *cun*, the cutting-mountain *cun*, the horizontal *cun*, and the uniform-and-connected-water *cun*. For each of these strokes and dots there are ancient and modern schools.[45]

And this is only a beginning. The 'four great masters' of the Yuan period are each classified by *cun*. The 17th-century formulations of an entire history of Chinese painting are partly in terms of *cun*. Most historians of Chinese painting make an embarrassed obeisance in the direction of *cun* and then quickly go on to something more interesting. There are few ways of killing a lecture on Chinese painting more effectively than expatiating on *cunfa*. But the problem may be one of a cosmological gulf. *Cunfa* can readily be described purely in terms of execution, as a particular movement of the brush; but in fact they transgress our categories in a very uncomfortable way, lying partly within technique, partly within subject-matter, partly within style, and partly within meaning. They arise out of a world in which surface and texture are inseparable. And they offend against the dichotomy of mind and body.

The peculiar phenomenon of the Chinese rock keeps on reasserting its relevance to all these conceptual issues. An obsession of Chinese environmental construction for well over a millennium, these rocks were classified in much the same way as paintings and calligraphic works. They perfectly demonstrate how our dichotomies, such as man/nature and mind/body, are simply irrelevant to the Chinese tradition.

Another category of analysis can be brought to bear on the problem of how to understand suface, both in Scholz's sense and also as a material

interface with culture. The work of Cyril Smith on material structures is particularly helpful, because it deals with structure at the threshold of its accessibility to human perception. Smith himself was the first to see in the patterns and textures of Chinese painting similarities to the way in which regions of different atoms in a metallic alloy behave at their mutual boundaries.[46] It is important to understand surfaces as boundaries in this sense, as necessarily occurring *between* multiple matters, and not simply *on* a single matter; as representing not only structure but also behaviour, and therefore as emerging from and re-entering history.[47] The current reluctance of art history to incorporate materiality in the analysis of meaning is a barrier that has to be breached in this discussion.

In an admittedly impressionistic way, we may begin to understand how surface can be so important in the Chinese tradition of perception, and even what one might mean by 'surface' in our present context. Classic monuments of eleventh-century mountain-and-water painting may take on fresh substance. But we started this in the seemingly rarified atmosphere of Yuan painting, and now must find a way back to questions of authorial presence.

The grounds on which to theorize are distributed over heterogeneous fields; and my canine theorizing involves circling through these fields while trying to keep the spot in question somewhere near the centre. Another spiral of diversion thus leads through the theory that lies within the tradition itself, and takes us first to a point made earlier. Chinese modes of constructing meaning lie of necessity within the material world, human and non-human. There is a distinct and persistent, albeit elusive, mapping of values across a structure of interiority and exteriority, and through a perceptual distinction of the hidden and exposed. The centres of energy and the sources of structural generation are 'within'. Values intensify as they move towards 'within-ness'. But the harder one looks for this 'within', the more it seems to dissolve and the more persistently one is returned to the outside. An exemplar is the human body, articulated according to a physiological system of energy transformations and flows, functions rather than organs. Its configurations are maintained by the 'ruling' function of the heart-mind. But this complex and hierarchical network of functions depends upon the surrounding flows of energy that are incorporated and exchanged not only through openings such as the mouth, but through the entire unfolding of the body's surfaces. In examining the body's most interior functions one is unavoidably returned to the outside. How embarrassingly true. This is not a world of neat, clean, geometrical order.

The ease with which we slip from rock slopes to human physiology is symptomatic of an inextricably material universe. Such shifts are like the moves through the self-similar levels in scalar structures such as the Mandelbrot set. There is no inherent reason to privilege or problematize any particular shift or level. Any problematic difference comes from linking the scalar progressions to other, hierarchizing, frames of meaning, such as anthropocentricism and society. Thus, in our particular set of questions, a further shift from physiology to mind is equally natural in a material sense, but not necessarily unproblematic in a broader cultural frame. There is a fundamental difference, we should note, between applying a material explanation to the problem of mind in a cultural situation where material and spirit have already been severed, and attempting to justify and explain certain ways in which mind *should* be differentiated from body in a cultural situation that never adopted a matter/spirit dichotomy to begin with. In the case of China, the possibility of such a dichotomy was articulated in complex and profoundly perceptive ways over several centuries. This was a major source of the problematization of even longer and deeper-running cultural constructions. The Neo-Confucian synthesis was, in large part, a co-ordination of these indigenous currents in a final reworking and rejection of such possibilities as interjected by Buddhism. In Irene Bloom's words, 'Part of the *problematik* of Neo-Confucianism lies in the fact that the integration of the person is no longer natural. It . . . has to be accomplished, both theoretically and practically, through an enormous effort of mind . . .'[48] The necessity of such an effort brought with it new possibilities, such as that of the purposeful construction of self in Yuan painting, fluctuating between levels that we might characterize as the conscious and the subconscious.

There is, however, no necessary coincidence of theory and practice here. What happens in verbal theorizing may be very different from what happens in a material practice. Even so, while realizing that we are looking at another manifestation and not an explanation, we would do well to look into Chinese theories of human nature. They are as distinctive as they are illuminating. In fact, the main thrust of what is somewhat misleadingly called philosophy in the Chinese tradition was in this field. Its major synthesis was achieved in the eleventh and twelfth centuries, in Neo-Confucianism and most substantially in the work of Zhu Xi, with whom the cosmological basis of human nature is clearly articulated. We may pick up this issue in relation to its two most important terms, introduced earlier: 'pattern' (*li*), and 'matter-energy'

(*qi*). Both 'matter-energy' and 'pattern' are co-extensive with existence. 'Matter-energy' exists in different qualitative states. 'Pattern' exists hierarchically and as a scalar phenomenon. Smaller patterns are always contained within larger. Phenomena, physical and psychological, are all patterned matter-energy. As Zhu Xi says, 'Matter-energy is that without which pattern would have no place to dwell.'[49]

But there is a baser physical nature beyond which the mind, to be a mind, must move. Sensory perception is much more restricted than intellectual grasp. Nevertheless, there is no mind/body dichotomy. In the words of Zhu Xi, 'The nature is the principle of the mind; the feelings are the movements of the nature; the mind is the master of the nature and feelings.' And as Irene Bloom enlarges, 'Individually endowed, mind is nonetheless capable of attaining a transpersonal reality . . . Mind is individual in its association with matter-energy and transpersonal in its association with pattern, functional in its association with matter-energy and the feelings and substantial in its association with pattern and nature.'[50] Despite the importance of mind, it is never a Cartesian ego.

Within each human is the *hunran quanti*, translated by A.C. Graham as the 'complete substance as a whole', with no visible shape or image.[51] In a pattern of responses to the environment, from within the human being as though structurally out of an interior of 'rooms and house-frames', as Zhu puts it, the categories of moral emotion called the 'four outcomes', *siduan* emerge. (The categories are the heart-mind of pity and commiseration, of shame and dislike, of modesty and yielding, of right and wrong.) In Graham's translation, 'Hence they respond as they are stimulated by whatever they happen on outside, with the consequence that when the four outcomes emerge, each is differently expressed on the surface.'[52]

The term translated here by Graham as 'surface' is *mianmao*, which is a binome that could lead us down many byways. *Mian*, verbal and nominal, is similar in many ways to the English 'face', in origin having an especial relation to humanity. It becomes the commonest word for 'surface', as in 'earth-face' and 'water-face'. It is essentially structural, an exterior implying an interior. The term *mao* is closely connected, referring to the activities materializing at this surface. 'Demeanour' is sometimes a useful translation.[53]

In a universal sense, the face is indeed the most critical of our surfaces. It is not only the most visible and the most coherent as a substructure of the whole, a microcosm of the body seen as a macrocosm; but is also the main surface through which interior and exterior communicate and

interact. In a stereotypical view of Chinese culture, of course, 'face' also implies perceived social standing, and the stereotype is not unhelpful. The *mianmao* face-surface in which the 'four outcomes' emerge in Zhu Xi's account, is exemplary of this cultural 'face'. To come somewhere nearer to a fuller sense of this, one has to emphasize that for Zhu Xi and for the dominant tradition in Chinese thought, both matter-energy and pattern are necessarily both part of the individual endowment and also a transpersonal reality. The mind is relational. One of Zhu Xi's most critical terms, drawn like many of his concepts from the Mencian grounds of his tradition, is *ren* – rather hopelessly translated as 'humaneness'. The patriarchal Mencius (*c.* 371–289 BCE), who became so central to the Neo-Confucian articulation, produced the classic formulation that, '*Ren* is what it means to be human, *ren*.' The two words are closely related. And, '*Ren* is man's mind'.[54] It is the network of arteries and vessels that makes humanity collective. In Irene Bloom's words, 'Zhu Xi saw *jen* [*ren*] . . . as the original substance of the human mind as well its character or communicative capacity.'[55] All functions of human nature are an interface. None of its functions can be defined from the inside or outside in isolation. The 'face' is the surface both as an exteriorization and a perception.

It is, I think, legitimate and it may be even necessary, to see a painting, such as those by Wu Zhen, Huang Gongwang and Ni Zan mentioned above, as a surface and a face in this sense. The implications here are of a psychodynamic reality. I think that the entire Chinese tradition has indeed been far more psychologically oriented than the Western. Taking Zhu Xi as representative here, it would be interesting to map his extensive and synthetic construction of human nature onto psychoanalysis.[56] Starting from the basis of an energetic, rather than a philosophically geometrical universe, his dynamically structural understanding, is in some structural and semiological respects comparable to that of Freud. Freud's revolutionary position was in part due to his foresight in incorporating the most potentially subversive aspects of the science of his time, and especially its conception of energy. On the other hand, it was also due to an extraordinary intensity of self-examination.

No-one who reads Zhu Xi can miss this same intensity. In examining the will, Zhu Xi differentiates between 'blood-energy' and 'will-energy', ascribing 'will-energy' to the 'deepest places of the mind'. As Irene Bloom writes, 'Zhu Xi is evidently reporting his own personal experience.'[57] One has, at least, to ask what such a situation might mean in the case of a painter.

Any engagement in any cultural context with the materiality of mind is likely to bring up recognizably similar concerns. As one culture is seen from the perspective of another, the larger meanings within which these concerns are framed may well be inverted. But it is sometimes through the mismatches and friction at such boundaries that significant problematics are realized. In trying to engage at a theoretical level with the relationships between surface and the boundaries of self in Yuan painting, we may thus try an even more perverse detour. Jacques Lacan said of Freud's concept of the psychic drives:

> Freud now introduces us to the drive by one of the most traditional ways, using at every moment the resources of the language . . . the three voices of active, passive and reflexive. But this is merely an envelope. We must see that this signifying reversion is something other, something other than it dresses in. What is fundamental at the level of each drive is the movement outwards and backwards in which it is structured.[58]

Lacan is modifying Freud's original description. The 'drives' are dynamic and purposeful functions in the psyche that have their origin in particular bodily processes and organs. A biological stimulus exerts an active pressure upon the physiological system, generating a drive aimed at neutralizing the disturbance in the organism; aimed, that is, at satisfaction. Such satisfaction is achieved by incorporating the object at which each drive is aimed. This incorporation, such as of food, re-modifies the organism's physical state and thereby re-establishes stability. Lacan extends Freud's account both further back into the origins of psychic structure and also much further out into the symbolic register. Drives thus become encoded into a way of incorporating desired objects from a person's environment. Such objects, objects of love, for example, may be incorporated in conscious satisfaction but they are, so to speak, caught within the encircling movement of an unconscious drive originally aimed at a quite different kind of object. These encircling movements, in a manner of speaking, balloon outwards and back in again through the aperture of the drive in question, such as the mouth. It is like a net of force-lines in an energy field, seeking an object whose original loss goes back to the infant's first engagement with its parents. The language of this description may seem curious, but it results from a constant resistance on Lacan's part to the dichotomizing of the language of description and theory, and the states of the material and the abstract.

Lacan's problem, in part, lies in doing with language and linguistic thinking what may come more naturally to material and psychological activity. But his efforts to avoid such dichotomies may tempt one to think

of the transfigured drive in terms of *shi*. The usefulness of thinking this way is also suggested by Lacan's presentation of the configuring of the drive as a topological surface, both physiological and symbolic; a surface passing through all three coexisting regions of psychic existence. Lacan labels these the 'real' (as opposed to the 'reality' of the organism in its entirely unknowable biological state); the imaginary, that is, the unconscious world of the ego among images as yet uninterpreted in language; and the symbolic, or linguistically articulated order of the speaking subject. The drives present peculiar problems in conceptualizing the dynamic relationships between the psyche's within and reality without. As J.S. Lee writes of this,

Lacan attempts to model the human subject with the paradoxical Moebius surfaces of topology – the 'interior 8', the Moebius strip, the Klein bottle, and the crosscap – each of which calls into question the apparently simple distinction between inside and outside.[59]

Topology developed in the nineteenth century, part of a long-continuing movement beyond the strict limitations of Euclidean geometry. Its popular definition is as the study of properties that are retained by an object under transformations such as twisting, stretching and squeezing; that is, all those deformations falling short of breaking or tearing. It can deal with surfaces in which outside and inside are continuous. The doughnut, or torus, is the layman's example. Topology is a study of surfaces and as such played a very important role in the development of chaos studies. It was also a great interest of Lacan's, and he resorted to it in trying to visualize the structure of the psyche.

In the surfaces of topology, it becomes easier to imagine *shi* simply as a logical necessity in the material world. Topology became possible through the application of algebra to geometry. Historians have pointed out the importance of the fact that the Chinese mathematical tradition was fundamentally algebraic rather than geometrical – and very successfully so down through the fourteenth century. Chinese pictorial space might be approached more appropriately through the semiotic relations of algebra rather than in the line and plane structures of Euclidean geometry. The suggestion is most readily dramatized in the mountain-and-water paintings (*shanshui hua*) of the mid-eleventh century, as seen in the light of Joseph Needham's analysis of Neo-Confucian cosmology. Proposing that its alternation of forces in the positive and negative extremes of the *taiji* and the *wuji* was a legitimate scientific abstraction, Needham describes the cosmology as 'a prototypic wave-theory [that we can express] in our own terms by drawing two sine curves of opposite

rhythms.'[60] He points out that, 'The motive power could not be localized at any particular point in space and time. The organization centre was identical with the organism itself.'[61] Such an ecological distribution of agency is also implicit in the cosmology of *shi*. The geometry of a graph is made possible by the algebraic translation of a position in space into the function of co-ordinates. Despite the inappropriateness of linear perspectival models to most Chinese mountain-and-water paintings, these latter are powerfully tied to co-ordinates of horizontality and verticality. The transformations of structure within many Chinese paintings, and perhaps even the transformations of style across them, might also be better compared to the way in which algebra generates formulae of movement and change in surfaces, rather than in the ways through which Euclidean structures are propagated in lines of sight. The development between Xu Daoning and Huang Gongwang might be seen as the unfolding manifestation of possibilities inherent in a topological mode.

Adapting to a cultural disposition to deal with textures and surfaces rather than with lines, angles, planes and volumes, we may begin to see ways in which configurations of the physical and psychological world may be both embodied and exemplified in a Chinese painting, and to sense how distinctively issues come to be articulated at the boundaries between surfaces of this kind. But why, still, do surfaces surface so prominently in Yuan painting? The answer I am inclined to give to this question is to accept at face value the literati painters' conscious engagement with a distinctive mode of self-construction at this time. And then to suggest that the material activity of brush and ink within the texture of the surface, preferably paper rather than silk, became an interface between self and society. The topologies of geology and Lacanian psychoanalysis, for example, suggest ways in which we might think about these surfaces along these paths.

If this framing is appropriate, then the more fertile comparison is probably between Zhu Xi's view of human nature and Lacan's derivation of Freud, rather than of Freud himself. In this respect, two aspects deserve special attention. The eye, for Lacan, is one of the organs of the drives. Within the circuit of the 'scopic drive', the subject incorporates symbolic objects of desire in the field of the visible. But this process does not emerge as though from an isolated subject. Lacan discusses it in what has probably been his most influential work for art historians – his analysis of the 'gaze'.

This discussion proceeds from his central account of human self-

construction as originating in an infant's earliest perception of the 'human gestalt' appearing in the face of another, or of her own face in a mirror. The first construction of the self can only be constructed in the image of the 'other'. Subjectivity cannot be extracted from the oscillations of this doubled aspect. The self continues to lie always in the field of the other.

Even before one becomes aware of one's own gaze outwards, one is constituted by the gaze of the other, in which the self is permanently alienated, and never able to belong fully to its own organism. 'The scopic fantasy identifies the subject as a 'given-to-be-seen' existing only in relation to an imaginal gaze', to use J.S. Lee's explanation.[62] Lacan chooses to describe this in terms of picture-making, and as seeing and being-seen. One is always a picture to the gaze of the other. The surface of this picture is characterized by Lacan as a screen, or sometimes as a mask or a stain. A painting is like a projection on a screen that is illuminated from the other side by the other's gaze. Painting, if I interpret him correctly, is a way of exploring this at the interface of the imaginal and symbolic registers. And one may wonder whether this coincides with the topological surface of the scopic drive's ballooning configuration. To quote:

Only the . . . human subject, the subject of the desire that is the essence of man – is not entirely caught up in this imaginary capture [by the gaze of the other]. He maps himself into it. How? In so far as he isolates the function of the screen and plays with it. Man, in effect, knows how to play with the mask as that beyond which there is the gaze. The screen is here the locus of mediation.[63]

Perhaps we could develop a theoretical frame for approaching fourteenth-century paintings as such a screen, or surface, in which are deposited complex exchanges between self and other, between non-geometrical inner and outer. In which there is, most essentially, a deposit of desire.

It may be more than a trivial coincidence that movable screens had an essential role in Chinese interiors, public and domestic, and exercised a particular fascination over Chinese artists. A story tells how a prince of the third century CE delighted in titillating his guests and himself. At moonlit parties he would sometimes bring women from his private quarters and present them within a transparent screen.[64] Never, perhaps, has the deposit of desire in a screen, within a Lacanian diagram of the gaze and the subject, been more vividly exemplified.

Screens were often painted, from the first century CE to the twentieth. During the Song dynasty, the notion of painting 'screens within a screen' became fashionable. An excellent example from the late thirteenth

Liu Guandao (*fl.* 1279–1300), *Whiling Away the Summer*,
late 13th century, handscroll, ink and light colours on silk.
The Nelson-Atkins Museum of Art, Kansas City, Missouri.

century is *Whiling Away the Summer* by Liu Guandao, who was a painter
at the Mongol Yuan court.[65] The representation appears to be in the
nature of a daydream, framed by the screen behind the entranced
gentleman. His gaze, however, seems fixed on the two serving-women,
and there is clearly a passage of desire. But the desire is then projected
through the surface of another dimension, back into the screens. It is
thereby doubly transformed, at first into the image of another scholar,
mirrored but with certain reversals, and then into the formations of a
landscape.

The prince's screen show is obviously reminiscent of the Lady Li's
visualization of bamboo, discussed above, which also took place in the
moonlight. That particular passage of desire was introduced above in
relation to the issue of the painter's material ground. These interrelated
issues become compressed in the rapid intensification of self-conscious-
ness that characterizes literati painting in the Yuan. We might do much
worse than to analyse a Yuan painting, in Lacan's words, as 'conscious-
ness, in its illusion of *seeing itself seeing itself*, find[ing] its basis in the
inside-out structure of the gaze.'[66] At the same time, in Chinese
paintings the anything that we might see as equivalent to the 'gaze of the
other' almost always seems de-centred and distributed across the sur-
face. There is no gaze of God.[67] Lacan's double-cone diagram, with its
two geometrical points derived from a perspectival system, would have
to be redrawn, if it could be drawn at all, in a system compatible with
the cosmology of traditional Chinese thought.

Speculation about what happens within this surface boundary of Yuan
painting may be pushed one stage further. Lacan's views, as has been
much discussed, bring Freudian constructions, based on an economy of

psychic energy, through a mesh of structural and deconstructionist theory. In saying that 'the unconscious is structured in the most radical way like a language,' in allowing for the role of language at the most fundamental level, Lacan allows 'desire' to become more fully human.[68] The deconstructionist turn enables one to see this desire as an operation of meanings, with meaning, on meaning.

Chinese thought seems to have been both structuralist and deconstructionist from its visible beginnings. Indeed, some views developed from these two positions in our own day sometimes seem to have been incorporated at the level of 'common sense' in the Chinese tradition. This can be seen, for example, both in Chinese views of language and in the complexes of *yin–yang* and correlative thinking that were so predominant. As A.C. Graham reveals, the paired categories of correlative thinking that are characteristically labelled as '*yin*' and '*yang*' are sequentially aligned as syntagmatic, and cross-linked, either in similarity or contrast, as paradigmatic (e.g. YANG-hot-fire-sun-round-illuminates-expcls-[does to] *vs* YIN-cold-water-moon-square-[retreats into dark]-[holds in]).[69] Language was understood as operating not with existence and identities, but with stuffs and differences, not with one-many but with whole-part divisions.[70] Basic assertions about the meaning of words were in binary terms, that is, of their being in the category of 'this', *shi*, or of 'not this', *fei*. The idea of 'absence', in the post-structuralist sense that meaning resides in those other terms against which something is defined, was built-in from the beginning. To quote: 'Using the meaning to show that the meaning is not the meaning is not as good as showing it by means of what is not the meaning.'[71] This is not a disciple of Derrida, but the poet-cosmologer Zhuangzi (between 399 and 295 BCE), as translated by A.C. Graham. These structural semiotics, however, are always invested in the material world. There is not a mind/body, theory/practice dichotomy. This account is not a matter of cultural one-upmanship. It raises important questions about the expectations and directionality underlying our analyses in such circumstances.

The categorical opposition of 'this' and 'not this' was sometimes put in terms of 'this' and 'that', or 'near' and 'far'. The relativist view that 'what is this to itself is that to another' was an inevitable extension. Some writers objected to it, but somewhat helplessly, as though swimming against the tide. The deconstructive turn was unavoidable. Graham writes of the *Daodejing*, the book of Laozi:

Lao-tzu is already undermining conventional assumptions by reversing the priorities in the standard oppositions 'high/low', 'strong/weak', 'male/female', in

a manner suggestive of the reversals which are the post-structuralist Jacques Derrida's initial move in the brand-new enterprise of deconstructing the conceptual schemes of the West.[72]

The importance of this situation is intensified by the manner in which most Chinese thought took language as the foundation of the human world. Although this issue has much to do with the nature of the script, we cannot discuss that here. As Zhuang Zhou notes, 'The Dao is brought about by walking; things are thus because of what we call them.'[73] The notion of existence that was for centuries dominant in Western thought – that existence can be predicated, that there can be immaterial 'entities' detached from the material matter (e.g. of God before creation) – such a notion could not 'exist' in this linguistic ecology. As Guo Xiang, a commentator of the third century CE on Zhuang Zhou said, 'there has never been a nothing.'[74] Something existing always has an environment, it is always 'had' by other things, it is always in time and space, there is no last boundary which one can ultimately transcend. It should not surprise us, given what we have discovered about our own situation, that so much of the Chinese tradition's engagement with reality seems to be in terms of inscribing and reading. The extraordinary and characteristically material validation of calligraphy is but one aspect of this. More broadly, we get the impression that the entire tradition saw itself as one enormous enterprise of interpretation, through phases of materialized meaning. Whether one is reading Chinese official histories (the largest body of such history in the world), Chinese poetry (of which the same could probably be said), or looking at Chinese calligraphy, or Chinese painting, one is dealing first and last with interpretation. In painting, interpretation expands not only outwards from the picture, through complex references to, and displacements by, other painters, other paintings, other places, but also through the painting itself. The horizontal handscroll format embodies this most explicitly. One might well ask, in fact, whether there is any existence outside the activity of interpretation. What drives this metonymic and temporal process of interpretation is an important and difficult question. I would suggest another of Lacan's elusive utterances as providing a valuable line of enquiry. Not only is interpretation directed towards desire. 'Desire, in fact,' he says, 'is interpretation itself.'[75]

One distinctive acknowledgement of this was in the obsessional love of material culture that the Chinese called *pi*. (*Pi* was originally a medical term denoting a physiological blockage and hence a pathological attraction to something.[76]) A wide-spread affliction among the literati, the *pi*

Yu Ming (1884–1935), *Mi Fu Bowing to Elder Rock*,
early 20th century, hanging scroll,
ink and colours on paper.

might be for overtly artificial cultural forms, such as poetry; but it was more usually for disguised cultural forms, such as flowers and rocks. One of the best known of all exemplars was Mi Fu's passion for rocks, which became both a textual and pictorial paradigm. A delightful modern representation by Yu Ming (1884–1935) peculiarly prefigures Lacan's diagram of the drive. Such nominally 'natural' objects were, in fact, as much phenomena of interpretation as poems or paintings. But their quasi-objective status made it easier to articulate a specific psychological attachment. Judith Zeitlin writes, 'The eleventh century intellectuals had already argued that obsessions were valuable as an outlet for personal ideas; in the sixteenth century, obsession as a vehicle for self-expression becomes the dominant mode.' She goes on to quote Yuan Hongdao (1568–1610), who observed:

The chrysanthemums of Tao Yuanming, the plum blossoms of Lin Bu, the rocks of Mi Fu – people all swap stories about these men's obsessions as delightful topics of conversation and then blithely take up something else as an obsession in

order to amuse themselves. Alas! They are mistaken. It wasn't that Tao loved chrysanthemums, Li loved plum blossoms, or Mi loved rocks, but rather in all of these cases, it was the self loving the self.[77]

In Yuan painting, where interpretation as a cultural function becomes paramount, the strength of desire is often tangible even if indicated only obliquely. Ni Zan sometimes expressed it explicitly, as in the couplet 'I make a poem to convey my far-reaching feelings/These gentlemen [bamboo] can truly be friends.' And, again, 'To express inspiration I need only brush and paper/To depict feelings I do not use a lute.'[78] But the desire is often most palpable when more implicit. On the painting *Twin Trees by the South Bank*, it is intense:

Having 'written' this picture for the young scholar Kung-yuan, I further composed a quatrain:

 I once tied my boat near the cottage at Fu-li,
 Where the green river and white gulls stirred my melancholy thought.
 I shall remember the two trees on the south bank,
 How the blue-green bamboo clings, after rain, like morning glories.[79]

One of the commonest terms referring to the content of a painting is *yi*, usually translated as 'idea'. In fact, it is frequently more an issue of 'intent', involving a directionality of feeling and, quite clearly, the vectors of desire.

The role of language as a structuring field is fundamental to both traditional Chinese epistemology and to any Lacanian analysis. For both, language is a structure of exchange. In Lacan, the unconscious, initiated through engagement with the other, is trans-individual from the beginning. It becomes a structure of signifiers without any signified. In the unconscious is constituted what Lacan calls the '*moi*' in the field of the imaginary. The speaking self, however, located in both space and time, is constituted in the milieu of the symbolic, the world in which our consciousness operates. As a conflict between these two, human subjectivity is permanently deprived of autonomy and coherence. There is no Cartesian *cogito*. Neither is there any such *cogito* in Zhu Xi's view of human nature. Much of Chinese thought, and perhaps much of Yuan painting, seems generated from a Lacanian juncture of energy and language. To what extent there is a notion of an unconscious in Chinese psychological thinking, however, is a difficult question. Although it is also an important question for the present discussion, it is obviously too large to deal with here. It is my personal opinion that space for an

analogy to the unconscious is structurally implicit in traditional Chinese thought. The concept of patterns of energy generated within and distributed throughout physical, social and psychological life, sometimes invisible and sometimes revealed, is very suggestive.[80]

We should note one other aspect of Neo-Confucian thinking here. The issue of transmission is archetypal in Chinese culture and, much as it has already been studied, it still needs more attention. Zhu Xi was deeply concerned with it, as he had to be in trying to construct his own role, and encapsulated this concern in his term *daotong*, 'the repossessing of the Way'.[81] In this cultural frame, the 'will' (*zhi*) of the entire cultural system is in many ways analogous to the 'will' of the individual. The definition of 'will' is a point of crucial distinction between the Western and the Chinese (not to speak of other) traditions. In the Chinese tradition, the will is not an exercise of free-choice that isolates the individual from society. Zhu Xi is exemplary in endorsing Mencius's statement that 'will is the directedness of the mind' (*xin you suo zhi wei zhi zhi.*) The agency of the will is 'to recognize connections and recover the metaphysical grounds for relatedness and communication.'[82] The will helps to sustain and direct society. Terms related to *zhi*, or 'will', such as *yi*, meaning 'idea/intention', generally maintain a sense of directionality. The 'lineages' of social and intellectual interpretative activity have several models, but one of the most powerful is that of the 'artery-pulse' – the articulated flows of energy that run through the organisms of the human body and the family.[83] I think it is appropriate to extend this view much more broadly into social and intellectual lineages.

Given such a dynamic structure, what and how does the individual contribute? The contribution can be seen as one of the 'transformations', *bian*, that articulate the flow of energy. But the individual's nature is quite definitely problematic. In Zhu Xi's conceptualization this nature is closely linked to the term *shen*, a term often translated as 'spirit' but more properly seen as the agency that controls the configuring of a specific configuration of energy, such as an individual. The *shen* can represent the creative power of the individual, for example, in the transmission and repossession of the Way (*dao*), and, one assumes, in a work of literature or painting. But how the *shen* stands out synchronically from the diachronic arteries of transmitted energy remains problematic. As a surface, one is tempted to surmise. The *shen* needs somewhere to dwell in the flow of time and space.

Dwelling in general is a very prominent theme in the discourses of the Chinese tradition, and any effort to analyse further how self is con-

structed as resident in Yuan painting would have to investigate the
rhetoric of *shen*.

The Neo-Confucian view of transmission and 'repossession of the way'
was centred on a 'way' that was coincident with culture itself, in the
context of dynastic fortunes and major historical shifts. The discourse of
dwelling itself always embodied both a culturally ahistorical, and a
sequentially historical, self-consciousness. The relationship between the
discourse as an historical product and the discourse as an historicizing
construct, is very hard to disentangle. Without even trying to do that, one
may speculatively historicize the play of boundaries and surfaces along
one route through the process.

The seventh and eighth centuries brought one of the highest levels of
expansionism and internationalism in all of Chinese history. This
expansive mobility of the empire's borders coincided with the high point
of Buddhism, especially in its most widely effective form, the cosmic
'Pure Land' paradise cults. Such paradises were visualized and pictorial-
ized in the form of the imperial palace. Such palatial paradise scenes
made extremely effective use of multiple, convergent, linear perspec-
tives.[84] These schema incorporate the viewer in a geometrically
perceptual structure; establish Buddhahood as the central focus; and
carry the viewers' gaze into worlds beyond the present. They construct
the promise of a religious and secular empire's infinite extension beyond
mundane borders. The period of highest popularity for such paradise
scenes seems to have extended well beyond a retraction of the empire's
grandeur in the mid-eighth century. One might suspect that the inher-
ently dream-like function of the paradise scenes became even more
alluring in such circumstances. But the boundaries of the dream acquired
a different meaning.

The great age of monumental 'mountain-and-water' painting comes
with the tenth and eleventh centuries, coinciding with the Northern Song
dynasty (960–1126). It might be suggested that the wide vistas and
remote distances of such paintings are simply a natural analogue for the
architectural glories of earlier Buddhist paradise scenes. There certainly is
a common function of the sublime. However, the 'mountains-and-
waters' are no less constructed and the issue is much more complicated.
The Northern Song, although socially, politically and culturally a period
of great distinction, was almost as self-contained as the Tang had been
extroverted. Northern Song borders were, in general, closer at hand and
more firmly accepted. Issues concerning the physical boundaries of
Chinese culture had a much greater immediacy than had ever been the

case before. The magnificent vistas of mountain-and-water paintings should probably be seen as a rhetoric of grandeur for both imperial and cultural territory, specifically in relation to their perceived limits. One of the most interesting records of the cartographic aspect of this is a topographical model, made from wax and sawdust by the great polymath Shen Gua (1031–95) when he was an official inspecting the border district.[85] Such map-models may have become a standard item in the imperial archives. This was exactly at the time that Guo Xi was experimenting with hand-moulded and trowelled plaster walls as a ground for his paintings. Unlike the perspectival structures of Tang paradises, and indeed in fundamental distinction to them, there is here already an incipient rhetoric of physical surface. The rhetoric, however, is usually still submerged or subverted. The distant vistas in such paintings stretch any possible belief in surface almost into incredulity. This inherent contradiction is subsequently exploited for two opposite possibilities, one of which was developed in the Southern Song period (1127–1279) and one in the Yuan.

　　The political and military collapse of the Northern Song court in 1126 is the most infamous retraction in the dynastic record. The late Northern Song government had, in fact, been constantly negotiating peace with northern neighbours. But the new border established by the conquering Jurchen people cut right through the heartland of China, between the Southern Song court, subsequently centred on the lower Yangtze in the south, and the Jin state controlling the Yellow River plains and beyond, in the north. This boundary of alienation within the cultural body itself may well have been the most highly problematized border in all of Chinese history. Almost every aspect of political and cultural life seems to have been affected by it. Since the end of the thirteenth century, it has been a convention that the extreme reduction in landscape composition to the 'one-corner' (*yi jiao*) schema of Ma Yuan (active before 1189 to after 1225) exemplified the 'remnant mountains' of Southern Song territory. To modern art historians this retrospective linkage of disparate phenomena has little or no validity. Its entry into the content of Yuan cultural rhetoric is, however, an authentically historiographic fact. But even if we disregard it, we must still take careful note of how painting at the twelfth-century court of the Southern Song makes two kinds of surface increasingly present. One surface is that of the immediate environment. The quality of visuality in these paintings is extremely high, but so closely focused are the represented scenes that a palpable sense of a surrounding physical envelope is often constructed, even if often it is

an envelope of mist. The second surface is that of the silk, on which the ink left by the painter's brush strokes is often vividly apparent. Whatever relationship there may or may not have been to more widely defined cultural borders, perceptual limits and boundaries become startlingly present in the painting of this time.

The Mongol Yuan dynasty brought about a China that was at once more unified, but now more deeply alienated, as Mongol rule deprived the literati and gentry of their ancient status and purpose. Since the end of the thirteenth century, it has been customary for critics to attribute major changes in Chinese painting of the period to this alienation. Yet the explanatory status of any such connection is extremely difficult to demonstrate. I would suggest that the notion of cultural selfhood acquired boundaries that it had earlier hardly known. Notions of 'China' and its culture, more concentrated than ever before, were now surrounded and enclosed by an alienating political environment. Thus, a sense of new boundaries against which the self itself might press, or by which it might be pressured, must surely have been inherent in the experience out of which, and in which, selves had to be constructed. It is customary to say that Chinese painting was never the same after the Yuan, and indeed it was not. But we do not usually allow for the extremity of Yuan painting itself. This is partly because we are reluctant to give too much weight to the traditional commonplace of a stylistic response to political circumstances. In fact, as one looks at later painting, it is difficult to find the same intensity of self-representation until the seventeenth century, when a gathering weight of collapse finally brought about formal dynastic change in 1644 with the founding of the Manchu Qing dynasty. Seeing this issue in terms of resonances between political, physical and psychic boundaries, and translating those into pictorially material structure, may provide one way of specifying the 'emotional' problem more exactly. One aspect of Yuan painting in this regard, however, could not be repeated. That is the intensity of the first full-fledged discovery of surface in such pressured circumstances, and this may have given the Yuan constructions of self a revelatory power that was never to be matched.

These boundaries of pressure must also have affected the notions of dwelling that are so fundamental to the Chinese cultural sense. To stretch Guo Xi's distinctions of the eleventh century into an historical sequence, Northern Song 'mountain-and-water' works are for travelling and wandering in, Southern Song landscapes are for viewing, and Yuan paintings are for dwelling.[86] Very rarely do the essential paths of

Northern Song structure a Yuan composition. Huang Gongwang's *Dwelling in the Fuchun Mountains*, a long horizontal composition, is exemplary. The journey through this work is within mountain arteries rather than along footpaths. The work is a constant negotiation with the realities of surface. At the centre of the scroll, the principal dwelling site is a hollow, a female structural pole. At the end, the activity of dwelling erupts in the phallic thrust of a single mountain peak.[87] Desire transformed into generic, but material, structures is rampant, and the surface boundary is subject to powerful distortions. It is important to note this work as a reference point, even as we concentrate on the less melodramatic activities of Wu Zhen and Ni Zan.

We noted at the beginning of this essay that the function and desire of dwelling are apparent in the paintings of both these artists.[88] As with most aspects of Ni's work, however, in his case this is layered with ambiguities that force us into a finer engagement with definition. Paradoxes and ambiguities delighted Ni. There is a very well-known expression of this in an inscription he wrote on a bamboo painting, preserved only in his literary works:

[Chang] I-chung always likes my painted bamboo. I do bamboo merely to sketch the exceptional exhileration in my breast, that's all. Then how can I judge whether it is like something or not . . . Often when I have daubed and smeared a while, others seeing this take it to be hemp or rushes. Since I also cannot bring myself to argue that it is bamboo, then what of those who look? I simply don't know what sort of thing I-chung is seeing.[89]

As objects incorporated in the circuits of desire, these things are never what they seem. Ni Zan is surely opening himself to a phenomenon that is to be found as much in Zhuang Zhou as Lacan – the displacement not only of objects but of signifiers themselves. Once language descends deeply enough into the psyche, where there are no signifieds but only signifiers, where on this side and that side of one signifier there are only other signifiers, the endless sliding of one signifier under another becomes the condition of the self itself. These slidings and displacements can perhaps be seen in the way Ni Zan sometimes inscribed a painting on its completion, and then re-inscribed it as it passed through other hands, as though it were thus remade. More than any other painter before, he is also characterized by the repetitiousness of his compositions. This emphasizes the linguistic nature of his painting, for the whole possibility of language lies in repetition. But it is again as though one painting is always sliding under another. It is possible for a painter to pin down this sliding, in a pictorial '*point de capiton*'.[90] Huang Gongwang did that in

no uncertain manner. Ni Zan may have deliberately avoided doing so, preferring to slide endlessly over his surfaces. But, more probably, careful analysis could show a subtly quilted pattern of meanings.

Literati rhetoric appears to have insisted, in Ni's words, that paintings were done 'only to sketch the exceptional exhileration in one's breast, that's all.' But, interpreting this in the context of literati society, with its equally intense insistence on intersubjectivity, one must wonder whether it was ever possible for Ni, or any other Chinese painter, to have painted only for himself. The answer should probably be, no. A painting such as the *Old Tree, Bamboo and Rock* (dated 1370 and 1373), assembled seemingly by chance and over time in passages authored by Zhang Shen (the tree and an inscription), Gu An (the bamboo) and Ni Zan (the rock and a poem), is simply an unusually explicit exemplar of a persistent circumstance; a Freudian slip, one might say.[91] The boundaries that exist between one painter/calligrapher and another are open, interactive and permeable in some respects. As with Cyril Smith's material boundaries, it is the interaction at the boundaries that generates much of the interest. In the nature of brush painting on paper, the boundaries between artists in this case are played out within their partially common surfaces.

If the surface of a painting was indeed the field into which the functions of self could physically project and visually reconstruct themselves, it was also a field in which presences at least analogous to Lacan's generic 'Other' and specific 'other' must also have been active. The only alternative would have been a complete narcissism. This may sometimes have been the case, but that would also have been a special case of exchange. Equally unavoidable is the fact that this surface was also the field of desire. Texts indicate clearly that this was the case, even though Western readings of these images, which sometimes seem to us so dessicated, may find that activity highly elusive.

The words that I have been using to describe this material stratum of physical practice are also elusive: surface, texture, screen, field and boundary, for instance. This is hardly surprising. As I have noted, language is inextricably connected with this region, but the indispensable materiality is itself an other to language, and irreducible to it. In meeting the surface, the painter's psyche is brushing a boundary. That is the nature of the activity and the surface. But there is depth within the surface, for the surface has a texture and the boundary is permeable. In working through it, it becomes a field of psycho-physical forces. It is also a screen in that one side is metaphorically internal and invisible, while the activity creates another side that is external and visible. The nature of the

boundary itself incorporates the 'Other' in a generic sense, but the working through of it draws many more specific transactions into this interface. The notion of a screen in which both sides may face the same way is a product of the physical ecology of a material work, an ecology that cannot be left out of the analysis. The topology of the Moebius strip is exemplary. In the recent history of such analyses, however, the field of film studies is even more so, for there the notion of the screen has exercised its most obvious allure.[92]

One of the most important aspects of these psychic structures, as analysed in Freud and Lacan, investigated in Zhu Xi, and represented by Wu Zhen and Ni Zan, is that they may be individualized ideologically, but psychologically they are socialized. The nature of this socialization has become apparent to us only through psychoanalysis. To quote Victor Burgin, 'Psycho-analytic theory does not construct a realm of the "subjective" apart *from* social life, it is a theory of the *internalization* of the social as "subjective".'[93]

All of these paintings are inextricably located in a social formation and in more than one dimension. Certainly, various visible forms of open social exchange can be incorporated and served in such works. But they do not exclude the level of social formation discussed here. It seems legitimate to suggest that the exercise of such painting in China was, in effect, a praxis analogous to our psychoanalysis – a practice that can only occur in trans-subjective space, between people. This suggestion, of course, is an extremely loose one. An entirely different social structure would require a sort of topological transformation of the Lacanian psycho-analytic situation.[94] But the functions that might be remapped include the psycho-analyst's various roles as the Other, the third party witness to truth representing also all the interlocutors of the past life of the subject. This complex of roles, symbolic of society, culture and language, is addressed in the psychoanalytic situation so that the critical message can finally be recognized. Some need for recognition was certainly endemic in literati painting, and the psycho-analytic analogy might provide an appropriate context for recognizing it.

What if this were the case? What would it be relevant to, or useful for? Anything? The answer is a matter of our own relation to history. It is certainly possible that such a psychoanalytic description might not prove analytically useless. We might not have any means whereby to engage with specific material in this manner. If there were any justification to the initial description, however, the possibility of an analytic outcome would have to be explored.

As a final echo in this chamber of reflections, we may note another convergence of Lacan and traditional Chinese painting. The psychoanalytic construction in Lacan's terms is a story, not in the past, but in the future anterior tense: constructions of what will-have-been. Indeed, Chinese culture was highly distinctive in the way in which it projected works of art into the future; paintings continued to live as long as they remained in a network of psychic, social and material interaction, so that the will-have-been was always becoming. This is another aspect of interpretation as a fundamental function, of culture itself and also of cultural choice. Where boundaries can or should be drawn in the activity of interpretation, is one of our own most current problems. Chinese paintings, especially of the Yuan period, project themselves readily into this milieu.

But this raises a much broader question concerning the state of what we are attempting to do. Lacan's lectures, reproduced in the *Four Fundamental Concepts of Psychoanalysis*, took as one of their most provocative themes the question, 'What is the analyst's desire?'[95] It is certain that our desire is also implicated in any art-historical analysis, from the moment that any move is made in the process. This is, perhaps, our most critical boundary, located in the screen between the historical subject and the gaze of history writing. When that subject is also an object, especially an object of art, the presence of desire may be especially intense, and the way in which we negotiate that boundary within the working of the object itself may beg the most important historiographic question of all. We may sometimes circumvent our normative expectations of what *should be*. It is far harder to subvert our ontological assumptions of what *is*. The dog, once settled in the desire of his dream, cannot even question the suspension of his disbelief.

5

The Suspension of Dynastic Time

JONATHAN HAY

In the conventional historical record, China's history appears as a succession of dynasties, a succession that is often complicated by the division of the country into areas under the rule of different regimes. But like the official maps of the London underground and the New York subway, which stretch, shorten, straighten and bend to create an illusion of carefully planned order, the chronological tables of Chinese history represent a ferocious editing of the historical process. The boundaries between dynasties were far from unambiguous to those who lived them. In this essay, I shall try to reconstruct some of the ambiguities of one such boundary, that between the Ming and the Qing dynasties, from the point of view of painting. The focus will be on what I shall call 'remnant' art, that is, the art of those intellectuals who defined themselves as the 'remnant subjects' (*yimin*), of the Ming dynasty.[1] Still more narrowly, I shall largely be concerned with two closely related painters working in the city of Nanjing, formerly China's southern capital under the Ming dynasty. Zhang Feng (died 1662) and Gong Xian (1619–89) are just two of many remnant artists who congregated in the suburbs of Nanjing, where the temples offered safe haven to Ming sympathizers and the Ming monuments were visible reminders of the previous dynasty.[2] The works I shall discuss are landscapes which exploit the heritage of landscape painting as the pre-eminent genre for the metaphoric exploration of the individual's relation to state and nation.

The year 1644 is commonly accepted now as the boundary between the Ming and Qing dynasties, the moment when the Mandate of Heaven passed from the Ming to the Qing. Yet there are nagging questions. Should the moment be localized more precisely in the suicide of the Chongzhen emperor on the nineteenth day of the third lunar month, as the 'rebel' Li Zicheng reached the city? Or in the arrival at the Forbidden City, in Beijing, on the first day of the fifth lunar month of the Manchu general Dorgon, after he defeated Li Zicheng? Perhaps the moment was a

longer one, bounded by these two events? In practice, the issue could be avoided neatly by the use of *jiashen*, the cyclical year corresponding to 1644. This usage gained symbolic support from the wave of loyalist suicides in that year, echoing Chongzhen's own. An alternative way of denoting the Ming-Qing boundary was as the '*jiayou* transformation', in reference to the two years jia*shen* (1644) and *yiyou* (1645): I take this to mean that what had been Ming at the beginning of 1644 was Qing by the beginning of 1645. The modern assumption of an objective boundary inscribed in the historical record thus coincides with a certain seventeenth-century recognition of the transfer of the Mandate. The issue becomes muddier, however, as soon as we move our standpoint away from the central linear axis of transmission of power. It then becomes important to take into account the fact that a (geographically limited) Qing dynasty had existed since 1636; and that the Ming resistance would maintain the existence of a Ming dynasty until 1662. If 1636 was not accepted to define the Ming-Qing boundary, it was because it was only in 1644 that the political centre – Beijing – passed out of the hands of the Ming and into those of the Qing. But a general consensus on 1644 as the defining moment did not emerge until the collapse of the Ming resistance in 1662, and was not finally cemented until the late 1670s when the Rebellion of the Three Feudatories, life-threatening for the Qing, had clearly failed.

I take the political boundary of 1644 to be an example of what Paul Ricoeur, following Emile Benveniste, has called an 'axial moment', the event 'in reference to which every other event is dated', thus making possible a calendrical form of time.[3] As 'the first year of the Shunzhi reign', inaugurating the Qing dynasty, 1644 belonged to a dynastic form of calendar time, in which the axial moment was periodically renewed by the initiation of a new dynastic cycle. From this point of view, what made the Ming-Qing boundary complex was that in its first, preliminary version, Qing dynastic time preceded 1644; while in its final, eventually abortive version, Ming dynastic time postdated it. For our purposes, the important point is that for some time after 1644 there were two truly competing frameworks of dynastic time. Though many people at the time probably accepted Qing dynastic time without question, Ming resistants continued to locate themselves within the Ming dynastic cycle. Neither of these options, however, accurately describes the situation of the many non-resistant remnant subjects, who included the vast majority of remnant painters of the post-1644 period.

While they acknowledged pessimistically that the Ming dynastic cycle was over, these men (and women) still refused to fully enter Qing

dynastic time. The limbo in which they found themselves can be seen from these few lines written by the painter Wan Shouqi during his final illness in 1652:

> What year is it now?
> Muddled, won't remember
> So many feelings in the corner of the room
> Where there still hangs a calendar of Chongzhen.[4]

Similarly, Gong Xian inscribed a painting of the 1650s with a poem which includes the line, 'In calculating the date, I mistakenly use the calendar of the previous dynasty.'[5] He was tempted, that is, to date the painting 'such and such a year of the Chongzhen reign', since any dynastic calendar calculated its dates only in reference to the current reign. Given this convention, of course, use of the dynastic calendar incorporated a statement of loyalty to a given emperor. Consequently, Gong Xian, like most remnant painters, refused to employ the Qing calendar, preferring to employ the two-character cyclical dates (*jiashen* and *yiyou* are examples) from the endlessly recurring sixty-year cycle of years which traversed the millennia with a cosmic disregard for the succession of dynasties. For such remnant subjects, then, 1644 as *jiashen* was a different kind of axial moment, the reference point for a calendar transcending the world of affairs which mapped the mortal time of a generation directly on to the immensity of the cosmic process. It is appropriate in the case of these remnant artists, therefore, to speak of a suspension of dynastic time.

Events, it would seem, could be decisive in establishing a boundary both in politico-legal terms and in consciousness, but the boundary was open to different interpretations. It may be useful here to borrow another analytic concept from Ricoeur, the distinction between authority and legitimacy. Only the active resistant contested the authority as well as the legitimacy of the Qing, thus keeping open – in theory, at least – the possibility of a change in the political situation and the restoration of Ming authority. We should distinguish this from the less extreme option that more often characterized remnant culture, in which Qing legitimacy was contested while Qing authority was reluctantly acknowledged. In Ricoeur's terms, the remnant culture that did not align itself with active resistance can be said to have opened up an utopian space: 'is it not the function of utopia to expose the credibility gap wherein all systems of authority exceed . . . both our confidence in them and our belief in their legitimacy?'[6] For remnant painting, this implies that it is necessary to

make a distinction between work that has its context within the Ming resistance proper and work that, in a sense, stood in for resistance, transposing the resistance onto a purely symbolic level. What is striking, though not surprising, is that while the Ming resistance did give rise to paintings, there are relatively few of these; the overwhelming majority of surviving remnant paintings contested only the legitimacy, and not the authority, of the artists' political masters.

Zhang Feng, one of the two artists I will focus on, was the son of a senior military officer who committed suicide in 1631 after losing a battle. His brother, Zhang Yi, was a Battalion Commander in the Embroidered Uniform Guard at court during the Chongzhen reign, who despite torture refused to surrender to Li Zicheng's forces, yet escaped execution.[7] Having obtained the lowest-level official degree prior to 1644, Zhang Feng himself would normally have sat for the higher examinations leading to an official career, but the fall of the Ming led him to abandon that ambition, and he subsequently supported himself through painting.[8] The three dated leaves of his twelve-leaf *Album of Landscapes* in the Metropolitan Museum of Art were painted, respectively, on the last day of the sixth lunar month of 1644, one week later, and a further three days after that.[9] There is nothing in the other paintings or inscriptions to suggest that the album was painted over a very long period of time; perhaps it belongs entirely to that summer of 1644, when the painter was in the Nanjing area where he had grown up, now the capital of the post-Chongzhen Ming regime. But he painted the album in the recent knowledge of the Chongzhen Emperor's suicide, the fall of Beijing to the Manchus, and the proclamation in Beijing of Qing dynasty rule over the whole of China. Very likely, too, Zhang would have known of the letter sent by the Manchu general Dorgon to the Ming court in Nanjing early in the sixth month. This letter sought an alliance against the Chinese rebels led by Li Zicheng whose successes had precipitated the Chongzhen Emperor's death and the Qing invasion, and who had been fighting both the Ming and the Qing dynasties in the name of a third, Shun, dynasty ever since. It also, however, threatened an attempt by the Qing to unify China at a later date. And Zhang would certainly have been aware of the vicious debates at court between partisans of appeasement and the partisans of resistance and reconquest. The album was painted, then, against the background of political infighting in Nanjing, with a transfer of authority from Ming to Qing in prospect. Although Zhang is sometimes suspected to have subsequently been an active resistant, his response to his circumstances in this work was not to affirm the

Zhang Feng (d. 1662), leaf 1 from an album of twelve paintings, *Album of Landscapes*, of which three leaves are dated 1644, ink and colour on paper. The Metropolitan Museum of Art, New York.

continuity of Ming dynastic time, but on the contrary to build up, through a series of very different images, a world outside dynastic time.

While the individual leaves are not extremely small, they were painted with very fine brushes, so that the paintings (and above all their inscriptions) only become fully legible when they are inches from the viewer's face – a visual equivalent to the hushed tones of conversations that should not be overheard. In the present sequence of leaves (which may or may not be the original one), the album opens with an image that the painter himself describes in his brief inscription as 'An inlet much like the Peach Blossom Spring, and yet it is not'. We see a moored boat on the left, and on the right a path leading into the mountains. Were this indeed the Peach Blossom Spring invented by the fourth-century writer, Tao Qian, we would be able to assume that the fisherman had left the boat, followed the path, and entered a cave to find on the other side a utopian community living in peace and harmony, unvisited by tax collectors, made up of the descendants of refugees from an ancient war. This was the classic literary embodiment of the suspension of dynastic time, and a favourite subject of post-1644 remnant painters. In this case, however, Zhang Feng's inscription does not allow the viewer the security of a

Zhang Feng, leaf 3 from the *Album of Landscapes*.

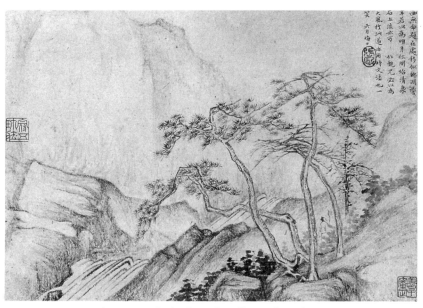

Zhang Feng, leaf 5 from the *Album of Landscapes*.

familiar fiction. Jarringly, he evokes escape only to suggest that it is unattainable.

In leaf 3, two men – perhaps Zhang Feng and the man for whom he painted the album, identified only by the name Beijin – sit in a back room of a house facing the garden, playing chess. One has the cap of a scholar, the other the hairknot of a Daoist. Wine gourds piled on a shelf are a further sign of withdrawal from public life. The garden wall, moreover, is partly ruined, while the gate in the wall for formal visitors, squeezed into the lower-left corner of the painting, is not only closed but is blocked off from the rest of the garden by thick bamboos. In contrast, we can see beyond the garden to the more utilitarian space of the courtyard and the side buildings, where a gate in the fence is conspicuously open, as if to welcome intimate friends.[10] Zhang's inscription turns out to hold its own dark surprise, qualifying the apparently idyllic character of the scene. The first three lines of poetry read:

> The red dust [of worldly affairs] does not pollute my doorstep,
> Green trees lean over, screening the corners of the house.
> Hazy mountains exactly fill the breach in the wall.

Following them, we learn that 'these lines are from a lyric (*ci*) by a Yuan poet', a poet, that is, who lived during the earlier period of Mongol conquest.[11]

In leaf 5, a single figure is framed by a group of pines: significantly, perhaps, there are four pines, instead of the canonical five, representing the various types of virtuous conduct. A mountain stream rushes past. 'The painting has no particular subject,' Zhang writes, 'it's just that where I was it was almost as if I could hear the sound of a mountain torrent. If you wish to take it as [Wang Wei's famous lines] "The bright moon shines through the pines; the clear stream flows over the rocks", you may. Brother Beijin will be thinking that Dafeng [Zhang Feng] also uses the methods of examination writing in painting. Ha!' One of the very few things we know of Zhang Feng's life at this time is that his response to the events of 1644 was to burn his examination notes, so the reference to examination writing is not only ironic but probably contains a political allusion as well. His citation of the eighth-century Wang Wei's couplet may be similarly pointed, for translated in a different way, it gives: 'The Ming moon shines through the pines, the Qing stream flows over the rocks.' The figure, framed by the pines, looks away from the rushing stream. The rigorous parallelism, evoking a tense equilibrium, is perfectly appropriate to the national circumstances of the summer of 1644.

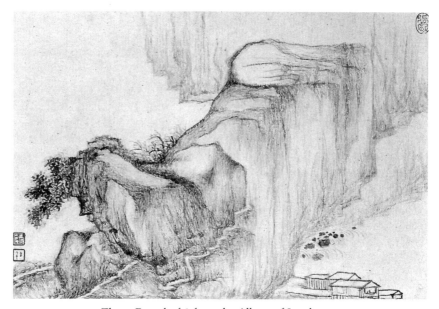

Zhang Feng, leaf 8 from the *Album of Landscapes*.

Zhang Feng, leaf 10 from the *Album of Landscapes*.

Just as he cited the Peach Blossom Spring utopia only to leave it out of reach, here Zhang Feng cites one of the canonical couplets of the lyric tradition, only to subvert it, transforming the evocation of utter tranquillity into its opposite.

Other leaves are uninscribed. In leaf 8, a massive ridge traverses the composition, separating the open space of a lake or river from the secluded enclosure where a few houses hug the bottom margin, with a lone, tiny figure visible within. A path snakes along the sides of the ridge, but seemingly makes no contact with the houses, leaving us to wonder where it leads. The ridge appears as the barrier against a world which, it implies, is hostile. In leaf 10 another snaking path traverses our view; where it comes from, where it leads to, are of no concern to the inhabitants of the scene. Flung out to the periphery of the image are a lone angler, a working fisherman, and – easily missed – Zhang Feng's own voice and presence, embodied in his oval seal. The angler echoes countless honourable recluse predecessors in the representation of interior exile, but his juxtaposition with a working fisherman adds a note of realism, prophetic of Zhang's post-1644 professional circumstances as a painter. An ancient tree, emblem of survival, anchors the scene, providing it with its centre of gravity. Against the implied movement of the road, the geometric patterns inscribed in the placement of the main motifs define a form of stasis.

Even after looking at only these five leaves, it is possible to map out and characterize the pregnant atmosphere of Zhang Feng's album. At a first level, the atmosphere is created by the abstraction of such moments from the flux of normal lived time, and their extension beyond reasonable bounds. But as the viewer passes from one landscape to another, their effect is cumulative, adding up to a dislocation of consciousness which removes the represented figure and the viewer from the specificities of dynastic time. The atmosphere of the album also has a specific emotional colouring, a mood that fluctuates between melancholy and desolation. This, no less than the accompanying dislocation, was to become a recurrent theme in remnant painting, as the principal expression of the feelings of loss attendant on the fall of the Ming. Indeed, the word most commonly used for the fall of the Ming dynasty was *wang*, referring to loss through death. The dynasty died and remnant painters such as Zhang Feng mourned its death, fulfilling their ritual responsibilities of mourning as surviving subjects by withdrawing from the world into the metaphoric space of exile known as the wilderness (*ye*). Like much of remnant painting, this very early album

could be described as articulating a wilderness iconography of with-
drawal through a poetics of loss.

This is not to suggest that all remnant painting was of this kind: there
was also, for example, an important poetics of guilt in remnant culture,
particularly associated in painting with the name of Chen Hongshou,
who took the name 'Belated Remorse'. Had not Ming intellectuals
contributed to the fall of their dynasty and the loss of their country by
their factionalism and materialism? Zhang Feng's depiction of four pines
rather than five in leaf 5 might be construed in these self-critical terms.

One can also identify a poetics of defiance that spoke of yet another
reaction to the Manchu invasion. Zhang most obviously contributed to
defiant painting of this kind in his more heroic works, such as his bold
portraits of the military tactician, Zhuge Liang, which bring to mind
Zhou Lianggong's biographical evocation of the artist: 'After the *jiashen*
year [1644] he burnt his study notes for the [advanced] examination.
Then putting on a short robe without the back part [i.e. dressed like a
soldier], and carrying a sword which was without a sheath and only
wrapped with hempen cloth, he went to the Northern Capital.'[12] Two
leaves of this album from 1644 edge on defiance. In one, a ragged flight of
birds returns to the sparse shelter of a withered tree that protrudes from
barren rocks at the centre of the image. In the other, a similarly centred
group of three bare but upright trees is pulled up to the surface of the
painting – thus confronting the viewer – by the horizontal brushstrokes
defining the rock outcrop on which they grow. The beginnings of a
bamboo grove soften the harsh scene with their implication of renewal.
One painting restates a wintry theme of hunger and cold from the period
of the Mongol occupation; the other is inscribed as being in the style of
the displaced Yuan-dynasty artist, Ni Zan.[13] Iconic images of survival,
these trees confront the world as signs, at once mute and eloquent, of the
artist's symbolic resistance.

In May of the following year, 1645, the city of Yangzhou, not far from
Nanjing, fell to the Manchus at great cost in human lives, and in June
Nanjing itself surrendered. In July, the Manchu authorities revoked their
initial suspension of the order by which the Chinese population had been
ordered to shave their foreheads and wear their hair in the Manchu
manner. This in turn led to renewed and ferocious resistance throughout
the Jiangnan region, which lasted into the autumn of 1645 and was
marked by several more huge massacres. In the wake of the brutal
Manchu establishment of power, many humiliated Chinese intellectuals
in Jiangnan took refuge in temples, where they could either conceal

Zhang Feng, leaf 6 from the *Album of Landscapes*.

Zhang Feng, leaf 2 from the *Album of Landscapes*.

themselves or take the full tonsure of a Buddhist monk, in order to avoid conforming with the haircutting edict. Although the main urban centres of Jiangnan were all under Qing control by the winter of 1645–6, resistance continued. Nanjing itself was attacked in September 1646, but the failure of the attempt announced what Frederick Wakeman has characterized as 'a general loyalist collapse throughout South China in the fall of 1646', from which the Ming resistance never recovered.[14]

The influence of Zhang Feng's uncomfortable vision of disorientation, which we have seen at its beginnings in 1644, can be seen in an album of ten landscape leaves which the much younger Gong Xian painted almost thirty years later, in 1671.[15] Indeed, the eighth leaf, an appropriately disjointed image, bears an inscription alluding to Zhang Feng as a friend who had often sought Gong's inscriptions for his work.[16] Gong himself spent most of the two decades after 1647 away from Nanjing, and only returned there definitively in 1666 to live in a house at the foot of the Mountain of Pure Coolness (Qingliang shan), which was located just within the western perimeter of the city wall, overlooking the Yangzi.[17] During most of Gong Xian's exile from Nanjing, the Ming resistance, while suppressed in the Jiangnan region, remained active and dangerous for the Qing in China's far south. Not until 1662 did the last of the Ming courts claiming succession to Chongzhen disappear, bringing the entire Ming dynasty (as a political fact) to an end. Gong Xian's 1671 album was thus painted in political circumstances vastly changed from those of Zhang Feng's much earlier album.

As is the case for that work, the leaves of Gong Xian's album reach us today in a sequence which may or may not be original: if there is a programme to be found in this or any other sequence, it has yet to be discovered. Unfortunately, the leaves have been severed from their original album context and are now mounted separately as hanging scrolls. However, the fold line down the centre of each leaf is an insistent reminder of the greater intimacy of the original folded format, which combined two smaller compositions into a third – the overall composition we now see. The eleventh leaf provides a commentary on the whole work:

On New Year's Day of the *xinhai* year [1671], sprinkling some tea about that I had specially set aside, I made sacrifice in the mountains to the vast heavens. I sealed my door and sat quietly, communicating with neither relatives nor friends. Having washed my ink-stone and tried out my brush, I brought out this plain album. I painted away like this for some ten days, but then my 'flower activities' became somewhat burdensome, and it was already the end of spring before I

finished it. I dare not say that I have enjoyed in full measure the unalloyed happiness of [this world of] man, and yet, compared with those who move attentively in the circle of ceremony and regulations, is not what I have attained much more? And so, I record this here with a smile. Resident of Half-an-Acre, Gong Xian. [seal] 'Left over in the wilderness'.[18]

Even at its inception, the execution of this work was clearly an event of some importance for Gong Xian. He aligns it with the beginning of the lunar new year, the new cycle of cosmic time, and locates himself cosmologically by a sacrifice in the mountains 'to the vast heavens'. He then empties his mind, breaking off contact with family and friends, and allowing himself to return to a state of quietude (this being one of the tropes of painting as self-cultivation). He prepares the inkstone, tries out the brush; finally, he brings out the 'plain' album. The theme is a familiar one, equating the creative process with cosmogony – the world spontaneously comes into being from an original non-differentiated state. However, it is the cosmological references of the first part of the inscription that are most relevant here, for they help to make preliminary sense of his comment on the finished work: 'I dare not say that I have enjoyed in full measure the unalloyed happiness of [this world of] man, and yet, compared with those who move attentively in the circle of ceremony and regulations, is not what I have attained much more?' We are to look for what he has achieved, not simply in the surface darkness, the lack of happiness, of his work, but in the favourable comparison between the order of his work and the order of 'ceremony and regulations'. Part of his claim is to have made contact with the moral order of the cosmos, in a way that 'those who move attentively in the circle of ceremony and regulation' could not do.

What he meant by this is made clearer by the present opening leaf of the album, which bears the following inscription:

Painting of the ancients compels respect and admiration from people when they view it. Like the Five Sacred Mountains, their peaks tower majestically upward. [From this] one knows for sure that they harboured no bits and pieces of mountains or tag ends of rivers in their breasts. This work derives from a study sketch by Lu Haoran [Lu Hong, active in the 8th century CE.].

The Five Sacred Mountains were, amongst other things, the symbolic guardians of the nation, while the term 'bits and pieces of mountains and tag ends of rivers' was a standard way of referring to the loss of the nation. By insisting, indirectly, that his own landscapes are not 'bits and pieces of mountains', Gong Xian makes the same point that another remnant artist, Bada shanren, would later make in a painting inscription

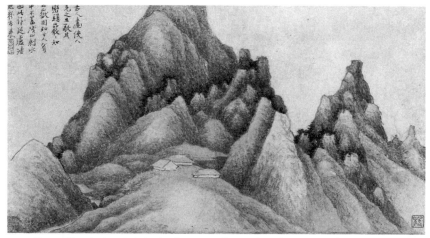

Gong Xian (1619–89), leaf 1 from an album of ten leaves, *Landscape Album [Shanshui ce]*, mounted as hanging scrolls, dated 1671, ink and colour on paper. The Nelson-Atkins Museum of Art, Kansas City, Missouri.

by claiming that the Yuan painter Huang Gongwang (whose style he was following) had continued to paint the mountains and rivers of Song.[19] The remnant painter could not accept the concept of a fragmented nation, any more than could the Qing state.

The reference to Lu Haoran (better known as Lu Hong), painter though he was, was probably meant to throw light less on the style of the painting than on its meaning. As we read in a text copied out by the loyalist artist Bada shanren in a 1702 album:

Emperor Xuanzong [r. 712–56] summoned the retired scholar of Songshan, Lu Hong, three times before he came, and then, when he presented himself at audience, he did not prostrate himself but merely bowed. The emperor asked him why he behaved in this way, and he replied, 'Ceremony is the weakest part of loyalty and trust, and cannot be relied upon. Your servant from the mountains, Hong, dares to present his loyalty and trust directly to Your Majesty.' Xuanzong was impressed, and commanded Hong to accept [various high positions and honours]. He refused to accept any of them.[20]

The mountain in Gong Xian's painting is thus Songshan, the Sacred Mountain of the Centre, here representing the emperor to whom Gong Xian presents his loyalty and trust directly. The Ming is identified, not as a specific dynasty, but as dynastic legitimacy itself, symbolized in mythic, cosmic terms.

If myth offers one form of dislocation, the dream offers another. Gong's inscription to leaf 6 reads: 'Having painted what I saw in a dream,

a friend now says, "The shores of the lake[s] in my Zhe[jiang] frequently have spots like this." We see villages, or a town, devoid of people but not ruined. If the village represents normal community life, one might suggest that for Gong Xian in his interior exile such normality was unrepresentable except as absence; an entire village or town was unrepresentable except as a dream.[21] In the painting, the unanswerable diagonal of the hillside leaves normal community life still further out of reach. This dream, with its geometricized surface structure, brings normal time to a halt.

A third form of dislocation is imagination, as in the effort to visualize what one has not actually seen. On leaf 2, Gong Xian writes: 'Some guests who came here from Changshan and Yushan tell me of the strange marvels of the landscape there. Taking up my brush, I record them here.' Changshan in the south-west corner of Zhejiang, and Yushan across the border in Jiangxi, marked the crossing-point between the two provinces. From Changshan one could travel by boat down the Fuchun River to Hangzhou, while from Yushan one could sail down the Xu River to Lake Boyang and the city of Nanchang. Between the two towns, however, one had to travel overland, so the image seemingly cannot refer to the journey between these two out-of-the-way, but strategically located, towns. Gong Xian does not tell us what, in his guests' description, stimulated his imagination. The stepped overlap of the boats echoes the oblique ridges of the foreground outcrop, suggesting movement, the flow of water. But then the movement is cancelled by a hidden geometry at the centre of the image: the top edge of the outcrop is perfectly horizontal on either side of the vertical axis, which is itself echoed in the stiff trees. A cove on the left corresponds to the boats on the right; a narrative is promised but not delivered: instead the artist operates a temporal short-circuit.

Although these pictorial strategies are reminiscent of Zhang Feng's album, they also differ in one fundamental way. Gong Xian's album depicts a world in which dislocation has a complex logic and confident equilibrium comparable to that of any reality. As he notes on the ninth leaf, 'The reality [of the scene depicted] here does not come up to what emerges from the paper and brush.' The implied diamond figure, the hint of a horizontal line traversing it – these are enough to ground an impossibly isolated pavilion in a dystopian stability. This album is not a shocked, disoriented response to the transfer of ownership, but a self-conscious symbolic refusal to allow possession. The painter is without illusions, and perfectly reconciled to his symbolic role. Thus, in leaf 10 –

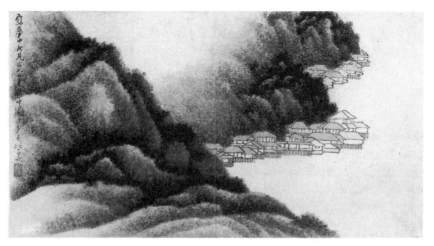

Gong Xian, leaf 6 from the 1671 *Landscape Album*

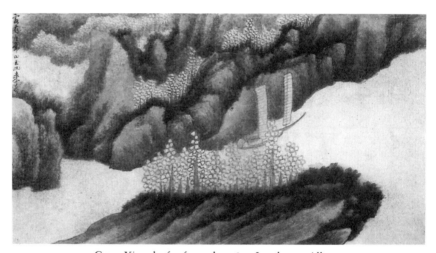

Gong Xian, leaf 2 from the 1671 *Landscape Album*

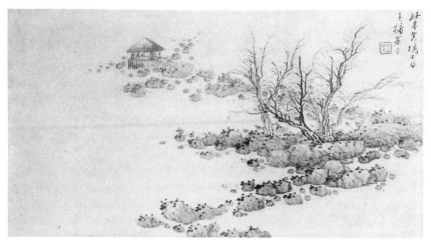

Gong Xian, leaf 9 from the 1671 *Landscape Album*

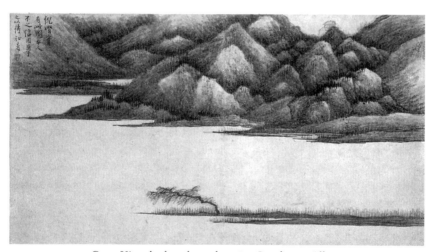

Gong Xian, leaf 10 from the 1671 *Landscape Album*

his interpretation of, and identification with, Ni Zan who painted under the Mongols – a lone, bent willow claims the vastness of the lake against the wall of mountains that weighs down upon it from above. The stockade-like structure in the upper right may be a reminder of contemporary circumstances: Lake Tai, as the reference to Ni Zan suggests this lake to be, was a troublesome centre of unrest for the Qing. As such, in the present sequence of leaves, this leaf provides an image of illegitimate oppression at the end of the album to answer the image of dynastic legitimacy with which it opens.

Gong Xian's visualization of the limbo of interdynastic time in this album goes beyond the poetics of loss that characterized Zhang Feng's album. Certainly, the melancholy and desolation that characterize the poetics of loss are present here, too, in the sombre stillness and the lack of human figures. But alongside this is a poetics of defiance that in Zhang's album is only anticipated by his iconic images of barren trees. It takes form in the lone tree that seems to defy the weight of the mountain wall, in the sacred mountain to which Gong Xian gives symbolic form, confronting us with it as if hoisting a flag, and in the visual barriers by which he prevents the viewer's easy access into the space of each painting. Resistance is here given symbolic form, exposing the gap between Qing authority and legitimacy. True, such imaginative resistance was always compromised, as it offered an escape from the death to which uncompromising courage would have led – as so many demonstrated in 1644. But what it lacked in finality, it made up for in endurance, as the painter stubbornly incarnated the memory of the fall of the dynasty, and of the nation, across the decades, locating himself in the interdynastic limbo – that is, in the dynastic boundary itself, which he thus prolonged. The necessary individualism of the gesture should not obscure its significance for the community. If such uncomfortable pictorial visions enjoyed widespread respect it was because the artists' articulation of broadly shared feelings of loss, hostility and guilt freed others to return to normal life.

Gong Xian lived on until 1689, through events and slower changes which gradually transformed the social significance of the remnant artists. In 1674, three Chinese warlords who had helped the Manchus to establish power turned against their former masters, and initiated the uprising which the Qing government termed the Rebellion of the Three Feudatories. After a moment of great danger for the Qing dynasty in 1674, the Qing soon gained the upper hand both militarily and in terms of public support, though the rebellion was not crushed until 1679. This

victory transformed government policy in the following decade, from 1679 to 1689. By 1679 the young Kangxi emperor felt secure enough to begin making active overtures toward southern intellectuals. In that year he decreed an extraordinary examination, many of the nominated candidates being drawn from remnant ranks. Five years later, in 1684, he essayed a first Southern Tour of inspection, which took him to Nanjing, where he was careful to pay his respects at the tomb of the Ming founder, Zhu Yuanzhang, located to the east of the city. In early 1689 the emperor came south again, this time to general acclaim. Kangxi used this decade to make it clear that remnant sensibilities would be respected, and remnant figures left in peace.

It was in 1689, the year of his own death in mysterious circumstances, that Gong Xian painted an extraordinary landscape hanging scroll that is now in the Honolulu Academy of Arts.[22] Ostensibly an art-historical work, a self-conscious exploration of the landscape painter's heritage, it also incorporates, as I shall try to show, a complex political discourse in and behind its stylistic concerns. In this work, Gong looked back to the origins of the landscape tradition to paint a mountainscape in which the heaped, rounded forms ultimately come from the southern artist Juran (active *c*. 960–85), while the towering mountain seemingly derives from such early northern landscapists as Li Cheng (919–67) and Yan Wengui (967–1044). These parallel references to the early landscape realism associated with the period of the Five Dynasties and Northern Song dynasty – when landscape and nation first became thoroughly identified in painting – are filtered through the calligraphy-inspired assertion of the painting surface which was the later innovation of literati painters under the Yuan dynasty. Gong Xian's dense inscription interweaves issues of social status, style and artistic lineage, but it is the last aspect that is most relevant here. Gong's opening words confirm the modern, art-historically informed view of the painting's antecedents:

In painting, one must make an orderly arrangement of the principles of the Song and the Yuan; afterwards, these may be distributed freely and [one's painting] will be of the untrammelled class.

Yet, the final part of the inscription puts the painting in a rather different light:

Mengduan [Wang Fu, 1362–1416] and Qinan [Shen Zhou, 1427–1509], in later years used Ni [Zan, 1301–74] and Huang [Gongwang, 1269–1354] for amusement, but for basic fundamentals they relied on Dong [Yuan, d. 962] and Ju [ran]. And these have truly been my own masters! I write this at the conclusion

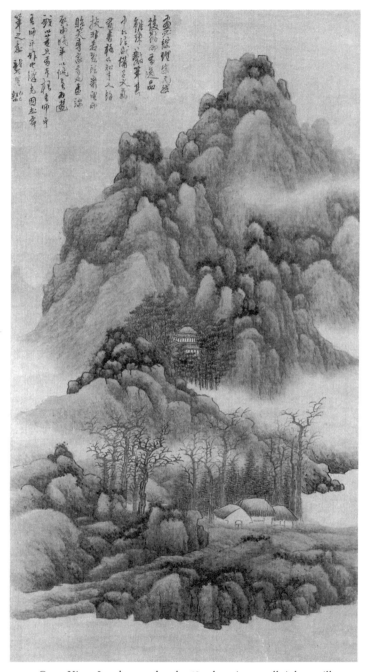

Gong Xian, *Landscape*, dated 1689, hanging scroll, ink on silk.
Honolulu Academy of Arts, Honolulu, Hawaii.

of this work on silk in order to set forth the intentions of my brush. Gong Xian, in the *jisi* year [1689], at the time of the 'grain-rains' [late spring].²³

What is curious here is Gong's exclusion of northern painters from his list of antecedents. To be sure, his roster of painters recognizably evokes the concept of a Southern School of landscape painting, a concept associated above all with the name of the influential artist and critic, Dong Qichang (1555–1636). But when Dong argued in the early seventeenth century for a southern tradition as the orthodox lineage of landscape painting, 'southern' had a metaphoric and not a geographic meaning. Dong's Southern School included several artists of northern origin: notably, the Five Dynasties (907–60) artists Jing Hao and Guan Tong were prominent in his listing. Dong Qichang's Southern School theory was widely influential in Gong Xian's time, both among artists associated with Qing power and among remnant artists. But in Gong Xian's transformation of it to a narrower, geographically influenced formulation, the six painters Dong Yuan and Juran, Ni Zan and Huang Gongwang, Wang Meng and Shen Zhou define a south Chinese tradition.

The roster of masters in this inscription was not an arbitrary selection. It is clear from Gong Xian's many other theoretical inscriptions that the northern artists Jing Hao and Guan Tong had little place in his system. What is more, in his eyes the early northern masters who would normally have been considered followers of Jing Hao and Guan Tong – Li Cheng, Fan Kuan (*c.* 960–*c.* 1030) and Guo Xi (*c.* 1010–*c.* 1090), for example – were seen to derive their art from the southerners, Dong Yuan and Juran. In fact, the most important figure missing from this inscription (in the sense that Gong often cites him elsewhere) was yet another southerner, Mi Fu (1051–1107). Gong was not the only late seventeenth century painter to favour such a restricted canon: these are much the same artists to whom Bada shanren (like Gong Xian a fervent admirer of Dong Qichang) returned again and again during the 1690s and early 1700s, again largely omitting northern painters from Jing Hao to Guo Xi. The explanation for the restricted canon of these remnant artists may lie outside the realm of art altogether. Richard Barnhart has pointed out that Bada shanren, taking his cue from earlier loyalist artists such as Zheng Sixiao – who took the name, Suonan, or 'Face South', after the fall of the Song – 'symbolically faced the south in his landscape paintings, as he did in every aspect of his life after 1644'.²⁴ By defining a southern, orthodox tradition of landscape as a geographically southern tradition, Gong Xian and Bada shanren were asserting the place of the south, and especially Jiangnan, as the cultural centre of the Chinese nation, in contrast to north

China – which had fallen to the Manchus first, which had supplied the vast majority of early collaborators, and where the Qing capital was now located. Narrowly art historical as it seems, Gong's inscription is equally a political statement: he is refusing to align China's cultural centre with its political centre, and he is doing so within a month of Kangxi's visit to Nanjing as the new Son of Heaven coming south to bring Jiangnan fully into the orbit of Beijing.

Within the parameters of Gong Xian's aesthetic universe, the classicism of the 1689 hanging scroll represents a radical shift of approach from what we have seen in the 1671 album leaves. Those were austere views from the margins – margins to which Gong Xian had been thrown by the utter disruption of his life. There was no room in those paintings for the traditional rules of hierarchical order. Instead, Gong Xian's recurrent use of surface geometry – the ancient visual rhetoric of moral order – allowed him to bypass the rules of hierarchy to construct a compositional stability and monumentality of a radically different kind. That order had a fundamentalist character, corresponding to the claims in his final inscription for a direct contact with the moral order of the cosmos. In contrast, the composition of the 1689 hanging scroll restores the primacy of the ancient rules of hierarchical order current from the tenth to the fifteenth centuries in the works of the painters cited in his inscription: orderly recession, a load-bearing base, a stable centre, primacy of the cardinal axes. Nor was the 1689 landscape a new departure; the painting shows the fruits of Gong Xian's general pursuit of a more peaceful stability from the late 1670s onwards.

The earlier dystopian vision had gradually become unviable for Gong himself, who continued to respond as a person and a painter to his contemporary (and changing) circumstances. The shift in Gong Xian's late work is not merely the abandonment of an earlier approach but, through the embracing of classicism, a reconciliation with the tradition.[25] In order to seize its significance, it is helpful to take a broader perspective on late seventeenth century painting and make the connection with non-remnant artists. The painting of literati associated with Qing officialdom over the fifty years following 1644 demonstrates a consistent preoccupation with continuity, for which classicism was the pictorial language of choice. Whether it was the early landscapes of Cheng Zhengkui (1604–76) during his tenure as head of the Board of Rites in the late 1640s and early 1650s, or the work of Wang Shimin (1592–1680) and Wang Jian (1598–1677) from the 1650s to the 1670s, or that of Wang Hui (1632–1717) and Wang Yuanqi (1642–1715) in the 1690s and later, the ideal of

political and cultural continuity through Chinese officials was indirectly affirmed through an appeal to a concept of culture that transcended dynastic boundaries, and which was formulated in painting as a canonical tradition. Certainly, Gong Xian's canon was different from these artists, as was Bada shanren's, and he would not have associated his classicism with the Qing cause any more than Bada shanren would have done. What we can say is that in making this shift, Gong Xian moved his poetics of loss and defiance on to a terrain – that of a discourse of stability – to which the success of the Qing had given legitimacy.

Gong Xian's 1689 painting depicts a landscape which is in its own way lush and rich: the uncompromisingly barren trees around the foreground homestead seem almost out of place, left over from another landscape. The painting, in short, proffers a vision of a calm and peaceful nation. As such, it should be seen in the context of the metaphorically laudatory landscape paintings which were painted for presentation to Kangxi during his southern tours in 1684 and 1689, sometimes voluntarily and sometimes at the request of Qing officials.[26] Metaphoric political meanings may also be visible in the way Gong chose to give the date: *jisi*, 'the grain-rains'. The period known as the grain-rains fell in the third lunar month. Gong Xian's choice of the festival name, the grain-rains, over a simple monthly date, is unusual: the term itself refers to the spring rains that will bring forth all the potential abundance of the earth. Rain, of course, was closely tied to the mandate of Heaven: it was the Emperor's ancient role to ensure adequate rain and to prevent droughts and floods. Indeed, rain patterns attracted enormous attention in this period, both from Kangxi himself and from intellectuals, and rain-related themes provided one of the political discourses of painting.[27] Given that this painting, so dated, was executed immediately after the Manchu emperor completed his southern tour, a main purpose of which was to inspect the state of waterworks, it seems certain that the date indicates a political dimension to the painting. It is much less certain, on the other hand, how the painting should be interpreted, except that it can hardly have been meant to celebrate the achievements of the Qing.

As the gap between authority and legitimacy rapidly disappeared, leaving nothing to expose, the whole basis of remnant art necessarily shifted. All around them, artists like Gong Xian saw the reconstruction of the country and the formation of a new national identity. Having served as the conscience of a generation, taking upon themselves the guilt of failure and the responsibility of mourning, they now came to represent a world of old-fashioned and increasingly marginalized values. They had from the

first been engaged in the struggle over national identity; now that the terms of the struggle had changed, the price of their continued participation was a transformation of their own role. It seems fair to say that the classicism and the peaceful vision of Gong Xian's 1689 painting were made possible – though they are not explained – by Qing respect for him and those like him and the role they had chosen to play. One can also safely argue that Gong's acknowledgement of that respect implies on his part a tacit recognition of the Qing as more than simply a disruptive force. And this in turn implies the historicization of the Ming, for it meant the restoration of dynastic time with its inexorable logic of succession. But how can we reconcile this with Gong Xian's undoubted life-long devotion to the Ming cause?

It is at this point that one can look again to mourning as the remnant artist's fundamental imperative. Most crucial is the fact that the decorum of mourning required that it not be taken to unreasonable lengths. Thus the classical text, the *Liji* [*Book of Rites*], stipulates: 'Three years are considered as the extreme limit of mourning; but though (his parents) are out of sight, a son does not forget them.'[28] And again: 'The rites of mourning are the extreme expression of grief and sorrow. The graduated reduction of that expression in accordance with the natural changes (of time and feeling) was made by the superior men, mindful of those to whom we owe our being.'[29] Looked at in this way, if the remnant artists as bereaved subjects of the Ming embodied the memory of the dynasty, at the same time those of them who lived on as late as 1689 might well be expected to have gradually softened their symbolic opposition.[30] This argument provides a context for understanding the painting's iconic dimension, its character as an image, and in the process Gong Xian's reference to the 'grain-rains'. The symbolic centre of the mountainscape, and at the same time the geometric centre of the composition, is marked by a large formal structure – a two-storey building with a hipped double-roof – nestled in the mountainside within a dense and extensive grove of pines. This building, in Jerome Silbergeld's evocative description, 'seems to glow with an inner light, as if having gathered into its custody all the eerie lights that had disturbed his earlier landscapes.'[31] At ground-level next to the water, meanwhile, framed by barren trees and bamboo, a homestead composed of three simple buildings confronts the viewer. A stretch of water at the bottom of the painting cuts off the viewer physically and psychologically from the almost face-like home, which seems easily understandable as the artist's metonymic self-reference, and exists in the protective shadow of the mountain and the important building at its centre.

Clearly, this painting is as much about these buildings and their hierarchical relationship as it is about a mountainscape. What is the building at the centre of the image? And does it relate to any real building? Many paintings by remnant artists in Nanjing, including Gong Xian himself, had a topographic reference, partly because Nanjing had been a Ming imperial city and was littered with Ming sites, and partly because topographic painting was part of the heritage from late Ming painting. Among the places which attracted the attention of these painters was the site of the tomb of the Ming founder at Mount Zhong (Zhongshan), amid the densely wooded Purple Gold Mountains (Zijin shan) to the east of the city. In their pictures, a two-storey formal building, nestled in a grove of conifers, identified the site from afar. Two identified depictions of the site by Hu Yukun (active *c.* 1630s–70s) make it possible to identify an unidentified 1682 album leaf by another remnant artist in Nanjing, Gao Cen, as a representation of the same subject, on the basis of the two distinctive structures at its centre which are also found in Hu's two paintings.[32] Taking even more liberties than Hu Yukun, Gao Cen has transformed the low hills of Zhongshan into a monumental mountainscape, the better to bring out the symbolic importance of the scene. The striking similarity of Gao's image to Gong Xian's 1689 painting, in turn suggests strongly that this truly monumental work is yet another, and still further transformed, representation of the Zhongshan mausoleum. It is true that there is only one structure at the painting's centre, rather than two, and that we do not see the wall of the mausoleum precinct. However, the point is not to make of Gong Xian's painting a topographic work, since his preoccupation here as elsewhere in his work is quite clearly with a symbolic landscape structure. Rather, my suggestion is that Gong drew upon the symbolic landscape of Nanjing in elaborating his own landscape image. We may assume that, for Gong Xian, no building in all of China could have laid a greater claim than the Ming founder's tomb – the pre-eminent icon of the Ming cause in the south – to the visual rhetoric of the 'centre' with which he dignifies this building. As we have already seen in his 1671 painting of Mt Song, this is a rhetoric which he associated with dynastic legitimacy. The issue of legitimacy was, of course, particularly alive in this spring of 1689 following Kangxi's triumphal southern tour. So too was the symbolic status of the Zhongshan mausoleum, for in 1689 the Qing emperor once again made a point of visiting Zhongshan to claim the Ming founder as his political ancestor, pouring the libations with his own hands.

This landscape is, then, a vision of the Ming nation, since one cannot

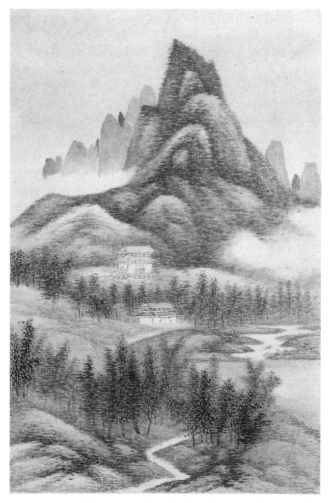

Gao Cen, *Album of Landscapes*, dated 1682, leaf 4 from an
album of eight leaves, ink and colour on paper.

imagine this die-hard Ming loyalist invoking the Song national landscape
and the life-giving power of spring rains to celebrate the Qing dynasty.
Gong Xian's death, barely half a year later, was attributed by his friends
to harrassment by some powerful figure with whom he refused to
cooperate, the implication of their veiled accounts being that the person
represented Qing power.[33] The painting is all the more precious because
visions of the Ming nation as a complete thing seem to have been rare.
Perhaps the reason is that to represent the Ming as a closed entity was to
step outside it – to step to the very edge of the interdynastic experience,

and thus to the very edge of Qing dynastic time. This image of the Ming dynasty depicts a national landscape centred on the south, and on Nanjing. At the symbolic centre of the remnant painter's Nanjing, as the counterpart to the Forbidden City in Beijing now occupied by the Qing emperor, is the tomb of the Ming founder – the very sign of dynastic death. In the shadow of this 'spirit palace', as tombs were sometimes called, there stand the houses that are the signs of Ming community; but these are houses whose inhabitants are to disembodied to be representable. What we see here, I believe, is proof of a sort that the remnant subject – much like the fisherman who passed through a cave to the utopian world of the Peach Blossom Spring beyond – by turning away from the normality of dynastic time into the dynastic boundary itself, found his way to a world that from one standpoint can be termed interdynastic, but which in the terms we see here is better described as the Ming dynastic afterlife. It is a realm of idealized but ghostly peace and prosperity that in the end is not unlike the interior of a tomb: Gong Xian could not have been more faithful to his subject. One must wonder if we do not have here a partial explanation of the lack of human figures elsewhere in Gong Xian's work, and in the work of many other remnant painters.

Elegaically, the landscape offers a vision of the Ming's greatness that would certainly not have been possible in the years before the fall of the dynasty. Perhaps in conscious symmetry to contemporary representations of Qing power, the Ming is visibly idealized, the memory of its governmental incompetence and societal disruption repressed. The central reference to the Ming's hopeful Hongwu beginnings fits in with this, as does the fact that Gong traces the landscape tradition no further than Shen Zhou, who died in 1509. Just as the deceased parent underwent a process of idealization in the transition from life presence to ancestral presence, so too the lost Ming was finally represented by Gong Xian in an idealized fashion – an idealization that was a condition of its being represented at all. One may suspect a recognition of the negative, purely imaginary status to which Gong Xian's vision is condemned in the way that he has allowed mist to encroach from both sides, and has left the foreground riverbank strangely floating, like an island of the immortals, as if the mountainscape might at any moment begin to drift free of its moorings and slowly disappear from sight, bearing with it the artist himself. Indeed, only the deaths, now imminent, of the final remnant subjects of the Ming would bring the Ming-Qing boundary to a complete end, and free the dynastic record to reduce the boundary to the brief linear moment of 1644.

6

Lady-Scholars at the Door:
The Practice of Gender Relations
in Eighteenth-Century Suzhou

DOROTHY KO

At ten, [the boy] went to a master outside, and stayed with him [even] over the night. He learned the [different classes of] characters and calculation . . . A girl at the age of ten ceased to go out [from the women's apartments]. Her governess taught her [the arts of] pleasing speech and manners . . . *Book of Rites*[1]

That the ideal Confucian society operates on a strict gender division is common knowledge. Since men and women were to occupy distinct social and physical spaces, such didactic texts as the *Book of Rites [Li Ji]* taught that it was only proper for them to internalize and embody this distinction from a tender age. The premise of this essay, however, is that this insistence on gender distinctions and separate male/female spheres is more a prescription for an idealized order than a description of real-life behaviour and experiences. As powerful as the normative male/female boundaries were, they did not consign men and women to compartment-alized fields of action, as scholars have often assumed. This essay offers a more dialogical view of gender relations by examining the terms of interaction between ten women poets and their male teacher in an eighteenth-century artist's community.

If Confucian norms could in fact dictate the realities of gender interaction, Ren Zhaolin (*fl.* 1776–1823), a Suzhou man of letters, would not have been able to call the ten women to whom he taught poetry and music his 'women-disciples' (*nüdizi*). The male teacher/female student relationship was doubly dubious in the eyes of the propriety-minded: not only did physical contact and intellectual exchange between teacher and disciple mock the supposed boundary between the man's sphere and the woman's, the very idea of women's education came dangerously close to overturning an overt assumption of patriarchy – the moral and intellec-tual inferiority of the weaker sex. Worse still, in the case of Ren, he proudly publicized his students' poetic achievements by compiling an anthology, *Selected Verses of Suzhou Ladies [Wuzhong nüshi shichao]*

which he published in 1789.[2] Yet curiously, while Ren's more famous (and infamous) contemporary Yuan Mei (1716–98) came under posthumous attack for gathering over fifty female disciples in the last fifteen years of his life, Ren Zhaolin and his students emerged as erudite symbols of community pride on the pages of local histories.[3]

The very existence, let alone its visible and respectable status, of a women's poetry circle under male auspices suggests a curious gap between the ideological rigidity of separate spheres and their laxity in practice. The personal and group dynamics of Ren and his ten lady-followers in this uncharted space comprise the subject of this essay. Analysing the names by which members of the group called themselves and the relational terms they used to address each other, I investigate two related processes: the crafting of an educated woman's personhood, as well as the making of hierarchies that informed both male/female and female/female interactions. In so doing, I argue that gender relations cannot be understood solely from the dead letters of moral precepts on the printed page; rather, they are to be sought first and foremost from the dynamic and personal relationships in everyday practice.

Viewing gender relations as individual and inventive acts does not imply that men and women interacted as equal parties, or that gender is the only category that mattered to social intercourse. In fact, I will show that the very terms of individual address used by Ren and his students were related to certain critical junctures in the social system – junctures where various hierarchies intersected. From this perspective, the so-called 'dominant power structure' or 'patriarchal system' was not a static, monolithic entity that routinely assigned fixed roles to men and women. Rather, this power structure itself was a product of contests between hierarchies that were constructed on both ascribed and achieved criteria – gender, age, religiosity and level of education or literary talent. The male teacher/female disciple relationship provides an intriguing example of the ambiguity of meaning that this process engendered to the men and women concerned.

Men teaching women: an illustrious genealogy

As teacher and patron, Ren Zhaolin was *sine qua non* to the exclusively female public poetry club that called itself the 'Ten Poets of Wuzhong [Suzhou]' [*Wuzhong shizi*] or the 'Clear Brook Poetry Club' (*Qingxi yinshe*). All ten members were Ren's disciples in the art of poetry and music; one of them, Zhang Yunzi (b. 1756), was also his wife.[4] The two names of the group are illustrative of the two frames of reference against

which the women established their collective identity: 'Ten Poets of Suzhou' situated them on a male-female axis, for it alluded to a famous male poetry society, the 'Ten Xiling [*Hangzhou*] Poets', and was most probably designated by Ren. 'Clear Brook Poetry Club', in turn, was named after one of the courtesy names of Zhang Yunzi – Clear Brook. As such it established the group's identity on a female-female axis. The next section of this essay examines the male-female axis by studying the roles that Ren assumed as teacher, while subsequent sections analyse the dynamics between the ten women themselves and the imagined communities that they constructed.

Ren's patronage of women poets was sanctioned by local culture and intellectual history. Since the late sixteenth century, gentry lady poets, poetry clubs and publication of their verse have flourished in the commercialized region of the River Yangzi delta, known as Jiangnan. By Ren Zhaolin's time, not only was it common for daughters from affluent families to receive a sophisticated cultural education from mothers or female tutors, there also existed a tradition of women seeking poetic instruction from men of letters.[5] While Yuan Mei was singled out for castigation after his death, he was neither the typical nor the first teacher of poetry to women.

Ren Zhaolin himself noted an illustrious tradition of men instructing women, which began with the famous early-Qing poet Mao Qiling (1623–1716), a leader of the 'Ten Xiling Poets', and was continued by other equally eminent literary leaders or philological scholars: You Tong (1618–1704); Hui Dong (1697–1758); Shen Dacheng (1700–71) and Hang Shijun (1695–1772). Yuan Mei was not mentioned because his first female pupil enrolled in 1783, four years after the publication of Ren's anthology.[6] While these early teachers had no more than one student each, Ren Zhaolin established the precedence of a multiple following, a pattern that became associated with Yuan Mei. Ren's links to this respectable tradition of male teachers were direct and personal: You Tong's daughter, Danxian, became his student; a woman who studied with both Shen Dacheng and Hui Dong, Xu Xiangxi (1728–62), was Zhang Yunzi's teacher.[7]

Unlike his predecessors, Ren Zhaolin enjoyed no national fame and possessed no degree higher than 'licentiate'. A well-to-do native of Zhenze, centre of silk production in the Yangzi delta, Ren led an idyllic life on a Suzhou lakeshore, calling himself 'Recluse in a Forest Shed' (Linwu shanren).[8] His intellectual pedigree, however, firmly linked him to the community of professional Han-learning scholars that flourished

in eighteenth-century Jiangnan. Eschewing the empty Neo-Confucian speculations of the Song dynasty, these empirically-minded scholars championed Han dynasty scholarship as a way to re-imagine antiquity and the Confucian canonical tradition. Qian Daxin (1728–1804), whom Ren called 'my teacher', was a foremost practitioner of Han evidential scholarship. In fact, it was Qian who first suggested that the poetry of Ren's disciples, being 'serene and exalted', was worthy of publication.[9]

Although women's learning was not a central tenet of evidential scholarship, it is no accident that Han-learning scholars – from the renowned Hui Dong and Hang Shijun to Ren himself – took the lead in teaching poetry to women.[10] The fact that they did not busy themselves with apologetic treatises defending their action bespeaks these scholars' matter-of-fact assumption of the propriety of poetic education for women. The reasons for this assumption have to be sought in the classical revival championed by evidential scholars in particular, and a prevalent valorization of the female poetic voice in the Jiangnan market towns in general.

Evidential scholarship enabled its practitioners to construct new visions of social and cosmological orders, and to re-think the place of men and women in them. The evidential scholars' commitment to subject all classical texts to a critical re-reading led to an erosion of the moral certainty of the Neo-Confucian orthodoxy in the eighteenth century. Received social and gender hierarchies, couched in such rigid dichotomies as high/low; respectable/mean or moral principle/human emotion, lost their aura as natural orders.[11] Those relegated to the bottom rung of ideological hierarchies – the young, the debased, females – were said to partake of the same human-ness, of which *qing* (emotion, feelings, sincerity) was an important marker.

Women, in particular, were no longer presented as mere moral metaphors, or as cogs in the political machinery that manufactured creeds of loyalty and chastity. A telling example was the famous scholar Dai Zhen (1724–77), whose unabashed sympathy for the moral dilemmas faced by the wives of itinerant merchants lent poignancy to his indictment of Neo-Confucian moralists who 'used moral principles to kill people'.[12] This recognition of a woman's human qualities translated into an affirmation of her intellectual and moral potential.

Even more pertinent than the recognition of a woman's moral and intellectual abilities was a valorization of her poetic voice. While eighteenth-century scholars generally considered research and scholarship a higher pursuit than poetry for the male literati, this preference

order was reversed for women.[13] For the evidential scholar, this was often couched in terms of an attack on the contrivance of the Chinese poetic tradition as it had existed since the Tang dynasty (618–906). The female voice, in contrast, was perceived to be sincere and serene by virtue of its marginality to the male-centred Confucian learned tradition. This valorization, first promoted by the commercial print culture in sixteenth-century Jiangnan, gained currency at the same time as its antithesis – that poetry is mortifying in that it causes woman's moral and physical downfall.[14] The tension that ensued from this pair of opposite constructions in a woman poet's self-perception merits a separate study; suffice it to note here that the warnings that poetry could kill failed to deter men from teaching poetry to women, or to deter women from writing.

Ren Zhaolin, taking clues from his teacher Qian Daxin, spoke of the exaltation of the female voice, not of poetry's consumptive dangers. In a preface that Ren wrote for the anthology of his students' poetry collections, he followed a familiar tactic in praising the classic *Book of Songs* [Shijing] which contained many ancient poems by women, as a precedence for both a purer form of poetry and for a role for women in its creation. Defending the naturalness of the woman's voice against critics who charged that the women's verse produced in the Song (960–1279) and Yuan dynasties (1279–1368) was laden with ornate expressions and sentimentalism, Ren Zhaolin contended that the entire poetic tradition was at fault, and one could not blame the women.

Ren went on to explain how a woman can be taught to emulate the *Songs* to resuscitate antiquarian ideals: 'It was mentioned in the *Rites* that there were four womanly virtues – "the word" was one of them. Hence many poems in the *Book of Songs* were composed by women. The Sage [Confucius] selected them as part of the classical canon, saying that [people who are] mild and gentle, sincere and good, they have been taught from the *Songs*. . . . In our days, women who pursue the poetic art should begin by studying the *Songs*, followed by reciting the gems from the mid-Tang period and before.'[15] In other words, Ren encouraged the women around him to rediscover the original intention of the Sage through the practice of poetry, much as philologists were called upon to unveil the unadulterated form and true meaning of classical texts.

In short, Ren's commitment to teaching women was rooted in the larger context of his training in evidential scholarship and the interest in women's poetic pursuits in the Jiangnan academic community. As such,

his relationship with his disciples differed both in rationale and content from that of his more controversial counterpart, Yuan Mei. Yuan's disdain for hair-splitting philological inquiries was matched by his contempt for conformity in behaviour and orthodoxy in thought. Unabashedly, he fashioned himself as a poetic genius, and as a lover of books and of sensual delights. Yuan's approach to life informed his views on the nature of poetry: 'Poetry is born of feelings (*qing*), and the most primal feeling is none other than that between a man and a woman.' The thrill he felt when he came across a choice verse was akin to the excitement of setting eyes on a breathtaking beauty.[16] That is to say, Yuan Mei considered the company of women essential to his poetic excellence; the relationships between him, his women disciples and their poetry were mediated by the all-pervasive force of *qing*.

'*Qing*', a concept in vogue since the late Ming period, denotes 'one's true nature' and, by extension, 'resonance with others'. Although often rendered as 'emotion' or 'love' in English, its connotations transcend mere physical love. After Yuan's death, critics charged that he had licentious affairs with his students. But no evidence was given, nor were these charges levelled at the time of the alleged transgression. Yuan's fifty-odd pupils were respectable ladies, and mostly hailed from well-known official families in Jiangnan. While Yuan admittedly had his share of sexual foibles with other women, it seems that what he valued most from his pupils was emotional and poetic resonance, not sexual union.[17] This resonance alone, compounded by Yuan's life-long pursuit of freedom beyond convention and artificiality, was sufficient grounds for offence in the eyes of his critics. Seen against the good repute of Ren Zhaolin and his students, it is clear that what Yuan's critics found most offensive was his libertine approach to life and literature, not the male teacher/female student relationship per se.

The consistent recruitment pattern of Yuan's disciples bespeaks the uniqueness of his case. First, these women were overwhelmingly the wives or daughters of Yuan's male disciples or friends. Only two came to admire Yuan's works through other women. Second, many were said to have requested lessons from Yuan by presenting him their poems. In most cases, it was the women who made the initial contact. Third, Yuan did make occasional trips to visit and coach his students and to recruit new ones.[18] In short, these were primarily personal relationships crafted between Yuan and the pupil concerned; the women did not see themselves as belonging to a group. Moreover, these relationships were often tenuous, maintained by occasional exchanges of verse in the mail,

or hardly maintained at all. As such, these famous cases of Yuan Mei's tutelage are too particular to be indicators of the terms of gender interactions among the educated class in eighteenth-century China.

Ren Zhaolin and the Suzhou Ten: the male-female axis

In contrast, the dynamics of Ren Zhaolin's circle were forged out of everyday contacts both between Ren and the students, and among the women themselves. Geographical proximity – all were residing in Suzhou – allowed them to interact frequently and to exert deep influence on each other's artistic and intellectual lives. This propinquity of residence and, for most, in native place as well, provided a natural milieu for the group's sociabilities – one that was not solely dependent on the highly individualized relationship of *qing*. Thus anchored in a time-honoured attribute of identity in Chinese society, the relationship between Ren and his students was shrouded in respectability. Not only were there no charges of scandal, as far as we can tell, their erudition was often valorized by local people as a mark of Suzhou's sophistication.

Superimposed on the natural affinities of local ties was a second unifying factor, based on the academic tradition – the notion of an artistic or scholastic 'school' (*men*, literally 'door'). The ten poets were aware that, whatever personal intimacies or strifes they might have, they all partook in an artistic community that was symbolized by Ren's 'door'. They commonly referred to each other as 'fellow students' (*tongxue*), while addressing Ren by the honorific 'master' (*xiansheng*). The only exception was Zhang Yunzi, who, being the master's wife, was most often respectfully called 'madam' (*furen*) by the other women.

Not all 'fellow students' were equal. While Zhang enjoyed a higher status by virtue of her marriage, others excelled because their teacher deemed them more worthy. Like all teachers, Ren was constantly rating his students, handing out gold stars and honorary names as he pleased. Jiang Zhu and Shen Xiang, for example, were designated 'the erudite two' (*liang boshi*) and were often referred to as such. Later, Ren also commended You Danxian by coupling her with Shen and calling them 'a pair of precious jade' (*shuang bi*). One early summer evening, the group hosted a poetry party where Ren presided as judge of their assignments. The three favourites – Jiang, Shen and You – joined the master's wife in receiving laurels of 'supremacy' for the rhyme-prose (*fu*) that they had composed about the white lotus flower. Four others trailed in the category of 'excellence'.[19] While gifted students earned their achieved status, Ren the master remained the arbiter of taste.

BIOGRAPHICAL DATA ON THE TEN POETS OF SUZHOU*

Name	Dates	Native place	Family background	Relationship
1. Zhang Yunzi	b. 1756	Jiading	foster father=*jinshi*	Ren Zhaolin's wife
2. Zhang Fen	b. 1764	Wu (Suzhou)	father=*juren*	first cousin of (1)
3. Lu Ying	?	Wu	father and husband=licentiate	sister-in-law of (4)
4. Lu Mei	?	Wu	brother=*juren*; husband=licentiate	sister-in-law of (3)
5. Xi Huiwen	?	Wu	husband=licentiate	Ren's pupil
6. Zhu Zongshu	b. 1764	Changzhou (Suzhou)	father=licentiate	niece of (1)
7. Jiang Zhu	1764–1804	Ganquan (Yangzhou)	husband=licentiate	Ren's pupil
8. Shen Xiang	b. 1773	Changzhou	uncle=*jinshi*; husband=licentiate	Ren's pupil
9. You Danxian	b. 1772	Changzhou	father=You Tong	elder cousin of (10)
10. Shen Chiyu	b. 1773	Changzhou	not known	younger cousin of (9)

*Their order of appearance here follows that in *Wuzhong nüshi shichao*.
Sources: Years of birth from 'Feicuilin guixiu yaji', in *Wuzhong nüshi shichao*, 124a–b.
Other information compiled from: Hu Wenkai, *Lidai funü zhuzuokao* (Shanghai, 1985);
Yun Zhu, ed., *Guochao guixiu zhengshi ji* (1831–6), *juan* 6 and 16; Cai Dianqi, *Guochao guige shichao* (1844); Shi Shuyi, comp., *Qingdai guige shiren zhenglüe* (Shanghai, 1987), pp. 335–8.

After all, it was taste that distinguished a poet. Already literate when they entered Ren Zhaolin's 'door', these women received personal instruction primarily to hone their poetic skills. A casual note that Li Mei attached to one of her poems described a typical encounter: 'Today, Master Xinzhai [Ren's courtesy name] came by to check on my drafts and made a few corrections.' At other times, Ren would assign each of them the same homework: emulate a certain poem by the poet Xie Tiao (464–99), or compose an inscription for a certain painting as it was being unrolled in front of their eyes.[20]

More fundamental than writing exercises was training in classical and historical texts, which were needed to broaden the serious poet's vision and to augment the range of poetic allusions at her command. Ren thus admonished Zhu Zongshu to 'advance from poetry to mastery of the classics'. In the same vein, You Danxian was encouraged to record her thoughts in verse upon reading the biography of Zhuge Liang (181–234), a brilliant minister-cum-military strategist from the Three Kingdoms period. Shen Xiang, upon reading a manuscript by Ren, responded with a series of ten poems, each being a commentary upon an official or minor dynasty in history.[21] Although Ren had published exegetical

studies of Mencius and the Mao recension of *Songs*, these women apparently did not receive systematic instructions in philology. The purpose of readings in the classics and history was to serve the ultimate pursuit of poetic art.

Besides poetry, the pupils also cultivated their skills in an array of fine arts. Jiang Zhu, a maverick, was an expert in wielding swords, although she did not learn this from Ren. What Ren expended much energy in teaching, however, was music. Compiler of a volume of ancient scores for strings, Ren also composed music for his wife, a player of the zither (*qin*). You Danxian and several women in the neighbourhood who did not formally belong to the group of ten were each skilled in a woodwind or percussion instrument. They often gathered to play, setting their own verses to music. One of Ren's favourite pupils, Shen Xiang, besieged Ren to compose music for the flute, her instrument. Ren consulted his teacher, Qian Daxin, on the meaning of certain names of ancient tunes, then spent a month producing a set of scores with a brief philological study of the origins of various woodwinds in the flute family. The thankful Shen handcopied the scores in her fine standard script (*kai shu*), contributed a preface and drew a diagram of the instrument for publication. She and Jiang Zhu also composed several song-lyrics that were set to Ren's music, and which were dedicated to each other or to Zhang Yunzi.[22]

Under Ren's tutelage, the ten poets thus constituted a vibrant community with artistic activities in tune with the rhythm of their everyday lives. Their interactions followed a well-recognized pecking order: privileged by gender, age and education, Ren was the undisputed arbiter of standards: those related to or favoured by him were deemed more respectable by the closely-knitted group. Yet the male master's privileged position was mediated by other factors.

Most significant was the levelling effect of religious experience. Many of the women practised meditation, as did Ren, and engaged in metaphysical conversations. A prolific nun frequented their quarters and exchanged poems with them, and they called each other 'friends in Chan' (*Chan you*). Ren, who had been cured from an illness when he was about sixteen by reciting a mantra, showed deep respect for his pupils' religiosity. In his adult life, Ren kept searching for the immortal who taught him the mantra. Admiring the ethereal air of You Danxian's person and poetry, Ren was also intrigued by the literal meaning of her given name, 'shouldering an immortal'. He mused, 'could she be the one?' and entertained the idea of seeking instruction from her.[23] Although we do not know if he actually did or not, Ren's musing is an

important admission: He did not think of the association of maleness with master and femaleness with disciple as inalienable.

Besides the religious dimension, it is also important to place Ren's circle in a larger social context of multiple affiliations and loyalties. A number of Ren's disciples studied with more than one teacher, hence belonging to more than one 'door'. As mentioned earlier, before Zhang Yunzi married Ren, she had taken lessons from one of the first women to study poetry formally with male teachers, Xu Xiangxi. Another core member, Jiang Zhu, studied with an old Suzhou poet before her apprenticeship with Ren and continued to dutifully refer to the former as her master. Zhang Yunzi and You Danxian, among the most active members of the Suzhou Ten, took part in a Suzhou gala for lady poets called by Yuan Mei in 1792. However intermittent their subsequent contact, Zhang and You had become Yuan Mei's disciples by their presence. Although a bad bout of blood-coughing prevented Jiang Zhu from attending, she crafted a verse for Yuan regretting that she could not attend to his 'red drapery' in person.[24] 'Red drapery' refers to the prop of a teacher's lecturing podium. These examples suggest that it was common practice for a dedicated woman poet to seek instructions from more than one teacher – male or female – in the course of her life.

It is thus important to emphasize that the Suzhou Ten, the exclusive focus of this essay, was merely one of the many networks that structured the life of the men and women concerned. Such ideological boundaries as male/female or senior/junior are not static and one-dimensional entities that lock an individual into absolute positions in a hierarchical order. Rather, they are relative and relational terms depicting selected aspects of the dynamic and multiple relationships that people forged in real life. No woman, no matter how junior or inexperienced, was always at the bottom rung.

An implicit argument that emerged from the above discussion on the multiplication of 'doors' in the eighteenth century is that education had become the foremost raison-d'être for voluntary association between upper-class men and women, as well as between women from different generations. This prevalence of women's learning in practice brings a profound irony into clear relief: while highlighting women's awkward position in the Confucian learned tradition, the spread of women's education also testifies to the flexible nature of the Confucian order and to its capacity for changes from within.

The educated women's ambivalent entrance into a scholastic tradition that accorded them no formal place is epitomized by the derivative nature

of the terms that members of Ren's circle used to describe their intellectual relationships. All of the terms mentioned above – 'door', fellow students, master, receiving instruction – were borrowed from the elaborate male patronage networks that were the lifeline of civil service examination candidates. On a positive note, the routine appearance of these terms in new contexts signifies new social configurations, in the form of either a woman master presiding over her own 'door', or women formally pledging to be the disciples of men. Through education, a woman could pursue a variety of subjects and assume non-kinship-related roles in the course of her life; the ease with which she glided in and out of 'doors' is suggestive of a fluidity and plurality that informed the lives of women from the privileged class in eighteenth-century Jiangnan.

While since the sixteenth century it had not been uncommon for daughters of the gentry to receive a literary education from their mothers in the depths of their private quarters, the public visibility of women 'masters' and 'fellow students' in the eighteenth century suggests a remarkable degree of *de facto* acceptance of women's roles not only as the educated, but also as the educator. It is no accident that the eighteenth century also witnessed the popularity of 'teachers of the inner chambers' (*guishushi*), a class of professional women itinerant teachers.[25] These developments in women's education, I would argue, constituted a nascent reform movement from within the Confucian tradition. A result of over two centuries of social and ideological ferment in Jiangnan, China's wealthiest and most commercialized region, this movement is suggestive of China's potential for change on the eve of its traumatic encounter with the West in the nineteenth century.

At the same time, the case of Ren Zhaolin and his pupils highlights the limitations of this nascent movement. The valorization of the female poetic voice as natural and serene, a major motive force for the promotion of women's literary ventures, was fraught with ambiguities. For all the gratification and edification that individual women enjoyed as a result, this valorization had the ironic effect of hardening the division between the perceived spheres of activities for the two sexes. The association of women with poetry and men with philological scholarship reinforced the doctrine of separate spheres, although the nature of the boundaries was being redefined. On top of the old demarcations of domestic/public responsibilities or manual/mental productions, men and women of the gentry were now also differentiated by the kinds of intellectual pursuits deemed most suited to their temperaments. The upper-class woman was told that feeding and clothing the family were

not her only destiny; but once she departed from the kitchen and the weaving-loom, she found that she had no place in which she could feel comfortable. In practice, the educated woman had long ventured out of her feminine abode, yet the official gender ideology had failed to keep up with her pace.

Not only were women masters such as Xu Xiangxi still far outnumbered by men, but the very fact that as women were gaining recognition as intellectual beings there were no terms to describe them but those formerly reserved for men, is telling of the hegemonic nature of the Confucian educational discourse. No matter how much *de facto* intellectual and social freedom a learned woman might enjoy, in her public appearances she had no legitimate identity but that of a surrogate man. This irony, however, seemed lost on the Suzhou Ten as they took pride in naming themselves 'lady-scholars'.

To be like man: the self-naming woman

An important marker of a man's public presence was his control over names. Chinese men, especially the learned ones, used a multitude of names to signify both the public identities and private beliefs or hobbies that they had acquired during successive stages of their life-cycle. Even male villagers, as the anthropologist Rubie Watson has shown, acquired the power to name themselves and others. For them, 'naming involves a dual process through which they achieve personhood by being bound to society, while at the same time they acquire an enhanced sense of individuality and distinctiveness.' In contrast, adult rural women were nameless and did not name others. 'Judged against the standard of men,' Watson continued, 'Chinese women do not, indeed cannot, attain full personhood.'[26] It was customary for educated women from the Ming-Qing period, however, to sign their writings and paintings with self-appointed sobriquets. The Suzhou Ten were no exception.

As self-representations, the sobriquets adopted by these women were revealing of two elements which they considered crucial to definitions of their personhood: literature and religion. Following a convention of the day, four of them celebrated their erudition by naming themselves 'So-and-so Lady-Scholar'. Particularly noteworthy was Zhang Yunzi, who fashioned herself 'Lady-Scholar from Jiangmen'. Jiangmen (literally 'artisan's door') was the courtesy name of her great grandfather, Zhang Dashou (1660–1723), a scholar-official and poet.[27] In making the connection, Yunzi declared herself heir to a family literary tradition normally transmitted through sons. Her claim was all the more intriguing

GIVEN NAMES AND SOBRIQUETS OF THE TEN POETS OF SUZHOU

Official name (ming)	Courtesy name (zi)	Pen name/sobriquet (hao)
1. Zhang Yunzi	Zilan (Lush Orchid); Qingxi (Clear Brook)	Taohua xianzi (Peach Blossom Fairy); Jiangmen nüshi (Lady-Scholar from Jiangmen)
2. Zhang Fen	Zifan (Purple Weed); Yuelou (Moon Pavilion)	Not known
3. Lu Ying	Suchuang (Plain Window)	Suchuang nüshi (Lady-Scholar Suchuang)
4. Li Mei	Wanxi (Fair and Agreeable)	Not known
5. Xi Huiwen	Lanzhi (Orchid Branch)	Yunzi (Hoeing Iris)
6. Zhu Zongshu	Deyin (Virtuous Voice)	Cuijuan (Graceful Jade)
7. Jiang Zhu	Bicen (Azure Hill)	Xiao Weimo (Little Vimalakīrti)
8. Shen Xiang	Huisun (Fragrant Weed)	Sanhua nüshi (Flower-Dispersing Lady-Scholar); Yuxiang xianzhi (Fragrant-Jade Fairy)
9. You Danxian	Sulan (Plain Orchid)	Jixiang nüshi (Lady-Scholar of Jixiang)
10. Shen Chiyu	Peizi (Jade Ornament)	Jiaoru (Fair Beauty)

Source: as for table on p. 205

in light of the fact that she first learned poetry from her mother, a published poet, then from another women, Xu Xiangxi, and finally from her husband, Ren. Although she also received instructions from her father's elder brother, Yunzi's actual intellectual and artistic pedigree was eclectic, a fusion of male and female traditions as well as the Zhang's and outsiders' 'doors'.[28] Unlike bloodline, intellectual descent is not restricted by biology; instead, it can be acquired or even imagined.

Zhang Yunzi's peers were aware that through literature they partook in a previously male-exclusive discourse. Instead of bemoaning the lack of a bona fide place for women (as opposed to surrogate men) in the past or attempting to craft a female-exclusive alternative for the future, they opted for a more accommodating yet no less radical stance: showing the men what a real woman could do on 'male' turf. This sentiment is amply expressed by Zhu Zongshu in a couplet: 'The classics, the histories, let them feed the bookworms; /From now, literature belongs to the moth-eyebrows [women]!' In other words, let men waste their time on the classics and history, curriculum for the Civil Service Examination, but the women will excel in literary creativity – a higher pursuit. Significantly, this couplet is part of a poem dedicated to Jiang Zhu. Buoyed by the comradeship of erudite women, the lady-scholar began to chant a virile and heroic tune.[29]

Jiang Zhu, the sword-wielder, reciprocated in kind. Ridiculing a man of letters who insinuated that she plagiarized her brother's works, she

declared, 'Confessing that my talents are shallow and vulgar,/I dare say that I am no second to my brother.' The theme of competing with men is also evident in a preface to one of her own poetry collections, where she used an overtly militant metaphor to refer to the Ten Poets of Suzhou – an 'army of amazons' (*niangzi zhi jun*). She designated Zhang Yunzi, Lu Ying and Shen Xiang the three 'majors' (*dajia*), and complimented them for leading the poetry club to attempt obscure tongue-twisting rhymes. In typical Chinese fashion, Jiang then contrasted herself with them as an unworthy peer, afflicted in body and spirit.[30] Such self-deprecation is largely literary trope, in light of both her earlier militant tone and the fact that among members of the group, she and Shen Xiang alone chose to author prefaces to their own published works. When women named themselves and wrote their own script, the lines between literature and life became blurred and superfluous.

Besides literature, religion also figured prominently in the women's personhood and social life. One of Shen Xiang's sobriquets, 'Flower-Dispersing Lady-Scholar', refers to a pious act honouring the Buddha. Jiang Zhu, in a stroke of genius, celebrated both her religious piety and literary achievements by calling herself 'Little Weimo (Vimalakīrti)'. Vimalakīrti, name of a lay follower of the Buddha, literally means 'the unspoiled name'. One of the three Chinese translations of the *sutra* bearing Vimalakīrti's name was particularly popular among the literati for its literary elegance.[31] In addition, Weimo, or its variant Moji, also happened to be the courtesy name of two great men in the history of Chinese literature: Xiao Tong (501–31), a Southern Dynasties prince who compiled a model anthology of prose and verse, and the Tang poet Wang Wei (699–759).

Indeed, the literary and religious themes were intertwined in the practice of planchette séance, popular since the late Ming among Suzhou literati men and women who vied to communicate less with dead relatives than with bygone writers. Jiang Zhu, for example, wrote of one séance in which the great Ming dramatist Tang Xianzu (1550–1617) dictated scores of poems to her and her brother. Tang, author of *The Peony Pavilion* [*Mudanting*], was an immortal in the eyes of numerous women readers on account of his creation of their alter ego, Du Li'niang; this character was an educated gentry daughter who pursued her lover unto death, and who in the end was rewarded with both love and life.[32] Jiang was thrilled by Tang's appearance to her in the séance, and especially by his claim that the two were destined to enjoy literary resonance (*wenzi yinyuan*).

The dramatist went on to describe three of Jiang's previous lives. She was, apparently, really a man who, having indulged in 'beautiful words', was now being punished by having to take on a woman's body. 'Beautiful words', one of the Buddhist 'ten evils', is believed to be a cause for transmigration. But if Jiang persevered in repentance and cleansing, Tang continued, she could be reborn a man again. Jiang, apparently pleased by this revelation, mused to herself: 'can the master's words be true or not?' In one of the three poems she crafted in response, she expressed hope that literature would offer her salvation: 'Life is as illusive as flower in the wind and reflection of moon on water,/Yet through literature, I meet my destiny./Cherishing our chance encounter, as if in a picture,/My words stand as testimony to humankind and Heaven.'[33]

Jiang's views of her gendered body were fraught with ambiguities. While in her poem she vindicated her existence as a woman through literature – an heroic effort that echoed her image of the women's community as an 'army of amazons' – Jiang seemed pleased with the prospect of assuming a man's body in her next life. Although she did not discuss the issue further in her extant poems, it is reasonable to conclude that Jiang was oblivious to the irony of a woman so eager to outperform men that she even tacitly accepted the male prejudice which construed the female body as polluted and inferior. Yet this is really another indication of the hegemonic nature of the prevailing discourse on gender discussed above; the lady-scholar surely deserves recognition for daring to imagine herself as a man – the wildest dream possible from the limited repertoire made available to her.

Negotiated hierarchies in a world of her own

Seen in the context of the dominating nature of the male-female discourse, the meaning of exclusively female sociabilities to the women concerned is all the more apparent. As fellow-students of Ren Zhaolin, the Suzhou Ten were made to compete with each other for the accolades of their master. In the end, despite such rankings, all were rendered equal in their subjugation to the authority of Ren. Once the reference point to Ren was removed, however, the women were much less guided by predetermined rules. In their relationships with each other, they negotiated a shifting set of hierarchies construed by kinship, age, religious experience, literary merit and personal preference. By fusing achieved criteria with those that they had been ascribed, these women wrote the texts of their lives – although they did not write them simply as they pleased.

IMAGINED HIERARCHIES OF THE TEN POETS OF SUZHOU

Name	Collection selected by	Preface by	Congratulatory poems by	Those called 'elder sister'	Those called 'younger sister'
1. Zhang Yunzi	self	R*	7,8,OS*	nil	7,8
2. Zhang Fen	1	R	1,9,OS	1,5,7	6,8,9,10
3. Lu Ying	1	nil	2,7	nil	nil
4. Li Mei	1	nil	OS	nil	nil
5. Xi Huiwen	1	7	OS	nil	8,9,10
6. Zhu Zongshu	1	R	nil	2,7	8
7. Jiang Zhu	1,8	Self	1,5,OS	1,5	8,9
8. Shen Xiang	1,7	Self,R,7	1,2	1,2,3,4,7	10
9. You Danxian	1	R,10	nil	2,3,5,6,7,8	10
10. Shen Chiyu	1	9	nil	5,7,8,9	nil

*R stands for Ren Zhaolin; OS refers to an outsider who is not a formal member of the Suzhou Ten
Source: *Wuzhong nüshi shichao*, passim.

The most unambiguous principles with which to organize a women's community and to establish order are kinship and age. As mentioned earlier, a number of these women were relatives; they sometimes retained the terms of address based on generational rank, such as *congmei* (younger first cousin) or *biao shengnü* (cousin's daughter). Equally pervasive is hierarchy by age. By and large, the one more advanced in years was accorded the respectful 'elder sister', who in turn addressed the other 'younger sister'. Hence Zhang Yunzi, Zhang Fen, Xi Huiwen and Jiang Zhu, older members of the group, were most often honoured as 'elder sister'; Shen Xiang, You Danxian and Shen Chiyu, junior by at least ten years to the others, were consistently dubbed 'younger sister'.

Although these categories of generational ranking and age appear to have been largely taken for granted, there are notable instances of defiance. You Danxian called Shen Xiang 'elder sister', although You was in fact a year older; Shen Xiang did not refrain from referring to Shen Chiyu, born the same year, as 'younger'.[34] Perhaps Shen Xiang's status as one of the master's favourites boosted her esteem and self-confidence. In addition, the changing ways in which Lu Ying addressed Li Mei suggest an ease in conflating male-centred kinship with other female-centred categories. Li Mei, wife of Lu's brother, was by conjugal ties Lu's sister-in-law. In one poem Lu called her such; in another Li was a 'fellow student'; in yet another she was respected as 'elder of our poetry club' (*yinchang*).[35] Identities were made, not fixed, and hence multifarious and opened to a degree of negotiation.

More indicative of the women's view of their community as one which

they imagined and constructed was their common practice of using terms of address that obscured the kin and seniority-based hierarchies into which they were born. A number of examples stood out: madame; fellow student; gentleman (junzi); the undifferentiated 'sister' (jiemei) to express cordiality, not seniority. Or, most common of all, they simply referred to the other's courtesy or pen-name without the family name. This emphasis on solidarity and individual identity, however, does not mean that the group was egalitarian. In using such honorifics as 'madame', these women retained their prerogative to make distinctions and to show respect to those they deemed worthy.

Besides terms of address, three elements in the packaging of each poet's collected verse provide additional clues to the women's assessment of each other's standing and their sense of the boundaries of their community: the identities of the selector, preface writer and contributors of congratulatory poems.

The selector was an authoritiative title, being vested with the power to go through a poet's corpus and to pick out compositions worthy of publication. It is noteworthy that Ren Zhaolin did not select any of the volumes. All paid tribute to his authority as master and arbiter of taste by naming him as a collator. But the honorific task of actual choosing fell to his wife Zhang Yunzi, who selected each of the ten collected works that made up the anthology. She alone was responsible for selecting her own volume. By marriage, age and experience, Zhang was the leader of the women's community. Yet two younger members shared the limelight by virtue of their literary merits. Jiang Zhu, one of the most learned, assisted Zhang in making selections for one of Shen Xiang's collections; Shen, in turn, lent a hand in selecting Jiang's. This selection process was a microcosm of the poetry circle at work: that no man was called upon to select their verse bespoke the sense these women had of belonging to a shared female community. Yet, however unified by gender, this community was not egalitarian. In addition, Ren's role as collator served as a reminder that a literate women's culture was seldom created without references to men.

Although preface writers were less powerful than selectors, they were publicly honoured, and were held deserving of the author's respect and gratitude. Not surprisingly, Ren Zhaolin was the most sought after, and his prefaces grace five of the ten collections. Among the women, Jiang Zhu stood out from the pack. Not only was she invited to contribute two prefaces, she and Shen Xiang alone authored their own. Moreover, Jiang Zhu was the only poet whose own preface alone sufficed as an

introduction to her collected verse. This long and intensely personal statement of Jiang's views on her women's community, literature and life, part of which was discussed above, was addressed to Ren and often couched in terms of a dialogue with him. This unusual practice epitomizes the ambivalent standing of the woman poet in the world of literati men: she was self-assured and learned enough to converse with him, yet it was not a free and reciprocal exchange. As she sought entrance to his world, he remained aloof from hers.

Contrary to the ranked order implied in the choice of selectors and preface writers, congratulatory poems were personal expressions of cordialities. Since they were solicited in a more casual manner from friends, they did not follow the established hierarchies that informed the other interactions in the poetry circle. Moreover, in sharp contrast to the reciprocity exhibited in the use of the kin and age-based terms of address discussed above, the exchange of these poems was marked by a lack of reciprocity. The only exception was Zhang Yunzi, who congratulated Jiang Zhu and Shen Xiang and received the same from them. Most other collections featured poems from friends who were not formal members of the Suzhou Ten, but who partook in their activities. Perhaps the inclusion of their commemorative poems was a way to recognize their contributions. That friendship ties cannot be reduced to easy formulas reminds us that personal resonance, however elusive to the historian, was a powerful counterbalance to the given and constructed hierarchies examined in this essay. The presence of a much larger community of women at the periphery of the Suzhou Ten, in turn, suggests that a flourishing poetry-based women's culture touched more lives than the ones discussed in this essay, although we do not know the full story of their names and deeds.

Educated women in the Confucian tradition

The creation of the Ten Poets of Suzhou, a respectable public poetry club that originated from the male teacher/female student axis, challenges our perception of the gender system in eighteenth-century China as rigid and hostile to women's learning. Its significance is grounded in the simple fact that it was a voluntary association sustained by the women themselves, albeit under male auspices. I have shown that in their dealings with other men and women, these poets enjoyed more leeway than was allowed by the strict rules prescribing distinctions along lines of gender, kinship and age. Personhood and gendered relationships are something constructed and imagined, not given and fixed, and thus they may allow individual

men and women to assume a multiplicity of identities, negotiate ideological hierarchies and pursue diverse courses of action.

As glaring as the practical freedom implied by this process of negotiation and contestation is its limitation, regardless of whether women in the eighteenth century were aware of this limitation or not. In their naming practices and eagerness to compete with men for literary laurels, the most erudite women of the time seem oblivious to their own problematic position in the Confucian tradition. Since the official ideology allowed little room for the highly educated woman to project a public presence *as* a woman, these Suzhou poets seem all too eager to claim victory as surrogate men – or even to aspire to be reincarnated as men. Ironically, the hegemonic nature of the Confucian gender system in the eighteenth century does not lie in its repressive ability to silence women, but in the exact opposite – the opportunities it allowed for diversity and plurality of expression. While from our perspective they appear circumscribed, these opportunities were seized upon by the educated women at the time as a gateway to personal fulfilment and greater gender equality.

Both the opportunities and their tacit boundaries were historical constructs, and represented a culmination of successive efforts by men and women since the late sixteenth century to bring Confucian teachings more into line with changing realities. The commercialization of the Jiangnan economy and the enormous surplus it generated created myriad social configurations; the role of women as students and teachers constituted merely one example. The undisputable respectability that Ren Zhaolin and the Suzhou Ten enjoyed demonstrates how far the system had gone to accommodate the new reality of the demand by women for an education. This, as argued above, was accomplished by a perpetuation of the doctrine of separate male/female spheres while the nature of the boundaries was being redefined. From this historical perspective, the Confucian tradition can be seen as a constructed instead of a natural order – and one that was multifarious and responsive to social change. If individual men and women cannot be construed merely as the 'acted upon' in practice, then neither can the 'dominant ideology' be reduced to a given, static and monolithic existence.

7
The Chinese Opera Star:
Roles and Identity[1]

ISABELLE DUCHESNE

The art of the actor, the keystone of traditional Chinese theatre (*xiqu*), brings into play many artistic disciplines, all of them highly codified: make-up, costume, speaking and singing, gesture and facial expression, mime, dance and acrobatics. Its most illustrious form today is Jingxi, that is, the 'Beijing theatre'.[2] As a hybrid form, successful in combining multiple artistic disciplines and in reaching a vast social and geographical public, Jingxi has gradually emerged from a vast world of local theatrical genres (*difangxi*) which are often limited in their currency by the 'local flavour' (*difang weidao*) of their dialect, music, general aesthetic, and public. Jingxi brought its own acting and singing to a prominent artistic position, first in the capital Beijing, in the nineteenth century, then across China, at the turn of the century. In consequence it is also often characterized as the 'theatre of the nation', or *guoju*. Its various Chinese names thus denote historical and artistic dimensions far beyond the term 'Peking Opera' – the common Western appellation – which reduces it to a single musical art that is attached to a single place.

The 'stars' of the 'golden age' of Jingxi, during the Republican years prior to the Japanese invasion (1912–37), offer a particularly rich subject for the study of the traditional actor. They used all the means open to the actor and singer in order to embody the characters they played and to galvanize the audience. The charm of these Chinese 'divas' was filtered, on a primary level, through the characters that they played. For this, they employed multiple artistic and dramatic conventions to create a complex play of role-type, specific character and identity. Yet, while the act of interpretation which was expected of a Chinese actor on stage was delimited by the conventional boundaries of his craft, it reached its height through transgressions – which only the greatest actors were able to carry out – in order to remake and personalize the content and form. If the dividing line between the personality of the professional man (or woman), and the individual as a social being and

private person, was generally difficult to discern, this was even truer of the most famous actors. Especially in their case, the public dimension of their image complicated further the expression and recognition of their personality.

Jingxi is unrivalled by any other traditional theatrical genre in China in the number of stars it has produced in the twentieth century. Indeed, the institution of the star is one of the ways in which Jingxi engaged with the modernity that Chinese society – especially urban society – was embracing. Here I shall try to unravel the 'play of identity' of the person who became an actor and star. I am interested in the way complex identities were constructed by defining boundaries between the professional, private, social and public realms of the life of the actor and the star. Moreover, in the particular case of stars, their public image had ramifications for their behaviour, leading to a blurring of the boundaries between their personas. My examples will largely be chosen from the early twentieth century, and pride of place will go to male actors playing female roles, as these were the pre-eminent stars of the time.

The apprenticeship

The actor first learnt the codes and conventions of the trade through a course of training which required at least seven years of rigorous discipline, involving frequent performances in increasingly difficult roles. He carried this knowledge with him throughout his career. From the very first years, he undertook arduous and highly diverse exercises that were intended to bring suppleness to the voice and the body, and to prepare him for the profession and its repertory. At the same time, on the basis of his physical appearance, his voice and his natural qualities, the child actor was assigned one of the characteristic role-types of Chinese theatre. Thus, a child with a broad facial bone-structure and an aptitude for physical exercises would normally by assigned to the 'military' (wu) category of male warrior roles.[3] The face-painting characteristic of these roles necessitates a large surface for make-up, and despite the physical demands of the movements the roles may include singing. Other children with less talent for singing would become buffoons (chou) or acrobats. An example from the opposing 'civil' (wen) category is given by the case of Zhang Junqiu (1920–), one of the last men to play female roles (dan) in Jingxi, and its greatest living star. He has explained that his mother regretted that all her children were boys, and always dressed him as a girl. His face was particularly beautiful, and by the age of ten his physical appearance was charming. When he seriously began his apprenticeship as

an actor at the age of thirteen, he was made to learn all the female roles, following the decision of his master, Li Lingfeng.[4]

It would seem, therefore, that the attribution of a role-type made the most of the natural attributes of the child (or person). Thereafter, the rigorous discipline and conventions which were imposed on him all day, even into the evening, completely moulded him within a system of representation, expression and dramatic behaviour that constructed, or reconstructed, him as a person.[5] The actor-apprentice received the bulk of his education by living within the reach of his teachers, in a theatre company or a school. In line with the rigorous discipline of his profession, he learnt anew how to breathe and project his voice; how to look, by the careful observation of the flame of a candle, the flight of a bird or the swaying of a kite; and how to stand, walk, speak and sing with poise.[6] He also had to assimilate the constraints of his role-type to become a particular kind of stage character, whether an impetuous warrior, an emperor or minister of mature age, a sorrowful widow, a delicate scholar, a vivacious servant, a simple man of the people, a fantastic animal, etc. This training process established a new set of guidelines in relation to gender, age and social status. The apprentice went beyond his own private experience to enter the realm of theatrical practice, crossing a boundary between self-definition and theatrical impersonation. This step was no less necessary for individuals making the switch from amateur status, such as former government officials Jin Zhongren (1886–1950), Yan Jupeng (1890–1943) or the Manchu prince Hongdou Guanzhu (1871–1952).

In the case of *dan* roles, the fact that he worked for as long as eight to twelve hours a day to incarnate the role-type often led the male actor to adopt its mannerisms and physical appearance as his own. Actors such as Zhang Junqiu, Zhao Rongshen (1916–) and Cheng Yuqing, though now of advanced age, can still be recognized as specialists in female roles when one meets them off-stage, even when they wear the Mao suit. No aficionado would mistake the significance of the smooth face and plucked eyebrows, the way of fixing their gaze and their lips, or their gentleness of voice, refinement of gesture and impeccable dress. The persona which the apprentice constructed for himself as an actor accompanied him throughout his life as a second nature – and not just within the boundaries of his career. A progressive blurring between personal and theatrical identity seemed inevitable and, perhaps, desirable, though how deliberate this was deserves further discussion.

The actor's official entry into the profession did not pass unnoticed.

For example, when an amateur (in principle unremunerated no matter how talented or skilled) became a professional, and was recognized as such by his peers, it was said that he 'threw [himself] into the sea' (*xia hai*). He often took a new stage-name to mark the event and thus consecrate his future career. This was also true of the professional actor, who after receiving his first high critical acclaim following a particularly successful performance would often decide to change his name thereafter. At a more lowly level of practice, the student entering a professional drama school was given a middle name shared with his peers in the same training programme in order to formalize his integration into a community of students and teachers who shared a number of artistic and ethical values. He often kept this middle name beyond graduation, and even well into his career, as if to acknowledge the role of the training process in the formation of his adulthood.

Again, at the beginning of the century, when a pupil was officially accepted as a disciple by a great master, the event was set for an auspicious day and was marked by a banquet, a solemn ceremony, and the offering of presents. The aspiring actor, who if he was young was often brought to the master by his natural father, had to prostrate himself before the former and acknowledge him as his father, paying homage to his family and ancestors as if they were his own. A new line of descent alongside the natural one thereby bound the disciple and the master within a framework of mutual rights and obligations. This rite of passage announced an important new stage in the life of the aspirant. It meant a sort of rebirth, the actor acquiring a new identity, not only in terms of the theatre, but as a person. (This was sometimes also the case for the master.)[7]

The disciple who underwent this decisive ritual of his apprenticeship definitively 'changed his skin'. Thereafter, without regard for his personal inclinations, his new mentor imposed harsh constraints which affected the student's personality ever more strongly. He no longer simply had to learn a role-type and its corresponding characters; now, conforming to the way of life of his future profession, he also had to learn to understand, feel and incarnate the characters according to an interpretation provided by his master. It was only by effacing his own self and assimilating totally his master's interpretation that he could gain access to the characters. Thus, there was a double process: on the one hand, a renunciation of self, and on the other a metamorphosis which pushed the student to mould himself to his master in order to incarnate the character. In order to succeed, he had to be constantly attentive to his master's

performance and receptive to the psychology of the character, while all the time developing his own stage intelligence. And when the disciple, having performed with his master or in supporting roles during his years of training, finally began an independent career, he often donated his first year's wages to his master. On the other hand, like the amateur turned professional, he also often adopted a new stage-name.

These descriptions can be interpreted from several different angles. Firstly, the adoption of new names in this twentieth-century theatrical world can be related to a practice deeply rooted in traditional Chinese elite culture. Scholars, artists, writers and others, often bore several names – official name at birth, private name, 'nom de plume' and various self-attributed names – as a means of positioning themselves in life, in both mental/emotional (*xin*) and social terms. Different names addressed different aspects of a single person, whether they were chosen by the person himself or by other people. Beyond simple identification, names signalled important stages in the life cycle of the person and constituted markers of personal development; they signified to some degree one's character, temperament or social attitudes. The privilege of adopting several names enhanced the richness of one's layers of experience and personal history, whether these names were only used at a specific moment in one's life or over a lifetime. By extension, names appeared to imprint one's life-span with a certain behavioural rhythmic pattern. It seems likely that those in the theatrical circles of the Republic – actors, apprentices or amateurs – found in this practice of combining names, behaviours and identities a means of attaining higher status on the model of the traditional elite.

Secondly, the ceremony mentioned above did not merely sanction the acceptance of a disciple by a master. When an older student was involved, there was also a conscious choice on his part to become the disciple of a particular artist. At the beginning of this century, the Yu family thus sent crock after crock of crude opium melted down with ginseng to Tan Xinpei, the most revered actor of 'mature men' (*laosheng*) at the time, to convince him to accept the still young Yu Shuyan as a disciple. When he finally agreed, they offered him two bottles of the most expensive Western snuff with an antique snuff bottle.

The ceremony and the subsequent change of names which often marked a successful pact between the master and his disciple therefore formalized a bonding in both directions. Looking at this practice from an anthropological perspective, one can locate such interpersonal dynamics at the interfaces between complex systems of lineage and adoption in

China. Broadly speaking, the master and his disciple in the theatrical world were joined in the same lineage through a symbolic adoption procedure. As in a clan context, the master-teacher became responsible for the care and education of his adopted child, while the disciple, in his new quality of kinship, owed respect to his new parents and their ancestors,[8] and became entitled to inherit his symbolic father's artistic legacy. Henceforth, mutual obligations bonded the master and his disciple. However, in contrast to clan adoption in China, the theatre disciple did not take his father's last name. Simultaneously, the theatrical procedure also bears some resemblance to the construction of religious lineages, in the way the accomplished student could choose to become the disciple of a particular master, and hence a symbolic heir of his master's teaching. In some religious contexts, for example Chan Buddhism, the disciple shared part of a name with his peers, to signify his entry into the lineage. There is a close parallel here with the customary adoption of the same middle name for every student in the same generation group, in the new professional schools of the early twentieth century. By contrast, outside the school context, when a young actor apprenticed himself to a master, he could adopt a name with personal overtones, free of any lineage designation.

Thus, the adoption of theatrical names was not only connected to the training process or the career progress of young actors. It was also relevant to the personal history of the apprentices and of the master-actors. The contractual relationship defined a network of mutual bonds across constructed boundaries, revealing a complex dynamic between individual and professional identities.[9]

Transvestism and the stage

Transvestism, in Jingxi of the nineteenth century and before, was often linked to sexual orientation. The activities of actors and *mignons* went far beyond the stage, as we know from such novels as Chen Linshu's *Precious Mirror to Appreciate the Flowers* [*Pinhua baojian*] of 1852, and other Chinese sources. Moreover, the promiscuity, both heterosexual and homosexual, which pervaded theatrical circles and partly explains the low status of actors in Chinese society, was the target of various edicts in Beijing from the seventeenth to the nineteenth centuries.[10] As an apprentice, the young actor sometimes had to accord his favours to the master of whose entourage he was a member. Once he became prominent in a transvestite role, he could continue to exercise his charms on the clientele after the performance; in such circumstances, transvestism

blurred the boundary between stage and life. These practices gradually disappeared at the beginning of the early twentieth century with the emergence of modern professional schools, where the apprenticeship took on a less intimate character, and in the context of female emancipation and the growing female presence in theatre companies and audiences.

And yet the canons of femininity in modern and contemporary Jingxi are largely due to the 'Four Great *dan*' (female roles), and thus to men.[11] The other actors and actresses of female roles were tempted to imitate the smallest details of their movements, poses and vocal inflections. Through the prism of roles of women of dignity and women of action, as well as the newly important roles of coquettes, actors now created – in this modern male formulation – a composite, idealized image of female character.[12] In addition to the ingenuity of young women and their moments of modesty, actors now explored their petulance, langour and interior anguish, as well as the older woman's tragic destiny and dignity in the face of difficulties, not to mention the immaterial grace of goddesses. There are echoes here of modern popular fiction, while the warrior heroines of the *dan* actor parallel the real-life female rebels and revolutionaries of the late nineteenth and early twentieth centuries such as the female revolutionary Qiu Jin (1875/7–1907), who posed for photographs as a Japanese woman in kimono holding a short sword, and as a man in Western men's clothing.[13] In this area, the modernization of the Jingxi tradition extended beyond the modern formulation of traditional characters to the creation of new role-types and characters.

In the face of an aesthetic of interpretation of female roles canonized by men, it was initially difficult for the actresses of the early twentieth century to find a place for their natural qualities; all the more so, given that they had less chance of studying with a great master and working with major actors. According to his male disciple Zhao Rongshen, one of the reasons why Cheng Yanqiu did not accept female disciples was 'the difficulty they had in singing the low notes in his style, since this required much more breath than the other styles and was easier for men than for women'.[14] There were, nonetheless, great actresses, notably Xue Yanqin (1910–86), Xin Yanqiu (1910–), Wang Yurong (1911–) and Zhang Eyun, who so succeeded in crystallizing such an 'acceptable' image of feminity in their movements and singing, that they became a mirror figure to their male counterparts, achieving a certain fame as the 'Four Great Female *dan*'. Like the male actors who were their models, they too achieved the quality of singing 'which curls around the rafters for three

days' – at once airy, pure and moving. It took another generation, however, for them to impose themselves. In Jingxi, there had been, in fact, wholly female companies in Beijing, Shanghai and Tianjin since the nineteenth century, which performed for a more restricted audience, and provided a training ground for the first famous female stars. These female companies disappeared entirely in the 1930s, when actresses became fully integrated into the professional body, unlike the female companies in the Yueju theatre that is popular in the Shanghai area, which still survive today.

Some actresses who had impersonated male roles while in female companies continued to do so when they performed with their male colleagues. The most celebrated example in Jingxi is Meng Xiaodong (1909–77). After starting out in roles of old women (*laodan*) in a Shanghai female company, she soon switched to those of mature men (*laosheng*) due to the quality of her voice, the way she carried herself, and her movements on stage. After establishing a solid reputation, in the 1920s she was finally able to play a leading role on the Beijing stage together with the most celebrated actors, at the important No. 1 Theatre. By the 1930s, actresses in all roles gained a higher status in the relatively conservative theatrical world of the capital, as attested by the success of Meng Xiaodong, Xue Yanqin, Xin Yanqiu and Wang Yurong among others. Yet, despite Meng Xiaodong's artistic reputation, she still had great difficulty in convincing Yu Shuyan to accept her as his disciple in 1937 – even though she was the most obvious heir to his artistic style. More traditionally minded actors were afraid that a relationship with a female student, however professional, would give rise to rumours. They only needed to invoke the fascination which women were believed capable of inspiring in men, the loose morals of earlier generations of actors and actresses, or the fact that it was still daring for a woman to appear in public as as an actress, to turn their backs on the eventual comradeship that could have developed from the fact that both individuals played the same theatrical role.

The fact that the public was fascinated by men in the roles of women in Jingxi, and vice versa, has more than a little to do with the sexual attraction which these actors exercized. As early as 1918, the critic Zhang Xiaocang attempted an explicit analysis of the phenomenon in the case of Mei Lanfang:

Now that he is adult, his face is gorgeous, his appearance fine and elegant. Those who watch him have the impression of seeing the concubine of Huan Wen in person and so, hearing him sing, they can not prevent themselves from being

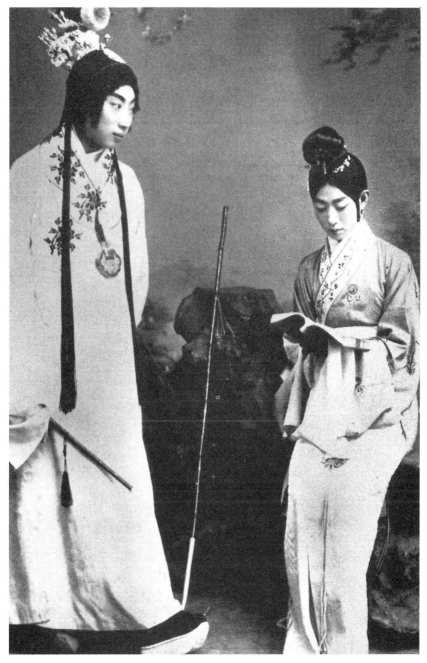

Jiang Miaoxiang ('young male lead', *xiaosheng*) as Jia Baoyu and
Mei Lanfang ('female role', *dan*) as Lin Daiyu, in *Daiyu Buries
the Flowers* (*Daiyu zang hua*), 1916.

deeply moved; some cover their faces to hide their feelings. At such moments, the emotion freed by his singing fills the entire hall.[15]

Legend had it that when Huan Wen's wife saw the concubine chosen by her husband, she exclaimed: 'Even I, a woman, cannot stop myself from loving what I see.' Used here by the critic, the reference is richly suggestive of the erotic relation of the actor to his audience. To convince oneself of this, one need only consult the contemporary photographs of the Four Great *dan*, as women and as men.

These ambiguities were sometimes thematized on stage in Jingxi, but the best-known example of this, somewhat more recent, is to be found in the Yueju theatre of the Shanghai region. Since 1923, Yueju's female companies have highlighted alluring young couples, and the play *Liang Shanbo and Zhu Yingtai* has been captivating the crowds both on stage and in its filmed version for decades. In this play a young woman, disguised as a man in order to pursue her studies further, falls in love with a fellow-student, and after much prevarication reveals her female identity and declares her love. A relationship between two – apparently male – young persons thus first develops as a troubled friendship, which is all the more believable given that two actresses are involved. Sexual transgression stimulates the interest of the public for most of the play, before all is resolved by a return to normality when Zhu Yingtai reveals herself to be a woman.

It is not impossible that in the twentieth century a certain sexual ambiguity continued to be tolerated in the private lives of actors and actresses playing roles of the opposite sex on stage, on condition that it did not become too visible. At the same time, it may even have been expected off-stage, lest the contrast destroy the professional illusion. In this optic, it becomes understandable that the most celebrated actors exploited their stage image to a certain degree off-stage as well, while generally shielding their private life from public view. This would help to explain why information on their domestic circumstances was so carefully filtered.

Richard Schechner, in *Between Theatre and Anthropology*, discusses the transformation experienced by the repeated impersonator of a certain type of role, on the basis of such case studies as that of the semi-divine sage Narad-muni, in the Ramlila performance of Ramnagar, in India.[16] He argues that the performer, after having been repeatedly 'transported' through performance, is 'transformed' even when the performance ends, and perpetuates his new role in his life, to the acceptance of his community. In his example, the performer comes to take on the same

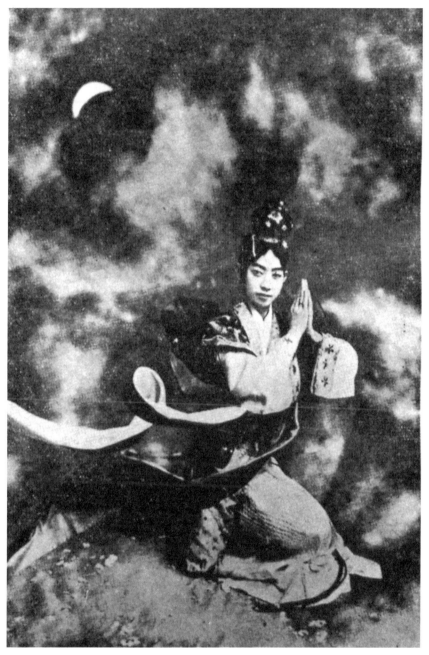

Mei Lanfang in *The Heavenly Maiden Strews Blossoms*
[*Tiannü san hua*], c. 1917–30.

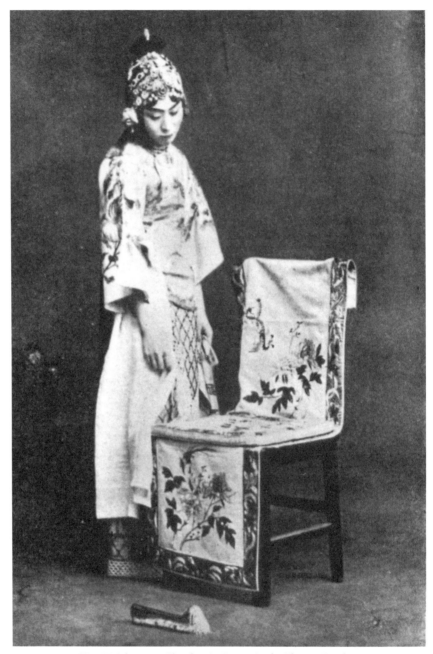

Xun Huisheng as Chunlan in *Errors in the Flower Garden*
[*Huatian cuo*], *c.* 1931.

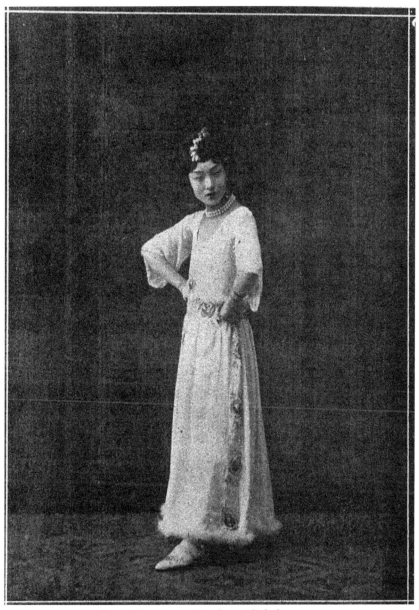

Shang Xiaoyun as a 'modern girl', before 1933.

漢歸姬文之秋豔程

Cheng Yanqiu in *Wenji Returns to Han China*
[*Wenji gui Han*], c. 1926–31.

priestly powers as the semi-sage that he incarnates, and behaves in the
same expected way.

Such a transformation experience places the actor in a space which
cannot be reduced to the mutual sum or exclusion of the personae of
the actor and his impersonations, on the one hand, and of the 'man', as
an individual and social person, on the other. Rather, it creates an
active field where several identities can overlap, somewhat close to the
Western psychiatrists' concept of 'altered or discrete states of con-
sciousness', commonly known as 'multiple personalities'.[17] Under
similar circumstances, transvestism in Chinese theatre could under-
standably affect the performer's appearance, status, behaviour and
identity, and his perception by the community/audience. The actor's
conscious or unconscious adoption of an effeminate presence off-
stage clearly signals the intrusion of his theatrical persona into his
'real life', and marks a blurring between his theatrical and personal
identities.

The actor and his flavour

The actor's personal investment and self-display in his art, as we see it in
the twentieth century, has its roots in an earlier tradition. We find
antecedents in seventeenth-century theatre as analysed by the aesthete
and dramatist Li Yu (1610–80). Li Yu formulated a concept that is still
important in Chinese theatre today: emotion in singing. In order to
impart a 'flavour' (*weidao*) which would remain with the audience long

after listening, the actor was to push expressiveness to the limit, letting his personal emotion shine through in his art:

When the mouth sings but the heart does not, when there is a song in the mouth but none shows on the face or in the body, this is what one calls a song without emotion. Just like an ignorant child who recites a book by heart, it is forced and insufficiently natural.[18]

This remark has implications far beyond the framework of musical technique, for it implies an investment of the individual in the dramatic interpretation. Without any direct knowledge of Li Yu's ideas, the great stars of Jingxi followed this same direction. This happened in part because they often practised a classical theatrical genre – Kunqu – as a personal discipline, since the singer who mastered the older genre had no difficulty in absorbing the related conventions of Jingxi. The aesthetic principles which guide Kunqu are themselves close to those of the *chuanqi* genre cultivated by Ming and early Qing dramatists such as Li Yu. Indeed, this specific principle of emotion in singing was taken up again at the beginning of the twentieth century by the critic Zhang Xiaocang, under the name of *chang qing*, as a criterion for the evaluation of the actor's art.[19] It continues to be transmitted through the teaching of actors until the present day.

During the Republican period we see, on the one hand, an unprecedented psychological realism in the representation of individual characters which goes beyond the traditional stylization and, on the other, a desire on the part of actors to affirm their personal identity through their art. Actors were not the first to declare an interest in the human individual. From the last century onwards, Chinese intellectuals translated into Chinese scientific, philosophical, literary and dramatic works, including works by Balzac, Freud and Ibsen, in which the psychology and the internal and external conflicts of the individual had an important place. From about 1910 onwards, love stories, *romans noirs*, and Chaplin's films, with their mixture of sentimentality and social comment, all had great popular success. This trend influenced traditional actors in the larger cities, where the modernization of society was directly affecting their profession. As unions, modern professional schools and Western-style theatres made their appearance, actors increasingly frequented the new urban patrons socially and even started to perform overseas: Mei Lanfang was the first, visiting Japan in 1919. In these new circumstances actors were no longer content, or able, to recycle the ready-made roles and stylistic formulae which had permitted their predecessors to switch rapidly from one role and play to another.

The central problem was that this traditional professional expertise in the use of conventions afforded little place to the individuality of the character and to the personal interpretation of the actor/actress. Wang Yaoqing (1881–1954) in 1933, for example, was of his time in criticizing the way that in the 1890s his illustrious master Chen Delin (1861–1930), not knowing the second part of one play, had been content to substitute another for it.[20]

In the 1920s Jingxi actors began to explore further the dramatic and cultural means at their disposal, developing new themes and exploiting the psychology of their characters. With increasing precision and subtlety they analysed the feelings, contradictions and conflicts of their protagonists in order to bring out an inner richness, not hesitating to modify stylistic conventions and role-types when necessary. In order for individuals, and not simply social or moral types, to be represented on stage,[21] actors were now required to be capable of transgressing extremely rigid dramatic conventions and marrying their own personality with that of the character. Sobriquets which lauded an actor's art through reference to his interpretation of a role now became common. The 'painted face' Jin Shaoshan (1889–1948), for example, was baptized Hegemon Jin after he took up the role of the ruler of Chu in the play *The Hegemon Bids Farewell to His Concubine* [*Bawang bie ji*].

In his memoirs, the actor Xun Huisheng discusses the new problems of characterization with reference to his play *The Two You Sisters* [*Honglou er You*], which he performed between 1928 and 1934. In this work, based on the novel *The Dream of the Red Chamber* [*Honglou meng*], he created an opposition between the character and reactions of the two heroines within the closed and oppressive world in which they are imprisoned. To this end, he first altered the attribution of roles:

I divided the play into two halves and two roles: during the first half I played the vivacious You Sanjie as a coquette (*huadan*), and then in the second I played the tender, gentle You Erjie as a *guimen dan* (a girl or unmarried young woman). This (his playing both roles) was quite daring for the period, since in Beijing theatre companies in the old days the roles were divided up (among the actors) very strictly, and for *dan* alone there were many divisions . . . I thought this held back the actor's talent and development.[22]

For each situation, Xun carefully considered their costume, the looks they gave, their postures and gestures. For example, for the moment when You Erjie finds herself face to face with the murderers of her child and their accomplices – people close to her – and is overcome by feelings

of impotence and despair, Xun approached the performance in a very personal way:

Speaking of the use of sleeves, the traditional custom for *dan* roles in Jingju was either to throw out a single sleeve, or to throw out both, and if it was both, you crossed them over your chest or lifted one and let the other hang . . . When, on that occasion, I let both of them hang, it was quite a bold experiment. I gave the movement the name of 'sorrowful sleeves'. What it means is that she's lost all hope; she's so discouraged that she doesn't have the strength to hold up her arms.[23]

All in all, this character You Erjie is an extremely weak person. If it was somebody else, then before she died she might still want to say a few straightforward words and accuse the people she hated. But You Erjie right up to her death is still like a piece of beancurd, or a sheep; she lets them slaughter her with hardly a word of protest. If it had been Sanjie instead, before she died she would have berated them with all her force. You compare the two, and it really is a powerful contrast.[24]

In this way Xun Huisheng's acting managed to expose the subtleties and multiple dimensions that entered into his understanding of a character. Even though he denies the actor's subjective participation, and hides behind the concrete description of his characters to justify himself, nonetheless these two accounts clearly reveal the 'voice' of Xun Huisheng: what those in the profession would term his 'flavour' (*weir* in the Peking dialect). His approach was only possible on condition that the actor lived through the characters he played, 'importing' his own experience as an actor and individual into the characterization. This implied a constant dialectic between representation and self-expression.

Individuality, modernization and the star

The need for self-expression which motivated the actor had its context in the accelerated modernization of China at the beginning of the twentieth century. Actors were affected by the repercussions of the May 4 Movement (1919), in which intellectuals and artists emerged as spokesmen for the values of their time. They were also influenced by the modernization of commerce and the emergence of more aggressive advertising on a large scale, which promoted both products and artists. In these circumstances, the actors of Jingxi, but also those of Bangzi ('clapper theatre'), Kunqu and the theatrical genres of Guangzhou and Shanghai, shared the modern desire to express themselves publicly and to attract the attention of the public at large. Under the Republic they tended to become media personalities, increasingly present in news-

papers, on the radio, on the wax rolls of phonographs, copper records and 78s, and in films of theatre.[25]

In a parallel development, their private life seems to have become a subject of general conversation. The image of the great Jingxi actors of the nineteenth century, such as the 'Three Legs of the Jingxi Tripod' [san dingjia] – Cheng Changgen (1811–80), Yu Sansheng (1802–66) and Zhang Erkui (c. 1820–c. 1860) – had remained more narrowly confined to theatrical circles. It was Tan Xinpei (1847–1917) and Chen Delin (1861–1930), who, at the turn of the century, started to gain greater visibility as they widened their audience socially and geographically. The more restricted image of the earlier actors was not only because the chroniclers of that time generally refrained from recounting the behaviour and exploits of such famous personalities of the day, due to the stigma attached to their profession and social class. Equally important is the fact that, despite some written accounts addressed to a cultivated readership – anecdotes, biographies and poems – there did not yet exist all the specialized publications and newspapers which in the 1920s and 1930s diffused all sorts of information about actors and the life of the theatre. Moreover, the major Beijing actors of the late Qing, partly patronized by the imperial court, had a much more restricted audience, and did not feel the same need to make themselves known as individuals to their public. In contrast, as communication networks multiplied in the 1890s, and still further in the Republican period, actors came to depend for their success on a generalized public, and no longer simply on the applause of an audience. To attain fame and attract a national audience, they became mobile, touring from town to town. Under the Republic, actors established their reputation in Beijing, but experimented and broadened their audience in Shanghai and Tianjin. If the label 'Beijing' was a guarantee of excellence and tradition for an actor, Shanghai 'was a fabulous city which could make an actor's fame and fortune, and yet, as many theatrical families knew only too well, break a man as quickly as it had made him.'[26]

At the same time, the actors of note began to polish their image in order to attract an urban audience more diversified and sophisticated than in the past, and thereby face the competition. In Shanghai, the newly emergent world of cinema and popular music offered a model for the business of promotion and commercialization. Specialized magazines, created by aficionados or the actors themselves, sprang up everywhere. Next to popularizing articles, one found anecdotes about this or that actor, together with his photograph. The photographs of the most

北平各界在東車站歡送程君玉霜遊歐攝影之二

Cheng Yanqiu before his departure for Europe from
East Railway Station, Beijing, 1932.

enterprising actors sometimes depicted them at the departure of a train,
or posed in Western male or modern female dress, rather than in the
traditional context of studio decor or on stage – thus placing them in the
van of modernity.[27] Farewell and welcoming committees were organized
when they travelled abroad, starting with Mei Lanfang's departure for
Japan in April 1919, as the first member of the acting profession to tour
abroad. On that occasion the members of the Beijing Actors' Association
celebrated his departure with great pomp at Beijing Railway Station.
Actors' names and appearance were no longer simply associated com-
mercially with record companies, but also with such items as make-up
and cigarette brands, just like the stars of cinema and popular song.
Sometimes they were invited to tour together with the former, as was the
case for Mei Lanfang who visited the Soviet Union in 1935 with the film
star and singer Hu Die, also known as 'Butterfly Wu'. In short, the actors
of note themselves became stars, by virtue of the means mobilized by, for
and around them. Thus Liu Shouhe, writing in the *Theatre Studies
Monthly* [*Juxue yuekan*] in 1933, could deplore the fact that the 'star
system' (in English in the text) of Chinese cinema was contaminating
Jingxi, and that female cinema stars were being compared with the 'Four
Great *dan*', and consequently with men.[28]

Advertisement for 'The Rat' brand cigarettes (early 1930s).
Beneath the drawing of Mei Lanfang the caption reads 'Smoking 'The Rat'
brand settles the mind; watching Mr. Mei's performances
wakes you up. Invigorating!'.

The new institution of the star reached its highpoint within traditional
Chinese theatre in the Jingxi form. As a star subject to broad public
exposure, the Jingxi actor was led to perform on several levels, both in his
professional life and outside it. This had a broader context in the new
cultural role of Jingxi in this period. Although Jingxi derived principally
from popular theatrical genres (*hua bu*), it proved capable of reconciling
different cultures to one degree or another (popular and literati, local and
national, traditional and modern), through means such as the synthesis of
dialects and musics. The actor, as the basis of traditional theatre in
modern China, was the principal vehicle of this integration.

At the beginning of the Republican period, the stars of Jingxi
sometimes went so far as to create plays and characters of a deliberate
modernism, which on occasion were inspired by real incidents of the
time. In *The Waves of the Evil Sea* [*Niehai bolan*], performed in 1914 at
the Tea-Garden of Heavenly Happiness in Shanghai, Mei Lanfang wore

a contemporary Chinese woman's dress and sat behind a Singer sewing-machine against a painted background, playing a young woman from a good family who had fallen into prostitution. Percussion accompaniment to dialogues and action was one of the play's rare concessions to tradition, along with the appearance of a male actor in the woman's role.[29] For *Spring Fragrance Disturbs the Study* [*Nao xue*] and *Heavenly Maiden Strews Blossoms* [*Tiannü san hua*], filmed for Commercial Press, Mei and the cameraman Liao Unsuo filmed the performance in long-shot in an artificially lit glass studio, which in 1920 was still the most modern method available in China.[30] The actor Yu Shuyan, whose conservatism has already been mentioned with regard to female students, allowed himself to be filmed by his friend Wu Youquan, during a private performance of *The Stele of Li Ling* [*Li Ling bei*] which Wu organized at his home in 1936. The experiment interested Yu, and following his friend's advice he decided to purchase a film camera and tape-recorder, both of them extremely expensive, in order to be able to document his own art. The hope was that in addition to ensuring that some trace of his outstanding interpretation would remain, the films would provide him with some means of support in his old age. Illness and, eventually, his death prevented him from bringing this project to completion.[31] In these various cases of fascination with modernity, Mei Lanfang and Yu Shuyan were motivated by personal work-related considerations, whether expressive, technical or other. The boldness of their acts contributed to their image as modern individuals, who were up-to-date with the latest technological innovations.

Actors were also led to socialize with those individuals who repesented the driving energy of an urban society in rapid transformation. They were found with politicians and other men of influence who were in a position to finance the actors' professional activities and ensure work for them.[32] These latter included bankers and entrepreneurs such as Feng Youwei, who in 1915 underwrote the construction of a stage for the preparation of a new play, *Chang E Flees to the Moon* [*Chang E ben yue*], for Mei Lanfang and his collaborators.[33] More sporadically, they were also sought out by foreign diplomats, admirers, directors and actors. For the most part, these contacts were in the nature of social and quasi-professional obligations. The actors made an appearance, fulfilling the public-relations function which their hosts expected of them. Often the meetings were immortalized by photographs of the participants in real-life poses: shaking hands, or sitting at the banquet table. Mei Lanfang's

Mei Lanfang and Mary Pickford, reproduction of a dedicated photograph, 1930.
The caption below reads 'Mei Lanfang in America with
the Empress Dowager of Cinema'.

Mei Lanfang (with a moustache) painting in his studio during the
Japanese occupation (c. 1938–45).

contacts with foreign celebrities during his tours abroad were, of course, duly reported in the Chinese press.

However, the foreign aggression that was a consistent feature of the modern Chinese experience until the 1940s, found a response in the theatre world as elsewhere, with stars such as Cheng Yanqiu and Mei Lanfang leading the way. On stage, they performed plays with patriotic themes, while off-stage they sometimes also took a public position. The most striking example of the latter type of response is Mei Lanfang's behaviour during the Japanese occupation. It goes without saying that a beard or moustache was out of the question for male actors playing *dan* roles. Mei Lanfang wore a moustache at only one point in his life, during the eight years from 1938 to 1945 when he refused to perform publicly for the Japanese occupiers, despite their requests and appreciation of his art. In this case, Mei Wanhua (Mei's personal name) took precedence over Mei Lanfang, his personal convictions displacing career consider-ations.[34] Such a move, which put the professional actor 'on hold', provisionally re-established the boundary between personal and theatri-cal identity.

The adulation of actors by aficionados (*ximi*, literally 'the theatre-fanatics') and the groups of amateurs (*piaoyou*) that thrived at the beginning of the century, expanded their popular base far beyond their new powerful connections. These individuals and groups were fierce partisans of their idols, and seized the slightest opportunity of approach-ing them, whether by attending their performances or by contriving to meet them off-stage; sometimes they offered a certain financial support, but above all they proffered their unwavering devotion. In New York today, the amateur groups of Kunqu, Jingxi and Cantonese theatre which have existed for decades mobilize *en masse* to welcome stars from mainland China, Hong Kong or Taiwan. Their efforts are often rewarded by the opportunity to perform on stage along with the star, but, no less important, the amateurs also gather every possible piece of information about the star in order to perfect their knowledge of his or her life, polishing further the star's aura and spreading new rumours. From the 1920s onwards, quite detailed biographies and critical studies were written by knowledgeable amateurs, who in this way indirectly shared some of the glory of their idol. Thus, the actor's admirers played a considerable role in confronting him with his own image, a phenomenon which is not unlike the devotional feedback upon which the Western opera star feeds.

The image of the star

In society's limelight, under constant pressure (at least, until the end of the 1950s) to perform in public, the stars of Jingxi had to contend with the fact that even their private life had a public dimension. In their leisure hours, we learn, the stars of the past above all practised traditional disciplines. The *dan* Zhao Rongshen has spoken to this writer of the seriousness with which his master, Cheng Yanqiu, practised the martial art of *qigong*, which teaches control of breathing and the flow of energy through the body.[35] More significantly, Cheng also studied the metrics of Chinese poetry. The fruits of this can be seen in his play *Wenji Returns to Han China* [*Wenji gui Han*]. This work, which exploits a literary theme, has as one of its highpoints an adaptation of a ballad that is generally attributed to Cai Yan of the Han period (206 BCE–CE 220). Cheng came from a poor Manchu family – his mother was an actress – but as a famous actor he was assisted by numerous collaborators; it is probable that librettists such as Luo Yinggong played a key role in introducing actors like him to a literary culture that was usually restricted to the highly educated. Numerous stars painted, or wrote calligraphy, most notably Mei Lanfang, who frequented Beijing's leading artists and produced a sizeable output himself.[36] He claimed to have been influenced in his stage movements by paintings that he had studied, and based more than one play on pictorial subjects. The stars sometimes also practised the Kunqu theatrical genre, the craft of which was particularly difficult and much appreciated by the literati.

Presented as providing the star with a moment of respite and solitude, these activities reveal the continuing relevance of traditional Chinese culture in enriching the star's sensibility, with obvious practical results for his art. However, in the case of painting and calligraphy they also helped to raise the star's social status in parallel with his social prominence, performing a role similar to the taking of several names. From another point of view, however, these rather serene activities also served to draw together the multiple individual, private, social, professional and quasi-professional personae of the Chinese star. Biographies often attribute a theatrical or educational goal to the star's 'private' activities. Such chronicling valorized the integrity of the man or woman in the theatre and in life, and provided the star with a positive image that cut nicely across all compartmentalization by erasing potential boundaries between the individual, the actor (actress) and the star. Only certain moments of – apparent – privacy were

divulged to the public. Their family relations and close friendships, not to mention their sexuality and way of life, remained for the most part in the shadows.

Our image of the life of the Chinese opera star is, for the most part, stripped of the arrogance, tantrums and annulations of performances which reinforce the aura of the divas of Western opera. It also lacks the suffering and tragedy which characterize the biographies of pre-war female cinema stars such as Ruan Lingyu and Zhou Xuan, who became living symbols of the oppression and exploitation of vulnerable individuals who attained popular success. The secrets of the great Chinese actors were better kept. To be sure, as soon as they became well known, reports of jealousy and bad temper, or drug addiction, or the slightest incident circulated among the aficionados. But at the time, this knowledge often remained at the level of rumour, and was subsequently suppressed by the establishment, both in mainland China and in Taiwan. Yu Shuyan, for cxample, found himself in a financially difficult situation at the end of the 1930s, despite a prosperous career as a *laosheng* that had lasted three decades. His biographer, Sun Yangnong, writing in the 1950s, attributes this to the costs of his illness and the inflation of the time, rather than to his probable free-spending during his years of glory. With the exception of rumours, which the actor was in a difficult position to control, the stars of the traditional Chinese theatre did not seem tarnished by the journalism of scandal.[37]

In reality, the dissemination of information to the public was rarely fortuitous or innocent. The biographies of stars were often written during their lifetimes or under the control of their families, and present their subject in a favourable light. They are sprinkled with anecdotes, and a certain number of more prosaic details intended to satisfy the curiosity of the public and to restore a human dimension to the person presented. The few private activities that were made known to the public provided the latter with no more than an idealized reflection of the star. While apparently lifting the curtain on his private life, the biography in fact constructs a personal mythology. The Chinese public respected this double game as conforming to its multi-dimensional conception of the human person, and did not perceive it as the symptom of a schizophrenic division between the actor and the individual behind the actor's mask. On the contrary, the public even contributed to the process itself, reinforcing the archetypal and integrated images of its stars. In the late 1970s, at Qufu, Shandong province, in windows adjoining the Temple of Confucius, one could see a display of fans painted with plum blossoms by

Mei Lanfang, as if to justify his greatness by placing a minor aspect of the man in a context heavy with cultural meaning.

The manipulation of the star's image reached an extreme point in the unsuccessful matchmaking of Mei Lanfang with Meng Xiaodong. As the first woman to accompany such actors in a male role, Meng earned the sobriquet of 'Emperor Meng'. It was at this point in her career, in 1926, that advisors to Mei Lanfang, then the leading male actor of female roles, in one of the strangest blends of life and art in modern Jingxi, arranged a marriage between Mei, 'the King of Actors' (who already had an actress wife, Fu Zhifang) and 'Emperor Meng'. To Mei's clique, which initiated this move, nothing seemed more natural than to transpose directly two such powerful stage figures into 'real life', at the cost of inverting the couple's on-stage gender position. The marriage proved to be short-lived, however. A year later a university student and admirer of Meng Xiaodong made an attempt on Mei's life, and this scandalous incident allowed Fu Zhifang to insist successfully on Mei's renunciation of Meng Xiaodong. This failed match surely took the porosity of the boundary between private and professional life to the extreme, as the stars' public image temporarily assumed control over their private life.

This history may put in a new light David Hwang's recent play, M. Butterfly (again, Western opera provides the Eurocentric point of reference for Jingxi), which was based upon the true love story between an actor of female roles from China, Shi Peipu, and a French diplomat. Shi Peipu had gained a certain reputation in Chinese theatrical circles in Paris during the 1980s. Shi's extraordinary adventures, involving a double scandal of espionage and transsexuality, were subsequently adapted in Hwang's play. Far from being upset over this turn of events, Shi at one point sought, unsuccessfully, to play his own role on Broadway, as if to blur the boundaries of his various personae even further. Shi himself, as an amateur performer in the much-changed circumstances of post-1949 China, would not normally have been able to attain Jingxi stardom. But his real-life career, even more than his exoticized dramatic characterization, was successful in reactivating the transsexuality latent in the famous male Jingxi stars of female roles of the past. Like them, he was able to reinvent a state of liminality between identities. Yet it is also a measure of the power of the stars of the Republican period who so enthralled Shi Peipu, that their play with boundaries, in which lies something of their 'star quality', survived onto the Broadway stage, albeit in distorted form, as one of the central themes of Hwang's play.

8

'Love Me, Master, Love Me, Son': A Cultural Other Pornographically Constructed in Time

REY CHOW

The cultural other: a pornographic construct in time

In an age in which 'identity' has become a crucial issue in cultural politics, the word we encounter most frequently is 'other'. To think in terms of our 'others' is to think, critically, of differences and boundaries. Often, it is assumed that the differences that define our 'others' imply a subversion, transgression and revolution of the stable boundaries of our existing identities, and thus the return of those boundaries to their constructedness and historicity. And yet, precisely because as a concept the 'other' is no less relative in function than other concepts, it can be the occasion for conservatism as much as it can be the occasion for radical possibilities. This essay is an attempt to demonstrate this ambiguity.

I take as my text a fictional narrative by a male Chinese writer about a lower-class woman: Bai Xianyong's (Pai Hsien-yung) *Yuqing Sao*. As it is almost a commonplace among critics and readers of non-Western culture to select for analysis a lower-class character, let me say at the outset that my interest is not that of idealizing a subaltern figure – an 'other' at multiple levels – as a means of criticizing some 'dominant culture'. Rather, it is to ask what happens when intellectuals such as ourselves – writers, critics, teachers – choose to represent this specific type of 'other' called 'the subaltern'. How do we become fascinated with subaltern figures, and at the same time protect ourselves from them precisely through the means of writing? Central to my concern are two issues: pornography and time.

The representation of subalterns shares a major characteristic with pornographic writing in the sense that it depends on a certain objectification and specularization of the 'other': the depiction of a subaltern, even when it is not replete with violence and aggression, is often replete with

details that excite our emotions because of the exoticism of the gender, race and, most importantly, class. I emphasize class because it is, in the most abstract sense, what signifies the difference between 'having' and 'lack', be that difference construed sexually, metaphysically, or, as is most commonly the case, economically. Both 'subaltern' writing and pornographic writing invest their fantasy in breaking the limits of propriety.[1] In each case the specularity/spectacularity of the object is produced not only by the act of representation but also by represent-ation-as-reflection-of-(the object's)-debasement. If the excitement of pornography can be described as something like 'the dirtier, the better', then the excitement of subaltern-representation may be described as something like 'the more socially deprived, the better'. Both types of excitement depend on the object's lack – that is, her great wantingness (or shall we say wantonness) and thus her invitation to the reader to actively fill that lack. In speaking thus, I am not, of course, against sympathy for the 'lower' classes. My concern is rather with the pornographic use of such classes for forms of intellectual pleasure and closure – conceptual or practical – that actually reproduces rather than challenges existing social injustice.

To see how social injustice is reproduced, another question must be asked: How is the representation of otherness mediated by time, often in ways that escape us? Take the example of East Asian literatures, in which time is frequently a thematic concern. Time is associated with the 'changefulness' that leads to deterioration – a state that is inferior because it lacks the plenitude of that which precedes it. The passage of time thus, it is often said, denotes the fleetingness of human experience, the futility of human endeavours, the transience of beauty, the imminence and certitude of death, and so forth. Bai Xianyong, for instance, describes himself as having been very sensitive to time since he was a young man.[2] This sensitivity depicts time as the supreme aggressor to whom the writer himself becomes subjugated. But unlike the pornographic image of the depicted object, time is invisible; its aggression is always understood only retrospectively, in the marks and traces it has left behind. How then does the belatedly-felt aggressivity of time become an active means of keeping the other in place and thus of intellectual self-defence? What is the structural relation between time and the pornographic?

The Story of Yuqing Sao

The novella *Yuqing Sao* was first published in 1960 by Bai, who spent his early years in mainland China, Hong Kong and Taiwan. He now resides

in the United States and teaches at the University of California, Santa Barbara. It tells the tale of a woman servant, Yuqing Sao, in the early part of the twentieth century in Guilin, a city in southwest China. A widow from a relatively dignified family, Yuqing Sao works at a wealthy household as the nanny to the young boy, Rong Ge, who is the narrator of the story. She is beautiful, clean, gentle and hardworking. She is popular with everyone, especially Rong Ge. She does not seem interested in getting married again. By chance one day, Rong Ge discovers that Yuqing Sao has a younger 'nominal' or adopted brother,[3] Qingsheng, a sickly but refined young man who lives by himself not too far away from the house in which she works. Rong Ge quickly develops a friendship with Qingsheng, taking the latter to restaurants and operas. Only at a later point does Rong Ge discover – uncomprehendingly – that Yuqing Sao and Qingsheng are lovers. The story takes a tragic turn when Yuqing Sao finds out that her lover has fallen for another woman. Trying in vain to keep Qingsheng to herself, she loses all hope in life. She goes to Qingsheng's house one day and stabs him to death. Then she kills herself.

The dangerous supplement

The fascination with characters from the lower class is a familiar one in modern Chinese literature. One paradigmatic type of narration is that frequently used by Lu Xun (1881–1936), who emphasized the irreparable gap between an intellectual narrator and a lower-class person.[4] The effect of Lu Xun's stories is always that of guilt, which we may describe as an emotion created – in the privileged – by the disparities between privilege and subalternity. In Bai's story, however, the emotional effect created by the object is of a different and arguably more dangerous kind. Whereas the boundary of class – the distinction between high and low – remains clear in Lu Xun, Bai merges the familiar interest (among twentieth-century Chinese writers) in subaltern figures with another interest, the formation of sexual desire *across* class boundaries, by depicting Yuqing Sao as a sexually attractive woman. In doing so, Bai comes much closer than most modern Chinese writers to the paradigmatic amalgamation of sexual excitement and social debasement as described by Peter Stallybrass and Allon White. Stallybrass and White show in their study of European male writers such as Sigmund Freud and Walter Benjamin that 'what is socially excluded or subordinated is symbolically central in the formation of desire.' This kind of desire, aptly summed up in the scenario described by Stallybrass and White as 'the conjunction of the maid kneeling in the dirt and the standing voyeur who looks on with fascination',[5] is usually the

desire of the middle-class male for those women who occupy lower-class positions such as maids, nurses, nannies and prostitutes.

In the case of *Yuqing Sao*, the merger of the two types of interest is further complicated by the fact that it is Yuqing Sao, the lower-class woman and the sexual object of the narrative gaze, who is depicted with active sexual desire, while the 'voyeur' – the on-looker from the higher class – is a little boy. As a subaltern, then, Yuqing Sao is a contradiction in terms, a lack and a void (in terms of social power and traditional gender construction) and an excess (in terms of sexual power and individualist agency) at once.

Let us first examine the excess. The excessive reality of love and sex in the modern world always carry with it an emancipatory potential. Someone 'coming out' is someone coming out of the repression of his/her secret but real sexuality; 'revelation' results in a kind of freedom. In *Yuqing Sao*, love and sex represent a form of emancipation as well, since as a widow in feudal China, a woman's active sexuality is supposed to have come to an end: a widow is not supposed to have another man in her life. Yuqing Sao's secret affair is, then, a direct challenge to the Confucian moralistic imprisonment of female sexuality. But this 'emancipation' does not carry with it the meaning of a teleological progress toward happiness and sexual fulfilment; it is the beginning, rather than the end, of her tragedy.

In her love for a younger man, Yuqing Sao's plea is a double one, mediated by two types of social hierarchies, both of which are related to gender. The first of these hierarchies is heterosexual difference, in which male sexuality is dominant; the second is age difference, which in traditional Chinese families means that those who are older are usually dominant, although in the case of an older woman and a younger man – as in this story – that dominance is uncertain. Yuqing Sao wants, in other words, to be loved both as a woman and as an older woman, by someone who is thus simultaneously her master and her son (or younger brother). Her love is as tender and caring as it is overbearing and oppressive. Time and again she begs her lover not to desert her: she will work a few more years, she says, and then they can retire to the countryside together. She would devote her entire life to him as long as he remains unchanged. This love takes the form of holding the loved-one prisoner; she is displeased even by the thought of Qingsheng's leaving the house for a walk by himself.

Yuqing Sao's relationship with Qingsheng is not merely a private subversion of social propriety, but a transgression of it at multiple levels.

As a member of the servant class, her 'secret' makes her vulnerable to further degradation. But more important is the way she breaks the rules of kinship. As she and her lover address each other by familial titles (Yu *zhi*, 'older sister Yu' and Qing *di*, 'younger brother Qing'), her love is virtually incestuous. ('Incest' in Chinese – *luanlun* – literally means a 'confusion' of the 'kinship codes' and has nothing to do with biological commingling *per se*.) She is also a nanny, a surrogate mother figure, the popular conception of whom is usually divorced from sex. The many social positions Yuqing Sao occupies – social positions that are demarcated clearly within the kinship system – mean that her transgression is an overdetermined one.

In his criticism of the phonocentrism of Western philosophical thinking, Jacques Derrida has described the activity of writing in terms of what he calls the supplement. As supplement, writing is that which seems to come later than the voice and is thus always attributed an inferior and derivative quality. According to Derrida, the peculiar truth about the supplement is that its secondariness is really a firstness: appearing as a mere addition, the supplement also substitutes, thus fundamentally replacing and reorganizing what came 'before'. It is thus a case in which two apparently incompatible events happen simultaneously. Derrida writes:

the concept of the supplement . . . harbors within itself two significations whose cohabitation is as strange as it is necessary. The supplement adds itself, it is a surplus, a plenitude enriching another plenitude, the *fullest measure* of presence. It cumulates and accumulates presence. It is thus that art, *technè*, image, representation, convention, etc., come as supplements to nature and are rich with this entire cumulating function . . .

But the supplement supplements. It adds only to replace. It intervenes or insinuates itself *in-the-place-of*; if it fills, it is as if one fills a void. If it represents and makes an image, it is by the anterior default of a presence . . . the supplement is an adjunct, a subaltern instance which *takes-(the)-place* [*tient-lieu*].[6]

The logic of criticism inherent to many contemporary discussions of otherness is the logic of the supplement, which Derrida, interestingly enough, emphasizes as a 'subaltern instance'. By introducing another culture, history, sexuality, class, race, body, etc., what we try to do is to add to but also restructure the boundaries of existing knowledge. In Bai's story we have a depiction of a cultural other, a subaltern figure, in multiple supplementary relations: Yuqing Sao's behaviour is enormously destructive because it throws into open confusion the codes of class, kinship, sexual difference, and age. For instance, Yuqing Sao is not

simply a nanny, an older sister, and a member of the lower class; she is a lower-class woman with sexual desire. But her sexual desire is not simply sexual; it is also motherly and sisterly, familial and kin-bound, and containing the affection of the older for the younger.

From the beginning, the narrative describes her in a way that is physically attentive. The little boy likes her immediately on seeing her:

When I came downstairs, the sight of Yuqing Sao standing next to my short aunt took my breath away. How neat and clean, and how pretty a person! She was wearing a moon-white servant's jacket and trousers and a pair of black cloth shoes with laces. Her shiny black hair was tied up loosely in a bun like that of Cantonese women, with a pair of almond-sized white earrings just hanging outside its tips. She had a clean-looking oval face, with eyes clear like water . . .

I could not say why, but I felt I wanted to be close to her the moment I saw her.[7]

By accident one day, Rong Ge catches her in one of her intimate moments with her lover. The image of the quiet pretty Yuqing Sao is now strongly contradicted by a fierce and aggressive picture:

Yuqing Sao looked frightening. Her face was red from being drunk. Her two cheek bones shone so bright that they looked like they would catch fire soon. Her forehead was full of sweat and her hair, soaked through with sweat, stuck to her face. Her eyes were half open and very bright; her mouth was slightly open and she was murmuring something. All of a sudden, she bit into Qingsheng's shoulder as if she had gone mad, gnawing back and forth so much so that her hair was all dancing. Like the claws of an eagle, her hands grabbed Qingsheng's pale back, digging deep into it. After a while, she raised her head and, holding Qingsheng by his hair, pulled him towards her breast with a force as strong as if she was trying to mash him into her heart. Qingsheng's two long thin arms kept shaking, much like the trembling small legs of a deeply wounded little rabbit which was paralyzed on the ground, weak and powerless. When Yuqing Sao bit him on his shoulder again, he struggled against her and rolled to the middle of the bed, and started sighing in pain. There was blood at the corner of Yuqing Sao's mouth, and Qingsheng's left shoulder was also bleeding . . .[8]

This violent scene is quickly replaced by one in which, alarmed by the pain she has caused her lover, Yuqing Sao touches him with her usual tenderness.

As a 'part object' of love, Yuqing Sao is thus both the good and the bad object, soliciting from the child the most idealizing and the most fearful emotions at once. But more important, I think, is the pornographic way in which she is described in the act of sexual intimacy. As readers, we share the hole in the paper window with the voyeuristic child. What we see is not simply a picture of a woman having sex but a picture of feminine sexuality-as-insanity-and-animality, even though Bai himself

described it afterwards in dignified humanistic terms.[9] In other words, the pornographic view here is 'enticing' not because of the overtness of sex but because sex is represented in an overlapping series of significations and displacements – as physical violence, as animal aggressivity, as lower-class and, ultimately, as older female and as servitude.

By drawing attention to this central scene in the story, my point is not exactly that of accusing Bai of dehumanizing Yuqing Sao. (This is a possible reading, but it is not the one I am following.) What I find interesting is that this pornographic scene, like Yuqing Sao herself, occupies a relation to the entire story that we may call, after Derrida, 'supplementary'. It comes second to the good and kind impression we have already formed about her, and its difference from that first impression forces the narrative to take a certain decision. The narrative, as it were, has to make up its mind about how it is going to deal with this 'addition'. The radical logic of the supplement, we remember, is that while it adds, it substitutes. But, as in the case of any boundary, there is nothing intrinsically uncontrollable or unmanipulable about the supplement. If the supplement's radicalism is potentially a source of chaos – a boundary, though seemingly stable, can itself be reconstituted over and over indefinitely – such radicalism also contains the option of conservatism and recontainment: what substitutes anarchically can be treated, retrospectively and deliberately, as *mere* addition, as mere ethnic detail to be bounded and incorporated.

Traditionally, a society has many ways of bounding and neutralizing the significatory force of the dangerous supplement. One effective way is by glorification – by raising the supplement to a different level of signification where it no longer shares the same relation with other members of the same society. For instance, we do this by sanctifying members of the lower classes so that, in a way that is stripped of basic human needs and desires, a lower-class person becomes a kind of sacred figure, raised to a moral level at which we forget precisely her daily cares. Modern Chinese literature is full of examples of this kind of sanctification of the dangerous supplement. Where a lower-class person's conduct may, in fact, threaten to overthrow the moral structure that holds a society together, literature often makes her part of the very support, the very boundary of that structure, by glorifying her. Central to such glorification in the case of lower-class women is a prohibition of their sexuality.[10] We thus have countless women characters who are 'admirable' because they live their lives as self-sacrificing motherly servants with little sexuality and subjectivity.

Yuqing Sao's story, because it transgresses social propriety at several levels at once, does not allow such a glorification/prohibition. As a lower-class woman, she is *also* sexually active. She thus makes it difficult for the usual normalization of the dangerous supplement to take place, but instead, brings the shattering power of that supplementarity – both social and sexual – into full force. She is a woman of the family who invades the stronghold of kinship bonds and emotions from within with the violence of an enemy from without: she is a sister and mother who acts as a woman with her own independent value system. The nature of her love is hopeless; it has no future even though she has invested her entire life (force) in it. She draws her happiness exclusively from this dead-end course of love. It is as if, having rejected the traditional mores of Confucian society, she helps consolidate those mores in a different way by basing her happiness entirely on a heterosexual emotional contract and on the emotional loyalty of her sexual partner. She exchanges her own life for this contract – for the supposed materiality of this contract – only to find that she has been cheated of her payment.

Yuqing Sao's extreme 'violence' and 'aggressivity' are thus the qualities of a woman who, like any despot, seeks to establish her own legitimacy by subjugating others. This, rather than a failed love/failed sexual relationship, rather than the adultery which causes tragedy in more 'proper' settings, is what constitutes the catastrophe of the narrative. The catastrophe is that the familial emotions of kinship representation no longer make sense, not even to Yuqing Sao herself. (Early on in the story, she rejects the chance of a second marriage, which would have repositioned her safely within conventional kinship bonds.) In terms of the 'Law' that is social propriety, Yuqing Sao is not simply opposed to it or resisting it; rather she is substituting her own law for it. Her 'breaking' of the Law is thus as absolute and irrational as the Law itself, and we are left incapable of either reaffirming the Law or (as in many cases of literary representation) affirming (the subversiveness of) the crime.

Bai's conscious frame of representation, however, refuses precisely to grant Yuqing Sao her legitimacy as a new Law and thus, we may say, her full significatory power as the dangerous supplement. Instead, he subordinates Yuqing Sao to a more familial, familiar and *readable* narrative – that of a woman who cannot be sexually aggressive without hurting/killing herself. Thus we have, once again, the conventional ending of a heart-rending female suicide. The act of suicide confirms Yuqing Sao's dependence on her male lover and thus the kinship system – her master – to which her life has in fact posed a fundamental challenge.

The narrative decides that as she kills this lover/younger brother/son, she also must kill herself. Only thus can the meaning of her life be 'preserved' by Rong Ge, her other son and her actual master in terms of economic class.

The innocent child

Bai keeps Yuqing Sao in a reticent position by constructing his narrative in such a way that she is already a memory – a time past. The story is told to us by Rong Ge, her 'master' in terms of class and her 'son'/'younger brother' in terms of gender. Rong Ge is at once the Law that punishes her and a version of the libido to which she submits in her love for a younger man.

In the key scene in which he sees Yuqing Sao in her sexual activity, Rong Ge's 'vision', because it is that of a child, is potentially a kind of indeterminacy. The use of a child is a method with which we can defamiliarize reality – to use the term from the Russian Formalists – for the purpose of shock. And yet, it can also be used for the opposite purpose, as I think is the case with the narration in *Yuqing Sao*. Instead of defamiliarization, the child is used here to make blank (and thus to normalize) a reality that has got out of control, so that the dangers of the other can be safely smoothed away in conventional understanding. Later, at the scene of the murder and suicide, Rong Ge literally 'blanks out', or faints, at the sight of the corpses of the lovers. Subsequently he recovers, grows up and writes the story, and Bai's own description of the novella highlights this 'recovery' and 'growth': 'This story can be classified as "enlightenment fiction". One of its chief themes is the growth of Rong Ge. Therefore the emphasis of the script falls on his psychological transformation on witnessing two major lessons of human life, love and death.'[11]

By distancing us from Yuqing Sao's story through the blanking/transparent frame of a child, Bai leaves many issues unexplored. The more or less innocent young boy intuitively senses the unusual relationship between Yuqing Sao and Qingsheng, but he does not understand it. At this point, it is important for us not to follow the logic of Bai's own description of the story that I quoted above, which, by casting the story in the form of a *Bildungsroman*, would have us conclude that Rong Ge's inability to understand would be overcome subsequently by his maturation. Instead, I want to offer a different kind of reading by highlighting the child as a strategic function of time. The most important feature of the young boy's representational frame is that Yuqing Sao's story is cast in the form of a memory of an *other* time. Why?

The little boy's narrative makes it difficult, if not impossible, for us to say that this is 'male subjectivity' representing female tragedy as spectacle. If it had been, straightforwardly, an adult male narrator, it would be possible perhaps to question the complicity of a male narrator who occupies the same time frame – the same kind of chronological age – as his object. A male narrator of this kind would not be able to claim that he did not understand what was going on. But because the narrative point of view is that of a child, who is, in terms of age, in a different kind of time, we cannot put the burden of responsibility of understanding on him – after all, the child is merely a 'white sheet of paper' recording what he sees, so how can we blame him? What the frame of the child does to the story of the passionate woman is a kind of caption written in the present about the past: 'As seen and remembered by a non-comprehending child.'

Once we stop thinking about the passage of the child to adulthood as a linear progress toward maturity, and instead view the two stages as two different temporal orders, we will see that the child in this story acts as the kind of alibi or turnstile that Roland Barthes describes as the mechanism of ideology in his early work *Mythologies*,[12] the mechanism that works by being precisely what we think it is not. Do we say that Rong Ge understands everything? No, because he is too young (and too much of a 'blank'). But do we say that everything escapes him? No, precisely *also* because he is 'blank' and 'transparent': he sees and records everything. Where the 'content' of Yuqing Sao stands out as a kind of corrupt 'signified', the child's narrative, as signifier, blurs its intricacy and emotional complexity; but where Yuqing Sao's story is subordinated to the more 'innocent' eyes of the child, those eyes have also captured and remembered all the 'pornographic' details vividly.

The questions of the child is thus not a simple one. To what is the child related in order to be the child that he is? To what kind of emotional structure, corresponding to what prospective identification? What 'future' subjectivity lies in wait for the particular childhood as con-structed here? To whom is the child a father, and – in what amounts to the same question – who is the father to the child? Most importantly, how is the father-child relationship formed? As Gilles Deleuze and Félix Guattari write in *Anti-Oedipus*:

... social investments are first in relation to the familial investments, which result solely from the application or the reduction (*rabattement*) of the social investments. To say that the father is first in relation to the child really amounts to saying that the investment of desire is in the first instance the investment of a

social field into which the father and the child are plunged, simultaneously immersed.[13]

The use of the child suggests a kind of ambivalence of structure as regards the 'female' content of the story. It is as if the author is fascinated enough by Yuqing Sao to want to write her story, and yet wants to defend himself from her destructiveness by pretending he is still a child himself. But what does it mean to represent an other in the past while the self remains a child? It means fixing the other in a specularized time which is dead, while imagining the self as a reversible time-machine that is able to move back and forth between the past and the present as it wishes. This temporal reversibility of the writing/intellectual self thus distinguishes itself from the other, who is cast in what I call a pornographic timelessness.

The woman that is not woman

Bai's treatment of Yuqing Sao is especially thought-provoking if one considers his own background. Bai had a privileged childhood much like Rong Ge's, although his family, which had strong connections with the Guomindang (Chinese Nationalist Party), had to leave China during the 1940s, around the time the Communists took over the mainland. They lived for a period in Hong Kong and then in Taiwan, and Bai eventually studied and settled in the United States. However, if his multiple-outsider identity is anchored fictionally in his characters, it is not much anchored in Yuqing Sao, who is portrayed in an idealized but extreme form, as it is anchored in the relationship between the young child and Qingsheng, Yuqing Sao's lover.

Interestingly, Qingsheng is portrayed in the way that many *heroines* of the traditional Mandarin Duck and Butterfly novels are portrayed: he is orphaned, good-looking, sickly and artistic. In the depiction of this male character, Bai is thus following what has been a strong trend in modern Chinese fiction since the early twentieth century, a trend by which 'woman' occupies a prominent position as the embodiment of social problem, fictional experiment and revolutionary hope. It was through the systemic transformation of women's status at the turn of the twentieth century – through the gradual availability of educational opportunities as well as the burgeoning of mass communications and entertainments in urban areas – that the awareness of the meanings of gender constructions became generally intensified. In this intensification of perceptual processes, the traditional injustices suffered by women became, for the first time, fully articulable as both narrative content *and* method. The appearance and prevalence of 'femininity' in narrative fiction is the mark

of a socio-perceptual change, partaken of by both male and female writers alike. To stage women as the objects of narration – as the 'other' that enables the unfolding of narrative time and space – is, by the mid and late twentieth century, a well-used narrative practice.

If both Qingsheng and Yuqing Sao are socially deprived people – we are told that Qingsheng was thrown out of the house by his relatives because of his illness before he was adopted by Yuqing Sao as a nominal brother – Bai seems undecided as to whether to associate the state of deprivation in gender terms with the man or the woman. While by the 'normal' conventions of gender, Yuqing Sao is the deprived woman, in their relationship Qingsheng is completely dependent, feminized and infantilized. The investment of vulnerability and lack in the male rather than female character is perhaps an early sign – early in terms of Bai's writing career – of Bai's effort to come to terms with his own homosexuality,[14] which finds its point of identification with the male lover and male child, both of whom are placed somewhat at the mercy of a powerful female character. Against the background of female power, the intimate brotherly bond between Qingsheng and Rong Ge is important in a way that is easily forgotten. There are episodes in which the male child's fascination with the physical features of his male friend is at least as strong as his fascination with the maternal figure, in a manner that is highly suggestive of homoeroticism.[15] One might say that the dissolution of Qingsheng and Yuqing Sao's relationship (and hence the demise of Yuqing Sao's power) begins when the two males start going out together and the younger boy takes Qingsheng to the opera, where he encounters and falls in love with a young actress.[16]

In his passivity, Qingsheng shares with Rong Ge the same kind of position vis-à-vis Yuqing Sao; that is, he simulates the male *child* whom, in spite of its title, this story is ultimately about. It is as if Bai only wants to 'know' about the difficult sexual relationship between a man and a woman from within the safe boundaries of a child's consciousness; it is as if he is presenting such a relationship in its full complexity and yet declaring that he has nothing to do with it because he does not understand it. The 'it' he does not understand is, precisely, the sexuality of the woman.

Hence we have a divided narrative: on the one hand, a violent sexual story of possessive female love; on the other, a kind of indifference or non-participation in that love even while it is recorded as a story complete with tabooed details. But the 'lack of interest' on the part of the narrative frame is not simply a matter of childlike innocence; it is more,

I propose, the lack of interest on the part of someone who belongs to a different sexual economy and who, for all his sympathy and affection, literally cannot enter Yuqing Sao's world. As in the case of some of his other narratives about women, Bai stops short of describing the female character's subjectivity.[17] His female characters thus remain fetishized as external objects – beautiful, fierce, powerful, but strangely unhappy and bound by time. On first meeting Yuqing Sao, Rong Ge thinks:

I really like her outfit, especially her earrings – they were so white that they were glittering, how lovely! But when I looked at her closely, I saw that there were a few wrinkles on her forehead. And when she smiled, there was a fish tail at the corners of her eyes.[18]

Wrinkles and crow's feet: even the child sees that this woman is getting old. (Yuqing Sao is just over thirty, but this is old by traditional Chinese standards.) This means that her 'good' life – her youth – is drawing to a close. The weight of time creeping up on her is such that she would not be able to escape. But all of this 'understanding' remains at the level of a careful noting of the woman's visible physical features only. While we know how Rong Ge thinks and feels, we only see Yuqing Sao from the outside.

If the dangerous passion of the woman is a supplement to the dominant law and order in Derrida's sense, then the child's function is to provide an escape route from the anarchic force of the supplement. The child reduces the danger of that supplement to fiction by way of his 'innocence', subtracts the supplement from what it has already substituted, and thereby returns things fantastically to a kind of pre-supplementary reality. The child's narrative undoes things in such a way as to make us feel that time is *reversible*. But precisely because there is no such thing as a child's unmediated narrative, what poses as temporal reversibility must itself be seen as a crafted writing, a conscious means of distraction, and a deliberate way of backing off from the feminine dangers it has introduced. In the language of time, the child's 'innocence' is the nostalgic longing for the infinite futurity that we associate with 'youthfulness'. The real meaning of Bai's self-proclaimed sensitivity to time is thus gerontophobia, the fear of aging that characterizes Western and non-Western literature alike,[19] and that he veils with the fetish of a lower-class woman's sexual life.

Yuqing Sao's plea, which I interpret as 'Love me, master, love me, son', is left in the form of that typical lack/deprivation of femininity which can only be completed by man and the social order he creates. Because that

plea can, in terms of that social order, never be fulfilled in the way she desires (to be loved both as mother/sister and as sexual partner, both as insider and outsider), she is returned to a conventional fate, murder and suicide, as her 'way out'. Throughout the story Yuqing Sao is shown to be someone who knows exactly what she wants and what she is doing. She is put in a kind of time in which her knowledge, will, labour, sexuality and action are 'at one' – time*less* – while the narrator is uncertain, changing and alive.[20] The narrative, constructed in what we might thus call male time, is possible and potent only because it does not understand the woman's point of view, and male time, we might say, is the reward for remaining an uncomprehending child.

9

Who Is Speaking Here?
Discursive Boundaries and Representation
in Post-Mao China[1]

ANN ANAGNOST

Scholarship on socialist China has long been caught in the riptide of cold war discourse. The revisionist scholarship of the late 1960s and 1970s strongly challenged our perception of socialist China as a demonic regime by carefully considering the apparent promise of a socialist road to development for nations confronting the economic and military challenges of advanced capitalist countries. In the post-Maoist era, leftist scholars must now contemplate the often enigmatic questions of what a socialist legacy has meant for China, while others dash ahead to declare an 'end to history' in the apparent global triumph of capitalism.

Therefore, in some circles, it has become fashionable once again to speak of Maoist China as a transcendental object that can be known absolutely or woefully misconstrued – as something 'gotten' right or wrong. For example, Steven Mosher's recent volume *China Misperceived* suggests that any positive reading of China's socialist revolution betrays a naive susceptibility to the artful surfaces of socialist realist representation.[2] The bloody crackdown of 4 June 1989 becomes in his narrative a mere unmasking, the exposure of a moral vacuity that was never acknowledged by Western apologists. A vacuity, moreover, that existed *from the very beginning* of the socialist experiment in China.

How curious that one of the most important documents in the case was never once mentioned! William Hinton's *Fanshen*, perhaps more than any other work, transformed American perceptions of the Chinese revolution and inspired a new generation of scholarship that sought to understand the success of socialist revolutions in engaging the 'hearts and minds of the people'.[3] *Fanshen* is clearly the most ethnographic account we have of how the revolutionary discourse of class struggle reshaped the world view of the great mass of China's illiterate peasants. Why, then, is Hinton so egregiously missing from the crew of leftist 'adventurers' and

writers targeted by Mosher's book? Perhaps Hinton stayed too long and saw too much to have fitted comfortably into Mosher's thesis of a journalism incapable, or unwilling, to penetrate the surface. Yet Hinton's authority as an ethnographer is not unassailable; indeed he does not enter his own narrative until he is halfway through it.

This fact more than any other demands that we should be aware of how deeply Hinton's account is implicated in the 'cogs of narrative' – already set to turning well before his arrival in Long Bow, the Chinese village in which his account is set.[4] And these narrative practices are what I wish to focus on in this essay, not only to reassess the very real value of Hinton's account for our understanding of the Chinese revolution in the aftermath of 1989, but also because they should lead us toward a more reflexive understanding of what it means to be 'doing fieldwork' in a place where ethnographic practice is sometimes dramatized as a guerilla operation aimed at eluding the ubiquitous presence of 'the state'.

The way in which Hinton was caught up in the cogs of narrative even before he entered into the complex drama of land reform and class struggle in Long Bow, evokes for me my experience of fieldwork in China in the early 1980s. What ties my present rereading of Fanshen to my earlier field research is a question that both experiences inevitably raise. Whether it is the poor peasants 'speaking bitterness' in Hinton's book, or the veteran artisans of Yixing County recounting their histories of work to me, we must ask: Who is the speaking subject? Is it the subject who speaks, unproblematically, as the liberated consciousness of the silenced in history, or, as poststructural theory would have it, is the narrative, somehow, 'speaking her'?

In the wake of constructive criticism, to assume that the spoken word conveys spontaneous thought, unmediated by invisible and often unconscious boundaries of a discursive order would, of course, be naïve. Indeed, for the ethnographer, this order is all too physically represented in the meeting room by those officials whose job it is to 'facilitate' the work of the foreign researcher. But even when one moves beyond the formal confines of the interview room, redolent with pleated slip-covers, tea and peeled fruit, to confront the 'masses' on the street, how is one to read the quoted fragments of 'official speech' which seem to surface so naturally in the chatter of everyday life?

Can this unexpected presence of 'official language' signify only the extent to which the power of the state has become internalized within the speaking subject? Can we not conceive of power as a more dialectical

process that returns some agency to the 'masses' in shaping the meaning-fulness of language? In all of our discussions of the boundary between state and society, ought we not to extend the mapping of this ephemeral topology to processes internal to the speaking subject herself? What happens to our dichotomies then? Would the objects of our gaze then dissolve into the atmosphere, like the mad paintings of Balzac's 'Unfinished Masterpiece'? To include in this collection on boundaries an essay intent upon dissolving the boundary between state and society – the very boundary it proposes to take up for examination – may perhaps be taken as a teasing sort of imposture; but the intention is serious enough. By starting with categories 'natural' to our thinking, their subsequent dissolution may help us to transcend the limitations of understanding a complex phenomenon too simply. What we call the 'state' and what we theorize as 'society', as somehow beyond, outside or separate from the state, become problematic when we refocus our inquiry upon the speaking subject. As noted recently, a 'state' has two senses; it is both an 'institutionalized political order *and* a condition of being', therefore it is 'as much a matter of politics of perception and experience' as it is 'an exercise in formal governance'.[5] I will argue that the speaking subject does not lie completely within or without the state, but represents the site of contestation whose 'voice' presumably gives access to the 'will of the masses' – the trope that both anchors and contests the politics of representation in socialist China.

To pursue these questions, I wish to take a closer look at *Fanshen* as a story woven from a multiplicity of narratives, most importantly those narratives called 'speaking bitterness' (*su ku*), which were critically important in the formation of a revolutionary consciousness in the period of class struggle and land reform. To the extent that these 'speaking bitterness' narratives were able to reorder memory and thereby bring into question all existing social relations, they became intricately involved with the 'politics of perception and experience' in the constitution of a class subject. Moreover, their chronicle of personal sorrow articulated a national consciousness in the lived experience of war and political dissolution, constituting in the process a national subject that is no mere adventitious effect, but an outcome deeply imbricated within the process of class struggle.

Moving away from *Fanshen*, to a discussion of my first fieldwork experience in the 1980s, I will illustrate how the 'speaking bitterness' narratives became institutionalized in the production of local histories, as they came to be written and spoken in post-revolutionary political

culture.[6] The power of these narratives as myths was their power to evoke the hellish conditions of the 'old society' against which the 'new' and socialist present could define itself. Yet this power was not boundless and these narratives, by insisting that their history was 'the only significant history', themselves became a form of alienated consciousness.[7] Given their initial power to 'launch national subjects', it is important here to ask why the mobilizational strategies of civil war remained so prominent in a post-revolutionary society.[8] Had class consciousness and national feeling become so intertwined in the drama of revolution that abandoning the first would have threatened the latter? The recalling to memory of class struggle may have masked the emergence of new contradictions internal to Chinese society; but at the same time, China felt increasingly isolated and besieged at the level of global politics. The forces bearing down on China from without were once again projected inward, in a process that proved to be self-destructive. Perhaps it is an irony of history that the venting of pain and rage, of 'speaking bitterness', echoed eerily in the days following the fall of the Gang of Four, when memory organized itself around a new point of rupture in which the Maoist period itself became the negatively valued past.

During my field research in the early 1980s, I found it difficult to move outside the formal rituals of 'going down to the countryside' (*xiaxiang*) to the local level.[9] It was apparent from the start that the formal presentations made to me by local workers were part of a larger narrative that had existed long before my presence as a researcher. This narrative was, in a sense, an official history, but to subsume it under the authority of the Communist Party seemed entirely too simple. The second section of this essay is a reflection on the dialogical emergence of the 'speaking bitterness' narrative even as it was written down and institutionalized within a local political culture, producing a locally specific politics of perception and experience that constituted local identities as well as national subjects.

In the final section of the essay, I will shift the discussion to the muting of the class subject in the post-Maoist period and the emergence of a quite different narrative of the nation that is grounded in despair, producing a new national subject in terms of 'lack'. Where the failure of China to progress in history had been assigned to external forces – the impact of imperialism and the world expansion of capitalism – it is now internalized as an insufficiency intrinsic to the self. The subaltern subject, defined in terms of 'peasantness' and poverty, is no longer constructed as a potentially progressive force in history, but as the source of China's

backwardness, in need of eugenic management and a wide array of orthopractic measures. The party continues to imagine itself as the supplement necessary to 'liberate' the masses, but in terms radically different from the harnessing of a revolutionary force. The subaltern is no longer the true subject of history, but an inert mass rendered passive by the flawed promises of Maoism. The party constructs itself as a pedagogical force intent on 'raising the quality of the people' (*tigao renmin suzhi*), inciting their productivity, their desire for commodities, and their attainment of new standards for civil behaviour. The urgency invested in activating this overpopulous and inert mass legitimates the modernizing rationality of a strong centralized state, deferring indefinitely the possibility of a more participatory politics.

This emergent discourse on 'population quality' (*renminde suzhi*) is not limited to official discourse. It underlies oppositional discourse, as well as pervading popular consciousness. In this circulation of meaning, the pronouncements of the state, where they are most vague and tentative, are elaborated in great detail in popular speech and practice as well as in mass media and scholarly discussion. The power of this discourse to articulate an historical accounting for the continuing failure of China as a nation 'to come to its own', to assume its rightful place among the developed nations of the late twentieth century, suggests that it has displaced the discourse of class to become a new currency of exchange in the politics of perception and experience of the last ten years – one that easily traverses the boundary between 'state' and 'society'.

The trajectory I will trace below is a discursive one, 'with all the connotations of circularity, of movement back and forth' that the Indo-European root of discourse suggests.[10] In mapping this circuit, we can interrogate the hypothetical boundary between state and society and, in the process, return some agency to the speaking subject in the continuous and indeterminate production of meaning.

Long Bow Village, 1947

Every revolution creates new words. The Chinese Revolution created a whole new vocabulary. (William Hinton)[11]

Subjectivity is engaged in the cogs of narrative and indeed constituted in the relation of narrative, meaning, and desire, so that the very work of narrativity is the engagement of the subject in certain positionalities of meaning. (Teresa De Lauretis)[12]

Fanshen appears to have been written in a pre-industrial time-space. It represents a complete world, much as the great 19th-century novels

presume to do. It dwells lovingly on the agrarian rhythms of peasant life and evokes, through all of the senses, the sounds, smells and sights of Long Bow Village on the eve of national liberation. I joke with my students, as they slog through its more than 600 pages, that this book was not written for the frenetic rhythms of capitalist production and mass culture (not to mention the academic quarter system).[13] But I insist that they do read it in its complex entirety, for *Fanshen* offers more than the sensory evocation of another time; it reminds us that all knowing is situated in a particular historical moment. It weaves together not only local narratives of oppression and survival, but embraces these within broader national narratives of struggle and liberation; it thereby renders meaningful the revolutionary process itself, not excluding the episodes of occasional violence that disrupt Hinton's text.

Indeed, rereading this violence in the wake of 1989 compels us to re-evaluate its place in the revolutionary process. If this violence must now be read differently, how must we read it differently? Do these empassioned moments of resentment that sparked into being profound divisions within society portend an escalating spiral of violence that led naturally and inevitably to the Cultural Revolution or the events of 4 June? Does it mean that a state power founded on violence must ultimately perish by its excess? Is the violence of the revolution the same or different from its later manifestations? It seems that these questions must be considered if we are now to contemplate the notion that the Chinese socialist state was motivated from the very beginning by a naked will to power, unmitigated by any sort of collectivist vision for a strong nation and more equitable society. Perhaps the answers to these questions lie in the power of narrative to construct a certain reality for those who were supposedly directing the action: the party organization of the guerilla state. Could it be that, despite their tragic errors and human failings, they may have been acting out of conviction? Given the historically given conditions of war and political weakness, is it too unreasonable to suggest that the party leadership saw their alternatives in terms of a Manichean struggle between good and evil? The historical narrative that Marxism offered may have seemed, at that particular conjuncture, the only one that made sense of their world; revolution was the only conceivable alternative to the death of the nation. Class struggle in Long Bow Village was the localized working through of that national struggle.

The power of narrative to shape memory and experience was intrinsic to the process of creating a revolutionary consciousness. Mao saw this

process as central to his revolutionary strategy, not just in terms of creating support for the Party, but also as an expression of his belief in the ability of revolutionary activity to create the conditions for its own fulfilment.[14] This was especially necessary given the immature conditions for revolutionary transformation in what was still fundamentally an agrarian society. According to Arif Dirlik, Mao was not posing the power of revolutionary consciousness against social and material reality; he was posing it against consciousness in general. Consciousness in general is the outlook on life and society that guides people in their everyday activity. It is shaped not just by immediate social and material circumstances, but by inherited cultural traditions. These are just as much a part of social existence as are the material conditions of life.[15] This consciousness in general is what Bourdieu calls 'doxa', or the universe of what goes without saying – the unquestioned premises of social existence.[16]

The narrative structure of 'speaking bitterness' provided a new frame for the reworking of consciousness in which the speaker comes to recognize himself as a victim of an immoral system rather than suffering as a result of bad fate or personal shortcoming. In order to be effective, these narratives had to articulate with memory and experience in such a way as to speak what was not speakable before. In pre-revolutionary China, outside of the Western-influenced intellectual discourse in the treaty ports, there was no concept of class. It was an alien category, 'discursively unavailable' for addressing one's social reality, which was bound by the vertical integration of primordial loyalties between patron and client, landlord and tenant, and the hierarchies of the Confucian family structure.[17] The job of a revolutionary vanguard was to present to the peasantry its image in history in order to help it achieve its historic destiny. The 'speaking bitterness' narratives provided this representational function. It was a way of working on people's ideology, not as a process of conscious intellection, but as a system of representations or images that encouraged people to 'see their specific place in a historically peculiar social formation' in a way that was entirely new to them, but which still articulated with memory and experience.[18] It did this by situating the speaker within a narrative structure of sorrow and loss as an 'I' victimized in the context of 'enchanted relationships' with those who become in the process identified as class enemies.[19]

The specific contribution of Maoism was its adaptation of Marx's theory of revolution to the essentially agrarian context of China, in which peasants, rather than proletarianized workers, became the privileged revolutionary actors. Marxian categories of class and exploitation had to

be radically reworked to address the complexity of interpersonal rela-
tionships in social contexts that had not yet been subsumed by capital-
ism. Dirlik has drawn our attention to Mao's political conceptualization
of class, which located actors within hierarchies of power 'especially in
terms of relations of exploitation', rather than in their relationship to the
means of production.[20] It is no wonder, then, that the 'speaking
bitterness' narrative focused so much on the *experience* of exploitation
and powerlessness. *Fanshen* records the complex discussions of how
exploitation is to be defined, how to locate and measure it, but above all,
how to situate individual actors with respect to it; a discussion that took
into account many factors other than the purely economic, including
factors of religious identity, sexuality, personality and, of course, status
and power. Maoism, therefore, constituted the class subject in terms of
relative powerlessness rather than simply in terms of relations of
production. These antagonisms, experienced in the context of village life,
were consciously linked to abstract and impersonal macro-level forces
that were given a recognizable face, personified by a cast of local
characters who thereby came to embody these larger processes. This
narratival form did not spring up *de novo* in the process of rethinking
experience through these novel categories. Although the process started
with the abstract categories of Marxism, these in turn had to be worked
through the concrete experience of village life, and in so doing they were
realized within a local politics, one that could effectively mobilize peasant
actors to support the revolution.

But where did 'speaking bitterness' as oral performance come from? Its
antecedents must have come from indigenous village culture. The public
venting of rage is a familiar event in daily life in both China and Taiwan.
In a public space, outside the walls of a work unit (*danwei*) or in the alley
outside a house, an injured party, usually a woman, will wail and loudly
proclaim the injuries, often physical, inflicted by husband or kin. A
crowd gathers and acts as a 'court of public opinion' which affirms or
contests the woman's sense of injury. The crowd of listeners actively
participate in assessing the moral liability of the accused, and may be
moved to intervene as mediators in the conflict.[21]

If 'speaking bitterness' was a pervasive feature of pre-revolutionary
village life, then the genius of the party's revolutionary practice was to
give this venting of rage an institutionalized place in the formalized
rituals of the struggle session as evidentiary proof of class-based inequity.
Wasserstrom and Esherick have suggested recently that the Confucians
of the imperial period 'mistrusted clever speech', preferring instead the

authority of the written word.[22] If China of imperial times was indeed graphocentric, in preferring the written word as more transparently 'truthful' than the spoken word, then what does this privileging of oral performance in the context of revolution suggest? It almost certainly reflects a Maoist rejection of Confucian tradition. The identification of speech with the subaltern subject (allowing women and low-status men to speak their anger) certainly represents the turning over of Confucian social and familial relationships. But, more profoundly, might it not have reflected a metaphysics of presence already inherent in Marxism itself, as one of the master narratives of Western modernity? Might it not have had something to do with the importance of these narratives in the actual process of constituting the class subject – not just in terms of inscribing the subjectivities of the one telling and those listening, but also in terms of creating a socialist realism, in which the different classes cease to be merely theoretical, but take on an embodied form as the subjects of history in the eyes of the party itself? In other words, I am suggesting here that Mao and his followers were not merely manipulating a politics of perception and experience, they were themselves caught up in the cogs of the Marxian master narrative. If class, as a Marxian concept, was alien to Chinese discourse, did not this phonocentrism (the location of truth in the spoken word as opposed to writing) speak to the ontological reality of class as a universally valid category of social analysis? By giving 'voice' to the subaltern class subject, the party engaged in a metaphysics of presence, one that authenticated its leadership as representing the constituencies its own discourse had constituted. Barlow talks of how 'woman' (*funü*), like 'class', was a category that presumed to represent the interests it had itself constituted. But class, like *funü*, became redefined in the context of local practice and began to look quite different from its 'universal' aspect.[23]

Thus the 'speaking bitterness' narrative was not simply an imposition of a narrative structure upon the speaking subject. It represented for the party the process of merging the consciousness of the party with that of 'the people', which legitimated its claim to represent the voice of the masses.[24] This trope of merging consciousness has not disappeared in the post-Maoist tropes of the party's rhetoric; it continues as an intrinsic part of the party's self-representation, but in terms of a rupturing of the 'relationship between party and masses' (*dangqun guanxi*) that must be redressed.[25] It is intrinsic to the narrativization process itself, for the reworking of memory into a narrative of class relations occurred not in solitude, but was very much a dialogical process initiated by a very

specific interlocutor (the party and its agents), and it necessarily reflects a meaning-making activity that came from both sides. Jack Belden describes for us this process in the case of a peasant named Ma, who required twenty-four sessions with the cadres to rework his memory into narrative form.[26] He begins by understanding his ill fortune in terms of his personal shortcomings or bad fate. But in his encounter with the cadres, he learns how to reinterpret his experience in the new terms of class analysis that attribute his misery to the landlord as the agent of a corrupt economic system. The familiar elements of his personal experience are reassembled into a new narratival form, and he slowly comes to recognize himself there.[27] But, as Hinton notes, this process also required the constant rethinking and redefinition of class identities by the cadres, who were faced with bringing them into accord with peasant experience.

Moreover, to suggest that the narratives were simply imposed onto the speaking subject is to fail to take note of their deeply emotional content. Indeed, it was precisely this emotional dimension, in their evocation of profound feelings of sorrow and loss, that made the narratives so powerful in eliciting an identification among class equals. Weeping is an intrinsic part of the structure of these narratives. In *Chen Village*, a recent history of a peasant community, we find a description of 'speaking bitterness' as public performance, in which, at a certain moment – such as the death of a parent – the story is suspended, by a breaking through of deep emotions that render the speaker momentarily speechless.[28] This is not to suggest that tears are merely part of a script and are therefore 'inauthentic', but rather that these narratives fit into what Raymond Williams refers to as a 'structure of feeling' in which meanings and values are 'actively lived and felt . . . defining a social experience which is . . . not yet recognized as social but taken to be private, idiosyncratic, and even isolating.' These structured emotions may later become institutionalized; but once this institutionalization is accomplished, a new structure of feeling will arise that better captures the 'true social present' in place of the already formed practices of social life.[29] The 'speaking bitterness' narrative became authorized as a means of making individual experience socially available for the inscribing of new subjectivities that would be defined in terms of class. But with the establishment of this mode in a post-revolutionary political culture, it ultimately lost the power to articulate with subjective experience in its failure to reflect sufficiently the 'true social present'.

The memory of personal sorrow is central to the 'speaking bitterness' narrative.[30] It constructs the old order as oppressive, inherently violent

and immoral, by recalling instances of social antagonism between individuals occupying very different positions within hierarchies of power in Chinese society. Within this narrative structure, the moral vision of the Confucian order, in which human relationships are ordered in terms of reciprocity and hierarchy, appears bankrupted by the struggle for existence. The old society is haunted by a spectre of necessity and need that reduces people to an almost animal existence, making them powerless against their class enemies. It is often quite literally a duel to the death. Despite its articulation with experience, this history was a mythic history in the sense that it also entered into the space of the imaginary. It did not convey the past as it really was, but as the negation of everything the new society promised to deliver. This is not to deny the misery of a society shattered by political distintegration and the tragedies of war, but rather to point to the constructed nature of how the contrast bctween old and new had to be rendered absolutely black and white, so that it became an unequivocal moral drama between the forccs of good and evil.

The narratives of class struggle dramatize these ruptures in the social fabric. Recalling social injustice led not just to the release of sorrow, but to a sense of violation and the unleashing of a wild fury. This wave of violence reached epic proportions in Long Bow Village and resulted in a dozen deaths. These deaths represented far more than a symbolic catharsis or the purging of those identified as the natural enemies of the new order. This unfolding of events had the quality of ritual drama in literally performing a new world into being.

In suggesting that class struggle was a kind of performance, I do not mean that it was scripted and manipulated from the very start. The process had a certain logic and dynamic of its own that was not fully controlled by the cadres who had helped to unleash these powerful forces. The party, to be sure, tapped into this tremendous release of energy, but to suggest that they were completely aware of all its potential outcomes is to overstate the case. Indeed, the very fury they had unleashed was, in a sense, an affirmation of their theory of history, the necessity and inevitability of revolution and class struggle. The violence fulfilled for them the function of the imaginary completion of their self-identity as the vanguard of a revolutionary force.

Whether or not conditions in pre-communist China had deteriorated to the extent to which revolution was inevitable is perhaps beside the point, although this issue animates an impressive body of Western as well as Chinese scholarship. It takes more than oppression and misery to

make a revolution, as Hinton makes very clear in his text. The undeniable fact is that, in China, a revolution happened, and that it was not just the result of the objective miseries of existence. There is no threshold of human endurance beyond which human beings automatically become revolutionary. A revolution is the product of the human ability to reflect on its conditions of existence and to work those reflections through a system of ideas that provides a vision of a more hopeful future, a social vision that exists at the level of the imaginary in the sense that it conceives of something that does not yet exist. Marxism provides a narrative that, although highly flawed, enabled people to see some hope for the future. And although the results may have been ambiguous, can we really criticize them for taking what seemed to be the only hopeful alternative to their destruction as a nation?[31]

The history of class struggle as a political strategy in the Chinese revolution is important for those who wish to rethink the parameters of a radical politics in the late twentieth century. In mapping out a post-Marxian position that can support a political imagination that calls itself socialist, Ernesto Laclau has made an important attempt to identify the flaws of the Marxian narrative that have led to its present impasse. For Laclau, the fatal error in Marxist theory was its misapplication of the Hegelian concept of 'contradiction' to the notion of class struggle. Class struggle is not inherent to the contradiction *sensu strictu* between the relations of production and the development of the forces of production, which, Laclau suggests, is an abstract and impersonal process of history that bears no human face. A Marxist conception of the relations of the production is not between fully fleshed social actors, but between their abstractions as buyers and sellers of labour power. Class struggle arises from social antagonisms embedded in historically specific processes external to the economic field: what Laclau refers to as the 'constitutive outside'.[32]

As suggested earlier, Maoist theory of class struggle attempted to incorporate this 'constitutive outside' into its theory of history. But class struggle is a contingent and not a necessary event. We see this in Mao's political strategy, in his emphasis on the role of revolutionary consciousness as something not inherent to the process of the working through of contradictions, rather as something that had to be quite consciously constructed by a revolutionary vanguard. And yet, in the unleashing of a politics of class resentment, social antagonisms were given the force of historical inevitability, constituting a subaltern subject as the subject of history, but also rendering the bodies and property of 'class enemies' into

the raw material through which social transformation could be repre-
sented. This linkage of Marx's vision of history, as the ineluctable
working out of contradictions, with the social antagonisms historically
specific to the conditions of village life, captures the sense in which Mao's
conceptualization of class was a political one. The 'speaking bitterness'
narratives gave voice to the total social being of an actor situated within
hierarchies of power, and not just as a seller of labour power, since indeed
the experience of exploitation did not take that abstract form, but was
embedded in the face-to-face context of village life. These social relations
were then made to stand in a metonymic relationship to the impersonal
and abstract forces bearing down on the nation. The categories of 'class'
thereby operated by way of a catachresis – that is, a misapplication of the
term – in which the social antagonisms of village life were identified with
macro-forces understood as historically ineluctable.

A recent critique of ethnographic writing has cited *Fanshen*'s conscious
representation of world-historical forces as they work themselves out at
the local level, as a model for what ethnographers should do. For George
Marcus, *Fanshen* succeeds in transcending the dichotomizing categories
of local and global processes that threaten to blunt the critical power of
an ethnography defined by its special focus on 'local knowledge'.[33] But
Marcus may not have fully recognized that this intersection between the
global and local was already part of a narrative process that was intrinsic
to what Hinton was recording. The revolutionary praxis forged by the
party in the crucible of class struggle was precisely to render the abstract
world-historical forces of imperialism and capitalism into a highly
embodied form identifiable within a local cast of characters. The power
of this personification is amply demonstrated by the periodic explosions
of violence in the text, in which persons became the targets of mob
violence.

The story does not end here. Once past the revolutionary period, these
narratives were not forgotten but were preserved as written documents.
This writing was not a singular event, but was ongoing. Throughout the
Maoist period, the same materials were worked and reworked, in the
context of successive political mobilizations. The process of writing these
as oral narratives became especially prominent in the 'Four Histories
Movement' (*sishi yundong*) which began in the aftermath of the Hundred
Flowers Movement in 1957, and reached a peak during the Socialist
Education Campaign.[34] More than a simple act of rendering oral history
into written form, the task itself was intended to enact the very process it
was recording. The Four Histories Movement was a pedagogical practice

which was to inscribe profoundly the subjectivities of those engaged in the task of writing. In the process of writing and rewriting, what had begun as oral performance passed into the realm of *mythos*. 'Speaking bitterness' as a narrative form became institutionalized within an emerging socialist culture that continued to inscribe powerfully the subjectivity of the 'revolutionary successors', for whom the old society was only known in its narrativization.

Yixing County, 1981

In 1981 I went to China to record the oral history of a local pottery industry in Yixing County. At that time I was interested primarily in the experience of work and how it was transformed when independent artisans were collectivized into large-scale factories. I had fixed on a life-history approach for the collection of my field data, not only because it seemed suited to my particular interests, but because it was already known to me as a genre within Maoist political culture.[35] However, I was unaware that the potters of Yixing had already recorded an extensive oral history of the traditional pottery industry and its socialist transformation. This history was, in fact, inextricably a part of that transformation to the extent that an historical consciousness was important in the development of a local political culture. Beginning in 1958, when a group of students from the History Department of Nanjing University was sent by the Provincial Party Committee to Yixing to participate in the Four Histories Movement, this historiographic activity has been a process of continuous writing and rewriting. The students from Nanjing concentrated their efforts on the three collective factories into which much of the pre-revolutionary industry had been organized. However, this activity was not simply an act of recording the past, for the students themselves were to be ideologically transformed through this indirect witnessing of history. The act of writing down these oral narratives was in a sense a re-enactment of the merging of consciousness with the masses as practised by the party work teams of a generation earlier.

This project was the local expression of a national movement that was later absorbed into the Socialist Education Campaign of 1962–6 as a gloss on Mao's dictum 'Never forget class struggle'.[36] Its purpose was to preserve China's revolutionary heritage for those generations who would never directly experience the old society. The exhortation for historians to leave the academy to write local histories from a popular perspective coincided strikingly with the rustication (*xiafang*) policies of the late 1950s.[37] Its emphasis on oral 'tradition' also reflected the anti-intellec-

tual political atmosphere of the anti-rightist campaign which advocated, as a corrective pedagogical practice, getting intellectuals out of the libraries and into the factories and fields so that they might learn from workers and peasants and reform their class outlook.

The history writing that took place in Yixing in 1958 began to appear in 1959 in mimeographed form with a limited distribution.[38] These early texts were later reworked into new forms, as the history of Yixing was rewritten a number of times. Authorship of these texts was for the most part attributed to the work of anonymous compilation committees, except for first-person narratives (where the speaker was identified by name). The composition of these committees reflected the time in which they were writing. In 1958, the writers were students; in 1975, they were a worker-soldier-peasant group; by 1978, individual names began to be identified on the title page.[39]

An important part of this history-writing activity was the translation from 'word' to 'text' of the 'speaking bitterness' narratives as they were enunciated locally. The structure of these narratives from Yixing share a similar structure with those from elsewhere. The moment of historical rupture is the event known as 'liberation' (*jiefang*) and the texts are structured in terms of a 'before' and 'after' (*jiefang quianhou*) in a way that compels comparison. This rupture was continually reiterated in the speech of people even when they related their personal histories to me verbally: 'In the old society'. The narrative is constituted by this one event of overarching significance. But the Yixing historical narrative was also locally specific in its reporting of the problems and solutions arising in the process of class struggle. For instance, the local economy was largely dependent on a handicraft industry that had developed a fairly elaborate social division of labour mediated by market relations. This presented special problems in defining both class identities and the relations of exploitation and power between rural artisans and petty entrepreneurs; in particular, great care was paid to the recording of an incipient tradition of labour activism among semi-proletarianized pottery workers. However, even these locally specific narratives of class antagonism situated Yixing within a larger national narrative of class struggle. But, this did not mean that they did not also actively work to construct local identities.[40] Indeed, Yixing's pottery tradition was also the basis of its reputation nationally, from the beginning of the eighteenth century and possibly before. This local identity was reproduced in accounts of how the unique and specialized skills of the Yixing artisan in themselves became a sign of value that was subject to expropriation by Shanghai capitalists.

When I first went to Yixing in 1981, I was totally unaware of this written repository of material, which would have been of incalculable value to my research, nor did anyone connected with my project, either in Yixing or at Nanjing University where I was affiliated, ever mention it to me. I was told only that a history of Yixing 'was in the process of being written', but was not yet completed. I could talk to some of those involved, but would not be able to take a look at the unfinished manuscript, or indeed any unpublished material whatsoever. One reason for this secrecy may have been political caution. With the change in leadership, the early 1980s was a time of ideological redefinition in which history was being cautiously rewritten.[41]

The reasons why I recount this personal history is that I, like Hinton, had entered a community whose narrativization of the recent past was already highly elaborated. In retrospect, comparing my taped interviews with the versions of the 'official' history that I was later to find, almost inadvertently, in a distant library collection, allowed me to become aware of the importance of narrative not just in recalling the past, but in constructing identities. It was precisely these identities that were being redefined in the early 1980s when some of those classified as class enemies were not only being rehabilitated but even, in one case, taking prestigious positions in the People's Consultative Congress. Not only was the past being rewritten, but my research experience was also a complex process of mirroring, in which the 'selective tradition' was made more selective still in terms of how local people wanted to represent their past to a foreign researcher.

Sidney Greenblatt has described the history-writing activity as a 'sporadic and recurrent mobilization of Chinese historical consciousness and historical resources'.[42] In other words, it is an important element in the Chinese socialist political culture as it is constructed nationally and locally. In the escalating political mobilization of the Maoist period, the process of recording the past had a specifically ideological function. These narratives were to work on the consciousness of those doing the recording. Once recorded, they would also work on the consciousness of those who were to read them (just as the narratives in *Fanshen* work on our consciousness as we read them). In their written form, they became an integral part of a system of representations that not only structured memories of the old society but also defined identities in the present. The emergence of a 'class status system' positioned individuals within the new society according to a logic of entitlement that was determined by their pre-revolutionary class status, or by that of their parents. These repre-

sentations operated at the level of a national socialist culture, in which the basic narrative became reworked into a vast array of different cultural forms: revolutionary opera, school textbooks, exhibits and fiction.[43] As mentioned earlier, these representations had an undeniable effect in the production of political subjects long after the revolution was over. In Chen Village we read how the urban youth sent down to the village 'saw' the miserable crew of 'bad elements' trotted out for their inspection soon after their arrival:

When I got to the village and saw these landlords and counter-revolutionaries, I felt that deep in their hearts they still wanted to overthrow everything and kill all of us. In movies, they had awful faces. And in the village, when I saw them I feared them and thought they were repulsive to look at. I guess ugliness is a psychological thing. I felt that they were somehow actually ugly.[44]

This passage offers us a striking example of how these narratives conditioned perceived 'reality' among a generation of 'revolutionary successors' – children who knew about the hardships of the old society not by direct experience but by their performance in post-revolutionary political culture. By the mid-1970s, however, this method of rousing righteous anger in a younger generation had apparently been played out. 'Hearing these stories was, for these young people, like watching an unreal movie. They joked about it, smirked and laughed at the old people telling these tales.'[45] The period intervening between these two events had witnessed the Cultural Revolution, during which the concept of class as a legitimate category of social analysis in the post-revolutionary present literally deconstructed itself in internecine fighting in local struggles all over China.

However, class categories continued to be salient categories into the early 1980s, although with decreasing emphasis as the post-Mao reforms were established. I saw my problem as a field researcher in terms of escaping the confines of this official history to see what other memories of the past may have been suppressed by it. I was especially interested to see whether independent artisans had experienced the collectivization process as alienating in terms of their artistic production and control over their product. This I found to be virtually impossible. In the Yixing of the early 1980s, I was offered no opportunities to operate beyond the rigid restrictions imposed on foreign social science research. My research 'access' was rigidly defined in terms of formal interviews with informants who had prepared their material in response to a list of questions that had to be cleared by the local party leadership prior to our meeting. There were very few opportunities to speak with my interviewees privately, to

build what anthropologists fondly like to call 'rapport', or to explore
areas outside the official history. All I had was the official version of the
past, and I felt that I had failed as an anthropologist because I had not
somehow eluded the state to connect directly with 'the people'. It was
only much later that I began to question my premises about what 'doing'
fieldwork means in terms of concrete practices. Intrinsic to my rethinking
was the question, 'Who is the speaking subject?', as well as the
problematic nature of assuming a clear-cut distinction between an
official history and the one that was 'hidden' in popular memory.

Moreover, it also occurred to me that in my search for the popular
voice, I was in some sense replicating the party's own legitimating
practices, in my search to establish my own (ethnographic) authority
through its 'presence' in my text. My resolution to these dilemmas was to
make as my proper object of inquiry the party's own legitimating
practices by taking the official history as my starting point. I had to accept
the possibility that it is impossible to elude the state, because its presence
is not just in a formal structure of governance, with all of its gatekeeping
functions, but within the speaking subject herself. This is not to subsume
all subjectivity within the power of the state, so that a dissenting voice is
impossible; but the state is always present, and one must seek its traces
even in places that define themselves as 'outside'. The state, as an absent
presence, is *the* defining variable of civil society; where the state is not,
civil society is. This present absence haunts any assertion that there exists
any autonomous social sphere completely outside the force field of power
relations that we call 'the state'.

Nanjing, 1991

After dinner and following an animated discussion of Chinese cuisine, our host
turned to one of his Chinese guests and said, 'China should, by rights, be a great
and prosperous nation.' The implication was, of course, that it clearly was not. A
sustained lull followed, as we all contemplated this apparently incontrovertible
'fact' (Author's field notes, 1991).[46]

In post-Mao China, the class subject has been muted. It is no longer
politically popular to use a rhetoric of class struggle to account for the
contradictions and antagonisms arising from economic reform. Instead,
a notion of population quality (*renmin de suzhi*) appears increasingly to
occupy that field. The notion of population quality covers a wide range
of discourses and practices: birth control, child rearing, sanitation,
education, technology, law, eugenics, etc. It is difficult to convey how
pervasive the project of raising population quality has become in party

rhetoric of the late 1980s and early 1990s.[47] 'Population' appears as a mass noun of some abstraction, but the issue of raising quality also applies to specific populations within the whole: the work of party members, the quality of labour, the genetic quality of minority or isolated populations. Its pervasiveness in both official and popular speech during the last half dozen years suggests its centrality to an emerging national narrative that focuses on the endogenous factors of Chinese underdevelopment.

Maoism, which named foreign imperialism and the expansion of world capitalism as the major factors in China's failure to modernize, has been displaced by an intensely reflexive auto-orientalist critique. The party and the state have focused on the presumed low physical and educational quality of the population, its ignorance, its excessive size, its lack of discipline; whereas intellectuals, such as the authors of the celebrated television series, *Heshang* ('River elegy'), have focused more on cultural factors, especially the traditional submission to authoritarian rule and China's impermeability to foreign influences. In the discourse of everyday life, the comments that people make about population quality tend to approximate those of the state, especially when it expresses popular concerns about China's ambiguous position in a world where it must confront the more rapid industrialization of the four little dragons (Taiwan, Korea, Hong Kong and Singapore) and Japan, as well as the collapse of socialism in the Eastern Bloc. It is often a narrative of despair and, in invoking the fear of *luan* ('chaos') – which expresses concerns about stability and social control – the narrative produces 'willed consent' for an authoritarian state.

This articulation certainly accounts for the apparent hegemonic status of the one-child family policy, perhaps the most stringent population policy in world history. In its grave demographic distortion of the Chinese population, and in the personal pain it causes, this policy appears as a monumental form of national self-mutilation. No policy is more resisted at the level of popular practices, and yet none has more power to reinvigorate the static projects of the party. The project to 'raise the quality of the people' is a direct extension of the policy to control population growth.[48] Even when resisting control over their own reproductive practices, people are quick to acknowledge the burden that the population size puts on China's ability to develop rapidly. Something much more complex is happening here than a mere demonstration of the 'power' of state propaganda on the birth policy to become internalized by the speaking subject. This is perhaps most evident in the tremendous

elaboration given to the notion of population quality in everyday speech and in the media.[49]

To understand the complexity of how the issue of population quality appears to orchestrate popular consciousness with the discourse of the state, we can start by tracing its trajectory in the last half decade. The idea may have first achieved prominence in Bo Yang's controversial essay, 'The Ugly Chinaman'. This essay by a Taiwanese author, first published in 1985, was quickly introduced to a mainland audience. The issues it raised about cultural impediments to the development of civility and democracy in China had a profound impact on Chinese intellectuals.[50] Not long afterwards, a major report on rural poverty sponsored by the State Council firmly laid the blame of China's backwardness on a deficiency in the 'quality' of some segments of the Chinese population. This report in turn was used as reference material in the writing of *Heshang*, the television series that the party leadership now blames for the student movement of 1989. Despite the association of *Heshang* with this oppositional movement, the issue of population quality has far from disappeared. It occupies a privileged position in the eighth five-year plan. Even more impressive to the ethnographer is the degree to which the notion of population quality suffuses everyday speech and becomes a means to articulate concern about China's present and future. But it is a highly multivocal concept; one that can mean different things in different contexts: in the population policy, in eugenics discourse and law, and in discriminating or articulating specific subgroupings or social interests (intellectuals versus students, Han versus non-Han ethnic minorities, core versus periphery) within the larger mass. In all of the above domains, a difference is defined within the Chinese people themselves, between 'backward' and 'advanced', 'civilized' and 'uncivilized', that translates directly into notions of value. This is clearly apparent when local level officials in the 1990s 'joke' about how the best development policy for China would be to kill off half their population, or the need to allow more play to the principle of 'survival of the fittest', or when intellectuals bemoan the fact that those who were killed in the crackdown were students and not peasants. Some bodies have more value than others in the larger context of nationally defined desires and longings.

Clearly, this idea of the low quality of the population plays well among urban peoples and intellectuals, especially when their referent is the unwashed masses of China's economic periphery. Indeed, the construction of the *pianpi* ('isolated areas'), in the rhetoric of the 1980s points to an emerging consciousness of a dramatic re-territorialization of

China in which much of the success of the economic reforms has been concentrated in the wealthy coastal provinces, which are far more successfully integrated in transnational flows of labour and capital. But how does it play in the places that are labelled as 'backward' (*luohou*) or 'peripheral' (*pianpi*)? A clue comes from a *getihu* ('entrepreneurial peasant'), travelling from Xiamen to his home village in the interior of Fujian province in late May 1989, who told me that the economic reforms were only on the surface (*biaomianshang*), and would only spread to villages such as his with political reform. Another clue comes from Huang Shumin's account of a research team who came to his village in Fujian to observe local progress in the 'establishment of a socialist spiritual civilization'. After being wined and dined, the head of the research team harangued the local leadership about the unsanitary condition of the village, the unpenned animals, stinky latrines and unpaved roads. The local party secretary's response was, 'Who did they think we were? A bunch of rich overseas Chinese building a retirement compound in the countryside? . . . After they ate our good food and smoked our special cigarettes, they slapped our faces for being filthy peasants.'[51] From such fragmentary evidence, we can assume that the inhabitants of the *pianpi* do not necessarily place the causal factors of their poverty and backwardness within themselves, but point instead towards their distance from a government that disvalues and excludes them.

And yet the party's efforts to restore its hegemonic position in the post-Mao period rests on this premise of improving the population. The unwashed masses are the *raison d'être* of the state. They are the subjects of a pedagogical project by the state that is anterior to any discussion of political reform. Quoting from Foucault, we could easily replace 'population' for 'sexuality' as the entity which becomes 'the theme of political operations, economic interventions (through incitements to or curbs on procreation), and ideological campaigns for raising standards of morality and responsibility: it was put forward as the index of a society's strength, revealing of both its political energy and its biological vigour.'[52]

But, the issue of population quality as suggested above, is not limited to the projects of the state. At the level of everyday practices, it is elaborated to an incredible degree. Because I had very young children with me during my field research in 1991, I was exposed to this set of concerns to an unusual degree. My infant son, especially, became the medium through which people would elaborate at length about the differing qualities of populations in the East and the West. I found myself caught up in a

complex mirroring process, in which China's internalized sense of lack was becoming expressed, sometimes in incredibly concrete ways, through the material body of my son. People would squeeze his arm or leg and comment appreciatively about the hardness of his flesh, the pallor of his skin, his size, the depth of his cranium. The conclusion would be that 'the quality of body' (*shenti suzhi*) of Western children was higher than that of Chinese children. They were larger, more supple, and had a glow of health that was assumed to be lacking in Chinese children.

This attention to my child's body was extended to his intellectual development as well. People would comment on his responsiveness to others, his eagerness to explore things, his strong will. These traits were praised as indicators of superior intelligence and creativity, but the subtext here is clearly that they also produce a less controllable child. This ambivalence is heavily inscribed in the word *pi*, used to describe naughtiness in children. When parents complain that their own children are *pi*, one detects also a secret satisfaction, albeit mixed with irritation. One senses here a subtle critique of the Chinese tradition of paternal authority as constraining creativity and intellectual freedom. There is, on one hand, great concern that the next generation of single children will be over-indulged, self-centred and difficult to control. And yet, on the afternoon of 4 June 1989, as I talked to one parent in an intellectual family about the bloody crackdown in Beijing, he said, pointing to his daughter, 'Her generation will not stand for this. And that, too, will be a kind of progress.'

It should be clear from this brief discussion, that any attempt to identify this notion of population as belonging exclusively to the state or to popular discourse would be to misunderstand its broad articulation with a wide array of interests and concerns in post-Mao China, all of which produce different meanings and different political registrations for what appears discursively as the same language. Once again, in mapping this circuit of meaning, we must ask who is the speaking subject. In the context of post-Mao China, this question is further complicated by the proliferation of local identities, all of whom may be speaking the same language but producing meanings of their own.

Conclusion

This essay has woven together three quite complex projects in the hope that their juxtaposition might enhance the exposition of each through their sometimes quite tenuous but important interconnections – the most important of which centres on the question of *who* is speaking. I will

conclude by restating these projects more explicitly. The first of these is how to rethink the socialist revolution in the post-1989 present in a Nietszchian way, not as a relationship between cause and effect, or as a search through the past for the origin of the present, but to explore how the liberatory discourse of socialist revolution might have been brought to its present impasse, an itinerary that has no predetermined *telos* or logical 'evolution', but which has left a discursive trail which can be tracked through time. Secondly, I have sought to interrogate the boundary between state and society by fixing on the speaking subject as represented in historical narrative and ethnographic practice. Finally, I have noted the displacement of the class subject by a new national subjectivity that is constituted through a highly reflexive discourse which mirrors to some extent China's opening out to the world – and the evaluative gaze of foreign capital – in the post-Mao period. These themes traverse many boundaries: the boundary between state and society, between the party and masses, between a Chinese self and its significant 'others', between past and present. The intent is to show the essentially discursive construction of all these boundaries and their siting in the speaking subject.

However, in accounting for the traces of an official discourse in the speaking subject, this essay explores only one side of a complex process. What is missing is a look at how popular voices, apparently unmarked by the state, become incorporated into official discourse. In the carefully composed texts produced by the state for ideological purposes (propaganda), the Party constructs its monological voice. It speaks for the 'People-As-One'.[53] But this construction of speaking for 'all the people' ventriloquizes subaltern voices (the peasant, woman, the huckster, the lumpen). These voices announce their presence with a language that is clearly marked as 'outside' the language of the state – as the *vox populi* or even the *vox vulgaris* – using a language of incivility to install an effect of an authentic popular voice, which in turn legitimates the party as 'speaking for the people'. Difference here becomes subsumed within the construction of 'the people' as a unified body, a process that I have discussed elsewhere at greater length.[54]

Zhang Hongtu / Hongtu Zhang:
An Interview[1]

Zhang Hongtu was born in Gansu province, in northwest China, in 1943, but grew up in Beijing. After studies at the Central Academy of Arts and Crafts in Beijing, he was later assigned to work as a design supervisor in a jewellery company. In 1982, he left China to pursue a career as a painter in New York. Since that time he has participated in numerous group exhibitions, and was a member of the collective Epoxy in the late 1980s. He was extremely active in art world protests following the Tiananmen massacre of 4 June 1989. At the time of this interview with Jonathan Hay (1991), he was the recipient of a grant from the Pollock-Krasner Foundation.

JH: *Like other East Asian artists in the West you encounter the particular problem that in the West the surname comes at the end instead of the beginning: are you Zhang Hongtu or Hongtu Zhang?*

ZHT: I'm Zhang Hongtu now. Actually, I changed my name to Hongtu Zhang right after I came to the United States. Then one day a friend said to me Hongtu Zhang sounds like *hong tuzhang*, 'a red official seal'. I hated this misunderstanding, so I changed my name back to Zhang Hongtu.

JH: *You have Chinese citizenship but have lived and worked in the United States for almost nine years. In fact, you have made your home here. How has your long absence from China affected your ability to think of yourself as Chinese?*

ZHT: For me being Chinese does not only mean someone who was born in China or still keeps Chinese citizenship, but also means someone whose mind or spiritual life is tightly related with Chinese culture, what people call their roots. When I left China I was thirty-seven years old, and

the roots – Chinese culture – had already become part of my life just as a tail is a part of a dog's body. I'm like a dog: the tail will be with me for ever, no matter where I go. Sure, after nine years away from China, I forget many things, like I forget that when you buy lunch you have to pay ration coupons with the money, and how much political pressure there was in my everyday life. But because I still keep reading Chinese books and thinking about Chinese culture, and especially because I have the opportunity to see the differences between Chinese culture and the Western culture which I learned about after I left China, my image of Chinese culture has become more clear. Su Dongpo (the poet, 1036– 1101) said: *Bu shi Lushan zhen mianmu / Zhi yuan shen zai si shan zhong.* Which means, one can't see the image of Mt. Lu because one is inside the mountain. Now that I'm outside of the mountain, I can see what the image of the mountain is, so from this point of view I would say that I understand Chinese culture better than nine years ago. I have also come to understand myself as a Chinese person better than nine years ago because I think that, as an artist, to understand oneself is crucial, and that's part of one's identity. One's identity is not just a matter of having citizenship or not.

JH: *You do two kinds of painting concurrently, one that is explicitly political and another that on the surface avoids politics. How do you separate them in your mind, or do you?*

ZHT: I don't really separate the two kinds of work in my mind. No matter which one I do, it's always related to my cultural background, my life experience. The political issue is part of my personal history, so this is why, although my political work is all about Mao, even my normal work which you mentioned avoids politics, also deals with social or cultural issues. That's why I say they are not clearly separated.

JH: *Your explicitly political work is perhaps better understood here than your studio painting . . .*

ZHT: I think that in my political work the basic approach is a contemporary Western one. The styles are familiar to Western people. For example, I use ready-mades, collage, the technique of laser xerox copy, Marcel Duchamp's way to change Mao's face, Picasso's ways to change Mao's face . . . the Western audience is familiar with these styles. Also the content is related to current events: the democracy movement is

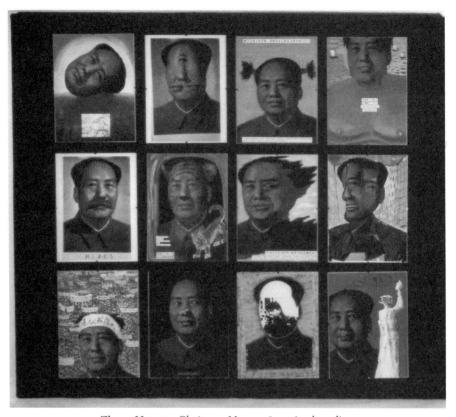

Zhang Hongtu, *Chairmen Mao*, 1989, mixed media.

found all over the world and especially in Eastern Europe. So these paintings are easier to understand. My studio work is more experimental in style. I want to make something unique, with my own language, and the content is more personal. This also creates a problem for the audience, to understand directly something from my personal experience. If somebody has something in common with me, some shared background, it's easier, but most people have a different life experience. So sometimes my studio work has less of an audience than my political work.

JH: *Staying with your studio work for a moment, it's a general problem, isn't it, for Chinese artists working in a contemporary mode in the West, that they have difficulty finding a Western audience. It occurs to me that along with other artists such as Gu Wenda, Zhang Jianjun or Hou Wenyi who work with iconic imagery and abstraction, you are in an awkward position in relation to the Western public. One might say that your*

reference points on the Chinese side are too obscure to Western viewers,
while your Western reference points are in a sense too familiar.

ZHT: Especially for artists who came from China when they were older,
over thirty, thirty-five or forty, the influence of Chinese culture, especially
ancient philosophy, is very, very strong. Somebody can say, 'No, I don't
like the old stuff, I'm going to break with the tradition', but nobody can
avoid its influence. That's why you find so many Chinese artists who in
the content of their paintings still keep the influence of Chinese culture.
But here, because one is living in this modern society, in New York, one
sees contemporary art every day, so this influence is also very strong.
Especially in New York, art is in step with everyday life. Modern
civilization, new techniques, new ideas about art, about culture, even
about science, all influence art. So one cannot take away from this kind of
influence as well. That's why in the results, visually, one can see the
references, or the influences, from Western culture. And these are very
familiar to people here. For me this is a challenge. Familiar is OK, but the
challenge is that I have to make something of my own, unique, not only
from my earlier life experience but also from my own knowledge of
Western contemporary culture. As for the content or the concept, from
Chinese history or culture, I don't have any reason to avoid that, because
it is part of my life. But I think that since the world is getting smaller and
smaller, and more Western people are studying Eastern culture, under-
standing each other may be easier in the future.

JH: *Most readers will not be familiar with your work. You tend to work*
by series. Until recently, your series were characterized by a strong image
to which you returned again and again: it might be a dark lumpish form
representing the sun, or the back of a head, or stencilled messages in
Chinese and English, or – in your explicitly political work – the image of
Mao Zedong. But your most recent series is rather different, since it is
characterized above all by a technique: you cut out the central motif and
leave it as a void. Also, the imagery is much more wide-ranging: you draw
on the imagery of various earlier series, but you have also added many
new images which I think of as emblems of cultural identity – for
example, the Great Wall, a Western-style book, a Doric column . . .
What significance does this shift in your work have for you?

ZHT: First of all, I would like to say something about the history of this
shift. A long time ago I had a very clear aim in my painting: it was to

Zhang Hongtu, *A Chinese Book* 2, 1991, book, burlap, acrylic,
cardboard on plywood.

combine modern Western art and Chinese traditional style. Already in
1962, 1963, when I was still at Middle School, I had this aim. I wasn't the
only one; many, many artists then were talking about how to give a
national [Chinese] character to oil painting . . .

JH: *Were you aware of what was going on in Taiwan and Hong Kong at
that time, painters like Liu Guosong and the Fifth Moon group (*Wuyue
huahui*) who were also pursuing an East-West synthesis?*

ZHT: No, not at all. At any rate, the result of that kind of aim on my part
was two different styles. One was oil painting – figure and landscape
paintings – with line . . .

JH: *Why was that? Why with line?*

ZHT: Because at that time it was very easy to think of Western painting
as being without line, since line – brushwork – is the most important
thing in traditional Chinese painting. But I found out that the Post-
Impressionists, especially Matisse, had already done much the same thing
long ago. The other result of my thinking in that period was a kind of
abstract ink painting on rice paper, which so many oriental artists have

done, a thousand times over. I didn't find anything new. But even when I arrived in the United States in 1982 I still had the idea underlying those two styles – I wanted to combine, or mix, Western and Chinese things. But one day I changed my ideas. At the end of 1982 I saw a show of Scandinavian contemporary painting at the Guggenheim Museum, and there were two sentences in the catalogue: 'All national art is bad. All good art is national.' This really shocked me, and it made me rethink my idea of combining two styles. The second sentence, 'All good art is national', was a really strong influence on me: to be a Chinese artist is not important, to be a good artist is important. So this was the next step: I could learn more and more from the new art world, from my reality in the United States. From that time on, I tried many styles. I was influenced by the mainstream, Neo-expressionists, people like Anselm Kiefer, but my works were too similar. Then later, I went back to reading Chinese books – history and philosophy – and by going back to myself, I found my way to the sunrise paintings and the back of the head paintings. The next stage was my political paintings after June 4, 1989, the Tiananmen massacre. At the beginning, I thought of it just as an immediate response. But later, after I had done two or three paintings of Mao, the paintings themselves taught me that this came from my life experience so it was not to be ignored, and I went on to do a series of political paintings all about Mao. So to get back to your question, changing my work had been very important to me for several years. At the end of the period when I was painting the backs of heads I found that my work had too much of a personal feeling, and that the message was always exchanged between the work and myself. Once I started cutting out images I found more freedom and more opportunity to express my ideas about reality. Now I can use many different images to make artworks, and since the images are always related to culture, to popular icons, it's easier to exchange the message with the audience. Asking myself about the significance of these images has made me rethink the relationship between art and culture, the relationship between art and society.

JH: *There you mention that these images you're using are popular icons, and have to do with culture and art. What does it mean to use, say, a Doric column?*

ZHT: This kind of idea comes partly from art history, but partly from my personal life. Nowadays the whole world is full of images – people speak of an image world – so any abstract form reminds people of something.

There is no absolute abstract form. If it's a square, people think about the modern city, a triangle, they think about a pyramid . . . This is different from Malevich's time, when you could say you were doing work that was pure, close to spirituality, nothing to do with reality. Nowadays every image will remind you of something. People use images to do many different things, in the same way that high art styles are also used for commercial work – this is reasonable, it's part of the historical process. In my case, if I had led a different life, if I hadn't lived in China, hadn't lived through the Cultural Revolution [1966–76], if I had had a different family background, if I had moved to Taiwan before 1949, then I would have been a very different artist. Maybe I would have become an absolute formalist – maybe, I don't know. But my life as a Chinese person, especially after the 1989 Democracy Movement, has influenced me strongly to think about history, about authority, about culture, and to doubt the authority of the image.

JH: *So this new kind of work you are doing has an indirect connection with the events of June 4.*

ZHT: Yes, an indirect connection.

JH: *These recent cut-out paintings bring to mind a standard phrase of traditional Chinese art criticism:* you wu zhi jian, *'between presence and absence'.*

ZHT: Yes, *you wu zhi jian* is good, but somehow I think *you wu xiang sheng*. It's from [the Daoist philosopher] Laozi: it means that presence and absence generate each other. In my understanding of it, life is in between presence and absence, or in between existence and non-existence, or in between reality and dream. In my new works, the image – I still believe in the power of the image – is still there but it's empty. Then there are nonsense words present, visible, on the burlap. Both are significant images. The burlap is a part of the work, alongside the cut-out, like the *yin-yang* symbol. Since the hole is a significant image, it is in between presence and absence as you said, but it is related to reality.

JH: *You mentioned the messages which you include on burlap, either that were already on it, or which you stencilled onto it in the same style. Some of the messages are in Chinese, others in English. You described them as nonsense words, but they are not wholly nonsense words, are*

Zhang Hongtu, *Danger: Extremely Flammable 6230*, 1990, acrylic on
burlap mounted on canvas.

*they? In the context of the artwork, they seem to me more ambiguous or
mysterious: DANGER, EXTREMELY FLAMMABLE, KEEP
OUT OF THE REACH OF CHILDREN. Could we say that some
sort of boundary is defined by language, or in your work is defined by this
particular use of language which promises understanding but does not
fully deliver.*

ZHT: Language promises understanding, any new language defines a new
boundary. In ordinary life, when people exchange messages with each
other, they have to use the same language. The problem is that artists are
always trying to break boundaries and find a new language. But the
significant thing is not just to break with the old but to create something
new as well. When a new language is created, a new audience is created,
so along with the creation of a new language the message of my work will
be more clear. If my artistic language is complete and strong enough, the
message in my work will be more clear. Even so, I still can't make a
message as clear as crystal. I don't like to teach the audience, instead I
want to give the audience more space to re-create.

JH: *The messages you stencilled on burlap could be interpreted to have
political meaning.*

ZHT: The words I used at that time were important, they had a message, but it wasn't really political, it was more for psychological effect: phrases like DANGER, KEEP OUT OF REACH OF CHILDREN, NO CHEMICALS, to make people think about the environment, the reality of the society, but only psychologically.

JH: *It's not a commentary on the paintings themselves . . . ?*

ZHT: . . . No.

JH: *. . . because from the point of view of the Chinese government – I'm thinking of the recent Campaign against Spiritual Pollution – it could be said that your works are dangerous, and flammable, and should be kept out of the reach of children.*

ZHT: To tell you the truth, with those paintings, I did not think too much about the relationship with the Chinese government. But you are right that if I showed the paintings with these messages in Chinese in China, the government, even the people, would definitely think this way, because people there are always ready to find some special meaning in any single word.

JH: *Then let's imagine that the political situation changes and you have an opportunity to exhibit in Beijing, do you think that your studio work could be understood in Beijing?*

ZHT: I think so, though maybe in a different way. But misunderstanding is acceptable. For example, I cut out the image, make a hole in my painting, and over here many people think this is a way of denying or being against something. But some of my Chinese friends think about Daoism, about nothingness, about something between nothingness and something, between *xu* (void) and *shi* (solid). To me it doesn't matter, you can think this way or that way, I just give you a chance to think, feel a different way with this image.

JH: *You said earlier that you want to give the audience space to re-create. That space must have a lot to do with the ground you give your images.*

ZHT: In my head paintings, there is a space which is the background for the head, an abstract space. And in my new paintings there is a real space

cut from wood, plywood, canvas, burlap, a physical space. But when I talk about leaving a space for the audience, for the viewer, to recreate, it's psychological, it has to do with the message. In my painting I'm not going to explain everything exactly and very, very clearly and completely. The space is exact – I cut it out – it's a real space, it's not an illusion. Maybe you want to see spiritual emptiness, maybe somebody wants to say because I cut the image out I negate something, I am against something. But for my own part, I just want to give you the chance to see the thing in a different way, not just see it in a surface way; for example, with the image of the Mona Lisa, not just see it as the smile, colour, artistic technique, but see all sorts of other things as well. But it's not unlimited. The image is still there, limiting you to think something, though not only something from the original painting such as her smile, or how great da Vinci is. So that's what I mean by space – the opportunity to think and feel about the image.

JH: *It's almost as if you are trying to give fresh life to symbols that have become clichéd and hackneyed . . .*

ZHT: Yes, everybody knows these are clichés, but I use them because they are something I have in common with people – they are public images, which I try to let people see from a new angle.

JH: *What I was trying to get at before was the way that the psychological space that you create for the viewer is also influenced by the physical way that you create it. I'm sure that your cut-out paintings would have a quite different effect if they were cut out of formica, for example, instead of burlap. So why do you choose rough physical surroundings for your images? You must have some sort of psychological effect in mind.*

ZHT: Yes, psychologically I would like to keep a distance from modern civilization, in other words, from my surrounding reality. Perhaps this is a traditional Chinese intellectual attitude. I am making a contrast with the machine-made or man-made world, both in everyday life and in the art world. If you go to see contemporary art in galleries or museums, you can see that many of the things look artificial. There's a sleek surface. Maybe this is the right direction – it's closer to high tech, to science – but personally I like to make a contrast with sleek surfaces and artificial materials, both in everyday life and in the art world.

Zhang Hongtu, *Landscape No. 5*, 1989, mixed media on canvas.

JH: *So this would be why, although your paintings are basically rectangular, the edges are always uneven.*

ZHT: But the shape of my paintings is still basically rectangular. You know why? Because I found that some artists – of course they're good artists, like Frank Stella, Elizabeth Murray – make the paintings totally non-rectangular. They can be any kind of shape. To me this is great, but it is merely different from reality. I make paintings that still look right-angled, look rectangular, yet none of the details are even. So it's different from, but at the same time related to, reality.

JH: *There's a kind of ambiguity. That's also true of the way your paintings mix painting and sculpture.*

ZHT: Yes, the materials, the surface and the edges all come from the same point of view.

JH: *So when you speak of making a contrast with modern civilization, with the machine aesthetic, you don't mean a complete contrast . . .*

ZHT: No. I don't want my work to look as if it comes from another planet.

JH: *In the past you have spoken to me in Daoist terms about the lumpish motif in your 'Sunrise' series of paintings. You have related it, for example, to concepts of unity. But you also once told me that you thought of your 'Sunrise' paintings as 'soft' political works.*

ZHT: Even the title has a political meaning in China, because 'Chairman Mao is the red sun in our hearts'. I'm sure that anyone of my age had to sing this slogan during the Cultural Revolution, not only chant it, even sing it. So the sunrise series I did after leaving China – including black suns, square suns, irregular-shaped suns – like other paintings I did at that time, was an attempt to extricate myself from the past. But I didn't want to do something that looked exactly like a political painting, like a political statement in my painting . . .

JH: *. . . Why not?*

ZHT: I did the sunrise paintings before 1989. I still thought art was art, I didn't want to use painting as a tool, as political propaganda. When I was in China, teachers, the government, everybody told you art is a tool of the government, of the party. You have to do something useful for the Communist Party. So when I left China I hated this idea; I thought art is art, art is not a tool, I am not a tool. As Lenin said, literature and art are 'cogs and wheels in the whole revolutionary machine'.[2] I knew when I painted the 'Sunrise' paintings that there was a kind of relationship with Mao's images and my life experience in China, but I deliberately avoided this kind of feeling. So I named them 'Impression: Sunrise, 114 years after Monet'. I preferred an art-historical reference, but of course I could not make the political meaning disappear.

JH: *I want to ask you a related question about your training as an oil painter and the way that it relates to your work today. Many of the artists of your generation, who trained as oil painters in China and studied socialist realist painting, after coming to the West have continued to work in a realist style. Even though they changed their subjects and the*

content of their work and their themes, nonetheless the style that they work in today is still very close to the style they trained in in China. But your style has changed enormously. Your studio work – the images of the backs of heads for example – on the surface has very little to do with socialist realism. However, I wonder if there is not some connection at a deeper level – I'm thinking of the socialist realist icons of smiling workers, for example, or other smiling figures.

ZHT: Socialist realism was the only artistic style permitted by the government in China when I was there. Also it was the only 'ism' taught in the art schools when I was a student. In fact, socialist realism dealt neither with the social, nor with reality. What people had to see in their everyday life, everywhere, was Mao's face, with its huge size and hypocritical smile – especially during the Cultural Revolution. That is part of my life experience. When I made the back of the head paintings I had not consciously connected the idea with this part of my memory but I am sure it was connected subconsciously. For example, the colours black and grey instead of yellow and red, the back of the head instead of the smiling face. But personally I like to put the question in this way: in my painting I show the back of the head to the audience, so the front of the head is actually facing empty space. That was my attitude during that time in China, to keep a distance from my reality. Maybe this is one way to relate the back of the head paintings and socialist realism.

JH: *Without suggesting that it was a conscious decision on your part, I was wondering too whether the very large scale of your head paintings might not owe something to the huge size of public icons in China?*

ZHT: If people try to make somebody look like a god through the huge size of the portrait, as in the pictures of Mao, the size can make the image funny and make it lose its power. But if somebody enlarges the size of an object from everyday life, it can transform a common feeling about the same object, like you see in Claes Oldenburg's work. I would prefer to say that I was influenced by Claes Oldenburg's work than by Socialist Realist icons.

JH: *When you speak of the image of the back of the head in terms of keeping a distance from your reality, it brings to mind some lines by the woman poet, Shu Ting, written in the late 1980s: 'Who is it remains silent*

Zhang Hongtu, *Portrait – The Back*, 1990, burlap and mixed media on canvas.

in all this hubbub? | Don't turn your head; | at your back is only the leaden universe.'³ Is there a shared experience?

ZHT: I like this poem: I had never read it before. I think we share some feelings about life and reality, though in my painting visually I turn the head toward 'the leaden universe', and leave the 'hubbub' at the back. But the main thing is that the person is between the 'hubbub' and the 'leaden universe', so I would say we share a similar feeling.

JH: *What struck me in the poem was the intense sense of the individual person, alone and trapped, but in public. It's not the individual at home in some quiet corner and alone, but alone surrounded by all these people and on an almost cosmic scale. And that's what brought your head paintings to mind, because they often remind me of crowds, partly because in some paintings you have more than one image of a head which makes one think of a crowd, and partly because the viewer's closeness to the back of this person's head is similar to the experience we have in a crowd. Standing in a crowd, or riding a bicycle in Beijing, much of the time you're seeing the backs of people's heads.*

ZHT: That's true. In fact, in China I did some paintings of people riding bicycles, and they were all seen from the back.

JH: *You have related the 'Sunrise' and head paintings, produced in the United States over several years, to your earlier life in China. Were they an attempt to come to terms with the past?*

ZHT: They were an attempt to come to terms with the past, but in the sense of an attempt to extricate myself from the past.

JH: *Is it your own head, then?*

ZHT: No, it's just a head. I did a few small paintings based on my own head, which was interesting for me, but I didn't need people to recognize it as my head. There was one show that asked for self-portraits, and there I gave my social security number to identify it.

JH: *To me that would suggest that these paintings also have something to do with the anonymity of life in New York.*

ZHT: Traditionally Chinese intellectuals and artists have kept a kind of distance from their reality. I mean that they haven't dealt directly with social and political problems in their art. But coming here allowed me to have a different approach. I feel isolated from my new reality here, perhaps because of the language problems, the difference of lifestyle, the culture shock. I can fit in but I still feel different. When I show the head surrounded by empty space, it shows that isolation.

JH: *Earlier you spoke of the psychological space that you try to create for the viewer with your studio paintings. But the explicitly political works also create a psychological space, and one which to my eyes is very disturbing, because they draw on the power of the Mao icon at the same time as they oppose it. However, I wonder how sensitive to this a Western viewer can be, unless he or she has lived under a Communist regime.*

ZHT: I agree with you. If one has never lived under a Communist government, Mao's portrait means nothing: it's just a popular image such as Warhol did, like Marilyn Monroe. But the first time I cut Mao's portrait with a knife and put it back together to make a new Mao image, I

felt guilty, sinful. Can you imagine? Mao died fifteen years ago, and I left China nine years ago, but I still felt guilty doing that artwork.

JH: *That reminds me of the incident at Tiananmen Square, before the crack-down, when three men threw paint on the portrait of Mao above the Tiananmen Gate, and were pursued by the demonstrators and handed over to the police.*

ZHT: Yes, one was sentenced to life imprisonment, one to twenty years, and the third to sixteen years. I heard that news just as I was doing the first group of Mao images, and it encouraged me to continue, because it was so unjust.

JH: *What you've just been saying raises the question of taboos, which are one very obvious way of establishing boundaries. From what you say one can easily see the way that a certain kind of art helped to keep things in place, and the way that your own art explores taboos that have been important in your life.*

ZHT: This may be a difference of cultural values between this country and China. In China, even before the Communist period, people always had to follow a standard, not only the intellectuals, everybody. The standard might come from history, from the government's ideas, but people accepted it. If something deviated from the standard, then even before the government said it was wrong, one censored oneself. I think this is the most terrible thing in China, self-censorship. One always follows the official standard. Sometimes it is not official, but social, and not only the government will say you're wrong but your classmates, your teachers, your friends will say you were wrong. In this country people have more opportunity to choose for themselves. But when I was in China, images and icons, not only Mao's but historical ones as well, were a very powerful influence on my everyday life.

JH: *In a widely reported incident in 1990, your version of* The Last Supper, The Last Banquet, *was banned from a federally-funded exhibition in Washington. Those who banned it thought, or believed that others would think, that by replacing Jesus and the Apostles with figures of Mao you were attacking Christianity, whereas you intended to attack*

Zhang Hongtu, *Last Banquet (Selected Works of Mao, No. 5)*, 1989,
laser photo prints, collage, acrylic on canvas.

Mao and socialist realism. How do you feel about that misunderstanding?

ZHT: The whole of history is full of misunderstandings. What I am
concerned with is less misunderstanding for myself, so that I can see the
world from my own perspective. I used Leonardo da Vinci's *The Last
Supper* just as Marcel Duchamp used a bicycle wheel. *The Last Supper*
for me is a ready-made image, so I replaced all thirteen faces, including
both Jesus and Judas's, with Mao's face. The story is that after Jesus says
'One of you will betray me', all the twelve apostles have different
reactions. In my painting the story is still there but the content is changed
– Mao was betrayed by Mao. Perhaps some people who have stronger
religious emotions are affected by that, so that even if they understand the
story they don't understand my intention.

Something else to mention is that after that painting was first exhibited
in a show protesting against the Tiananmen massacre, but before the
Washington exhibition, one Chinese painter whose name unfortunately
is similar to mine went back to China from New York. At Beijing airport,
in the customs office, he was held by a Chinese official. He asked him:
'Are you Zhang Hongtu?' He was only released after he showed all his ID
cards.

JH: *So did the Chinese authorities understand your painting better than
the American authorities?*

ZHT: At least they understood my purpose. They didn't know the story,
perhaps, but they got the point.

JH: *Your use of a Christian story for* The Last Banquet *brings to mind the role that religion played in your early life. You grew up in Beijing, which is still the centre of China in a symbolic sense, but in a Moslem family, that's to say, outside the ethnic centre of the Chinese population. In fact, yours is an unusual Moslem family, since your father is a prominent Moslem scholar who has been working for many years on a Chinese translation of the Koran. How were the boundaries marked between the culture of your community and Han Chinese culture?*

ZHT: Han chauvinism is everywhere in China. It doesn't only come from the government, it comes from the psychology, from everybody. It's a terrible thing. The government has spent almost forty years destroying the boundary between Han and other peoples in China, both culturally and psychologically, so I am not very clear about the boundary, even though I live in a Moslem family. To give an example, idolatry is banned by Islam, but every Moslem family had Mao's portrait during a certain period. And not only did they have a portrait, but they had to put it on the wall at the centre of the room up above everything else. There were also small sculptures, because you could buy them anywhere. This was really idolatry but all Moslem families had Mao's portrait, both a picture and a sculpture.

JH: *Isn't it true that in the past, before 1949, Han families but not Moslem families would have put up another kind of image, of a domestic god? So there is actually a religious background for the placement of the Mao icon.*

ZHT: Yes, that's true. Not every family, but most families, though not Moslem ones. For example, people might have had a Guanyin (*Bodhisattva*) in the living-room, and almost everyone had a stove god in the kitchen.

But I can still talk about a difference between the two cultures, without talking about boundaries. In a Moslem family through religious influence I reached Western culture much earlier than others in my generation. When I was young my parents and all my relatives called each other by Islamic names. Even I have my Islamic name, Mohammed. Also, if my father had the chance we talked about Islam – if he had the chance, but not during the Cultural Revolution, of course. So I became more open-minded; my interest and knowledge were not glued by Confucianism and Daoism. Through the religious influence I had more knowledge about the

West. I know many stories from the Old Testament, which is also a part of Western culture: if you study Western art history you have to understand the Bible. In this way I think I had a chance to reach Western culture earlier than my generation. So that's one difference. But I don't think that I can use the word boundary, because it's very hard to see a boundary. If you ask someone else from a Moslem family, they would say that there's almost no difference, just the lifestyle, not eating pork, that's maybe the only thing.

JH: *How conscious were you of belonging to a different community?*

ZHT: There's no community. Even in the Niujie area where I grew up. It was a Moslem community in Beijing before 1949, but after that people were all mixed together. But spiritually I still have a relationship with the Middle East, with Western culture, especially since my father studied Arabic in Egypt when he was eighteen years old, and travelled to Mecca, to Pakistan, to many countries. He talked with us about that, about his experience, so this was an influence on our consciousness. We had a kind of relationship with the world outside China.

JH: *Has any of this found its way into your painting?*

ZHT: Not directly, but it certainly influenced my attitude toward my everyday life.

JH: *Including your attitude toward the practice of painting?*

ZHT: Yes. I can give you an example. I started to study painting at a very early age. The purpose wasn't to learn painting, I was just interested. But later my father told me many times: if you study something, you have to do it with a pure purpose. For example, art is art. You cannot use art as a tool to do something, for a name, for money, to make a living. Art is just like religion. In his thinking you have to put all your mind and body into religion. So this was the most important influence on my commitment to my career, to art. Also, the paintings about Mao, and then the cut-image paintings – these are connected with icons. Maybe there is an influence from the Moslem family here, because Islam is against idolatry. I believe in the power of the image, but I don't believe in the authority of the image.

References

Introduction

1 Within the Foucauldian approach, fragments of which are touched upon here, one might note focused projects such as *Boundary 2*, a journal of postmodern literature begun in 1972.

2 *Cultural Currents*, for example, a newsletter published by the distinguished East West Center at the University of Hawaii, in issue No. 1 (1993) had as its lead article, 'Sites of Crossing: Borders and Diasporas in Late 20th-Century Expressive Culture', and in No. 2 (1993), 'Post-Orientalist Voices: Women's Studies in China and the Instability of East-West Borders'. Both of these authors are at the University of California at Santa Cruz, where the Center for Cultural Studies has contributed much to these interests.

3 See, for example, Peter Stalleybrass and Allon White, *The Politics and Poetics of Transgression* (Ithaca, 1986).

4 Referred to in Borges' essay 'The Analytic Language of John Wilkins' (Emir Rodriguez Monegal and Alastair Reid, eds, *Borges, A Reader: A Selection From the Writings of Jorge Luis Borges*, New York, 1981, p. 142). Borges entitles the encyclopaedia 'Celestial Emporium of Benevolent Knowledge' and attributes the information to a Dr Franz Kuhn. The extract sounds like a fragment of a divination manual but may well have been fictitious.

5 M. Foucault, *The Order of Things: An Archaeology of Knowledge* (London, 1970), p. xix.

6 Kwang-chih Chang, *Art, Myth and Ritual* (New Haven, 1983), pp. 95–106.

7 The differences of 'ontology', 'epistemology' and 'phenomenology' are themselves very problematically alien in analyses of Chinese traditions of thought.

8 Quoted from Robert W. Bagley, in Wen C. Fong, ed., *The Great Bronze Age of China: An Exhibition from the People's Republic of China* (New York, 1980), p. 198. The vessel is well illustrated and discussed in this catalogue. See also Cho-yun Hsu and Katheryn M. Linduff, *Western Chou Civilization* (New Haven, 1988), pp. 94–106.

9 Kwang-chih Chang, in Fong, ed., *The Great Bronze Age*, p. 44.

10 Arthur Waldron, *The Great Wall of China: From History to Myth* (Cambridge, 1990).

11 The difference of self/other is perceptible in some of the Shang divinatory inscriptions, in reference to military campaigns. It is made explicit in the concept of *Hua-hsia* during the Zhou period.

12 See Sen-dou Chang, 'The Morphology of Walled Capitals', in G. William Skinner, ed., *The City in Late Imperial China* (Stanford, 1977), pp. 75–100; Arthur F. Wright, 'The Cosmology of the Chinese City', in *ibid*, pp. 33–73; and Nancy Shatzman Steinhardt, *Chinese Imperial City Planning* (Honolulu, 1990), pp. 36–53, *et passim*. See also Paul Wheatley, *The Pivot of the Four Quarters* (Edinburgh, 1971).

13 Translation by W. Allyn Ricket, in *Guanzi: Political, Economic and Philosophical*

Essays from Early China, vol. 1 (Princeton, 1985), p. 226. This is in the first of 'Eight Observations'. A similar passage occurs in the fifth (p. 231).

14 *Ibid*, 'Cultivation of Political Power', p. 95.

15 *Ibid*, 'Shepherding the People', p. 57.

16 *Ibid*, 'Conditions and Circumstances', p. 65.

17 Translation adapted from Steinhardt, *City Planning*, p. 33. She has a very useful discussion of the whole passage.

18 The best systematic summary is still Manfred Porkert, *The Theoretical Foundations of Chinese Medicine: Systems of Correspondence* (Cambridge, Mass., 1974). Paul Unschuld, *Medicine in China: A History of Ideas* (Berkeley, 1985), is also a very important secondary source, especially pp. 1–100 for the present issues. A very helpful application of these and other sources is Judith Farquahr, 'Multiplicity, Point of View, and Responsibility in Traditional Chinese Healing', in Angela Zito and Tani E. Barlow, eds, *Body, Subject and Power in China* (Chicago, 1994), pp. 78–102.

19 See Porkert, *Principles*, p. 214. Very recently, Shigehisa Kuriyama has written illuminatingly about the ambiguity of the body's autonomy, noting that in relation to a harmonious environment the self's 'propensity towards temporal uncoupling' is dangerous, but when the environment is disordered then it is an advantage: 'We must understand the utter seriousness with which Chinese physicians monitored the body's orifices in the light of this ambiguity. For the skin divided inner breaths from outer winds. It was through its pores that [diseases] penetrated the body. . . . Of the myriad orifices puncturing the skin – medieval texts count 84,000 pores – none were more intensely investigated than the points of acupuncture.' See 'The Imagination of Winds and the Development of the Chinese Conception of the Body', in Zito and Barlow, *Body, Subject and Power*, pp. 36–7.

20 There are now several studies of this earth-pattern system, which applied to the dwellings of the living and the dead equally. The kind of diagram illustrated is discussed by Hong-key Yoon, *Geomantic Relationships Between Culture and Nature in Korea* (Taipei, 1976). Korean 'geomancy' seems to be essentially the same as Chinese, and Yoo's book can serve as an excellent introduction.

21 Some discussion of *shi* can be found in most studies that try to treat of Chinese material reality, such as those of Needham and Porkert. I have tried to correlate some of these ideas in 'The Persistent Dragon (*Lung*)', in Willard Peterson, Andrew Plaks and Ying-shih Yu, eds, *The Power of Culture: Studies in Chinese Cultural History* (Princeton, 1994), pp. 119–150.

22 No. 632 in the *Mathews' Chinese-English Dictionary* (American edition 1943), with three meanings given: 'boundary, limit', suffix for 'class, world', 'to rule a line'.

23 See especially the work of A. C. Graham, such as in *Disputers of the Tao: Philosophical Argument in Ancient China* (La Salle, Ill., 1989).

24 *Language and Logic in Ancient China* (Ann Arbor, 1983), pp. 31–39, I consider this an extraordinarily important book. See also Hansen's more recent work, *A Daoist Theory of Chinese Thought* (Oxford, 1990).

25 *Ibid*, p. 55, quotation marks adapted.

26 A. C. Graham, translator and commentary, *Chuang Tzu: The Inner Chapters* (London, 1981), p. 30.

27 *Ibid*, pp. 54–55, quotation marks adapted.

28 For an excellent discussion of *xiang* and the *Yijing*, see Willard Peterson, 'Making Connections: "Commentary on the Attached Verbalizations" of the Book of Change', in *Harvard Journal of Asiatic Studies*, XLII/1 (1982), pp. 67–116. Peterson renders *xiang* as 'figure'. The emphasis on a world contained by potentiality/actuality is my own. I believe it to be a profound conceptual gulf between sinologists and pre-modern China, though the pre-modern and modern senses of 'participation' are closer to each

other than Newtonian observation is to either. See also Pauline Yu, *The Reading of Imagery in the Chinese Poetic Tradition* (Princeton, 1987), pp. 37–43.

29 Introduced in the most succinct form in Frederick W. Mote, *The Intellectual Foundations of China* (New York, 1971), pp. 17–18. As Mote acknowledged, the idea owed a great deal to the extensive work of Joseph Needham in the several volumes of his *Science and Civilisation in China* (Cambridge, 1954). Views of the extent and breadth of this gulf have been much modified in subsequent debate, and the more recent methodologies of sinology have tended to skirt it. I believe, however, that the problem Mote articulated remains as critical as ever.

30 Buddhism was changed by East Asia as much as East Asia was changed by Buddhism, thus *The Buddhist Conquest of China*, to use the title of E. Zurcher's great study of 1959, and *The Chinese Transformation of Buddhism*, to use the title of Kenneth Chen's book of 1973, have been an area of substantial Buddhological research for many years. Important work has been done on the linguistic boundaries of exchange, and some good work on the social boundaries. Although the phenomenon of boundaries is inherently prominent in this field, little theorizing has yet been done.

31 Nathan Sivin and Shigeru Nakayama, eds, *Chinese Science: Explorations of an Ancient Tradition* (Cambridge, Mass., 1973), p. xxi.

32 Angela Zito, 'Silk and Skin: Significant Boundaries', in Zito and Barlow, pp. 114–17. Zito's recent work is exceptionally valuable in relation to the concerns of the present volume, and her essay should be read in this connection.

33 David Hawkes, *Ch'u Tz'u, The Songs of the South* (Oxford, 1959), from the translation of 'Summons to the Soul', p. 104. For extensive discussion of the Mawangdui material, see Michael Loewe, *Ways to Paradise: The Chinese Quest for Immortality* (London, 1979).

34 Hawkes, *ibid*, pp. 42–51; Kwang-chih Chang, 'Shang Shamans', in Willard J. Peterson, Andrew H. Plaks and Ying-shih Yu, eds, *The Power of Chinese Culture: Studies in Chinese Cultural History* (Princeton, 1994), pp. 10–36.

35 A. C. Graham, *Chuang Tzu: The Inner Chapters*, p. 23. See also pp. 176–80 for a discussion of 'the cult of immortality'.

36 Translation by Siu-kit Wong, in *Early Chinese Literary Criticism* (Hong Kong, 1983), p. 40.

37 See the careful review of these events in Denis Twitchett and Michael Loewe, eds, *The Ch'in and Han Empires, 221 BC–AD 220*, vol. 1 in *The Cambridge History of China* (Cambridge, 1986), pp. 69–72.

38 In the introduction to John W. Haeger, ed., *Crisis and Prosperity in Sung China* (Tuscon, 1975), p. 12.

39 Extensive work has been done on Zhao Mengfu, especially by Chu-tsing Li (although the terms used here are peculiar to this account). For an excellent overall discussion and bibliography, see James Cahill, *Hills Beyond a River: Chinese Painting of the Yuan Dynasty, 1279–1368* (Tokyo and New York, 1976), pp. 3–14, 38–46.

40 For the arguments in general, see the indispensable study by Susan Bush, *The Chinese Literari on Painting: Su Shih (1037–1101) to Tung Ch'i-ch'ang (1555–1636)*, (Cambridge, Mass., 1971). For references to *jiehua*, see Susan Bush and Hsio-yen Shih, *Early Chinese Texts on Painting* (Cambridge, Mass., 1985), pp. 111, 137, 248–9. The issue deserves close study.

41 Zito, 'Silk and Skin', pp. 120, 122. Zito also contributes a very helpful discussion of "face" as surface in this article (p. 119), which was unfortunately unpublished when I wrote my essay.

42 Subject of the most recent block-buster enterprise in Chinese art. There is an immense concentration of invaluable research in Wal-kam Ho and Judith Smith, eds, *The*

Century of Tung Ch'i-ch'ang (1555–1636), vols 1 and 2, and *Proceedings of the Tung Ch'i-ch'ang International Symposium* (Kansas City, Missouri, 1992).

43 I tried to explore the possibilities of this for art history, in terms of a Foucauldian episteme, in 'Subject, Nature, and Representation in early Seventeeth-century China', in Ho, *Proceedings*, section 4.

44 Jonathan Spence and John Hillis, eds, *From Ming to Ch'ing* (New Haven, 1979), Introduction.

45 See Marsha Widener, 'The Conventional Success of Ch'en Shu', in an important historical contribution to this field, Marsha Weidner, ed., *Flowering in the Shadows: Women in the History of Chinese and Japanese Painting* (Honolulu, 1990), pp. 123–56, quotation from p. 149. For Liu Yin, see in the same volume James Cahill, 'The Painting of Liu Yin', pp. 103–21; and for a survey see Ellen Johnston Laing, 'Women Painters in Traditional China', pp. 81–101.

46 Building on archival work by Chinese scholars in the twenties and thirties, the methodological move was marked initially by studies such as Joanna Handlin's 'Lu K'un's New Audience: The Influence of Women's Literacy on Sixteenth-Century Thought', in Margery Wolf and Roxane Witke, eds, *Women in Chinese Society* (Stanford, 1975), pp. 13–38. See more recently Rubie S. Watson and Patricia Buckley Ebrey, eds, *Marriage and Inequality in Chinese Society* (Berkeley, 1991). Literature and theatre are now proving fertile fields and much of importance has been happening while this volume was in preparation.

47 See Keith McMahon, 'The Classic "Beauty-Scholar" Romance and the Superiority of the Talented Women', in Zito and Barlow, *Body, Subject and Power*, pp. 227–52.

48 Discussed by Joanna Handlin, in 'Lu K'un's New Audience', pp. 23–24. Hua-mu-lan has also become popular in scholarship, as exemplary in the woman-warrior genre.

49 See, for example, Charlotte Furth, 'Androgynous Males and Deficient Females: Biology and Gender Boundaries in Sixteenth- and Seventeenth-century China', in *Late Imperial China*, IX/2 (1988), pp. 1–31.

50 'Theorising Woman: *Funu, Guojia, Jiating* [Chinese Woman, Chinese State, Chinese Family]', in Zito and Barlow, *Body, Subject and Power*, p. 258.

51 See Brett Hinsch, *Passions of the Cut Sleeve: The Male Homosexual Tradition in China* (Berkeley, 1990). Hinsch notes that lesbianism is largely absent from the records of a patriarchal culture.

52 In February 1993, a conference on 'the subject of China' was organised by Christopher Connery at the University of California, Santa Cruz. A variety of papers displayed very clearly both the topicality of these issues and the lively divergence of views.

53 Translation by Arthur Waldron in *The Great Wall of China*, p. 216.

1 *Robin Yates: Body, Space, Time and Bureaucracy: Boundary Creation and Control Mechanisms in Early China*

1 *Xunzi*, Book 5; John Knoblock, trans., *Xunzi: A Translation and Study of the Complete Works*, I (Stanford, 1988), p. 206. A first draft of this paper was presented as the inaugural lecture of the Burlington Northern Professorship of Asian Studies in Honor of Richard M. Bressler. I would like to thank the Burlington Northern Foundation and Richard M. Bressler for their generous support of my research activities; Grace S. Fong of McGill University for making numerous suggestions for the improvement of successive drafts; and my research assistant at Dartmouth College, presidential scholar Victoria Martens. Any remaining errors and infelicities are entirely my own responsibility.

2 In my analysis of the discourse of boundaries in pre-imperial and early imperial China, I draw upon Michel Foucault and Bryan S. Turner's elaboration of the economy of

discipline and the body in *Surveiller et punir: Naissance de la prison* (Paris, 1975), translated as *Discipline and Punish: The Birth of the Prison* (London, 1979), and *The Body and Society: Explorations in Social Theory* (Oxford, 1984). Though their analyses aim to articulate the nature of modern Western society and the emergence of the modern Western individual, they nonetheless help to illuminate certain facets of the problems associated with social control and personal self-control in ancient China. See also Michel Foucault, trans. Robert Hurley, *The History of Sexuality, I: An Introduction* (New York, 1980) and M. Featherstone, 'The Body in Consumer Society', *Theory, Culture and Society*, 1 (1982), pp. 18–33.

3 Except for Rao Zongyi and Zeng Xiantong, *Yunmeng Qinjian rishu yanjiu* [Researches on the Almanac Texts on the Qin Slips from Shuihudi] (Hong Kong, 1982); Marc Kalinowski, 'Les Traités des Shuihudi et l'Hémérologie chinoise à la Fin des Royaumes-Combattants', in *T'oung Pao*, LXXII (1986), pp. 175–228; Michael Loewe, 'The Almanacs (*jih-shu*) from Shui-hu-ti: a Preliminary Survey', *Asia Major*, 3rd series, 1/2 (1988), pp. 1–27 and a few others.

4 Zhiming Bao, 'Language and World View in Ancient China', *Philosophy East and West*, XL/2 (1990), p. 195.

5 A. C. Graham, *Later Mohist Logic, Ethics and Science* (Hong Kong, 1978); Chad Hansen, *Language and Logic in Ancient China* (Ann Arbor, 1983); Hansen, 'A *Tao* of *Tao* in Chuang-tzu', in Victor H. Mair, ed., *Experimental Essays on Chuang-tzu* (Hawaii, 1983), pp 24–55.

6 Edouard Chavannes, 'Les Inscriptions des Ts'in', in *Journal Asiatique*, series 9, no. 1 (1983), p. 494.

7 It is quite possible that, historically speaking, some of the ideas for the longer sets appeared early in Chinese civilization, or were developed in different regions of China. I believe, however, that the elaboration of the sets into a coherent system that held explanatory power for the world developed after the binary pairs. (Cf. Graham, *Yin-Yang and the Nature of Correlative Thinking* (Singapore, 1986).

8 Yu Mingguang, *Huangdi Sijing yu HuangLao sixiang* [*The Four Classics of the Yellow Emperor and HuangLao Thought*], (Harbin, 1989), p. 241.

9 Cf. *He Guanzi* (Shanghai, n.d.), A.11b, 'Huanliu'.

10 Burton Watson trans. *Basic Writings of Mo Tzu, Hsün Tzu, and Han Fei Tzu* (New York, 1963), p. 125, quoted in Graham, *Disputers of the Tao* (La Salle, 1989), p. 236, romanization changed.

11 Alfred Forke trans., Wang Chong, *Lun Heng* (New York, 1962), Part 1, p. 198 (Wang Chong, 'On Poison').

12 Marcel Granet, *La Pensée chinoise* (Paris, 1934), p. 89.

13 Ibid., p. 93.

14 Lien-sheng Yang, 'Historical Notes on the Chinese World Order', in John King Fairbank, ed., *The Chinese World Order: Traditional China's Foreign Relations* (Cambridge, 1968), pp. 20–33.

15 Derk Bodde, 'Myths of Ancient China', in Samuel N. Kramer, ed., *Mythologies of the Ancient World* (New York, 1961), p. 398.

16 Ibid., p. 400.

17 For a discussion of the new evidence concerning the land systems of the lineages fighting for control of the state of Jin from the Yinqueshan *Sunzi*, see Robin D. S. Yates, 'New Light on Ancient Chinese Military Texts: Notes on their Nature and Evolution, and the Development of Military Specialization in Warring States China', *T'oung Pao*, no. 74 (1988), pp. 217–18.

18 J. J. L. Duyvendak trans., *The Book of Lord Shang: A Classic of the School of Law* (Chicago, 1963).

19 A. F. P. Hulsewé, *Remnants of Ch'in Law* (Leiden, 1985), D136, pp. 164–5; see also group G, pp. 211–15.

20 'Social Status in the Ch'in: Evidence from the Yün-meng Legal Documents. Part One: Commoners', *Harvard Journal of Asiatic Studies*, XLVII/1 (1987), pp. 197–237.

21 Cf Tu Cheng-sheng, *Bianhu qimin* [The Registration of Households and Equalizing the People] (Taibei, 1990).

22 David N. Keightley, 'The Religious Commitment: Shang Theology and the Genesis of Chinese Political Culture', *History of Religions*, XVII/3–4 (1978), pp. 211–25. The process of divining was fairly complicated, but, in brief, the Shang drilled depressions in the reverse side of specially prepared carapaces of turtles and scapulae of cattle, and then applied a hot rod to the front side in such a way that the bone cracked. The cracks were then interpreted as the ancestors' or deities' answers to the questions posed to them. The question and the answer were then carved into the bone as a record of the divination.

23 Cho-yun Hsu, *Ancient China in Transition: An Analysis of Social Mobility, 722–222 BCE* (Stanford, 1965).

24 Joseph Needham, 'Time and Eastern Man', in *The Grand Titration* (London, 1969), notes that it was the Neo-Confucians, drawing on ancient Daoist and Buddhist beliefs, who were particularly attracted to this type of cyclical thinking. He accepts (p. 228) Granet's interpretation that in ancient China 'time . . . was always divided into separate spans, stretches, blocks or boxes, like the organic differentiation of space into particular expanses and domains.'

25 Johannes Fabian, *Time and the Other: How Anthropology Makes its Object* (New York, 1983).

26 Book 2, Section 62; D. C. Lau, trans. Lao-tzu, *Tao Te Ching* (Harmondsworth, 1981), p. 123. There is disagreement about whether or not Laozi was an historical figure and, if he was, when he lived. Most scholars are of the opinion that the text *Laozi* was written down about 300 BCE, but it may have circulated in oral form before that time.

27 The dating of the newly discovered HuangLao texts from Mawangdui and that of the HuangLao sections in the *Guanzi* is still disputed by scholars. It is quite possible that HuangLao thought was a different tradition of Daoism separate from that of the *Laozi*, possibly prior to or contemporaneous with the ideas expressed in the latter book.

28 J. J. L. Duyvendak, *The Book of Lord Shang* (Chicago, 1963), pp. 160–1, 228, 238.

29 Yi-pao Mei, trans., *The Ethical and Political Works of Motse* (London, 1929), p. 182.

30 *Yunmeng Shuihudi Qinmu* bianxiezu, *Yunmeng Shuihudi Qinmu* [The Qin Tombs at Shuihudi, Yunmeng County] (Beijing, 1981); Kalinowski, 'Les Traités'; Loewe, 'The Almanacs'.

31 Forke, *Lun Heng*, Part 1, Chapter 8, p. 136. The original quotation appears in *The Analects* of Confucius, Book 12, paragraph 5 (Lau, *Analects*, p. 113).

32 Knoblock, *Xunzi*, Book 5, p. 203.

33 Wu Jiulong, *Yinqueshan Hanjian shiwen* [Transcription of the Han Slips from Yinqueshan] (Beijing, 1985), has identified fifteen fragmentary bamboo slips belonging to the text on physiognomizing dogs. The text on the art for horses was found written on silk at Mawangdui and the transcription was published in *Wenwu*: see Mawangdui Hanmu boshu zhengli xiaozu, 'Mawangdui Hanmu boshu *Xiangma jing* shiwen' [Transcription of the *Classic of Physiognomizing Horses* in the Silk Manuscripts from the Han Tomb at Mawangdui] *Wenwu*, no. 8 (1977), pp. 17–22; *Lüshi chunqiu* [*Spring and Autumn Annals of Mr Lü*], henceforth LSCQ (20.19a) records the names of ten physiognomists specializing in horses, each one of whom made his interpretation on the basis of a different part of equine anatomy.

34 *Huainanzi*, Sibu beiyao ed. (Taibei, 1966), Chapter 3, p. 1a.

35 Manfred Porkert, *The Theoretical Foundations of Chinese Medicine* (Cambridge, 1974); Paul U. Unschuld, *Medicine in China: A History of Ideas* (Berkeley, 1985); Donald J. Harper, *The 'Wu Shih Erh Ping Fang': Translation and Prolegomena* (Berkeley, 1982)

36 Forke, *Lun Heng*, Part 1, p. 138.

37 Cf. *Guanzi, ce* 2, *pian* 39, 'Shui Di', 14:74: 'water is the blood and *qi* of earth and flows through as though in the muscles and arteries.'

38 Derk Bodde, *China's First Unifier: A Study of the Ch'in Dynasty as seen in the Life of Li Ssu (280?–208 BCE)* (Hong Kong, 1967).

39 *LSCQ*. Chapter 12, pp. 10ab.

40 Hulsewé, *Ch'in Law*, passim.

41 *Pian* 49, *ce* 2, ch. 16, p. 103.

42 Quoted in Hidemi Ishida, 'Body and Mind: The Chinese Perspective', in Livia Kohn, ed., *Taoist Meditation and Longevity Techniques* (Ann Arbor, 1989), p. 47; cf. W. Allyn Rickett, trans., *Kuan-tzu: A Repository of Early Chinese Thought. A Translation and Study of Twelve Chapters*, I (Hong Kong, 1965), p. 166.

43 *Guanzi, pian* 49, *ce* 2, Chapter 16, p. 102; Rickett, *Kuan-tzu*, p. 163.

44 *Huainanzi*, Chapter 7, p. 1a; translation adapted from Ishida, 'Body and Mind', p. 47.

45 *Huainanzi*, Chapter 7, p. 2a.

46 Chapter 2, p. 3a.

47 *Guanzi, pian* 36, 'Xinshu shang', *ce* 2, Chapter 13, p. 62; Rickett, *Kuan-tzu*, p. 172; *Huainanzi*, Chapter 7, p. 2a.

48 Harold H. Oshima, 'A Metaphorical Analysis of the Concept of Mind in the *Chuang-tzu*', in Mair, *Experimental Essays*, pp. 63–84.

49 Cf. Ishida, 'Body and Mind'.

50 Derk Bodde, 'The Chinese Cosmic Magic Known as Watching for the Ethers', in Søren Egerod and Else Glahn, eds, *Studia Serica Bernhard Karlgren dedicata* (Copenhagen, 1959), pp. 14–35; A. F. P. Hulsewé, 'Watching the Vapours: An Ancient Chinese Technique of Prognostication', *Nachrichten der Gesellschaft für Natur-und Volkerkunde Ostasiens*, no. 125 (1979), pp. 40–9; Michael Loewe, 'The Oracles of the Clouds and the Winds', *Bulletins of the School of Oriental and African Studies*, LI/3 (1988), pp. 500–19.

51 Yu Mingguang, *Huangdi*, pp. 240–1.

52 *Huainanzi*, Chapter 7, p. 5a, trans. Ishida, p. 64.

53 *LSCQ*, Chapter 19, p. 13a. Note that this opinion of the *LSCQ* is in opposition to that espoused in the *Laozi* referred to above.

54 James Legge trans., *The Sacred Books of China; The Texts of Confucianism*, III: *The Li Ki*, I–X (Oxford, 1885), p. 380.

55 It seems that one of the reasons that ancient Chinese thinkers were so anti-female is that women were conceived of as embodiments of, or generators of, desire in men and thus they caused early death. Han Feizi argues, 'Heaven has its destiny; human beings have their destiny, too. Indeed, anything smelling good and tasting soft, be it rich wine or fat meat, is delicious to the mouth, but it causes bodily illness (*bingxing*). The beauty having delicate skin and pretty white teeth pleases feeling (*qing*) but exhausts energy (*jing*). Hence avoid excesses and extremes. Then you will suffer no harm.' See Han Feizi, 'Wielding the Sceptre' ['Yang Quan'] in W. K. Liao, trans., *The Complete Works of Han Fei Tzu* (London, 1959).

56 *Xunzi*, Chapter 19; Watson, *Basic Writings*, pp. 88–111.

57 James L. Watson and Evelyn S. Rawski, eds, *Death Ritual in Late Imperial and Modern China* (Berkeley, 1988).

58 Legge, *The Li Ki*, pp. 410–11.

59 The Han Confucian text 'Li Yun' preserved in Book 7 of the *Li Ji*, states, 'Therefore

Man is the heart and mind of Heaven and Earth, and the visible embodiment of the five elements [phases]. He lives in the enjoyment of all flavours, the discriminating of all notes (of harmony), and the enrobing of all colours.' See Legge, *The Li Ji*, p. 382.

60 The later Mohists were unique in explaining time in terms purely of 'duration' (*jiu*), which they defined as 'pervasion of different times', and space (*yu*) as 'pervasion of different places'. See Graham, *Later Mohist Logic*, A40, p. 293; B14–16, pp. 364–9.

61 So argues the *Huainanzi*, Chapter 3, p. 1a; Ishida, 'Body and Mind', p. 65.

62 Wang Ming, *Taipingjing hejiao* [Collected Collations on the *Classic of Great Peace*] (Beijing, 1979), p. 292; Ishida, 'Body and Mind', p. 63.

63 The cycle is created out of a combination of ten so-called 'stems' and twelve 'branches', the first year being named by a combination of the first 'stem' and first 'branch', the second year the second 'stem' and second 'branch' etc; the sixty-day cycle is similarly constituted.

64 *LSCQ*, Chapter 17, p. 1a.

65 The 'Yueling' calendar was but one of many: Rickett, *Kuan-tzu*, mentions some others that were transmitted through the centuries and several others have been found recently in a Shandong tomb. See Wu Jiulong, *Yinqueshan*.

66 cf. Granet, *La Pensée chinoise*.

67 Kalinowski, 'Cosmologie et Gouvernement Naturel dans le Lü Shi Chunqiu', *Bulletin de l'Ecole Française d'Extrême-Orient*, no. 71 (1982), p. 192.

68 *LSCQ*, Chapter 13, p. 3b; Kalinowski, 'Cosmologie', p. 178.

69 *LSCQ*, Chapter 17, p. 7b. Hanfeizi states, 'Hence the saying: "So quiet, it rests without footing; so vacant, it cannot be located." Thus the intelligent ruler does nothing, but his ministers tremble all the more. It is the Tao [Dao] of the intelligent ruler that he makes the wise men exhaust their mental energy and makes his decisions thereby without being himself at his wit's end . . . Tao exists in invisibility; its function in unintelligibility. Be empty and reposed and have nothing to do. Then from the dark see defects in the light. See but never be seen. Hear but never be heard. Know but never be known . . . Cover tracks and conceal sources. Then the ministers cannot trace origins. Leave your wisdom and cease your ability. Then your subordinates cannot guess at your limitations.' 'The Dao of the Sovereign' in Liao, *Complete Works*, I, pp. 32–3. These ideas seem to have derived from Shen Buhai whom Hanfeizi quotes as saying, 'If the superior's cleverness is visible, people will bewilder him; if his knowledge is visible, people will disguise themselves; if his ignorance is visible, people will hide their faults . . .'. Liao, *Complete Works*, II, 'Outer Congeries of Sayings, Upper Right Series', p. 99.

70 Liao, *Complete Works*, I, p. 49; *Hanfeizi*, Chapter 7; translation slightly amended.

71 Kalinowski, 'Cosmologie', pp. 197–8; *LSCQ*, Chapter 24, p. 5b; cf. Hanfeizi, Chapter 55, 'Regulations and Distinctions' in Liao, *Complete Works*, II, pp. 330–3 and Chapter 7, 'The Two Handles', I, pp. 46–51. It should be noted that the reality of the Qin administration as now revealed by the new legal documents was that it combined the prescriptions of the 'legalists' (such as Shang Yang) and the 'administrators' (such as Shen Buhai), separated by Creel, 'The *Fa-chia*: "Legalists" or "Administrators"?', in *What is Taoism? and Other Studies in Chinese Cultural History* (Chicago, 1970), pp. 92–120.

72 It is interesting to note that there was a distinction between the punishments of hard labour coupled with bodily mutilation (*xing*) applied to criminals in the general population and the fines imposed on refractory or incompetent officials. By mutilating the body of a convict, the Qin authorities inscribed on the body of that criminal an outward manifestation of his crime and, in doing so, made him not whole (*buquan*), thus creating, as it were, a 'symbolic pun', for they altered his form (*xing*) by means of mutilation (*xing*). Tu, *Bianhu*, pp. 261–315; Hulsewé, *Ch'in Law*, pp. 14–18;

Katrina C. D. McLeod, 'Law and the Symbolism of Pollution: Some Observations on the Ch'in Laws from Yün-meng', unpublished paper, 1978.

73 Interestingly enough, as far as I can determine, none of the new documents record the day of the Great Exorcism of evil spirits and the New Year's Day, festivals which we know from historical sources the Qin adopted some hundred years before the unification of China. These festivals became extremely important under the next dynasty, the Han. Derk Bodde, *Festivals in Classical China: New Year and Other Annual Observances during the Han Dynasty 206 BC–AD 220* (Princeton, 1975).

74 H. Hubert and M. Mauss, 'Etude Sommaire de la Représentation du Temps dans la Religion et la Magie', *Mélanges d'Histoire des Religions* (Paris, 1929), pp. 189–236.

75 Clifford Geertz, 'Person, Time, and Conduct in Bali' in *The Interpretation of Cultures* (New York, 1973), p. 391.

76 *Yunmeng Shuihudi*, slip 788. Probably it is powerful astral deities who do the stabbing and striking, causing one to lose one's good fortune.

77 Cf. Pierre Bourdieu, *Outline of a Theory of Practice*, trans. Richard Nice (Cambridge, 1977).

78 In the construction and control of time, therefore, the Qin may have been much less autocratic and despotic than has been traditionally maintained. In other words, it may not have been able to force the people to carry out its policies, which required strict adherence to its own temporal sequence, as effectively as it would have liked.

79 Granet, *La Pensée*; Needham, 'Time', p. 228.

80 For 'lived' time, see Bourdieu, *Practice*.

81 Kalinowski, 'Les Traités', pp. 206–16.

82 Presumably when they have just been built or have just been purchased.

83 Note that the rules on marrying imply that the calendar is addressed to a man, not a woman: did women have their own, unrecorded, calendars, their own time?

84 Under Qin law, children who were 'not whole' (*buquan*) could be killed by their parents with impunity (Hulsewé, *Ch'in Law*, D56: 139). Because they were not whole, in other words, deformed in some fashion and either lacking some segment or portion of the body or having an addition, neither of which conformed to the ideal shape or form, they were not considered to be human.

85 The meaning of the last sentence is highly obscure.

86 See above, p. 59.

87 Edmund Leach, 'Two Essays Concerning the Symbolic Representation of Time' in *Rethinking Anthropology* (London, 1961), pp. 133–4.

88 *Yunmeng Shuihudi*, slip 062.

89 According to the *LSCQ*, Chapter 5, p. 4a, humans were humans because they had received their natures from Heaven: in this they were no different from other creatures. And they had received, likewise from Heaven, desires, and humans were bound to pursue them. Heaven gave humans evil and they could not avoid it. Thus humans received both desires and evil from Heaven.

90 *LSCQ*, Chapter 14, p. 9a.

2 Wu Hung: Beyond the 'Great Boundary': Funerary Narrative in the Cangshan Tomb

1 As Wolfgang Bauer has suggested, in Han thought immortal lands are often connected with the east and the west. W. Bauer, *China and the Search for Happiness*, trans. M. Shaw (New York, 1976), pp. 95–100.

2 Burton Watson, tr., *The Complete Works of Chuang Tzu* (New York, 1968), p. 33. Ying-shih Yü remarks: 'The only difference between the *hun* (soul) and the *hsien* (immortal) is that while the former leaves the body at death, the latter obtains its total freedom by transforming the body into something purely ethereal, that is, the heavenly

chi'i (breath, ether, etc.). '"O Soul, Come Back!" – A Study in the Changing Conceptions of the Soul and Afterlife in Pre-Buddhist China', *Harvard Journal of Asiatic Studies*, XLVII/2 (1987), p. 387.

3 Sima Qian, *Shi ji* [Historical Records], (Beijing, 1959), vol. IV, pp. 1369–70; Burton Watson, tr., *Records of the Grand Historians of China* (New York, 1961), vol. II, p. 26.

4 Ying-shih Yü, 'O Soul, Come Back!', p. 378.

5 During Emperor Wu's time, Penglai was often associated with a divine master named An Qisheng, who was originally a necromancer of pre-Qin times. Sima Qian, *Shi ji*, vol. II, pp. 453–55; B. Watson, *Records of the Grand Historian*, vol. II, pp. 38–40. Another legendary figure, Xiwangmu or the Queen Mother of the West, was first among a number of personages who, according to Zhuangzi, had succeeded in attaining immortality. See J. Legge, *The Tao Te Ching, the Writings of Chuang-tzu, the Tai-shan*, in Sacred Books of the East, vols 39–40 (Oxford, 1891), p. 293. This figure became associated with Mt. Kunlun during the Han. I have discussed this integration process in *The Wu Liang Shrine: The Ideology of Early Chinese Pictorial Art* (Stanford, 1989), pp. 117–26.

6 Sima Qian, *Shi ji*, vol. IV, p. 1388.

7 For a sociological explanation of the development of Han funerary art, see Wu Hung, 'From Temple to Tomb', *Early China*, XIII (1988), pp. 78–115.

8 Sima Qian, *Shi ji*, vol. I, p. 364.

9 *Li ji*, (Book of Ritual) in Ruan Yuan, ed., *Shisanjing zhushu* [The Annotated Thirteen Classics], 2 vols (Beijing, 1980), vol. 1, p. 1292.

10 Sima Qian, *Shi ji*, vol. VI, p. 265. I have argued elsewhere that each of the three sections of the Lishan mausoleum assumed a different function and symbolism: the heart of the mausoleum inside the inner walls was the burial and sacrificial area and the emperor's 'forbidden city'; the area between the two walls symbolized his inner court and was occupied by ceremonial officials and their departments; and the large region outside the funerary park symbolized his kingdom, with the underground terracotta army, an enormous underground stable, and tombs of high officials and slaves to the east and west. 'From Temple to Tomb', 94–5. For a more detailed reconstruction and discussion of the mausoleum, see Robert Thorp, 'An Archaeological Reconstruction of the Lishan Necropolis'. in G. Kuwayama, ed., *The Great Bronze Age of China – A Symposium* (Los Angeles, 1983), pp. 72–82.

11 This brief discussion of the Mawangdui tomb is based on my paper, 'Art in a Ritual Context: Rethinking Mawangdui', Early China, XVII (1992), pp. 111–144.

12 Sun Zuoyun, 'Luoyang Xi-Han Bu Qianqiu mu bihua kaoshi' [An Interpretation of the Murals in the Bu Qianqiu Tomb of the Western Han in Luoyang], *Wenwu*, no. 6 (1977), pp. 18–19.

13 Lei Jianjin, 'Jianyangxian Guitoushan faxian bangti huaxiang shiguan' [The Finding of an Inscribed Pictorial Sarcophagus from Guitoushan in Jianyang county], *Sichuan wenwu*, no. 6 (1988), p. 65; The Neijiang Administrative Institute of Cultural Relics and the Jianyang Cultural House, 'Sichuan Jianyangxian Guitoushan Dong-Han yamu' [An Eastern Han Cave Burial at Guitoushan in Jianyang county in Sichuan), *Wenwu (Cultural Relics)*, no. 3 (1991), pp. 20–25; Zhao Dianzeng and Yuan Shuguang, 'Tianmen kao – jianlun Sichuan Han huaxiang zhuan(shi) de zuhe yu zhuti' [An Examination of 'the Gate of Heaven' – Interpreting Motif-combinations of Han Dynasty Pictorial Stones [and Bricks] from Sichuan], *Sichuan wenwu*, no. 6 (1990), pp. 3–11.

14 This excavation is reported in *Kaogu (Archaeology)*, no. 2. (1975), pp. 124–34. The date of the Cangshan tomb has been the focus of a scholarly debate, primarily because the inscribed date is ambiguous: 'the first year of the Yuanjia reign period' could be

either 151 or 424 CE. The excavators first dated the tomb to 424, but most scholars have rejected this dating.

15 Among other Han funerary structures which bear explanatory inscriptions, the famous Wu Liang Shrine and the Guitoushan sarcophagus have cartouches identifying each individual scene; an inscription on the An Guo Shrine contains sentences briefly introducing the layout of the carvings. None of these inscriptions can match the Cangshan text, which describes the narrative content of the decoration.

16 A number of factors enable us to identify the writer of this text as the designer of the tomb. In addition to the many wrong characters and homonyms in the text (which suggest a poorly educated author), the most obvious indication is the indefinite appellations for the deceased. In two places, the occupant of the tomb is addressed as *guiquin*, 'an honourable member of the family', and *jiaqin*, 'a member of the family'. The writer's attitude towards the decreased, therefore, differs fundamentally from that of the patron of a funerary structure, who in their devotional writings always first identified and properly introduced the deceased. All the information about the deceased usually provided in a stele-inscription – his education, official career and virtuous conduct – is absent here; nor does the text give an account of the family's practices of filial piety as was the custom in a shrine-inscription. In fact, the Cangshan text seems to have been composed by a writer who simply did not know who the deceased was, and his writing could have been used in the tomb of any family, since a dead person could always be referred to as 'an honourable member of the family'. Moreover, we recognize this writer's cultural background in his language, which differs markedly from that used in stele-inscriptions and shrine-inscriptions. Stylistically, the Cangshan text is a rhymed ballad, with most lines consisting of three, four and seven characters. This form differs from all other inscriptions, which are mainly prose compositions – sometimes with a dirge of uniform four-character lines. In content, the Cangshan text offers none of the allusions from the Confucian classics or formulaic accounts of filial piety so abundant in the inscriptions by the descendants or friends and collegues of the dead. This is not to say, however, that the writer of this inscription was free from cultural conventions. On the contrary, his language is likewise formulaic, but of a different sort. The text contains many popular sayings related to folk beliefs of the time. Many sentences and phrases are 'auspicious words' (*jiyu*) in couplets, which one can find on bronze mirrors and other objects for daily use. These include, 'Tigers and dragons arrive with good fortune; a hundred birds fly over to bring abundant wealth'; 'You who devote yourselves to learning, may you be awarded high rank and official seals and symbols; you who devote yourselves to managing livelihood, may your wealth increase a hundred-fold each day'; and, 'In the middle, dragons ward off evil; at the left, there are the Jade Fairy and immortals.' Other formulae in the text are prayers, including the well-known expression: 'All figures and animals, may you eat in the Great Granary and drink from the rivers and seas.' The 'Great Granary' refers to the Han state granary that was established by the chief minister Xiao He in 200 BCE. During Han times, however, commoners used this term as a symbol for the greatest grain depository, just as rivers and seas were considered the greatest depository of water. By inscribing this sentence on a mortuary structure, the writer was expressing the hope that the figures and animals in the tomb would not seize food from the living, but would eat and drink from greater natural sources.

17 A rough transliteration of the text appeared in the excavation report, and some passages were quoted as iconographic sources of the pictures engraved in the tomb. The author of the report, however, cautiously avoided punctuating and interpreting the whole text. Five years after the publication of the report in *Kaogu*, a short publisher's note appeared in the magazine, saying that the editorial board had received

several articles criticizing the transliteration and interpretation of the inscription as provided in the report *Kaogu*, no. 3 (1980), p. 271. Since then, different punctuations and interpretations have been proposed by Li Falin, and Fang Penjun and Zhang Xunliao. See Li Falin, *Shandong Han huaxiangshi yanjiu* [A Study of Han Dynasty Pictorial Carvings from Shandong], (Ji'nan, 1982), pp. 95–101; Fang Penjun and Zhang Xunliao, Shandong Cangshan Yuanjia yuannian huaxiangshi tiji de shidai he youguan wenti de taolun' [A Discussion of the Date and Other Related Problems of the Inscription on the Yuanjia First Year Pictorial Carvings from Cangshan in Shandong], *Kaogu*, no. 3 (1980), pp. 271–8.

Li Falin's basic method is to discover literary references for individual words and phrases and then to find the relationships between these units. Fang Pengjun and Zhang Xunliao, on the other hand, focus on phonology and punctuation and have found that the whole text is actually a rhymed composition. After a careful phonological study, these two authors have concluded that 'the recognition of (these rhyming rules) is the key to interpreting the text.' These studies have all provided the present author and translator with important clues. Fang Pengjun and Zhang Xunliao's punctuation differs markedly from Li Falin's, and is more convincing in my opinion. On the other hand, Li Falin's work has provided many literary sources that are important for our understanding of the text.

18 Li Falin interprets the character *song* as 'to present' or 'to donate', and the sentence as '. . . we completed the construction of this tomb chamber to present to you, the honourable member of a family.' The later parts of the inscription, however, clearly suggest that this tomb was a vehicle for the dead to travel to the other world. The character *song* can thus be more properly translated as 'to send off' or 'to send away'.

19 Li Falin provides two different interpretations for the terms *boshu* and *huaguan*. (1) *boshu* means 'simple and coarse' and *huaguan* means 'rooms decorated with pictures', he thus explains the sentence as: 'Chambers decorated with pictures are inside the simple and coarse tomb.' (2) *boshu* means 'decoration and carving' and *huaguan* means 'paintings which people can view and enjoy'; he then interprets the sentence as, 'In the decorated and engraved tomb chambers are pictures which people can see and enjoy.' My understanding of this sentence differs. In Han literature, the character *bo* and *bu* are interchangeable: the latter means 'a list' or 'to list'. The meaning of *shu* is close to *bu* and can be translated in certain contexts as 'to list', 'to explain', or 'to propose'. See Yan Shigu's commentary in Ban Gu, *Han shu* [History of the Former Han Dynasty], (Beijing, 1962), vol. 8, p. 2467. As defined in *Shuo wen*, the original meaning of *guan* is 'to see'. Its secondary meanings include 'to show', 'to appear', or 'appearance'. The word *huaguan* thus means 'the appearance of the pictures' or simply 'the pictures'.

20 A commentary to the 'Yueling' chapter in *Li ji* reads: '*Zhongliu* means the central chamber. The element "earth" governs the centre and its spirit is in the chamber.' *Li ji*, vol. 1, p. 1372.

21 Li Falin mis-identifies the character *yang* as *jia*, and reads *jiashi* together as the tomb's side-chamber. Two factors lead me to identify the supposed placement of these scenes (hence the meaning of the phrase *shishangyang*) as the ceiling of the rear chamber. Firstly, the location of the images of the Blue Dragon and the White Tiger in the present tomb; and secondly, the narrative sequence of the inscription, which progresses from the rear section to the front part of the tomb.

22 A *ping* is a type of carriage especially used by women. As *Shi ming* defines it, '*ping* means "to shield". A *ping*-chariot is covered on all four sides; it is an ox-drawn carriage for female transportation.' *Han shu* records that the Great Empress Dowager and the Empress Dowager took *ping*-carriages with purple decoration on their daily travels. See Li Falin, *Shandong Han huaxiangshi*, p. 97.

23 *Fengsu tongyi* defines *ting* as 'the commune where travellers rest'. A commentary on *Han shu* by Yan Shigu reads: '*Ting* means "to stop"; it is the commune where travellers rest and dine.' See Li Falin, ibid., p. 98.

24 *Youxi* is a low official rank in an administrative body called a *xiang* (a large village). His principal duty is to maintain public order and to capture thieves and robbers. *Xu Han shu* records that 'in every *xiang* district there is a *youxi* who is in charge of the prohibitions against stealing and robbing.' See Li Falin, ibid.

25 According to the *shuo wen* and other Han texts, the character *hui* in the inscription means 'coffin' or 'small coffin'. A hearse carrying a coffin is thus called a *hui*-carriage. See Lin Yin and Gao Ming, eds, *Zhongwen dacidian* [A Comprehensive Chinese Dictionary], (Taipei, 1973), vol. 5, p. 405.

26 The title *dudu* is absent in Han official documents, but can be found in several Eastern Han inscriptions. On the *Baishishen jun bei* 'Stele of the Divine Master White Stone', donors' names are listed according to official rank. Two persons entitled *dudu* are listed after those who held the post *jijiu* (the ceremonial official), but before those entitled *zhubu* (the chief of records). Li Falin has thus suggested that *dudu* was a relatively low official rank during the Eastern Han. See *Shandong Han huaxiangshi*, p. 71.

27 According to the chapter on official ranks in *Xu Han shu*, 'the responsibility of a *zeicao* concerns robbery.' Ibid., p. 99.

28 Li Falin interprets the term *chengqing* as 'favourite official assistant'. Indeed, the character *cheng* was usually associated with official titles to mean '*assistant*' or '*junior*'. *Qing*, however, is not a Han official post, but is sometimes used to mean *gongzi* (a young master). The term *chengqing*, therefore, can be understood in the context of the inscription as a 'junior master' – the son of the deceased – who stands at the entrance of the reception hall to greet guests, while the *xinfu*, his bride, is serving drink. The term *xinfu* was used in Han times for either a 'daughter-in-law' (as seen in *Lienü zhuan*) or for a 'bride' (as seen in *Zhanguo ce*, 'Wei Ce'; *Liang shu*, 'Cao Jingzong zhuan'). This reading is further supported by an Eastern Han carving from Xinjing, in Sichuan. Three kneeling figures are portrayed on the two door-leaves of a tomb. According to the accompanying cartouches, the woman is 'a filial daughter-in-law' and the two men are 'worthy son Zhao Chuan' and his younger brother Zhao Mai. See Richard C. Rudolph and Wen Yu, *Han Tomb Art of West China* (Berkeley and Los Angeles, 1951), p. 30; Wen Yu, *Sichuan Han dai huaxiang xuanji* [Selected Han Dynasty Pictorial Carvings from Sichuan], (Beijing, 1956), pls 21, 22. It is not difficult to find parallels between this carving and the Cangshan images in terms of both decorative position and subject-matter.

29 Li Falin identifies the bridge mentioned here as one of the three Wei Bridges outside the Western Han capital Chang'an. He thus infers that the person buried in the Cangshan tomb must have held an official post in the capital before his death. In my opinion, the inscription employs the term Wei Bridge in a general and symbolic sense. The first or Middle Wei Bridge was built by the First Qin Emperor to connect the Xianyang Palace and the Changle Palace, which were separated by the River Wei. The second or East Wei Bridge was constructed by Emperor Jing of Han to connect the capital and the emperor's tomb. The third or West Bridge was built by Emperor Wu to link the capital and his own tomb. The two bridges built during the Han were both part of imperial funerary constructions. By connecting the capital and the imperial tombs they made it possible for ritual processions to cross the river to the mausoleums.

30 For such figures, see Omira Seigai, *Shina Bijutuist chōsohen* [A History of Fine Arts in China: Sculpture], (Tokyo, 1915–20), fig. 188.

31 I have discussed the iconography and symbolism of the Wang Hui sarcophagus in *Stories from China's Past* (San Francisco, 1987), pp. 75, 178.

32 James L. Watson, "The Structure of Chinese Funerary Rites: Elementary Forms, Ritual Sequence, and the Primary of Performance," in J. L. Watson and E. S. Rawski, eds, *Death Ritual in Late Imperial and Modern China* (Berkeley, 1988), p. 4.

33 Ibid., p. 4.

3 *Pauline Yu: The Chinese Poetic Canon and Its Boundaries*

1 For a critical exploration of this and other commonplaces, see Stephen Owen, *The Great Age of Chinese Poetry: The High T'ang* (New Haven, 1981).

2 This collection of slightly over 300 poems was compiled by the scholar-official Sun Zhu (1711–78), known as the Recluse of Hengtang (*Hengtang tuishi*) in 1763 or 1764. The circumstances and goals of its compilation will be discussed in greater detail below.

3 For another discussion of issues pertaining to canon formation, with specific reference to anthologizing, see my article, 'Poems in Their Place: Collections and Canons in Early Chinese Literature', *Harvard Journal of Asiatic Studies*, L/1 (1990), pp. 163–96.

4 'Canon and Period', in *History and Value* (Oxford, 1988), p. 115.

5 Robert Weimann, 'Shakespeare (De)Canonized: Conflicting Uses of "Authority" and "Representation"', *New Literary History*, XX/1 (1988), p. 71.

6 From his 'Introduction: Invisible Center', in Russell Ferguson et al., ed., *Out There: Marginalization and Contemporary Culture* (New York, 1990), p. 10.

7 Ibid., pp. 12–13.

8 '"But Is It Any Good?": The Institutionalization of Literary Value', in *Sensational Designs* (Oxford, 1985), pp. 188–9.

9 Raymond Williams, *Problems in Materialism and Culture* (London, 1980), p.16; as cited by James Chandler in 'The Pope Controversy: Romantic Poetics and the English Canon', *Critical Inquiry*, X/3 (1984), p. 481.

10 In *State and Scholars in T'ang China* (Cambridge, 1988), pp. 225ff.

11 From the section on 'Shi ping' ('Criticisms of Poetry') in Guo Shaoyu, ed., *Canglang shihua jiaoshi (A Collated and Annotated Edition of Canglang's Talks on Poetry)* (Beijing, 1961) p. 136.

12 These comments from Yang Shen's *Sheng'an's Talks on Poetry* [*Sheng'an shihua*] and Wang Shizhen's *Words Flowing from a Goblet in the Garden of Art* [*Yiyuan zhiyan*] are cited by Guo Shaoyu, ibid., pp. 136–7.

13 While it is not known precisely when the writing of regulated verse first came to be tested, there are poems included in the Song dynasty anthology, the *Glorious Blossoms from the Garden of Letters* [*Wen yuan ying hua*], compiled in 987, that are clearly examination pieces from as early as the Kaiyuan and Tianbao reign periods, i.e., 713–55 – the High Tang. See Wang Yunxi, 'Shi He yue yingling ji xu lun sheng Tang shi ge' [Explicating the Discussion of High Tang Poetry in the Preface to the *Collection of Eminences of Our Rivers and Peaks*], in *Tang shi yanjiu lunwen ji* [Collected Studies of Tang Poetry] (Beijing, 1959), vol. I, p. 29, n. 1.

14 Wu Qiming notes that fifty-one anthologies are listed in the bibliographical treatises written for the two official histories of the Tang dynasty, thirteen other titles are given in various Song dynasty bibliographies, and an additional six are mentioned in the collected writings of Tang authors. See his 'Tang dai shi xuan xue lüelun' [Outline Discussion of the Study of Tang Dynasty Poetic Anthologies] in Luo Songlin et al., eds. *Quanguo Tang shi taolunhui lunwenxuan* [Selected Essays From the National Conference on Tang Poetry], (Xi'an, 1984), p. 525. Eight of these collections were published together in the Ming by Mao Jin (1599–1659) in an edition known as *Tang Selections of Tang Poetry* [*Tang ren xuan Tang shi*]; a ninth Tang anthology of poetry, plus the collection of both poetry and prose compiled by Yao Xuan

(968–1020) in the early Song known as the 'Essence of Tang Writing' [*Tang wen cui*], were added to these eight, edited, and reprinted in the Qing as 'Ten Anthologies of Tang Poetry' [*Shi zhong Tang shi xuan*] by Wang Shizhen (1634–1711). The nine Tang anthologies, with the addition of fragments from a tenth collection included in the manuscripts from the Dunhuang caves, have been reprinted in a modern edition under Mao Jin's title (Shanghai, 1958). A concise but useful account of collections of Tang poetry up through the Qing dynasty can be found in Shi Zhicun, *Tang shi bai hua* [One Hundred Lectures on Tang Poetry] (Shanghai, 1987), no. 100, pp. 765–84. I am grateful to Professor Kang-i Sun Chang for recommending this essay to me.

15 Little is known of Yin Fan, other than the facts that he was a native of Danyang and passed the *jinshi* examination. He edited at least one other and much smaller anthology, the Danyang Collection [*Danyang ji*], which contained poems by eighteen poets from his native place; it does not appear to have survived intact, although information about its contents is given in a variety of sources.

16 The Ming scholar Hu Zhenheng (1569–1644 or 1645) observes that the esteem these two collections enjoyed from the Tang dynasty on, as well as their longevity in the context of dozens of other vanished volumes, merit serious consideration. See his *Tang yin kui jian* [Sounds of the Tang, Book Ten] (rpt. Beijing, 1959), 32.268.

17 Shi Zhicun, *One Hundred Lectures*, p. 766.

18 There are more than three times as many ancient-style poems as there are newer forms. For a discussion of this issue, see Wang Yunxi and Yang Ming, 'He yue yingling ji de bianji niandai he xuanlu biaozhun' [The Compilation Date and Selection Criteria of the *Collection of Eminences of Our Rivers and Peaks*] in *Tang dai wenxue luncong* [Collected Essays on Tang Dynasty Literature], no. 1 (Shaanxi, 1982), pp. 197–218.

19 *Tang Selections of Tang Poetry*, p. 41.

20 In addition to the *Collection of Eminences*, the following Tang anthologies include poems by Wang Wei: the *Collection of the Nation's Accomplished Talents* [*Guo xiu ji*], compiled by Rui Tingzhang approximately contemporaneously with Yin Fan's volume, in the mid-1750s; the *Collection of Utmost Subtlety* [*Ji xuan ji*], edited by Yao He, a *jinshi* degree holder of 816, whose selection of one hundred poems by twenty-one poets leads off with Wang Wei and emphasizes the limpid and understated style for which he is well known; the *Collection of Additional Subtlety* [*You xuan ji*], edited by the poet Wei Zhuang (*c.* 836–910) in 900; and the *Collection of Talents* [*Cai diao ji*] of Wei Gu, an early tenth-century anthology that evinces a strong preference for the ornate style cultivated late in the Tang and which only includes two poems by Wang Wei out of a total of one thousand. Li Bai's works appear in the *Collection of Additional Subtlety* and the *Collection of Talents*, as well as in the fragmentary collection from Dunhuang included in the modern edition of the *Tang Selections of Tang Poetry*.

21 As Owen puts it, this popular interest in eremitic themes among officials at the Tang capital reveals the process by which 'the great topics of social renunciation were domesticated to the bucolic yearnings of the great.' *The Great Age of Chinese Poetry*, p. xiii.

22 *Tang Selections of Tang Poetry*, p. 27.

23 *The Great Age of Chinese Poetry*, p. 255.

24 Judging from the preface (dated 856) to the *Classified Selection of Tang Poetry* [*Tang shi lei xuan*] of Gu Tao, a *jinshi* degree-holder of 844, Du Fu was prominently represented in the volume, along with Li Bai. The preface is included in the *Complete Tang Prose* [*Quan Tang wen*], *juan* 765 and in Luo Liantian, *Sui Tang Wudai wenxue piping ziliao huibian* [Compendium of Materials on Sui, Tang and Five Dynasties Literary Criticism] (Taipei, 1978), pp. 225–6. But the anthology is no longer extant

and was already difficult to come by in the Ming, as noted by Hu Yinglin (1551–1602) in his *Shi sou* [Preserve of Poetry] (rpt. Beijing, 1958), outer chapter 3, p. 158.

25 Included in the *Complete Tang Prose, juan* 40, and translated here by Owen in *The Great Age of Chinese Poetry*, p. 183.

26 Guo Shaoyu chronicles the history of this recognition in his *Canglang's Talks on Poetry*, pp. 158–9.

27 See Shi Zhicun, 'One Hundred Lectures', pp. 772–3. Scholars have long suspected that this anthology was compiled by another Song dynasty figure, most likely Song Minqiu (1019–79), although Wang appears to have had a hand in revising it.

28 See the *Siku quanshu zongmu tiyao* [Digest of the Contents of the Emperor's Four Treasuries], ed. Ji Yun et al. (rpt. Taipei, 1971), 188.4180.

29 See *Shi sou*, outer chapter 3, p. 158. Hu Zhenheng makes the same point in the *Sounds of the Tang, Book Ten*, 31.268. Some of the issues surrounding this question are raised by Craig Fisk in 'On the Dialectics of the Strange and Sublime in the Historical Reception of Tu Fu', in Zoran Konstantinovic et al., eds, *Literary Communication and Reception*, Proceedings of the IXth Congress of the International Comparative Literature Association (Innsbruck, 1980), pp. 75–82.

30 This is evident in the burgeoning efforts to identify or establish 'schools' with clearly recognizable doctrines or styles, and in the ensuing struggles among them. In the literary context, Wu Xionghe notes that the notion of a poetic 'school' (*pai*) takes root with Lü Benzhong's (fl. 1119) grouping of twenty-five poets into the Jiangxi school of poetry, with Huang Tingjian (1045–1105) as its patriarch, which was in turn based on similar practices already common in Zen Buddhist hagiography. See his *Tang Song ci tonglun* [Comprehensive Discussion of Tang and Song Dynasty song Lyrics] (Hangzhou, 1985), p. 152.

31 This was discussed at great length in papers presented by Professors Peter Bol, Michael Fuller and Robert Gimello at a panel entitled 'Doubting the Self' at the 1991 meeting of the Association for Asian Studies.

32 See his *Scripture, Canon, and Commentary* (Princeton, 1991), p. 39. Many scholars of Western literature have also noted the coincidence of canon-formational activities with national regroupings after a period of strife.

33 Particularly influential was his charting of the Tang into five 'period styles', labelled as follows: (1) Beginning Tang style (*Tang chu ti*); (2) High Tang style (*Sheng Tang ti*); (3) Dali (reign period, 766–835) style (*Dali ti*); Yonghe (reign period, 806–20) style (*Yonghe ti*); and Late Tang style (*Wan Tang ti*). From *Canglang's Talks on Poetry*, p. 48. The vague and unsystematic nature of Yan Yu's schema has been criticized since its very inception, but it offers important insights into both the theorizing of literary history and the connections between periodization and canon formation.

34 From 'Alternate Routes to Self-Realization in Ming Theories of Poetry', in Susan Bush and Christian Murck, eds, *Theories of the Arts in China* (Princeton, 1983), p. 319. Lynn also discusses Yan Yu's poetics and its implications in several articles, among them: 'Orthodoxy and Enlightenment: Wang Shih-chen's Theory of Poetry and Its Antecedents', in Wm. Theodore de Bary, ed., *The Unfolding of Neo-Confucianism* (New York, 1975), pp. 217–69; 'Tradition and the Individual: Ming and Ch'ing Views of Yuan Poetry', *Journal of Oriental Studies*, XV/1 (1977), pp. 1–19; and 'The Talent-Learning Polarity in Chinese Poetics: Yan Yu and the Later Tradition', *Chinese Literature: Essays, Articles, Reviews*, V (1983), pp. 157–84.

35 Included in *Canglang's Talks on Poetry*, p. 234, as translated by Richard John Lynn in his review of John Timothy Wixted's book, *Poems on Poetry: Literary Criticism by Yuan Hao-wen (1190–1257)* (Wiesbaden, 1982), in the *Harvard Journal of Asiatic Studies*, XLVII/2 (1987), p. 710.

36 'Preface to a *Selection of Tang Ancient-Style Poems*' [*Gu shi xuan Tang xu*], compiled

by his friend Lin Yuzhi, in the *Collected Writings of Su Pingzhong* [*Su Pingzhong wenji*], *Sibu congkan*, ed., 4.20a. Su Boheng's critique is cited, and disputed, by Qian Zhongshu in the opening of his monumental work of Chinese literary criticism, *Tanyi lu* [Discourses on the Arts] (Shanghai, 1948), pp. 1–2.

37 As noted by Cai Yu in 'Gao Bing shixue yanjiu' [A Study of Gao Bing's Poetics], MA thesis, National Taiwan University, 1985, p. 181. n. 2.

38 *Digest of the Contents of the Emperor's Four Treasuries*, 188.4180. The comment is included in Li's 'Talks on Poetry from the Hall at the Foot of the Hill' [*Lu tang shihua*] in Ding Fubao, ed., *A Continuation of Talks on Poetry through the Ages* [*Xu lidai shihua*] (rpt. Taipei, 1974), II, p. 1647 (1.6a). Li goes on to rank Zhou Bi's 'Three Forms of Poetry' [*San ti shi*] second; this anthology, compiled in 1250, restricts itself to five- and seven-word regulated verse and five-word quatrains, and Li criticizes it for its overly minute discriminations. And even these two outstanding volumes, he continues, contain poems that should not have been selected.

39 Gao Bing begins his elucidation of the 'General Principles' (*fanli*) of his collection by stating that he took his lead from Lin Hong, the acknowledged leader of the group, who argued, against prevailing taste, for the superior merits of High Tang poetry; this opinion was then confirmed in Gao's mind by his reading of *Canglang's Talks on Poetry*. In 'Graded Compendium of Tang Poetry' [*Tang shi pinhui*] (rpt. Shanghai, 1982), p. 14.

40 Richard Lynn, 'Alternate Routes to Self-Realization', pp. 320–1. Strictly speaking, however, Gao Bing distinguished his 'Graded Compendium' from a true 'anthology', because comprehensiveness was of a higher priority than selectivity. In the 'General Principles' to the text, therefore, he explicitly states that 'This edition is not called an anthology because of its profusion of Tang styles and breadth of selection. Thus it does not set up individual styles or differentiate among schools . . . Some [poets] have more than one hundred works, and some as few as one or two. Anything that could not be omitted has been exhaustively recorded – this is the basic meaning of "graded compendium".' 'Graded Compendium of Tang Poetry', p. 14. Gao Bing reserved the true task of selective anthologizing for another volume he compiled, the 'Orthodox Sounds of Tang Poetry' [*Tang shi zheng yin*], which included a much higher proportion of High Tang to Late Tang verse than is true of the 'Compendium'; as noted by Shi Zhicun, *One Hundred Lectures*, p. 775.

41 The dates given actually reflect a refinement on Gao Bing's original determination by the late Ming scholar Shen Qi in the preface to 'Elucidating and Discriminating among Poetic Genres' [*Shi ti ming bian*], because Gao's Early Tang did not include the realm of the founding emperor, and his Middle Tang period was too short. As noted by Zhu Ziqing in 'A Discussion of "Poetry Expresses Intent" ' [*Shi yan zhi bian*] (rpt. Taipei, 1975), p. 179. For an account of many of these issues in English, see Maureen Robertson, 'Periodization in the Arts and Patterns of Change in Traditional Chinese Literary History', in Bush and Murck, eds, *Theories of the Arts in China*, pp. 3–26.

42 Translated by Richard Lynn in an unpublished manuscript, 'The Canon of Tang Poetry: Gao Bing's *Tangshi pinhui*', pp. 18–19. I am grateful to Professor Lynn for kindly allowing me to cite this translation.

43 For a discussion of this wide-ranging tradition, see John Timothy Wixted, 'The Nature of Evaluation in the *Shih-p'in* (Gradings of Poets) by Chung Hung (CE 469–518)', in Bush and Murck, eds, *Theories of the Arts in China*, pp. 227–8.

44 I am using Richard Lynn's translations of these terms from his manuscript, 'The Canon of Tang Poetry'.

45 From his discussion of Voltaire's *Temple du goût*, first published in 1733, in ' "Phoenix from the Ashes", or: From Canon to Classic', *New Literary History*, XX/1 (1988), p. 147.

46 'Alternate Routes to Self-Realization', p. 321.

47 Ibid., p. 320.

48 As noted by Lynn, ibid., and by the editors of the *Digest of the Contents of the Emperor's Four Treasuries*, 188–189.

49 Poetry was still very much a part of literati social intercourse, although one measure of the nostalgia for the official, political context it enjoyed during the Tang was the tendency from the Song onwards for poets to form groups of societies (*she*) that often developed quite formal procedural protocols, including competitions reminiscent of civil service examinations. The great Qing novel by Cao Xueqin (?1715–?64), 'The Story of the Stone' [*Shi tou ji*], better known as 'The Dream of the Red Chamber' [*Hong lou meng*]), portrays at considerable length one such organization formed within the protagonists' family compound.

50 Yang Songnian provides an extensive discussion of this anthology in his article, 'Li Panlong ji qi Gu jin shi shan yanjiu' [A Study of Li Panlong and His *Edition of Ancient and Modern Poetry*], *Zhong wai wenxue* [Chinese and Comparative Literature], IX/9 (Feb. 1987), pp. 38–53.

51 See Shi Zhicun, *One Hundred Lectures*, pp. 775–82.

52 For a tabulation of appearances of poems by Li Bai, Du Fu and Wang Wei in anthologies from the Tang dynasty to the twentieth century, see the series of three articles by Ling Ziliu, 'Tang shi xuanben Li Bai shi caixuan tongji' [A Statistical Study of the Selection of Li Bai Poems in Anthologies of Tang Poetry] in *Chongji xuebao*, IV/1 (November 1964), pp. 57–75; 'Tang shi xuanben Du Fu shi caixuan tongji' [A Statistical Study of the Selection of Du Fu Poems in Anthologies of Tang Poetry] in *Zhuang Zhaixuan jiaoshou qi zhi jin wu jinian wenji* [A Collection of Essays in Commemoration of Professor Chaihsüan Chuang's Seventy-fifth Birthday on 28 August 1970], no. 4 (1970), pp. 26–63; and 'Tang shi xuanben Wang Wei shi caixuan tongji' [A Statistical Study of the Selection of Wang Wei Poems in Anthologies of Tang Poetry] in *Zhuhai xuebao* [Zhuhai Journal], no. 5 (Jan. 1972), pp. 175–99.

53 From his 'General Principles' to the 'Discriminating Selection of Tang Poetry' [*Tang shi bie cai ji*], first printed in 1717 and revised and expanded in an edition of 1763 (rpt. Beijing, 1975), p. 3. More than one-tenth of the almost 2000 poems in the volume are by Du Fu.

54 Again, Shi Zhicun's digests of Ming and Qing anthologies provide a helpful overview; see his *One Hundred Lectures*, pp. 775–84.

55 It is likely that Sun Zhu, the editor of this volume, modelled his selection heavily – although not completely – on that of Shen Deqian. See Wang Zhong, 'A Discussion of the Criteria for Selecting Poems in the "Three Hundred Tang Poems" ' [*Lun Tang shi sanbaishou xuanshi de biaozhun*], in Zhou Kangxie et al., eds, 'Collected Studies of Tang Poetry' [*Tang shi yanjiu lun ji*] (rpt. Hong Kong, 1971), pp. 265–9.

56 James J. Y. Liu provides a comprehensive view of the many currents in Chinese criticism in his *Chinese Theories of Literature* (Chicago, 1975). For a discussion of these influential Ming and Qing celebrations of individual expression, see Richard John Lynn, 'Orthodoxy and Enlightenment: Wang Shih-chen's Theory of Poetry and Its Antecedents' and 'Alternate Routes to Self-Realization', and Jonathan Chaves, 'The Panoply of Images: A Reconsideration of the Literary Theory of the Kung-an School', in Bush and Murck, eds, *Theories of the Arts of China*, pp. 341–64.

57 This discussion has been restricted to poetry. It should go without saying that research from the beginning of the twentieth century has also done much to widen the critical lens, so that rather than focusing entirely on elite written traditions, it has begun to reveal the increasingly wide authorships and audiences for drama and fiction in late imperial China.

58 From the 'General Principles' of his 'Discriminating Selection of Tang Poetry', p. 3.

59 From the 'Original Preface by the Recluse of Hengtang' (*Hengtang tuishi yuan xu*), i.e., Sun Zhu, in the 'Three Hundred Tang Poems' (rpt. Beijing, 1959), p. 3.

60 One such text was the 'Pure and Elegant Collection of Tang Regulated Verse' ['Tang lü qingli ji'], compiled by Xu Rilian and Shen Shijun immediately after the change in the examination in 1757. See Shi Zhicun, *One Hundred Lectures*, p. 781.

61 From 'Shakespeare (De)Canonized', p. 68.

62 The persistence of this construction is evident even in challenges to it. The twentieth-century critic Qian Zhongshu, for example, disputes the traditional historicist linkage of poetic syle to political history (Tang vs Song), but nonetheless retains a dichotomy between two 'Tang' and 'Song' styles that are construed simply as aesthetic temperaments. See 'Discourses on the Arts', passim., and Theodore Huters, *Qian Zhongshu* (Boston, 1982), pp. 40–48. Qian's work is, in effect, a monumental and ultimately quite systematic argument against the valorization of the Tang, one which he highlights by ironically using as the title for his work one that had been used by another of the Former Seven Masters, Xu Zhenqing (1479–1511), who of course supported the Ming archaistic programme to canonize the High Tang.

4 John Hay: Boundaries and Surfaces of Self and Desire in Yuan Painting

1 James Cahill, *Hills Beyond a River: Chinese Painting of the Yuan Dynasty, 1279–1368* (New York, 1976), p. 5.

2 Wen C. Fong, *Images of the Mind: Selections from the Edward L. Elliott Family and John B. Elliot Collections of Chinese Calligraphy and Painting at the Art Museum. Princeton University* (Princeton, New Jersey 1984), especially pp. 74–129.

3 Jerome Silbergeld, 'In Praise of Government: Chao Yung's Painting *Noble Steeds* and Late Yuan Politics.' *Artibus Asiae*, XLVI (1985), pp. 159–202; and Jonathan Hay, 'Khubilai's Groom', *Res*, XVII/XVIII (1989), pp. 117–39.

4 Many of the best known of their works are now in the National Palace Museum, Taipei, Taiwan, a fact that itself exemplifies their position in the orthodoxy of cultural history at the 18th-century imperial court. For a very convenient catalogue of illustrations, transcriptions and comments, extensively translated by Karen Brock and Robert Thorpe, see *The Four Great Masters of the Yuan* (Taipei, 1975). I have not thought it necessary in this essay to cite more specialized sources.

5 Cf. James Cahill, *Three Alternative Histories of Chinese Painting* (Lawrence, Kansas, 1988).

6 Susan Bush, *The Chinese Literati on Painting: Su Shih (1037–1101) to Tung Ch'i-ch'ang (1555–1636)* (Cambridge, Mass., 1971). This volume continues to be the best study of this development.

7 The concept of the 'painter's charge', was introduced by Michael Baxandall, *Patterns of Intention: On the Historical Explanation of Pictures* (New Haven, Connecticut, 1985), p. 42 ff.

8 *Four Masters*, no. 205, and p. 52.

9 *Images of the Mind*, especially Chapter 3, 'The Rise of Self-expression', offers the clearest exposition of this approach as a mode of analysis.

10 Norman Bryson, *Vision and Painting: The Logic of the Gaze* (New Haven, Connecticut, 1983), pp. 89–95.

11 Ronald Egan, 'Ou-yang Hsiu and Su Shih on Calligraphy', in *Harvard Journal of Asiatic Studies*, XLIX/2 (1989), p. 400.

12 See James Cahill, '*Wu Chen: A Chinese Landscapist and Bamboo Painter of the Fourteenth Century*,' Ph.D. diss., University of Michigan, 1958, pp. 154–7.

13 Translation adapted from Cahill, *Wu Chen*, pp. 203–4, where the inscription is discussed.

14 *Four Masters*, no. 205, and p. 53.

15 See Cahill, *Wu Chen*, pp. 159, 204; and *Hills Beyond a River*, pp. 72–3. Translation adapted from Cahill.

16 See John Hay, 'Surface and the Chinese Painter: The Discovery of Surface', in *Archives of Asian Art*, XXXVIII (1985), pp. 95–123; and 'Poetic Space: Ch'ien Hsuan and the Association of Poetry and Painting', in Freda Murck and Wen C. Fong, eds, *Words and Images: Chinese Poetry, Calligraphy and Painting* (New York, 1991), 173–8.

17 The Song literati ideal of 'hiding the brush' in painting is a typically topological value of interiority. The intentional power/control in the work of the brush cannot but be visible in the stroke, but a variety of very subtle techniques are used to translate the structural and manipulable core of the material brush into a visible aspect of the ink trace on the paper that can be read as 'centred'. Correspondingly, there is also an exterior. The control is centred and therefore 'hidden'. But all of this occurs on the surface of the paper or silk. In the evolution of style, of course, this ideal was embodied in changing ways.

18 *Four Masters*, no. 102, and pp. 44–7.

19 Translation by Cahill, *Hills Beyond a River*, p. 87. Huang's concern is repeated throughout his *Secrets of Landscape Painting*, as it is also persistently apparent throughout his painting.

20 'Stages of Development in Yuan Landscape Painting, Parts 1 and 2', *National Palace Museum Bulletin*, IV/2 (1969), pp. 1–10; IV/3 (1969), pp. 1–12.

21 See the text by Guo Xi, translated in Susan Bush and Hsio-yen Shih, *Early Chinese Texts on Painting* (Cambridge, Mass., 1985), pp. 168–9; and for a discussion of 'level extension' in the context of actual painting, Richard M. Barnhart, *Marriage of the Lord of the River: A Lost Landscape by Tung Yuan*, Artibus Asiae Supplementum XXVII (Ascona, 1970).

22 For some initial comments, see Hay, 'Surface', pp. 108–11.

23 See Cahill, *Hills Beyond a River*, pp. 114–20.

24 See Fong, 'Ni San: The Noble Recluse', in *Images of the Mind*, pp. 105–27.

25 Reproduced and discussed in *Four Masters*, fig. 307, pp. 62–3. Mounted as third in a sequence of short 14th-century horizontal compositions. The painting seems to be dated very shortly after the establishment of the Ming dynasty. Perhaps the placid surfaces of the poem are related to this.

26 *Four Masters*, no. 304, and pp. 59–60. Reproduced in Cahill in *Hills Beyond a River* (fig. 41) and discussed (p. 117). During this period Ni Zan's home district was subject to constant military and political chaos. The year 1363 was exceptionally bad.

27 The poem is known in Ni's literary collection. Translation by Susan Bush, in *The Chinese Literati on Painting*, p. 134.

28 Recorded in the 12th-century *Huaji*. Translation by Robert J. Maeda, *Two Twelfth Century Texts on Chinese Painting*, Michigan Papers in Chinese Studies, no. 8 (Ann Arbor, 1970), p. 59.

29 For example by Cahill, *Hills Beyond a River*, Chapter 1, p. 3.

30 As a technique, and one that was always important to the issue of surface taken more widely, this flourished much earlier, in the T'ang dynasty (618–906). From T'ang China it journeyed to even greater glory in Japan. There is no doubt that the history of surface was also extremely important in Japan but, even so, it was not the same history.

31 Reproduced and discussed in Sherman E. Lee and Wai-kam Ho, *Chinese Art under the Mongols* (Cleveland, 1968), no. 254; and in *Eight Dynasties of Chinese Painting: The Collections of the Nelson Gallery-Atkins Museum, Kansas City, and the Cleveland*

Museum of Art (Cleveland and Kansas City, 1980), no. 110. Wai-kam Ho dates the painting to around 1348.

32 Translation adapted from Lee and Ho, ibid.

33 See John Hay, *Kernels of Energy, Bones of Earth: the Rock in Chinese Art* (New York, 1985); and Nancy Berliner, 'The Rosenblum Collection of Rocks', in *Orientation*, XXI/11 (1990), pp. 68–75.

34 Recorded as early as the 14th century, in the *Zhupu* by Li Kan. See Marsha Weidner, et al., *Views from Jade Terrace: Chinese Women Artists, 1300–1912* (Indianapolis, 1988), pp. 18 and 67.

35 Ho Peng Yoke, *Li, Qi and Shu: An Introduction to Science and Civilization in China* (Hong Kong, 1985), pp. 6, 7. This book is a good introduction to Needham's *magnum opus, Science and Civilization in China* (1954–).

36 Stephen Toulmin, *Human Understanding: The Collective Use* (Princeton, 1972). I have made these very general references before, and there is no doubt that one of the most difficult problems in applying Toulmin's analysis is getting beyond the problematization of the initial perception. The subsequent track of Toulmin's own publication suggests the same thing.

37 James Gleick, *Chaos: Making A New Science* (New York, 1987), p. 3.

38 A classic reference in the history of chaos studies is Benoit Mandelbrot, *The Fractal Geometry of Nature* (New York, 1977). There are doubtless many students of art history working with fractal thought. The first occasion I heard them applied to Asian art was by David Waterhouse of the University of Toronto, at a conference on 'The Occident and the Orient', held by the Humanities Research Centre at Australian National University, Canberra, 24–27 August 1987.

39 Quoted in Gleick, ibid., p. 195. The analogies being made here are very simple-minded exercises of the sort represented on a cosmic scale by Joseph Needham's *Science and Civilization in China* (Cambridge, 1954–). The issue of an increasing compatibility between the assumptions of Chinese thought and the changing foundations of modern science has been repeatedly made by Needham, among others. Needham's own principle mentor was Alfred North Whitehead. The dynamics of the comparison itself cannot but change, either towards or away from relevance, but the field of chaos studies seems to be especially helpful.

40 Gleick, ibid., p. 105.

41 Gleick, *Chaos*, p. 106.

42 The term 'ornamental', often used in English to indicate these selected rocks, is superficially appropriate. Such rocks, varying in size from an inch or so in height to several feet, were inevitable ornaments of garden, courtyard and studio. But it would be more appropriate to call them the 'Chinese fundamental rock'. The Chinese have usually referred to them by a type, often a location (especially by the eponymous Lake Tai). Nowadays they are *de rigeur* in hotels and even in airports, and the label 'ornamental' has become more fitting.

43 Bush and Shih, *Early Chinese Texts*, p. 167.

44 The categories occur in *Explanation of Names*, a dictionary of the 1st century CE, as two in a typology of mountain formations. For Guo Xi's formulation in the 11th century, see Bush and Shih, ibid., p. 178.

45 Maeda, *Two Twelfth Century texts*, p. 25. The most convenient summary of *cunfa* in English is in Benjamin March, *Some Technical Terms of Chinese Painting* (Baltimore, 1935).

46 See Cyril Smith, 'Structural Hierarchy in Science, Art and History', in Judith Wechsler, ed., *On Aesthetics in Science* (Cambridge, Mass., 1981), pp. 11–12. This essay is extraordinarily rich in ideas and I tried to pick up on some of them in 'Values and History in Chinese Painting, II: The Hierarchic Evolution of Structure', in *Res*, VII/VIII

(1984), pp. 102–36. The issues are too large to expand on here, but also too important to go unmentioned.

47 For a description of how surfaces, or boundaries in this sense, enter the work and history of art, see the essays by Cyril Smith and Elaine I. Savage, 'The Techniques of the Japanese tsuba-maker', in *Ars Orientalis*, II (1979), pp. 291–328.

48 Irene Bloom, 'On the Matter of the Mind: The Metaphysical Basis of the Expanded Self', in Donald Munro, ed., *Individualism and Holism: Studies in Confucian and Taoist Values*, Michigan Monographs in Chinese Studies, no. 52 (Ann Arbor, 1985), p. 310.

49 Bloom, ibid., p. 311.

50 Bloom, ibid., p. 310.

51 A. C. Graham, 'The Cheng-Chu Theory of Human Nature', in *Studies in Chinese Philosophy and Philosophical Literature* (Singapore, 1986), p. 433.

52 Graham, ibid., p. 432.

53 It is the first of the 'five things to do' (*wushi*) in the *Hungfan*. See A. C. Graham, *Yin-Yang and the Nature of Correlative Thinking*, Singapore: The Institute of East Asian Philosophies, Occasional Paper and Monograph Series, no. 6 (1986), p. 78.

54 Bloom, 'Matter of the Mind', p. 304.

55 Bloom, ibid., p. 314.

56 Such an exercise would have to acknowledge fundamental limitations. Some constructions that are key to the practice of Freudian psychoanalysis, such as the Oedipal/castration complex in particular, may well be completely lacking. Some equally essential functions, especially that of repression, are highly problematic (although not, I think, beyond consideration). The problem of the unconscious, a matter of great debate in psychoanalysis itself, is equally tricky although also very intriguing. I am thinking rather of the possibility that the structural/functional understanding of the psyche in traditional Chinese thought was such that, first, it was broadly compatible with the frame of Freudian analysis and, second, particular theories (such as the Oedipal) could be hypothetically fitted in without destroying the entire enveloping structure. That is to say, whilst the Freudian analysis was revolutionary in the history of Western culture, it would not be in the Chinese case. There could not, however, be any conclusive answer to such an enquiry – witness the arguments over Oedipus within psychoanalysis itself.

57 Bloom, 'Matter of the Mind', p. 313.

58 Jacques Lacan, *The Four Fundamental Concepts of Psychoanalysis* (New York, 1978), p. 177. Lacan's 'movement outwards and backwards' may immediately remind us of Zhu Xi's classic definition of permanence as 'going in and out' (see translation by Wing-tsit Chan, in *Reflection on Things at Hand: The Neo-Confucian Anthology*, New York, 1967, p. 14). Zhu Xi's view of permanence implies a correlation with life in generic, cosmological sense, in which processes of the human body are implicated as micro- to macro-cosm. This mode of definition may also be extended to the traditional Chinese concept of 'shape', *xing*, as a temporary state of fixedness that is transient within the enduring configuring processes of the *shi*. Conversely, the Freud/Lacan notion of 'satisfaction of the drive', as a stable state that is necessarily transient so long as the organism lives, offers a very interesting way to think about the cosmological context of *xing*-shape. These problems are very close to those in the foreground of this paper.

59 Jonathan Scott Lee, *Jacques Lacan* (Boston, 1990), p. 134.

60 Joseph Needham, *Science and Civilization in China*, III, *Mathematics: The Science of the Heavens and the Earth* (Cambridge, 1959), pp. 8–9.

61 Needham, ibid., II, *History of Scientific Thought* (Cambridge, 1956), p. 466.

62 J. S. Lee, *Lacan*, p. 157.

63 Lacan, *Four Concepts*, p. 107.

64 I am much obliged to Wu Hung, of the University of Chicago, for this information. He included it in an equally fascinating paper on 'Double Screens: Dream and Illusion in Chinese Painting', presented at a panel on Dreams and Representation in Chinese Art and Literature, organized by himself and Judith Zeitlin for the 1991 Annual Meeting of the Association of Asian Studies, New Orleans. The prince was Sun Liang of Wu.

65 In the Nelson-Atkins Museum, Kansas City. Reproduced and discussed in *Eight Dynasties of Chinese Painting*, pp. 112–13. I discussed this work in 'Dream and Imagination in Song and Yuan Painting', a paper given at the panel on dreams and representation, above. The purposes the artist may have entertained in this painting are several, but the structure of desire deposited in a screen is probably basic to all of them.

66 Lacan, *Four Concepts*, p. 82. Liu Guandao's picture appears to be in a very different genre from that of Ni Zan's painting. It makes no apparent claim as a construction of the artist's self and was probably commissioned by an official. It may, therefore, be a remarkably astute and complex commentary on these constructive circumstances.

67 Cf. Randolph Starn, 'Seeing Culture in a Room for a Renaissance Prince,' in Lynn Hunt, ed., *The New Cultural History* (Berkeley, 1989), pp. 205–32. Starn analyses the ceiling of the Camera degli Sposi in the Palazzo Ducale at Mantua in terms of the 'glance', the 'measured view' and the 'scan'. The importance of this analysis depends in large part on its sensitivity to both the architectural structure and its contemporary politics, but both are properly seen within an encompassing view of divinity. Lacan's view of the subject, of course, is radically decentred and he makes a fundamental distinction between specific 'others' and generic 'Other'. In his diagram, the gaze is dispersed across the screen. On the other hand, his interest in the optics of light that generates the diagram indicates that cultural histories are still as important here as universal psychologies. The cross-cultural importance of this remains largely unexplored. Whereas it seems to me undeniable that the concept of 'Other/other' should be extremely valuable in some sinological analysis, there is no doubt that it will have to be thought through again from the ground up.

68 The statement about language and the unconscious is perhaps the most famous of his gnomic pronouncements, and is also a leitmotif of one period of his work (see *Four Concepts*, p. 20). Paul Ricoeur initiated the most substantial discussion of the problem of Freud's 'energy discourse' and Lacan's possible lack in this respect. See Ricoeur, *Freud and Philosophy: An Essay of Interpretation* (New Haven, 1970), p. 395 ff., and *Freedom and Nature: The Voluntary and the Involuntary* (Evanston, Ill., 1966). For further discussion, see, for example, Edward S. Casey and J. Melvin Woody, 'Hegel, Heidegger, Lacan: Dialectic of Desire', in Joseph H. Smith and William Kerrigan, eds, *Interpreting Lacan* (New Haven and London, 1984), pp. 75–112; and Joseph H. Smith, 'Epilogue: Lacan and the Subject of American Psychoanalysis', in ibid., pp. 259–76, especially p. 264.

69 A. C. Graham, *Yin-Yang*, pp. 25–41.

70 For an extended analysis, see Chad Hansen, *Language and Logic in Ancient China* (Ann Arbor, 1983). For a summary, see Hansen, 'Individualism in Chinese Thought', in Munro, ed., *Individualism and Holism*, pp. 35–56.

71 Graham, 'Shih/fei and Yu/wu in Chinese Philosophy', in *Studies in Chinese Philosophy*, p. 338.

72 Graham, *Yin-Yang*, p. 3.

73 Graham, 'Shih/fei', p. 339.

74 Graham, 'Shih/fei', p. 347.

75 Lacan, *Four Concepts*, p. 176.

76 See Judith T. Zeitlin, 'The Petrified Heart: Obsession in Chinese Literature, Art, and Medicine', in *Late Imperial China*, XII/1 (June, 1991), pp. 1–26.

77 Zeitlin, ibid., pp. 8–9.

78 Susan Bush, *The Chinese Literari on Painting*, p. 137.

79 The painting is in the Art Museum, Princeton University. Translation by Wen Fong, *Images of the Mind*, p. 118.

80 Whether there was a *Freudian* unconscious, or any conceputalizing analogous to Freud's analysis of how the unconscious is generated, is a much more specific and difficult question. See above, note 56.

81 Wm. Theodore de Bary's translation, in *The Liberal Tradition in China* (New York, 1983), p. 13. I would be inclined to interpret it as 'the rethreading of the Way', as in 'rethreading' a necklace.

82 Bloom, 'The Matter of the Mind', p. 312.

83 As Zhu Xi says, 'Each kinship group has its own central base. Descendants' bodies are here and ancestors vital force (*qi*) is here. There is an artery that links them.' Translated by Donald Munro, 'The Family Network, the Stream of Water, and the Plant: Picturing Persons in Sung Confucianism', in Munro, ed., *Individualism and Holism*, p. 267.

84 This phenomenon has still not received the conceptual analysis it deserves, but the visual and iconographic material is very well described and analysed by Roderick Whitfield in *The Art of Central Asia: The Stein Collection in the British Museum*, I (London, 1985), pp. 300–308 (pls 8–11).

85 His account is translated by Joseph Needham in *Mathematics*, p. 580. The map was carved in wood for presentation to the imperial archives.

86 'In landscapes there are those through which you may travel, those in which you may sightsee, those through which you may wander, and those in which you may live.' Bush and Shih, *Early Chinese Texts*, p. 151.

87 An interpretation, but one of which I am convinced.

88 And in an enormous number of other paintings. It may well be the commonest function in Chinese mountain-and-water painting as a whole. In the work of the Yuan painters Huang Gongwang and Wang Meng it is perhaps even more intense than with Wu Zhen and Ni Zan.

89 Bush, *Chinese Literati on Painting*, p. 134. Romanizations are Wade-Giles.

90 Lacan, *Ecrits: A Selection*, trans. by Alan Sheridan (New York, 1977), p. 154. The metaphor derives from the points in which upholstery quilting is fastened.

91 Reproduced, with discussion, inscriptions and translation in *Four Masters*, no. 315, and pp. 68–70. The painting appears to have been started in 1370 on two sheets of paper, and another, irregularly shaped piece added on the right to accomodate Ni Zan's rock and inscription in 1373. The painting is also reproduced and discussed by Cahill (*Hills Beyond a River*, pl. 86, pp. 175–6). His comments are the conclusion to his study of Yuan painting and could hardly be bettered as a summary: 'It should be seen as Messrs. Ku, Chang, Yang, and Ni intended it to be seen, as a record of the interaction of four personalities, and of calligraphy and painting, and of words and images, and of ink, brush and paper. . . . The Yuan revolution in painting was complete' (romanization is Wade-Giles).

92 One of the best examples of such analysis, and one of the most useful explanations of Lacan's 'screen', is an article by Kaja Silverman, 'Fassbinder and Lacan: A Reconstruction of the Gaze, Look and Image', in *Camera Obscura*, no. 19 (1989), pp. 54–84. I thank Steven Goldberg, University of Hawaii, for this reference.

93 Victor Burgin, *The End of Art Theory: Criticism and Postmodernity* (Atlantic Highlands, New Jersey, 1986), p. 113.

94 Reservations similar to those in note 56 must be stated. One of them revolves around the principle that the patient and the psychoanalyst must be strangers – which I presume must relate to problems of 'otherness' at the psyche's centre. One might well

think that the fact that literati painting was intended for a coherent and exclusive group would mean that any topological transformation here would by disqualified by a tear rather than a twist. Nevertheless, the notion of what 'being a stranger' might mean is obviously subject to broader sociological conditions and it is possible that the fabric might be preserved. Derrida's view of psychoanalysis as 'a repetition of the structure it seeks to analyse' (see Barbara Johnson, *Yale French Studies*, nos. 55–56 [1978], pp. 498–9) might be of some interest here. There is already, of course, an established practice of psychoanalytic textual criticism (see Peter Brooks, 'The Idea of a Psychoanalytic Literary Criticism', in *Critical Inquiry*, XIII [Winter 1987], pp. 334–48; and Michael Riffaterre, 'The Intertextual Unconscious', *Critical Inquiry*, XIII [Winter, 1987], pp. 371–85). I am suggesting that Yuan literati painting may have been written this way to begin with.

95 Lacan, *Four Concepts*, p. 9.

5 *Jonathan Hay, The Suspension of Dynastic Time*

1 The term *yimin* is usually given the rather clumsy translation of 'left-over subjects'. Frederick Wakeman, Jr, in his recent study of the Ming-Qing transition, *The Great Enterprise: The Manchu Reconstruction of the Imperial Order in Seventeenth-Century China* (Berkeley, 1985), uses the term 'remnant'. Wakeman's study is the basis for the information on historical events presented here.

2 On the Nanjing art world in the late seventeenth century, see Hong-nam Kim, 'Chou Liang-kung and His "Tu-hua-lu": Patron, Critic and Painters in Seventeenth Century China', Ph.D. dissertation, Yale University, 1985.

3 Paul Ricoeur, *Time and Narrative*, III (Chicago, 1990), p. 106.

4 Wakeman, op. cit., p. 783.

5 Jerome Silbergeld, 'Political Symbolism in the Landscape Painting and Poetry of Kung Hsien (*c.* 1620–89)', Ph.D. dissertation, Stanford University, 1974, pp. 233–4.

6 Paul Ricoeur, *Lectures on Ideology and Utopia* (New York, 1986), p. 17.

7 Richard Strassberg, *The World of K'ung Shang-jen*, p. 205.

8 On Zhang Feng, see Rao Zongyi, 'Zhang Dafeng jiqi jiashi' [Zhang Feng and His Family Background], *Journal of the Institute of Chinese Studies of the Chinese University of Hong Kong*, VIII/1 (1976), pp. 51–69; and Kim, op. cit., III, pp. 116–22, for a discussion of Zhang Feng by Zhou Lianggong. According to a poem by Zhang Feng's brother, Zhang Yi, included in Zhou Lianggong's discussion, 'He painted landscape in order to escape poverty.'

9 For earlier discussions of this album, see Julia K. Murray, 'Chang Feng's 1644 Album of Landscapes', unpublished manuscript, 1976; and the catalogue entry on the album by Maxwell K. Hearn in Wai-kam Ho, ed., *The Century of Tung Ch'i-ch'ang (1555–1636)* (Kansas City, 1992), II, pp. 118–20. I have drawn on these authors' translations of Zhang Feng's inscriptions as the basis for my own.

10 As pointed out by Hearn, op. cit., p. 120.

11 The lines come from a lyric song by Ma Zhiyuan (*c.* 1260–1324), included in a larger song cycle entitled 'Autumn Thoughts', See *Yuan Ming Qing Qu xuan* [Songs in the Qu Form from the Yuan, Ming and Qing Dynasties], 1953, vol. 1, p. 28. I owe this information to Murray, op. cit.

12 Kim, op. cit., p. 117.

13 On this theme in the work of Luo Zhiquan (active *c.* 1300–30), see Richard Barnhart, *Wintry Forests, Old Trees: Some Landscape Themes in Chinese Painting* (New York, 1972), p. 43.

14 Wakeman, op. cit., p. 734.

15 This album, in the Nelson Gallery-Atkins Museum, has been published by Marc

Wilson in *Eight Dynasties of Chinese Painting: The Collections of the Nelson Gallery-Atkins Museum and The Cleveland Museum of Art* (Cleveland, 1980), no. 214.

16 Silbergeld, op. cit., p. 259.

17 Kim, op. cit., III, p. 100.

18 This and subsequent translations of inscriptions from the album are by Marc Wilson, from *Eight Dynasties of Chinese Painting*, with a few slight modifications.

19 Wang Fangyu and Richard M. Barnhart, *Master of the Lotus Garden: The Life and Art of Bada shanren (1626–1705)* (New Haven, 1990), p. 141.

20 Author unknown, text copied by Bada shanren in an album of calligraphy from 1702. See Wang and Barnhart, op. cit., pp. 201–2.

21 Cf. the concept of 'internal emigration' which has been applied to the work of certain painters who remained in Germany after the Nazis took power. See David Elliott, 'Absent Guests – Art, Truth and Paradox in the Art of the German Democratic Republic', in *The Divided Heritage: Themes and Problems in German Modernism*, ed. Irit Rogoff (Cambridge, 1990).

22 Silbergeld, op. cit., pp. 71–4.

23 Translation by Jerome Silbergeld (abbreviated), op. cit., pp. 231–2.

24 Wang and Barnhart, op. cit., p. 144.

25 This is the same shift which we can see in the work of the Ming prince-painters Bada shanren (after 1692) and Shitao (after 1697). On Bada shanren, see Wang and Barnhart, op. cit.; and on Shitao, see my 'Shitao's Late Work (1697–1707): A Thematic Map', Ph.D. dissertation, Yale University, 1989, Chapter 5.

26 See Hay, op. cit., pp. 14; 19–23.

27 See Hay, op. cit., pp. 429–30, n. 55.

28 *The Sacred Books of China, Part III: The Li Ki, I–X*, translated by James Legge (Oxford 1885; Delhi 1968), p. 124.

29 Ibid., p. 167.

30 Richard Barnhart notes that Bada shanren only attained 'relative serenity' in the 1690s. Op. cit., p. 18.

31 Silbergeld, op. cit., p. 117.

32 The two works by Hu Yukun are: leaf F of the album *Scenic Views of Jinling (Nanjing)*, dated 1660, reproduced in *Baiyun tang canghua*, vol. I, p. 135; and the hanging scroll *Cloudy Mountains in Mist and Rain* in *Chinese Paintings and Calligraphy*, exhibition catalogue: Hanart Gallery Inc., 1988, cat. no. 27. Gao Cen's painting is the fourth leaf of his *Album of Landscapes*, dated 1682 (Christie's New York, *Fine Chinese Painting and Calligraphy*, 25 November 1991, lot 136). This group of Zhongshan images can probably be expanded to include a large hanging scroll on satin by Gao Cen's nephew, Gao Yu, *Verdant Ring of Spring Mountains*, dated to the 16th day of the eleventh month of 1689 (Christie's New York, *Fine Chinese Paintings and Calligraphy*, 4 June 1993, lot 124). Gao Yu signs himself as 'Gao Yu of Zhongshan'.

33 Silbergeld, op. cit., pp. 71–4.

6 *Dorothy Ko: Lady-Scholars at the Door: The Practice of Gender Relations in Eighteenth-Century Suzhou*

1 Li Chi, *Book of Rites*, tr. James Legge (New York, 1967), I, pp. 478–9. The *Book of Rites*, [*Li Ji*] one of the Confucian classics, is an eclectic text; its content ranges from philosophical pronouncements to precepts for daily conduct. This collection of Zhou to early Han texts was compiled in the Han dynasty.

2 Ren Zhaolin and Zhang Yunzi, *Wuzhong nüshi shichao* [Poems of Suzhou Ladies] (1978). Copies in the Harvard-Yenching Library and Tōyō Bunka Kenkyūjo, Univer-

sity of Tokyo. This anthology is made up of ten individually-titled collected works and three miscellaneous appendices, each with its own pagination. On the other side of the margin, the pages are also numbered cumulatively without chapter divisions. Citations in this essay refer to the latter unless otherwise noted.

3 The total number of Yuan Mei's female students was established by Japanese scholar Goyama Kiwamu to be 'over fifty' in his recent article, which is much higher than the conventional count. Goyama, 'En Bai to jodeshi tachi', *Bungaku ronshū*, XXXI (1985), pp. 113–45. For the objections of Yuan Mei's most vehement critic, Zhang Xuecheng, see Susan Mann, '"Fuxue" (Women's Learning) by Zhang Xuecheng (1738–1801): China's First History of Women's Culture', *Late Imperial China*, XIII/1 (1992), pp. 40–62.

4 Zhang Yunzi was said to be Ren Zhaolin's 'second wife' in *Suzhou fuzhi* [Gazetteer of Suzhou] (1883), 139/6a. All other sources refer to her as 'wife'.

5 I have studied this women-to-women education in an earlier article, 'Pursuing Talent and Virtue: Education and Women's Culture in Seventeenth and Eighteenth Century China', *Late Imperial China*, XIII/1 (1992), pp. 9–39. The communities and culture created by gentry lady poets in seventeenth-century Jiangnan comprise the subject of my book, *Teachers of the Inner Chambers: Women and Culture in Seventeenth-Century China* (Stanford, 1994).

6 Yuan's first female student was Chen Shulan, a Nanjing woman who later committed suicide at the death of her husband. Goyama, 'En Bai to jodeshi', pp. 121–2. Goyama has also argued that Mao Qiling was the first person to use the term '*nü dizi*', or 'woman-disciple' (p. 113). For Ren's full list of seven male teachers and their students, see Ren Zhaolin, 'Xiaochunge shiji xu', in *Wuzhong nüshi shichao*, 102b.

7 Xu Xiangxi had published her own collected poetry, *Nanlou yingao* [Verse Drafted in Southern Pavilion]. See Hu Wenkai, *Lidai fanü zhuzuo kao* [Women's Writings Through the Dynasties] (Shanghai, 1985), p. 478. It is interesting to note that Ren Zhaolin's father had also formally taught poetry to a Suzhou woman, Tao Qingyu. Ren Zhaolin, *Xinzhai shigao* [Ten Works by Xinzhai (Ren Zhaolin)] (n.p., 1781–8). Copy in the Naikaku Bunko.

8 For brief biographies of Ren Zhaolin, see Li Yuandu, *Guochao xianzheng shilüe* [Deeds of Exemplars from the Reigning (Qing) Dynasty] (n.p.), 35/29b; Li Huan, *Guochao qixian leizheng* [Notable Elders from the Reigning (Qing) Dynasty] (1884–90), 420/58a). For titles of Ren's writings and his involvement in compiling various local gazetteers, see Zhang Huijian, *Ming-Qing Jiangsu wenren nianbiao* [Year-by-Year Accounts of Jiangsu Literati from the Ming and Qing Dynasties] (Shanghai, 1986), pp. 1196, 1222, 1243, 1246, 1260, 1285, 1332, 1363, 1373, 1406.

9 Qian Daxin made a few corrections to the drafts that Ren showed him in 1788, and suggested that they be sent to Wang Qishu (1728–c.1799), a Huizhou scholar-publisher who was preparing sequels to his major anthology of women's verse, *Xiefangji*, first issued in 1773. Ren, however, followed the wish of his wife to have the manuscripts published under separate cover. Ren, 'Wuzhong nushi shichao xu', in *Wuzhong nüshi shichao*, 5a. For the professionalization of the Jiangnan academic community and Qing evidential scholarship, see Benjamin Elman's classic, *From Philosophy to Philology* (Cambridge, Mass., 1984).

10 Another teacher of woman poets, Mao Qiling, attacked the fallacy of Neo-Confucian *daoxue* (Elman, op. cit., p. 53). Hence, although he was not, strictly speaking, a Han-learning scholar, Mao was certainly a sympathizer of its cause.

11 Susan Mann has discussed how the erosion of social hierarchies prompted a 'new discourse on marriage' in the eighteenth century, in which Han-learning scholars valorized the family and the privileged role of the wife in it. 'Grooming a Daughter for Marriage: Brides and Wives in the Mid-Ch'ing Period', in *Marriage and Inequality in*

Chinese Society, ed. Rubie Watson and Patricia Buckley Ebrey (Berkeley, 1991), pp. 204–30.

12 Yoshida Jun, 'Etsui tsoto biki koron', *Chūgoku shakai to bunka*, IV (1989), pp. 176–91. I am grateful to Professor Benjamin Elman for bringing this article to my attention. Dai Zhen's sympathies for the Huizhou merchant wives are discussed in Benjamin Elman, 'The Failure of Contemporary Chinese Intellectual History: Some Comments for Discussion', paper presented at the UCLA Conference on Chinese Intellectual History, Los Angeles, Feb. 13, 1993.

13 Wang Zhaoyuan (1763–1851), a Shandong woman distinguished by her philological scholarship, not poetry, was a notable exception. Harriet Zurndorfer has analysed the ironies that this entails in her 'The "Constant World" of Wang Chai-Yuan: Women, Education, and Orthodoxy in 18th Century China – A Preliminary Investigation', in *Family Process and Political Process in Modern Chinese History* (Taipei, 1992), I, pp. 581–619.

14 I have traced this valorization of the female poetic voice to the commercial success of anthologies of women's poetry in late sixteenth-century Jiangnan in Chapter 1 of my book. For a summary of arguments against women learning poetry in the eighteenth century, see Liu Yongcong [Clara Lau], 'Qingdai qianqi guanyu nüxin yingfou you "cai" zhi taolun' [Early Qing Discussions on Whether Women Should Have Talent or Not], *Zhonghua wenshi luncong*, XLV (1989), pp. 317–27.

15 Ren, 'Wuzhong nushi shichao xu', 5-ab, Confucius's saying is from the *Book of Rites*. My translation follows that of James Legge in *Li Chi: Book of Rites*, II, p. 255. In the seventeenth century, the meaning of 'womanly word' was enlarged to refer to not just the spoken word, but the written word as well. See Dorothy Ko,' Pursuing Talent and Virtue: Education and Women's Culture in Seventeenth and Eighteenth Century China', *Late Imperial China*, XIII/1 (1992), pp. 9–39 [29–30].

16 Goyama Kiwamu, 'En Bai no koshikiron' [On Yuan Mei's love of women], *Bungaku ronshū*, XXXVI (1990), pp. 127–65. Quotations from pp. 145–6, 148. For Yuan's fondness for young concubines and beautiful women, see Arthur Waley, *Yuan Mei: Eighteenth Century Chinese Poet* (London, 1956), pp. 34, 46, 75, 84, 106, 147, 149–50, 154. See also pp. 167–75 for Waley's discussion of Yuan's views on poetry and his comparing of Yuan to early nineteenth century European romantics.

17 This is also the view of Goyama, an expert on Yuan Mei. Goyama has suggested that many of Yuan's posthumous critics were his former friends or students. Their denouncements could have stemmed from jealousy for Yuan's fame or their own attempt to control Yuan's legacy (Goyama, 'En Bai to jodeshi', pp. 141–5). For citations of the charges levied against Yuan by Zhang Xuecheng and others, mostly after his death, see Jian Youyi, *Yuan Mei yanjiu* [A Study of Yuan Mei] (Taipei, 1988), pp. 311–29.

18 My statements on recruitment patterns here are drawn from the information presented in Goyama, 'En Bai to jodeshi', passim.

19 *Wuzhong nüshi shichao*, 54a, 58a, 67b. For the poetry party and the commended rhyme-prose compositions, see 124a–132b. There were also contests in various styles of regular verse and song lyrics, but these entries were not printed. These examples of Ren comparing his women students to each other accord with a general practice of art critics. A woman artist was rarely likened to a man. Ellen Johnston Laing, 'Women Painters in Traditional China' in *Flowering in the Shadows: Women in the History of Chinese and Japanese Painting*, ed. Marsha Weidner (Honolulu, 1990), pp. 93–4.

20 *Wuzhong nüshi shichao*, 38b–39a, 41a, 52b, 53a–b.

21 Ibid., 48a–b; Yun Zhu, *Zhengshi ji* [Correct Beginnings: Poetry of Ladies from the Reigning (Qing) Dynasty], 16/8b–9a (n.p., 1831–6). Shen's commentary on dynasties

is in her 'Feicuilou ji', in *Wuzhong nüshi shichao*, 84b–87a. See similar poem by You Danxian, 114a.

22 The scores for strings, 'Xiange guye pu', was compiled in 1783. It is appended to Ren Zhaolin, *Xinzhai ji*, in *Xinzhai shizhong*. The scores for the flute and song lyrics are published as 'Xiao pu', appendix to *Wuzhong nüshi shichao*. It was common for gentry women at the time to practice a range of polite arts – poetry, calligraphy and painting, for example – together. See *Views from Jade Terrace: Chinese Women Artists, 1300–1912*, exhibition catalogue by Marsha Weidner et al.: Indianapolis Museum of Art (Indianapolis and New York, 1988), p. 16.

23 *Wuzhong nüshi shichao*, 102b–103a. For poems that the women exchanged with the nun, Wang Jiju, see, for example, ibid., 26b–27b. Wang's short biography can be found in Yun Zhu, *Zhengshi ji, fulu*/14a.

24 An uncle of Zhang Yunzi's was recommended to the same Special Examination in Beijing that Yuan Mei attended in 1736. In this sense Yuan and Zhang's uncle were 'same-year colleagues' (*tongnian*) according to the male examination network. Goyama, 'En Bai to jodeshi', pp. 130–31.

25 For 'teachers of the inner chambers' and the general topic of women's education in the sixteenth and seventeenth centuries, see my 'Toward a Social History of Women in Seventeenth-Century China' (Ph.D. dissertation, Stanford University, 1989). Advances in gentry women's education were in part responsible for the sporadic outcries of literati men condemning footbinding and female infanticide. For the emergence of such 'proto-feminist' criticisms in the eighteenth century, see Paul Ropp, 'The Seeds of Change: Reflections on the Conditions of Women in the Early and Mid Ch'ing', *Signs* II/1 (1976), pp. 5–23.

26 Rubie Watson, 'The Named and the Nameless: Gender and Person in Chinese Society', *American Ethnologist*, XIII (1986), pp. 619–31. Quotes from pp. 629 and 619, respectively.

27 For Zhang Dashou, see Zhang Huijian, *Ming-Qing Jiangsu wenren nianbiao* [Year-by-Year Accounts of Jiangsu Literati from the Ming and Qing Dynasties], pp. 698, 936, 961, 972, 987, 997, 1009. Zhang Yunzi highlighted her role as Dashou's successor in many ways. As a girl, Yunzi studied in Dashou's studio, the name of which became the title of one of her poetry collections. Her courtesy name, Clear Brook, was in turn taken from the title of Dashou's poetry collection.

28 There is no mentioning of Zhang Yunzi's siblings in the available sources. Since she studied with her uncle and was the foster daughter of an official surnamed Peng, it seems likely that her father died young. Her mother was mentioned in the postscript to her poetry collection, crafted by a distant nephew, and is appended to Zhang Yunzi, *Chaoshengge shiji* [Poetry from the Ascending Tide Pavilion], 16a–b, in *Wuzhong nüshi shichao*.

29 Zhu Zongshu, 'Zeng Jiang Bicen zi', in Yun Zhu, *Zhengshi ji*, 16/5a–b.

30 Jiang Zhu, 'Zixu shigao jianheng Xinzhai xiansheng', in *Wuzhong nüshi shichao*, 53a–55a. Her self-defence against charges of plagiarism is in the same work, 63b–64a.

31 Nakamura Hajime, ed., *Japanese-English Buddhist Dictionary* (Tokyo, 1965), p. 332.

32 I have discussed the practice of planchette séance and the popularity of *The Peony Pavilion* among women in Chapter 2 of *Teachers of the Inner Chambers*. The drama has been translated into English: Tang Xianzu, *The Peony Pavilion*, tr. Cyril Birch (Bloomington, 1980).

33 *Wuzhong nüshi shichao*, 63a–b.

34 Ibid., 80a, 106b.

35 Ibid., 33a–b, 36a, 37a.

7 Isabelle Duchesne: The Chinese Opera Star: Roles and Identity

1 The illustrations to this article are reproduced courtesy of C. V. Starr East Asian Library, Columbia University. I am indebted to Jonathan Hay for his criticisms of this essay at various stages.

2 This also translates its other common Chinese names of 'Pingju' and 'Jingju'.

3 The role-types, like the repertory of plays and the musical instruments, are divided into the two categories, 'civil' (*wen*) and 'military' (*wu*). These distinguish roles and plays that are associated above all with literary and romantic themes, with corresponding costumes and gesture, and where singing and melodic instruments predominate, from roles and plays with a warrior theme, with military costumes and fighting movements, accompanied above all by percussions and reed instruments and only limited singing.

4 These were Bangzi plays (a northern genre accompanied by woodblocks), and the speciality of his mother. Zhang Junqiu, lecture at Columbia University, New York, 2 May 1990.

5 I am drawing here on the theories of Jean Piaget. See his *Six Psychological Studies* (New York, 1968), pp. 64–73.

6 Mei Lanfang, *Mei Lanfang wenji* [Collected Writings by Mei Lanfang] (Beijing, 1962), p. 136; Zhang Yinde, *Qiu Shengrong yu Jingju hualian yishu* [Qiu Shengrong and the Art of Painted Face Roles] (Tianjin, 1984), p. 72; A. C. Scott, *Mei Lan-fang Leader of the Pear Garden* (Hong Kong, 1959), p. 27.

7 When Cheng Yanqiu (1904–58) accepted as his disciple Xun Lingxiang, the son of his colleague Xun Huisheng, in 1932, he set the ceremony for the first of January (his own birthday), and took advantage of the occasion to change his name from Yushuang to Yanqiu. See Zhang Tidao, 'Xun Lingxiang bai shi ji' [How Xun Lingxiang Became Cheng Yanqiu's Disciple] in *Juxue yuekan* [Theatre Studies Monthly], I/1 (Beijing, 1932).

8 I have not been able to establish, at this point, what kind of relationship – if any – the disciple maintains with his natural parents and ancestry once he enters the master-teacher's family. Nevertheless, under certain adoption terms, the adopted child can belong to both lineages, as Arthur Wolf and Chieh-shan Huang demonstrate in their work *Marriage and Adoption in China, 1845–1945* (Stanford, 1980), pp. 83–4, 111–13.

9 The protagonists of such a pact changed if a young child-apprentice was entrusted to a master by an intermediary or a parent, or if the apprentice was able to make a conscious decision.

10 Colin Mackerras, *The Chinese Theatre in Modern Times: From 1840 to the Present Day* (London, 1975), pp. 72–5.

11 The 'Four Great *dan*' are Mei Lanfang (1894–1961), Cheng Yanqiu (1904–1958), Shang Xiaoyun (1899–1976) and Xun Huisheng (1900–1968).

12 Encouraged by their master, Wang Yaoqing (1881–1954), the 'Four Great *dan*' transgressed the strict divisions of female roles, refusing to restrict themselves to a single type (e.g. women of action).

13 See the photographs reproduced in Mary Backus Rankin, *Early Chinese Revolutionaries: Radical Intellectuals in Shanghai and Chekiang, 1902–1911* (Cambridge, Mass., 1971), pp. 42–3, originally in *Qiu Jin shiji* [Manuscripts of Qiu Jin] (Shanghai, 1958).

14 Author's unpublished interview with Zhao Rongshen, Beijing, 28 June 1984.

15 Zhang Xiaocang, *Jubu congtan* [General Talks about Theatre] (Shanghai, 1916), reprinted in *Pingju shiliao congkan* (Collection of Materials on Beijing Theatre), VII, eds, Liu Shaotang and Shen Weichuang (Taipei, 1974), p. 255.

16 Richard Schechner, *Between Theater and Anthropology*, Chapter 3, 'Performers and Spectators: Transported and Transformed' (Philadelphia, 1985), pp. 121–4.

17 Frank W. Putnam, 'Altered States: Peeling Away the Layers of a Multiple Personality' in *The Sciences*, ed. Peter G. Brown (New York, 1992), pp. 30–6.

18 Li Yu, *Xianging ouji. Yan xi bu. Jieming qu yi* [Feelings confided leisurely. Drama performance. To illuminate the meaning of the song], reprint in *Zhongguo meixue shi ziliao xuanbian* [Collection of Historical Documents on Chinese Aesthetics], II (Beijing, 1980), p. 575.

19 See above, note 15.

20 Wang Yaoqing, interviewed by Shao Mingsheng, 'Wode zhongnian shidai' [My Mature Years] in *Juxue yuekan*, II/4 (1933). According to Wang, Chen Delin replaced the second part of the play *Hun yuan he* by Qintiao, a famous Kunqu play from the *chuanqi Yu zan ji* [The Jade Hairclip].

21 Robert Hegel and Tanaka Issei both distinguish different types of values and content in Ming-Qing vernacular literature and local drama, according to the type of audience and performance setting. In particular, they correlate the refinement and the canoniz-ation of the repertory with certain local elites. See Robert E. Hegel, 'Distinguishing Levels of Audiences for Ming-Ch'ing Vernacular Literature', and Tanaka Issei, 'The Social and Historical Context of Ming-Ch'ing local Drama', both in *Popular Culture in Late Imperial China*, eds David Johnson, Andrew Nathan and Evelyn Rawski (Berkeley, 1985), respectively pp. 112–42 and 143–60.

 While a similar argument could associate the archetypal moral characters and plays of *Jingxi* with the Qing elite in opposition to more popular play formats in the nineteenth century, nevertheless there is a historical shift in the way that actors and their various audiences universally sought a more personalized portrayal of characters at the beginning of this century.

22 Xun Huisheng, 'Honglou er You de biaoyan he changqiang' [The Dramatic Interpret-ation and Vocal Music of 'The Two You Sisters'] in Xun Huisheng, *Xun Huisheng yanju sanlun* [Various Reflections on my Performances] (Shanghai, 1983), p. 143.

23 Ibid., p. 153.

24 Ibid., p. 154.

25 As late as the 1980s there was still a market in mainland China for photographs of these actors in stage costume.

26 A. C. Scott, *Mei Lan-fang Leader of the Pear Garden* (Hong Kong, 1959), p. 59.

27 For Jingxi, see Shang Xiaoyun's photographic portrait as a 'modern girl', reproduced in this volume. For Cantonese theatre, see that of the star Ma Shizeng, also wearing a white dress, in Ma Shizeng, *Qianli zhuang you ji* [Collection of Great Tours Far Away] (n.p., 1931).

 The term '*modeng ga*', which qualifies Shang Xiaoyun in the Chinese text, though referring ultimately to the English 'modern girl', was probably adapted from the Japanese '*moga*', as Japan played a major role in the introduction of modern ideas into China. According to Miriam Silverberg, the 'modern girl' was a current trope of Japanese life in the 1920s, and the critic Ōya Sōichi wrote about 'the modern girl' in his ethnography of Japanese modernity entitled *Modan sō to modan sō* [Modern Social Strata and Modern Mores], *Ōya sōichi zenshū* II (Tokyo, 1930). Sōichi is quoted in Miriam Silverberg, 'Constructing the Japanese Ethnography of Modernity', *The Journal of Asian Studies*, LI/1 (Milwaukee, 1992), pp. 32–3.

28 Liu Shouhe, 'Zhongguo dianying de qianlu' [The Future of Chinese Cinema], *Juxue yuekan* [Theatre Studies Monthly] II/3 (1933), pp. 55–6. Hu Die is compared to Mei Lanfang, Ruan Lingyu to Cheng Yanqiu, Chen Yanyan to Xun Huisheng and Chen Yumei to Shang Xiaoyun.

29 For a description, see A. C. Scott, op. cit., pp. 77–8.

30 Jay Leyda, *Dianying: An Account of Films and the Film Audience in China* (Cambridge, Mass., 1972), pp. 19–20.

31 Sun Yangnong, *Tan Yu Shuyan* [About Yu Shuyan] (Hong Kong, 1953), pp. 153–4.

32 Perhaps the most notable of these was Du Yuesheng, already married to one actress, and of whom Meng Xiaodong became the fifth wife. Du was an extremely powerful figure in Shanghai society, as secret society head, banker, infiltrator of unions, philanthropist, ally of Chiang Kai-shek, organizer of the purge of communists in Shanghai, industrialist, and orchestrator of military campaigns and national resistance. To mark the building of his family's ancestral hall, Du organized three days of theatre performance in June 1931, featuring the best actors then available – and then invited them again afterwards.

33 A. C. Scott, op. cit., pp. 72–3.

34 Mei Lanfang had been warmly received in Japan during two tours in 1919 and 1924. In China, Japanese residents studied Chinese drama, frequented the theatres, and produced records for the Asian Market.

35 Author's unpublished interview, Beijing, 28 June 1984.

36 See 'Mei Lanfang de huihua' [Mei Lanfang's Paintings], from *Yihai zazhi* [Yihai Magazine] (c. 1930s), in the xeroxed compilation *Mei Lanfang chuanji ziliao* [Biographical Documents on Mei Lanfang], pp. 52–8.

37 I will only mention, without giving her name, the case of a celebrated Jingxi actress who, during a tour outside China in the 1980s, had to be granted a special authorization to use opium in order to be able to perform.

8 *Rey Chow: 'Love Me, Master, Love Me, Son': A Cultural Other Pornographically Constructed in Time*

1 '. . . limits are, in a sense, what fantasy loves most, what it incessantly thematizes and subordinates to its own aims.' Judith Butler, 'The Force of Fantasy: Feminism, Mapplethorpe, and Discursive Excess', *Differences: A Journal of Feminist Cultural Studies*, II/2 (1990), p. 111.

2 Cai Kejian, Interview with Pai Hsien-yung, *Playboy*, Chinese edition, no. 24, July, 1988, p. 39.

3 '*Gan didi*' in Chinese. This title refers to the practice by which persons outside the kinship family are adopted nominally as members of the family.

4 For a discussion of the implications of Lu Xun's narrative method, see Rey Chow, '"It's you, and not me": Domination and "Othering" in Theorizing the "Third World"', in *Coming to Terms: Feminism, Theory, Politics*, ed. Elizabeth Weed (New York, 1989), pp. 152–61.

5 Peter Stallybrass and Allon White, *The Politics and Poetics of Transgression* (Ithaca, 1986), Chapter 4, pp. 152, 155.

6 Jacques Derrida, *Of Grammatology*, trans. Gayatri Chakravorty Spivak (Baltimore, 1976), pp. 144–5; emphases in the original.

7 All references to this story are taken from Bai Xianyong, *Yuqing Sao* (Taipei, 1985) and translated from the Chinese by me. This quotation is from p. 111 of the original.

8 Ibid., pp. 143–4.

9 'Love is sometimes very frightening, especially when it reaches a certain degree. Some people perhaps prefer to describe it mildly, but I feel that when one person falls in love with another, it's really . . . really shaking up heaven and earth! . . . Even the physical love in *Yuqing Sao* is, for me, a manifestation of the explosion of such internal emotions.' Interview in *Playboy*, p. 41.

10 I have discussed Xu Dishan's short story 'Big Sister Liu' (*Chuntao*) in this light. See Rey Chow, *Woman and Chinese Modernity: The Politics of Reading between West and East* (Minneapolis, 1991), pp. 145–50.

11 *Yüqing Sao*, p. 5; also quoted on the back cover.

12 Roland Barthes, *Mythologies*, selected and translated from the French by Annette Lavers (London, 1973).

13 Gilles Deleuze and Félix Guattari, *Anti-Oedipus: Capitalism and Schizophrenia*, trans. Robert Hurley et al. (Minneapolis, 1983), pp. 274–5.

14 Unlike most Chinese writers, Bai is open about his sexuality. He describes his homosexuality as *'tiansheng de'* – that is, something he was born with. Interview with *Playboy*, p. 43.

15 For instance: 'I was really curious as to why his moustache was so fine and so soft . . . if only I could touch it, it must feel real nice . . .' (*Yuqing Sao*, p. 130). 'I really didn't understand why, but as soon as I saw that soft and smooth moustache I was beside myself with excitement. I couldn't restrain myself from gently touching it. An itchy and numbing feeling made me laugh . . .' (*Yuqing Sao*, p. 131).

16 For an argument of how the constitution of homosocial bonding between men takes place through women, see Eve Kosofsky Sedgwick, *Between Men: English Literature and Male Homosocial Desire* (New York, 1985). If the bond between males is structured by the object of woman, it is structured also by a lack – the father. This is why, for instance, Bai said that *Niezi* (Hong Kong, 1988), his novel about young male homosexuals in present-day Taipei, can be described as 'xun fu ji' – a 'story of looking for the father'. Interview with *Playboy*, p. 42. For an English translation of *Niezi*, see *Crystal Boys*, trans. Howard Goldblatt (San Francisco, 1991).

17 This is a point made by Christopher Lupke in his talk 'Nativism, Modernism and Bai Xianyong's "Wandering in the Garden, Waking from a Dream" ', the Association for Asian Studies Annual Convention, New Orleans, April 1991. See, for instance, some of the stories in the collection *Wandering in the Garden, Waking from a Dream: Tales of Taipei Characters*, trans. Pai Hsien-yung and Patia Yasin, edited by George Kao (Bloomington, 1982).

18 *Yuqing Sao*, p. 111.

19 For an argument about the ageist ideology and dominant gerontophobia of twentieth-century Western culture, see Kathleen Woodward, *Aging and Its Discontents: Freud and Other Fictions* (Bloomington and Indianapolis, 1991).

20 Bai is here consciously or unconsciously sharing Freud's biased judgement about femininity. Freud claims that in matters of sexuality women are always *certain* about what they want. While a little boy does not understand the meaning of the female genitals until much later than when he first sees them, a little girl behaves differently: 'She makes her judgement and her decision in a flash. She has seen it and knows that she is without it and wants to have it.' ('Some Psychological Consequences of the Anatomical Distinction between the Sexes', 1925.) This attributed 'certainty' of feminine desire goes hand in hand with the view that women become fixed and rigid – that is, *old* – much earlier than men: 'A man of about thirty strikes us as a youthful, somewhat unformed individual, whom we expect to make powerful use of the possibilities for development opened up to him by analysis. A woman of the same age, however, often frightens us by her psychical rigidity and unchangeability. Her libido has taken up final positions and seems incapable of exchanging them for others. There are no paths open to further development; it is as though the whole process had already run its course and remains thenceforward insusceptible to influence – as though, the difficult developments to femininity had exhausted the possibilities of the person concerned' ('Femininity', 1933.) The two passages are in *The Standard Edition of the Complete Psychological Works of Sigmund Freud*, 24 vols, trans. and ed. James Strachey (London, 1953–74), vol. XIX, p. 252; vol., XXII, pp. 134–5.

9 Ann Anagnost: Who Is Speaking Here? Discursive Boundaries and Representation in Post-Mao China

1 I wish to thank the Fulbright Committee and CSCPRC for funding my two periods of field research in 1981–2 and in 1991 respectively.

2 S. Mosher, *China Misperceived: American Illusions and Chinese Reality* (New York, 1990).

3 W. Hinton, *Fanshen: A Documentary of Revolution in a Chinese Village* (New York, 1966).

4 See Teresa De Lauretis, *Alice Doesn't: Feminism, Semiotics, Cinema* (Bloomington, 1984).

5 Jean Comaroff and John Comaroff, *Of Revelation and Revolution: Christianity, Colonialism and Consciousness in South Africa*, vol. 1 (Chicago, 1991), p. 5 (emphasis in original).

6 My use of political culture here is taken from recent discussions on the historiography of the French Revolution. On the extension of these discussions to Chinese socialism, see Elizabeth J. Perry, 'Chinese Political Culture Revisited,' in *Popular Protest and Political Culture in Modern China: Learning From 1989*, ed. J. N. Wasserstrom and E. J. Perry (Boulder, 1992), pp. 1–13.

7 This phrase refers to what Raymond Williams has called a 'selected tradition: that which, within the terms of an effective dominant culture, is always passed off as "*the* tradition," "*the* significant past".' See R. Williams, *Marxism and Literature* (Oxford, 1980), p. 39. This point has, of course, been elaborated with great effect in *The Invention of Tradition*, ed. E. J. Hobsbawm and T. Ranger (Cambridge, 1983) which shows how the construction of a national tradition by the modern nation state is a complex process of 'inventing, remembering, and forgetting.' See Takeshi Fujikawa, 'Inventing, Forgetting, Remembering: Toward a Historical Ethnography of the Nation-State' in *Cultural Nationalism in East Asia*, ed. H. Befu (Berkeley, 1993), pp. 77–106.

8 For this notion of launching national subjects, see Tani Barlow, 'Theorizing Woman: Funu, Guojia, Jiating [Chinese Woman, Chinese State, Chinese Family]', *Genders*, 10 (1991), pp. 132–160.

9 See Louisa Schein, 'An Ethnography of Distinction: Fieldwork and the Chinese Social Order', (unpublished manuscript) for a summary of the tropes of moving 'downward' as characteristic of the regime of power/knowledge of the Chinese socialist state.

10 Hayden White, 'Michael Foucault,' in *Structuralism and Since*, ed. John Sturrock (Oxford, 1979), pp. 82.

11 Hinton, *Fanshen*, p. vii.

12 De Lauretis, *Alice Doesn't*, p. 106 (cited in Barlow, 'Theorizing Woman', p. 153).

13 Indeed Hinton himself notes that the torturous working through of the revolutionary process in Long Bow Village would never have been accommodated within a society governed by industrial production. In a limited sense, therefore, narrative time appears to approximate 'real time' in Hinton's account.

14 Arif Dirlik, 'The Predicament of Marxist Revolutionary Consciousness: Mao Zedong, Antonio Gramsci, and the Reformulation of Marxist Revolutionary Theory', *Modern China*, IX/2 (1983), pp. 182–211.

15 Dirlik, 'The Predicament'.

16 P. Bourdieu, *Outline of a Theory of Practice* (Cambridge, 1977).

17 See Barlow, 'Theorizing Woman', for a related discussion of how *funu* ('Chinese women') was constructed as a category parallel to that of class in creating new subjectivities that could be mobilized for party objectives. The author is greatly indebted to this groundbreaking study.

18 James H. Kavanagh, 'Ideology' in *Critical Terms for Literary Study*, ed. F. Lentricchia and T. McLaughlin (Chicago, 1990), p. 310.

19 Benveniste's theory of language and subjectivity focuses on how pronouns locate the subject in the social field by its positioning in language. See, for instance, Kaja Silverman's discussion of Benveniste in *The Subject of Semiotics* (Oxford, 1983). See also Bourdieu, *Outline*, for a discussion of how social relations are 'enchanted' in their masking of exploitation as reciprocity and obligation structured within unquestioned primordial loyalties of kinship and patronage.

20 Dirlik, 'Predicament', p. 196.

21 See Bourdieu, *Outline*. Most of the events that I have personally witnessed have been the venting of wives against husbands. Similarly, Marjorie Wolf (*Women and the Family in Rural Taiwan*, Stanford, 1972) has described the power of the women's community in Taiwanese villages as a forum in which women can report abusive behaviour to a gossip network that threatens to damage the 'face' of abusive husbands and mothers-in-law.

22 Joseph W. Esherick and Jeffrey N. Wasserstrom, 'Acting Out Democracy: Political Theater in Modern China', in *Popular Protest and Political Culture in Modern China: Learning From 1989*, ed. J. N. Wasserstrom and E. J. Perry (Boulder, 1992), pp. 28–66.

23 See Barlow 'Theorizing Woman'. The classic story of 'Goldflower' in J. Belden's *China Shakes the World* (New York, 1970), if read as an example of the speaking bitterness narrative, shows how this metaphysics of presence worked in the creation of *funu*, the reinscribed gendered subject. See also, Ann Anagnost, 'The Politicized Body', *Stanford Humanities Review* II/1 (1991), pp. 86–102, for a more extended discussion of this circular progression of what Bourdieu calls 'political fetishism'. See Pierre Bourdieu, 'Delegation and Political Fetishism', *Thesis Eleven* 10/11 (1984/85), pp. 56–70.

24 See Dirlik, 'Predicament'.

25 See Ann Anagnost, 'Socialist Ethics and the Legal System', in *Popular Protest and Political Culture in Modern China: Learning From 1989*, ed. J. N. Wasserstrom and E. J. Perry (Boulder, 1992), pp. 177–205.

26 Belden, *China Shakes the World*.

27 Marc Blecher, 'Structural Change and the Political Articulation of Social Interest in Revolutionary and Socialist China,' in *Marxism and the Chinese Experience*, ed. A. Dirlik and M. Meisner (Armont, NY, 1989), pp. 190–209, uses this same passage to demonstrate a closely related argument on the coexistence of statist with participatory politics in socialist China.

28 A. Chan, R. Madsen and J. Unger, *Chen Village: The Recent History of a Peasant Community in Mao's China* (Berkeley, 1984), p. 79.

29 Williams, *Marxism and Literature*, p. 132. My argument can also now call on a growing literature on the anthropology of emotions and especially of weeping, in which both may be seen to be culturally structured but are not judged as 'inauthentic'. See, for instance, C. Lutz and L. Abu-Lughod, *Language and the Politics of Emotion* (Cambridge, 1990).

30 I wish to note here how tears and emotion still remain a prominent feature of the party's self-representation. The narratives that describe an alteration in the consciousness of the subject in response to party tutelage often include the shedding of tears, but in the post-Mao context, these are tears of gratitude or shame, rather than sorrow and loss, a change which reflects quite profoundly the reconceptualization of the relationship between the party and masses.

31 I do not mean to suggest here that the nation-state is a natural form or an essentialized political destiny, but rather that it was the term which dominated the political imaginary of the mid-20th century.

References

32 The supposed contradiction in the relations of production depends on Marx's 'reduction of concrete social agents to the economic categories of buyer and seller of labor power'. But concrete social agents are much more than this abstraction when viewed in the totality of their social being, and antagonisms between them and their relations of production arise from contingent factors external to the relations of production themselves, that is, 'the contingent power relations between forces that cannot be reduced to any kind of unified logic.' E. Laclau, *New Reflections on the Revolution of Our Time* (London, 1990), pp. 9–10.

33 George Marcus, 'Contemporary Problems of Ethnography in the Modern World System', in *Writing Culture: The Poetics and Politics of Ethnography*, ed. J. Clifford and G. E. Marcus (Berkeley, 1986), pp. 165–193.

34 The four histories were to be of families, villages, communes and industries.

35 S. L. Wong, *Sociology and Socialism in Contemporary China* (London, 1979) and Sidney L. Greenblatt, 'Introduction', in *The People of Taihang: An Anthology of Family Histories*, ed. S. L. Greenblatt (White Plains, 1976), pp. xiii–lii.

36 Wong, *Sociology and Socialism*, p. 96.

37 Greenblatt, 'Introduction', p. xix.

38 Among these titles were *Taodu gongren huiyilu* ('Worker Recollections of the Pottery Capital'), *Yixing taoye jinxi* ('New Dawn of the Yixing Pottery Industry') *Yixing taoci gongye de fasheng, fazhan yu gaizao* ('The Origin, Development and Transformation of the Yixing Pottery Industry') all in mimeo versions, dated 1959. *Yixing taoci shi caogao* ('History of Yixing Pottery') was a manuscript of over 600 pages compiled by a worker-soldier-peasant team and dated 1975 and, finally, *Yixing taoci jianshi* ('A Short History of the Yixing Pottery Industry') was a photocopied manuscript dated 1978. Copies were placed in the archives of the participating collective factories, the research archives of the Yixing Pottery and Porcelain Company, the Nanjing University History Department and elsewhere.

39 Of course, prior to 1978, all university students presumably were 'worker-soldier-peasant students' (*gongnongbing xuesheng*), so that the process of writing was still being done by university students.

40 One hopes, for these reasons, that this repository of written history, especially those entitled 'reminiscences' (*huiyilu*), is not being systematically weeded out of library collections. Given their primitive form as objects, written on extremely poor quality paper by an unmechanized mimeo process, and given their obviously politicized nature in a new academic environment that prizes 'objectivity' in scholarship, they may no longer be valued as primary material. They would be invaluable resources for anthropologists and other social scientists, as well as to historians, interested in following the role of historical narrative in the development of local political cultures in the post-revolutionary period. The way in which these narratives articulate with Yixing's local tradition is in their emphasis on the pottery industry. This may have been because these rural artisans and pottery workers represented, in the context of the more universal narrative of class struggle, a proto-proletariat whose class consciousness could be demonstrated.

41 The reasons for this reticence were complex and varied, but foremost among them must have also been the fear of being scooped. The local archivists were, as stated above, preparing a definitive history and perhaps did not wish to share their sources with an outsider. Also, as I was to discover somewhat later, knowledge about the pottery tradition now had a tremendous market value elsewhere in Asia, in which the ritual of tea drinking had become part of a reclaimed Chinese tradition actively being rediscovered by post-industrial Chinese subjects in Taiwan and Singapore, not to mention Japanese interest in this tradition, which inflated values considerably.

42 Sidney L. Greenblatt, 'Introduction' to *The People of Taihang: An Anthology of Family Histories* (White Plains, 1976), pp. xiii–lii.

43 For extended discussion of some of the forms taken by this representational process, see Jean-François Billeter, 'The System of "Class-Status"', in *The Scope of State Power in China*, ed. S. R. Schram (London, 1985), pp. 127–69, for a discussion of the class-status system, L. Dittmer, 'Radical Ideology and Chinese Political Culture: An Analysis of the Revolutionary *yangbangxi*', in *Moral Behavior in Chinese Society*, ed. R. W. Wilson, S. L. Greenblatt and A. A. Wilson (New York, 1981), pp. 126–51, for revolutionary opera (*yangbangxi*) and Sidney Greenblatt, 'Introduction', for family histories. The canon of socialist realism in artistic production is perhaps the most obvious case of something much more encompassing. One thinks of the famous tableau, 'Rent Collection Courtyard,' a direct translation of speaking bitterness into three-dimensional form.

44 Chan et al., *Chen Village*, p. 16.

45 Chan et al., *Chen Village*, p. 253.

46 Author's field notes, 1991.

47 It was cited in Jiang Zeming's 1991 speech marking the 70th anniversary of the founding of the Chinese Communist Party as the most pressing task alongside economic and technological development. It was mentioned by every party cadre I interviewed in 1991.

48 Indeed, the Chinese population policy has seemed to shift its emphasis gradually from population quantity to quality beginning in the mid 1980s. See Ann Anagnost, 'A Surfeit of Bodies: Population and the Rationality of State in Post-Mao China', in *Conceiving the New World Order: Local/Global Intersections in the Politics of Reproduction*, ed. F. Ginsburg and R. Rapp (Berkeley, forthcoming).

49 A detailed study of this phenomenon in the domain of 'eugenics' discourse (*yousheng youyu*) is currently in progress by Susan Champaign, a doctoral candidate in education at Stanford.

50 See Bo Yang (Guo Yidong), *Choulou do Zhongguoren* [The Ugly Chinaman], (Hong Kong, 1988). Richard Bodman situates the reception of Bo Yang's essay within the context of the cultural debates of the 1980s which culminated in the making of *Heshang*. See R. Bodman and P. P. Wan, *Deathsong of the River: A Reader's Guide to the Chinese T.V. Series* Heshang (Ithaca, 1991). The report mentioned is Xiaoqiang Wang and Nanfeng Bai, *Furaode pinkun: Zhongguo luohou diqu de jingji kaocha* [The Poverty of Wealth: An Economic Investigation of China's Backward Areas], (Chengdu, 1986). I note the publication of Bo Yang's essay here as the event which triggered the debates about population quality in the mid to late 1980s. The idea did not originate here, and indeed it is as old as the Chinese encounter with the challenge of Western technological 'superiority' (at least for the past century and a half). It was certainly an issue at the very centre of the rural reconstruction movement during the Republican era, and certainly the present emphasis on *weisheng* ('sanitation') is striking here. The historian Bryna Goldman has embarked on a study of *weisheng* as a discursive formation during the Republican Period. I merely note this connection, although my interest is more in why and how this notion has taken such primacy in the last half dozen years.

51 Shu-min Huang, *The Spiral Road: Change in a Chinese Village Through the Eyes of a Communist Party Leader* (Boulder, 1989), p. 168–9.

52 M. Foucault, *The History of Sexuality* (New York, 1978), vol. 1, p. 146. Indeed, we must make this replacement if we are to accept the possibility that 'sexuality' as a discursive formation does not occupy the same pervasive positions that Foucault claims for it in Western post-enlightenment thought.

53 Claude Lefort, 'The Image of the Body and Totalitarianism', in *The Political Forms of*

Modern Society: Bureaucracy, Democracy, Totalitarianism (Cambridge, Mass., 1986), pp. 292–306.

54 See Anagnost, 'Politicized Body', for a discussion of how the inclusion of these voices constitute the party as a subject writ large.

10 *Zhang Hongtu/Hongtu Zhang: an Interview*

1 Although the present text is based on several hours of interviews, it is not a verbatim transcript but has been edited and amended by both interviewer and interviewee (JH, ZHT).

2 'In the world today all culture, all literature and art belong to definite classes and are geared to definite political lines. There is in fact no such thing as art for art's sake, art that stands above classes, art that is detached from or independent of politics. Proletarian literature and art are part of the whole proletarian revolutionary cause; they are, as Lenin said, cogs and wheels in the whole revolutionary machine'. Mao Zedong, 'Talks at the Yenan Forum on Literature and Art' (May 1942), excerpted in *Quotations from Chairman Mao Tse-tung* (Beijing, 1966). (JH)

3 From the poem 'Resurrection', included in 'Smoking People: Encountering the New Chinese Poetry', ed. John Rosenwald, *The Beloit Poetry Journal*, XXXIX/2 (Winter 1988–9), pp. 26–7. Translation slightly modified. (JH)

Select Bibliography

Anagnost, A., 'The Politicized Body', *Stanford Humanities Review*, II/1 (Winter, 1991).

Bao, Z., 'Language and World View in Ancient China', *Philosophy East and West*, XL/2 (1990).

Barnhart, R., *Wintry Forests, Old Trees: Some Landscape Themes in Chinese Painting* (New York, 1972).

Barthes, R., *Mythologies*, selected and trans. by Annette Lavers (London, 1973).

Bourdieu, P., *Outline of a Theory in Practice*, trans. by Richard Nice (Cambridge, 1977).

Bush, S., *The Chinese Literati on Painting: Su Shih (1037–1101) to Tung Ch'i-ch'ang (1555–1636)* (Cambridge, Mass., 1971).

Bush, S. & Murck C., (eds), *Theories of the Arts in China* (Princeton, 1983).

Bush, S. & Shih, H., *Early Chinese Texts on Painting* (Cambridge, Mass., 1985).

Butler, J., 'The Force of Fantasy: Feminism, Mapplethorpe, and Discursive Excess', in *differences: A Journal of Feminist Cultural Studies*, II/2 (Summer, 1990).

Cahill, J., *Hills Beyond a River: Chinese Painting of the Yuan Dynasty, 1279–1368* (Tokyo, 1976).

Cai, K., Interview with Pai Hsien-yung, *Playboy*, Chinese edition, no. 24 (July, 1988).

Chang, K., *Art, Myth and Ritual* (New Haven, 1983).

Chow, R., *Woman and Chinese Modernity: The Politics of Reading between West and East* (Minneapolis, 1991).

Clifford, J. & Marcus G., (eds) *Writing Culture: The Poetics and Politics of Ethnography* (Los Angeles, 1986).

Creel, H., *What is Taoism? and Other Studies in Chinese Cultural History* (Chicago, 1970).

de Bary, W., ed., *The Unfolding of Neo-Confucianism* (New York, 1975).

Deleuze, G. and Guattari, F., *Anti-Oedipus: Capitalism and Schizophrenia*, trans. Robert Hurley et al. (Minneapolis, 1983).

Dirlik, A. & Meisner, M., eds, *Marxism and the Chinese Experience* (London, 1989).

Egerod, S. & Glahn, E., eds, *Studia Serica Bernhard Karlgren dedicata* (Copenhagen, 1959).

Eight Dynasties of Chinese Painting: The Collections of the Nelson Gallery-Atkins Museum and the Cleveland Museum of Art (Cleveland, 1980).

Fabian, J., *Time and the Other: How Anthropology Makes its Object* (New York, 1983).

Fairbank, J. K., ed., *The Chinese World Order: Traditional China's Foreign Relations* (Cambridge, Mass., 1968).

Ferguson, R., ed., *Out There: Marginalization and Contemporary Culture* (Cambridge, Mass., 1990).

Fong, W., ed., *The Great Bronze Age of China: An Exhibition from the Peoples' Republic of China* (New York, 1980).

Foucault, M., *Discipline and Punish: The Birth of the Prison* (London, 1979).

Foucault, M., *The Order of Things: An Archaeology of the Human Sciences* (a translation of *Les Mots et les choses*) (London, 1970).

Graham, A. C., *Disputers of the Tao* (La Salle, 1989).

Graham, A. C., *Yin-Yang and the Nature of Correlative Thinking*, Occasional Philosophies (Albany, 1986).

Graham, A. C., *Studies in Chinese Philosophy and Philosophical Literature* (Albany, 1986).

Granet, M., *La Pensée chinoise* (Brussels, 1934).

Guo, Shaoyu, ed., *Canglang shihua jiaoshi* [A Collated and Annotated Edition of Canglang's Talks on Poetry] (Beijing, 1961).

Haeger, J. W., *Crisis and Prosperity in Sung China* (Tucson, 1975).

Hansen, C., *A Daoist Theory of Chinese Thought* (Oxford, 1992).

——, *Language and Logic in Ancient China* (Ann Arbor, 1983).

Henderson, J., *Scripture, Canon, and Commentary* (Princeton, 1991).

Hinsch, B., *Passions of the Cut Sleeve: The Male Homosexual Tradition in China* (Los Angeles, 1990).

Hinton, W., *Fanshen: A Documentary of Revolution in a Chinese Village* (London, 1966).

Ho, W. & Smith, J., eds, *The Century of Tung Ch'i-ch'ang (1555–1636)*, vols 1 & 2, and *Proceedings of the Tung Ch'i-ch'ang International Symposium* (Kansas City, 1992).

Hobsbawm, E. & Ranger, Terence, eds, *The Invention of Tradition* (Cambridge, 1983).

Hsu, C. & Linduff, Katheryn M., *Western Chou Civilization* (New Haven, 1988).

Huters, T., *Qian Zhongshu* (Boston, 1982).

Johnson, D., Nathan, A. & Rawski, E., eds, *Popular Culture in Late Imperial China* (Los Angeles, 1985).

Kalinowski, M. 'Cosmologie et Gouvernement Naturel dans le Lü Shi Chunqiu', *Bulletin d'Ecole Française d'Extreme-Orient*, LXXI (1982).

Keightley, D., 'The Religious Commitment: Shang Theology and the Genesis of Chinese Political Culture', *History of Religions*, XVII/3–4 (1978).

Kermode, F., *History and Value* (Oxford, 1988).

Knoblock, J., trans., *Xunzi: A Translation and Study of the Complete Works*, I/1–6 (Stanford, 1988).

Ko, D., 'Pursuing Talent and Virtue: Education and Women's Culture in Seventeenth- and Eighteenth-Century China', *Late Imperial China*, XIII/1 (1992).

Kohn, L., ed., *Taoist Meditation and Longevity Techniques* (Ann Arbor, 1989).

Lau, D. C., trans., *Chinese Classics: Tao Te Ching* (Hong Kong, 1982).

Lau, D. C., trans., *Confucius: The Analects* (Harmondsworth, 1979).

Legge, J., trans., *The Sacred Books of China: The Texts of Confucianism*, Part III, *The Li Ki*, I–X (Oxford, 1885).

Leyda, J., *Dianying: An Account of Films and the Film Audience in China* (Cambridge, Mass., 1972).

Liu, S. & Weichuang, S., *Pingju shiliao congkan* [Collection of Materials on Beijing Theatre], VII (Taipei, 1974).

Loewe, Michael, *Ways to Paradise: The Chinese Quest for Imortality* (London, 1979).

Lutz, C. & Abu-Lughod, L., eds, *Language and the Politics of Emotion* (Cambridge, 1990).

Lynn, R., 'Tradition and the Individual: Ming and Ch'ing Views of Yuan Poetry', *Journal of Oriental Studies*, XV/1 (1977).

Mackerras, C., *The Chinese Theater in Modern Times: From 1840 to the Present Day* (London, 1975).

Mair, V., ed., *Experimental Essays on Chuang-tzu*, Asian Studies at Hawaii, no. 29 (Honolulu, 1983).

Mann, S., ' "Fuxue" (Women's Learning) by Zhang Xuecheng (1738–1801): China's First History of Women's Culture', *Late Imperial China*, XIII/1 (1992).

McMullen, D., *State and Scholars in T'ang China* (Cambridge, 1988).

Mei, L., *Mei Lanfang wenji* [Collected writings by Mei Lanfang] (Beijing, 1962).

Mote, F., *The Intellectual Foundations of China* (New York, 1971).

Needham, J., *Science and Civilisation in China*, I– (Cambridge, 1954–).

Nelson, C. & Grossberg, L., eds, *Marxism and the Interpretation of Cultures*, (Champaign, Ill., 1988).

Owen, S., *The Great Age of Chinese Poetry: The High T'ang* (New Haven, 1981).

Peterson, W., Plaks, A. & Yu, Y., eds, *The Power of Culture: Studies in Chinese Cultural History* (Princeton, 1994).

Qian, Z., *Tan yi lu* [Discourses on the Arts] (Shanghai, 1948).

Ricket, W., trans., *Guanzi: Political, Economic and Philosophical Essays from Early China* (Princeton, 1985).

Ricoeur, P., *Lectures on Ideology and Utopia* (New York, 1986).

——, *Time and Narrative*, III (Chicago, 1990).

Ropp, P., 'The Seeds of Change: Reflections on the Conditions of Women in the Early and Mid-Ch'ing', *Signs*, II/1 (1976).

Schechner, R., *Between Theater and Anthopology* (Philadelphia, 1985).

Schwartz, B., *The World of Thought in Ancient China* (Cambridge, Mass., 1985).

Scott, A. C., *Mei Lan-fang Leader of the Pear Garden* (Hong Kong, 1959).

Shi, Z., *Tang shi bai hua* [One Hundred Lectures on Tang Poetry], (Shanghai, 1987).

Skinner, G., ed., *The City in Late Imperial China* (Stanford, 1977).

Smith, J. & William K., eds, *Interpreting Lacan* (New Haven, 1983).

Spence, J. & Hillis, J., eds, *From Ming to Ch'ing: Conquest, Region, and Continuity in Seventeenth-Century China* (New Haven, 1979).

Stallybrass, P. & White, A., *The Politics and Poetics of Transgression* (Ithaca, NY, 1986).

Steinhardt, N., *Chinese Imperial City Planning* (Honolulu, 1990).

Turner, B., *The Body and Society: Explorations in Social Theory* (Oxford, 1984).

Twitchett, D. & Loewe, M., eds, *The Ch'in and Han Empires, 221 BCE–CE 220, The Cambridge History of China*, vol. 1 (Cambridge, 1986).

Unschuld, P., Medicine in China: A History of Ideas (Los Angeles, 1985).

Views from Jade Terrace: Chinese Women Artists, 1300–1912, exhibition catalogue, ed. by Marsha Weidner et al. (Indianapolis, 1988).

Wakeman, F. Jr., *The Great Enterprise: The Manchu Reconstruction of the Imperial Order in Seventeenth-Century China* (Berkeley, 1985).

Waldron, A., *The Great Wall of China: From History to Myth* (Cambridge, 1990).

Waley, A., *Yuan Mei: Eighteenth-Century Chinese Poet* (London, 1956).

Wang, F. & Barnhart, R. M., *Master of the Lotus Garden: The Life and Art of Bada Shanren (1626–1705)* (New Haven, 1990).

Wasserstrom, J.N. & Perry, E., eds, *Popular Protest and Political Culture in Modern China: Learning from 1989* (Boulder, 1992).

Watson, B., trans., *Basic Writings of Mo Tzu, Hsün Tzu, and Han Fei Tzu* (New York, 1963).

Watson, J. & Rawski, E. S., eds, *Death Ritual in Late Imperial and Modern China* (Los Angeles, 1988).

Watson, R. & Ebrey P., eds, *Marriage and Inequality in Chinese Society* (Los Angeles, 1991).

Weed, E., *Coming to Terms: Feminism, Theory, Politics* (London, 1989).

Wheatley, P., *The Pivot of the Four Quarters* (Edinburgh, 1971).

Widener, M., ed., *Flowering in the Shadows: Women in the History of Chinese and Japanese Painting* (Honolulu, 1990).

Williams, R., *Problems in Materialism and Culture* (London, 1980).

Wilson, R., Greenblatt, S. & Wilson, A., eds, *Moral Behaviour in Chinese Society* (London, 1981).

Wolf, A. & Huang, C., *Marriage and Adoption in China, 1845–1945* (Stanford, 1980).

Wolf, M. & Witke, R., eds, *Women in Chinese Society* (Stanford, 1975).

Wong, S., trans., *Early Chinese Literary Criticism* (Hong Kong, 1983).

Wong, S., *Sociology and Socialism in Contemporary China* (London, 1979).

Woodward, K., *Aging and Its Discontents: Freud and Other Fictions* (Indianapolis, 1991).

Yoon, H., *Geomantic Relationships Between Culture and Nature in Korea* (Seoul, 1976).

Yu, P., 'Poems in Their Place: Collections and Canons in Early Chinese Literature', *Harvard Journal of Asiatic Studies*, L/1 (June 1990).

——, *The Reading of Imagery in the Chinese Poetic Tradition* (Princeton, 1987).

Zito, A. & Barlow, T., eds, *Body, Subject and Power in China* (Chicago, 1994).

Index